Lorenzo de' Medici

and

the Art of Magnificence

❧❦❧

THE JOHNS HOPKINS SYMPOSIA
IN COMPARATIVE HISTORY

The Johns Hopkins Symposia in Comparative History are occasional volumes sponsored by the Department of History at the Johns Hopkins University and the Johns Hopkins University Press comprising original essays by leading scholars in the United States and other countries. Each volume considers, from a comparative perspective, an important topic of current historical interest. The present volume is the twenty-fourth. Its preparation has been assisted by the James S. Schouler Lecture Fund.

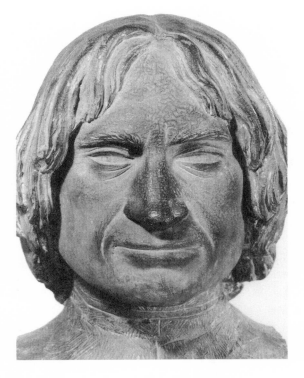

Portrait bust of Lorenzo de' Medici, Ashmolean Museum, Oxford

(*Ashmolean Museum, Oxford*)

Lorenzo de' Medici

and

the Art of Magnificence

F. W. KENT

The Johns Hopkins University Press
Baltimore & London

© 2004 The Johns Hopkins University Press
All rights reserved. Published 2004
Printed in the United States of America on acid-free paper
2 4 6 8 9 7 5 3

The Johns Hopkins University Press
2715 North Charles Street
Baltimore, Maryland 21218-4363
www.press.jhu.edu

Library of Congress Cataloging-in-Publication Data

Kent, F. W. (Francis William), 1942–
Lorenzo de' Medici and the art of magnificence / F. W. Kent.
p. cm. — (The Johns Hopkins symposia in comparative history ; 24)
Includes bibliographical references and index.
ISBN 0-8018-7868-3 (hardcover : alk. paper)
1. Medici, Lorenzo de', 1449–1492.
2. Statesmen—Italy—Florence—Biography.
3. Intellectuals—Italy—Florence—Biography. 4. Florence
(Italy)—History—1421–1737. I. Title. II. Series.
DG737.9.K46 2004
709'.2—dc22
2003016412

A catalog record for this book is available from the British Library.

Contents

Illustrations

Illustrations follow page 48.

Acknowledgments

This study began as a paper given at the international symposium "Verrocchio at Orsanmichele and Medicean Patronage in the time of Lorenzo the Magnificent" at the Metropolitan Museum of Art in New York in September 1993. I owe a debt of gratitude to Peggy Haines for then encouraging me to publish my findings; but not, she implied, before I had delved deeper into Lorenzo de' Medici's many-layered involvement in the visual arts. I recall in particular her injunction that I must undertake archival research into Lorenzo's role in the affairs of Florence's cathedral in order to show, in a famous phrase, "how it really was." During the 1990s I delivered revised versions of the original paper to audiences in London, Florence, and Melbourne, and I am grateful for the many helpful suggestions made to me by colleagues, especially art historians, on those occasions. Vivien Gaston insisted that I must attempt to discuss Lorenzo's taste and aesthetic formation, advice I have followed to the best of my ability.

This book remains, however, a historian's contribution to the art-historical debate on Lorenzo de' Medici and the visual arts. I have sought to provide a firm historical context, and a precise chronology, for his activities in this field and to publish such new documentary evidence as I have found. My purpose has not been to analyze stylistically the works of art and architecture associated with Lorenzo. If the present book eases the way for my art historian colleagues seeking to accomplish this task, then it will have succeeded in its aim. It also goes without saying that there is much more to say concerning Lorenzo de' Medici's magnificence, which he sought to express in myriad ways.

An essay has become a small book because I was invited to deliver the James S. Schouler Lectures by the Department of History of the Johns Hopkins University in October 1999. I am deeply grateful to my hosts in Baltimore for both the invitation and their warm hospitality; above all, to Richard Goldthwaite for his kindly encouragement at every stage and to Henry Tom, Joanne Allen, and their colleagues at the Johns Hopkins University Press.

The present monograph is a pendant study to my two-volume biography of Lorenzo de' Medici, in preparation. Although this is not the place to acknowledge the help of the scores of friends and colleagues who have helped me in so many ways with these companion projects, there is one exception that must be made. As I was preparing this manuscript for the Press in August 2002, Nicolai and Ruth Rubinstein died within ten days of each other in London. He, the greatest historian of Florence of his generation, had, as the Italians say, "followed" my research since the late 1960s, when I was privileged to write a Ph.D. thesis under his supervision; she, a fine scholar of the "after-life" of antique images in the Renaissance, took a friendly interest in my Laurentian studies, especially the present lectures. This small book is unimaginable without their large contribution to our field and the example they have been to all of us who follow.

Otherwise, for the moment it must suffice to single out for thanks Caroline Elam, references to whose pioneering essays on Lorenzo's architectural patronage and on Florentine urbanism liberally punctuate these pages, which she has also most generously read, thereby saving me from many errors of fact and interpretation. A brilliant, unpublished lecture she gave at the Courtauld Institute some twenty-five years ago on the subject of this study inspired my early interest in it. Alison Brown has read the manuscript, supplied many references, and been in every respect a friend both to this study and to its author. In the notes I have thanked other scholars who have alerted me to particular information or have kindly allowed me to consult unpublished papers and theses. It is only proper, however, that I acknowledge here not only Laurie Fusco's careful reading of the manuscript but also her extreme generosity in allowing me to read and cite her forthcoming book, the fruit of many years of research done in collaboration with Gino Corti, *Lorenzo de' Medici, Collector*.

Acknowledgments
❧ *xii* ❧

Dr. Corti has also been my expert research collaborator, as so often in the past, and I remain profoundly in his debt. Jill Burke and Cecilia Hewlett have discussed this study with me while acting, from time to time, as research assistants. It is impossible to describe with any precision the role of Wendy Perkins in the making of this book. Not only has she prepared successive illegible manuscripts with unequalled skill and patience but she has been research assistant, editor, and proofreader.

I have been supported financially in my research on Lorenzo de' Medici by grants from Monash University and the Australian Research Council. The Harvard University Institute for Italian Renaissance Studies provided me with ideal conditions to complete my research for this particular study during my visiting professorship there in 1995–96, for which period of busy leisure I am most grateful to the then director, Walter Kaiser, and my friends and colleagues at Villa I Tatti.

It must not go without saying that I acknowledge with pleasure the expert help of the librarians and archivists who have made my research possible, above all the staffs of the state archives of Florence, Mantua, and Milan, of the Warburg Institute in London, of the Berenson Library at Settignano, and of the Matheson Library at Monash University in Melbourne. Particular thanks go to the long-suffering Inter-Library Loan division of this last library. The Department of History at Monash University has been my academic home for my entire career, and I count myself very lucky to have had colleagues and students so supportive of my Italian research and so committed to our common intellectual enterprise.

The award of a Lila Wallace–Readers' Digest Grant for Publication Subsidy by Villa I Tatti enabled me to commission Ralph Lieberman to undertake a photographic campaign, the striking and beautiful results of which are found in the illustration gallery. It has been a privilege to work with him.

Carolyn James has persuaded me by her example to look north of the Apennines, not only the better to understand Lorenzo de' Medici and Florence but for the sheer pleasure of it. This study would not exist without her singular ability successfully to combine scholarly with domestic cooperation.

Acknowledgments

Lorenzo de' Medici

and

the Art of Magnificence

❧ ONE ❧

Introduction:

The Myth of Lorenzo

In the spring of 1477 the citizens of Pistoia responsible for erecting a tomb commemorating Cardinal Niccolò Forteguerri in the cathedral there made a considerable error of judgment. Writing to Lorenzo de' Medici, they asked the young leader of Florence's republican regime to choose between two models *(modelli)* for the monument: one by the sculptor Andrea del Verrocchio, who had first been given the commission but was charging too much, and another by Piero del Pollaiuolo. "Now to you, as to our protector, we send the said models, because you have a quite complete understanding of such things, and of everything else." So far so good. It was unwise of the Pistoian committee, however, to say that it had found Piero's model "more beautiful and more worthily crafted [*più dengnio d'arte*],"[1] for Lorenzo's reply, which does not survive, extracted from the unfortunate citizens the admission that it had been foolish of "persons with poor expertise" such as they to presume to judge "those matters in which we had little experience."[2] The matter was left in Lorenzo's hands, and Verrocchio, his favorite sculptor in the post-Donatello generation, finally obtained the commission. Truly major artist that he was, Verrocchio began what has been described as one of the most original funerary monuments of the period (Fig. 1). His remarkable terra-cotta model for the project can still be seen in the Victoria and Albert Museum.[3]

It was not mere flattery on the part of the Pistoian citizens to call Lorenzo de' Medici their "protector" and to defer to his "very complete

understanding [*pienissima intelligentia*]," at least of politics. Recent writers have emphasized Lorenzo's early assertion of authority over the government, institutions, and families of that faction-ridden provincial city in the 1470s, his creation of networks of dependants whom he helped in myriad ways—giving them dowries for their daughters, appointing them to administrative posts—in return for informal influence in the workings of government and the distribution of patronage. "So great have been the continual graces, favours and kindnesses received at different times and in various instances by your city from the magnificent and generous house of the Medici," declared the law of 1478 granting Lorenzo and Giuliano de' Medici the right to place their heraldic insignia within Pistoia's seat of government, "that it would be almost impossible . . . to list them in a manner that would do them justice."[4] The very strength of Lorenzo's influence in Pistoia in the 1470s, when the city found itself divided as never before, caused resentment and opposition, some of it expressed in the furor over the Forteguerri monument.[5]

In Florence itself, still a republic despite the growing Medici ascendancy after 1434, Lorenzo achieved many of his dynastic and political goals after becoming the family's leader in December 1469. This he accomplished by exerting his skills as what contemporaries called a *gran maestro* (literally, "great master"), what today might be described as a political boss, patron, or even fixer. More elaborately than Cosimo and Piero de' Medici before him, and perhaps more systematically, Lorenzo surrounded himself from a young age with webs of *amici*, friends and clients, with whose cooperation, and in the name of civic unity and friendship, he consolidated his informal authority over the city. By the 1480s we find Lorenzo referred to as a *maestro della bottega* (boss of the shop), a neologism expressive of his almost unique position as unofficial ruler of a proud republic. The Florentine *maestro della bottega* was not merely or only a distributor of "jobs for the boys," a Chicago-style "city" boss avant la lettre.[6] He was expected to be not only a "broker of power and influence" but "an arbiter, with a reputation for wisdom and judgement" in disputes between institutions and people of every class in the city, its territories, and even beyond.[7] Hence the Pistoian request that Lorenzo apply his superior understanding to the question of the Forteguerri monument.

For Lorenzo *maestro della bottega* and Lorenzo amateur and patron of art were one and the same person. As Niccolò Machiavelli so acutely observed, if "in Lorenzo you saw two distinct persons," then they were "more or less made one by an impossible fusion."[8]

Lorenzo was a remarkable man, then, who not only attracted but also orchestrated extravagant praise from humanist rhetoricians and pliant citizens, by whom he came to be regarded as a "true and living God," a new Solon, and so one might go on multiplying contemporary eulogies.[9] He himself contributed to the creation of the myth of Lorenzo de' Medici, wise and munificent statesman, which so burgeoned in the sixteenth century, first in the discussions in the Rucellai Gardens and later at the Medici grand-ducal court. He cannot have discouraged those humanists who called him a Maecenas—the first such reference apparently dates from 1468, when he was a mere nineteen years old[10]—and there is no reason to believe that, good musician that he was, he considered out of tune the chorus that in the 1480s sang his praises as a *bonus architectus* (fine architect), in the words of Cristoforo Landino,[11] an intellectual who, as Filippo Redditi expressed it, "has adorned and perfected the theory of architecture with the highest reasons of geometry."[12] Now, Landino was a Medici intimate, and Redditi and his brother were "long-time friends of our house," as Lorenzo himself put it.[13] It had been a late medieval topos of praise, too, to attribute to a ruler a rare appreciation of the liberal arts and of that noble occupation, architecture. According to Christine de Pisan, Charles V of France "se demoustra vray architecteur et deviseur certain et prudent ordeneur."[14]

Little wonder that from the 1960s onward scholars sought to demolish the myth, past and present, of Lorenzo the Magnificent—"one of the two greatest art patrons of all time," as J. K. Galbraith once remarked[15]— to demonstrate that his reputation is largely a creation of humanist rhetorical exaggeration, or *amplificatio,* and partisan deference. Shorter of funds than his ancestors, so the argument goes, Lorenzo was more interested in collecting antique *objets d'art* than in commissioning works from contemporary artists, more concerned to be an ultrarefined arbiter of elegance than to be an active patron. As the near contemporary historian Francesco Guicciardini said, by comparison with Cosimo, his grand-

father, Lorenzo "built almost nothing."[16] In this analysis, first proposed by Martin Wackernagel, given currency by André Chastel, E. H. Gombrich, and others, and still the view of many scholars, the Pistoian committee's reference to Lorenzo's "very complete understanding" of sculptural models tells us little about his knowledge of, and interest in, what we now call the visual arts, but it tells us a good deal about his exertion of a political authority that elicited—no, demanded—such exaggerated praise.[17]

This rigorous application of Ockham's razor to the myth of Lorenzo the Magnificent deserves to be taken seriously, although not when its motivation is a snobbish dismissal of the Medici as "parvenu bankers" in comparison with the seigneurial dynasties of northern Italy.[18] Any historian steeped in the incomparably rich archives of Florence is well aware of the complexities of that city's sophisticated society and of its ability to produce talented people. Lorenzo was, after all, one among many very able Florentines; and hero worship is always a dubious way to honor the distinguished dead. David Abulafia has engaged recently in a salutary cutting down to size of that other *stupor mundi,* Emperor Frederick II, from whose court Lorenzo possessed precious objects, by the way.[19] To be frank, both Quattrocento and contemporary scholarly praise of Lorenzo de' Medici can be little short of nauseating, and there has been an unhappy tendency in the recent literature—witness some of the publications that emerged from the celebration in 1992 of the five-hundredth anniversary of his death—to recreate the superman described in the Renaissance rhetoric, against which Gombrich and others understandably reacted forty years ago. Lorenzo's influence in this or that painting is asserted without a shred of documentary confirmation; his omnipresence and preeminence in all matters cultural are assumed without question.

We might consider several examples. Despite assertions to the contrary, Lorenzo was hardly the first, let alone the exclusive, exporter of the new Renaissance style to the kingdom of Naples; that prize should certainly go to members of the Strozzi family, no friends of the Medici, who had a strong sense of artistic *gusto,* or taste, and to the da Maiano workshop.[20] As for the newly found document that allegedly demonstrates that Lorenzo was the architectural patron of a confraternal meeting

place never before associated with him, San Lorenzino in Piano, it says no more than that his eldest son, Piero, donated some land, apparently for building, to that confraternity in early 1494, two years after Lorenzo's death.[21] Contemporaries began this bad habit of flattering hyperbole, sometimes insisting *pour encourager* the Medici themselves that the family's patronage, of ecclesiastical foundations in particular, had been more extensive than we have good reason to believe it was.

This tendency to adulate the Medici is all the more embarrassing for those scholars who do find hard evidence (if one can use that adjective in the postmodern era) that Lorenzo indeed had a more active and catholic interest in patronage of the arts than recent scholarship has maintained. It is disconcerting to give Lorenzo the Magnificent an inch, only to find that he and his admirers steal a yard. Discover him doing more things in more documents than the skeptics would allow, and someone else will uncritically go on to exaggerate the extent of his influence and activities. The myth of Lorenzo the Magnificent has evidently lost little of its seductive allure, and it is more than disconcerting to find his portrait illustrating an authoritative book on Renaissance Europe whose narrative begins one year after his death. It was rumored among the Florentine populace that in early April 1492 a seriously ill Lorenzo released a ghost (*spirito*) that he had long imprisoned in a ring on his finger, so causing a sudden lightning strike on the cathedral dome and the collapse of tons of precious marble, portents, it was said, of his death some days later.[22] In what follows it is my task, as enviable as not, to try somehow to release Lorenzo himself from the contra-myth that has recently imprisoned him without causing a new mythic explosion.

For the contra-myth about Lorenzo and the arts can be as resistant to evidence and to argument as the myth itself has been. If Lorenzo, in Guicciardini's words, built very little by comparison with Cosimo, it must be remembered that the former died at an age, forty-three, when most grand Renaissance architectural patrons, including his grandfather, were only starting out. Yet by 1492 Lorenzo had begun several major architectural projects that expressed an innovatory, modern taste informed by a studious appreciation of the antique. As Guicciardini also remarked, in a passage that is neglected by scholars, Lorenzo "delighted" not only in fine

books and music but also in "sculpture, painting, and architecture, rewarding and supporting all the men excellent in those arts," a view endorsed by Raffaele Maffei, a hostile contemporary witness.[23] Such concerns are increasingly well documented, and it can be foolish too quickly to dismiss as myth even the apparently more far-fetched traditional stories about Lorenzo as patron and amateur of the arts.

Years ago, for example, when I read in a Victorian guidebook that Lorenzo had contributed in a major way to the rebuilding of the Benedictine female convent of Le Murate in the early 1470s, I ignored this unsubstantiated claim because of the romantic context in which it was presented. Subsequently, the story turned up in a conventual chronicle of the late sixteenth century, and on further examination there was Quattrocento archival evidence to confirm it. This donation, discussed below, emerged as very probably Lorenzo's first, admittedly anonymous but not insubstantial, act of architectural patronage.[24] My skepticism on Lorenzo's supposed ability to influence the artistic and other affairs of Florence's cathedral, which was administered by the Wool Guild and remained a civic monument, also proved to be overcautious. Several months spent reading the records of the Wool Guild and of the Opera del Duomo, the cathedral works committee, revealed that very early in his ascendancy Lorenzo obtained considerable authority in both bodies, above all through an extraordinary new committee, the six *provveditori*. He also placed trusted allies in key positions in the Wool Guild. It had not previously been known that his beloved secretary and friend, Niccolò Michelozzi, was chancellor of the guild without interruption from 1475 onwards. By such means, it emerged, at the cathedral Lorenzo could influence everything from clerical appointments to what today would be called artistic policy.[25] Philip Foster had clearly been right in his suggestion some years ago that Lorenzo, in requesting the measurements of an unnamed church façade in 1476, was concerning himself with the completion of the Duomo façade, a project that certainly absorbed him fifteen years later. A very recent archival find demonstrating that there was an abortive façade competition in that year clinched Foster's point.[26]

Enough self-laceration. When Ascanio Condivi asserts in the mid-sixteenth century that marble for Lorenzo's projected library was being

worked in his sculpture garden near the church of San Marco, modern skeptics, for whom Condivi and Giorgio Vasari are the arch-Medicean mythmakers, dismiss this as a "mythic library."[27] There are sound reasons, however, for believing that Lorenzo was starting to build a library, almost certainly in the Palazzo Medici, toward the end of his life—Vespasiano da Bisticci had first suggested the general idea to him in 1472[28]—when Medici was furiously adding manuscripts, above all Greek texts, to his collection, an activity that demonstrated not only his love of learning but his "magnificientia," as Paolo Cortesi later wrote, magnificence a marbled library would appropriately have expressed.[29] There are several archival references of 1490 to "marbles [*marmi*] for your library,"[30] which, according to a reliable witness, was "half built" in 1494.[31] While in late-fifteenth-century usage *marmi* might mean sculpted marble heads, other documents make clear that, for whatever purpose, the Medici had a considerable marble hoard in their palace at the time of Lorenzo's death. Approval to sell "some pieces of marble" in the family's possession was granted by the authorities in early 1495,[32] and as we have recently been reminded, a contemporary document stated that marble held by the Opera del Duomo in 1500 and used to construct altars in the cathedral "had come from Lorenzo de' Medici's house."[33] An early-sixteenth-century document mentions where in the Palazzo Medici the library was to have been, marbled or not.[34]

As for that quintessential "myth," the sculpture garden presided over by the sculptor Bertoldo di Giovanni, where the young Leonardo da Vinci and Michelangelo Buonarotti learnt their trade under Lorenzo's benign eye, research by Caroline Elam has quite literally put the Medici garden firmly back on the Florentine map, from which our academic fathers had almost erased it: there it is in a later-fifteenth-century image, next-door to the church of San Marco and surrounded by cypresses. That there was ancient sculpture in the garden is beyond contradiction even if cautious scholars cannot confidently identify which surviving pieces might have been found there.[35] One does not need to claim that the sculpture garden was a precocious "academy" of the arts—it is chastening to remember James Hankins's recent demolition of the Platonic Academy of Marsilio Ficino—nor to imply that Lorenzo's magnificence somehow called

into being the genius of Michelangelo and other artists (Michelangelo certainly learned fresco painting in the workshop of Domenico Ghirlandaio about 1487) in order to agree with Elam and others that sculptors such as Michelangelo might well have worked on and learned from the antique statuary in the garden near San Marco.[36]

The enigmatic marble figure of a youth now in Manhattan and very recently reintroduced to the art-historical community by Kathleen Weil-Garris Brandt as the "Archer" may have been a fruit grown in this garden. I cannot comment on the controversy among connoisseurs aroused by her attribution of this innocent figure, with its "sweetish allure,"[37] to the very young Michelangelo. The one thing about which almost all scholars agree, however, is that whether the sculpture is by the young Michelangelo or by his teacher Bertoldo, it must be closely associated with, if it does not come from, the late Quattrocento artistic ambience of Bertoldo and his master, Lorenzo.[38]

Bertoldo *scultore* was indeed an intimate of Lorenzo's, as we shall see, and there are examples of the young Medici enjoying a domestic as well as creative relationship with artists, artisans, engineers, and intellectuals other than him. Angelo Poliziano, one of the finest poets of his day and a major classical scholar, has very recently been described as "this Medicean house-philologist,"[39] and the composer Heinrich Isaac was "a most beloved servant of the blessed memory of Lorenzo," according to one witness.[40] It is true that we know almost nothing of Leonardo's early years; David Brown's sensitive recent reconstruction has to be described as highly speculative, not least in the possible Medicean contexts suggested for some of the painter's youthful *oeuvre*.[41] The very opaque ambiguity of Leonardo's late observation that "[t]he Medici created and destroyed me," even if one grants that the reference is to Florence's leading family and not to "the doctors," sums up well our lack of knowledge.[42]

Michelangelo, however, is another matter, as the garden skeptics themselves admit. There is firm enough evidence of intimacy between Lorenzo and the youthful Buonarotti, even putting aside—and perhaps one should not—some of the suspiciously attractive biographical detail in the mid-sixteenth-century sources and the recent scholarly speculation that the two men would have considered themselves related on the dubious

grounds that Bernardo Rucellai, Lorenzo's brother-in-law, was a third cousin once removed of an obscure Rucellai kinswoman who had married Michelangelo's maternal grandfather, Neri del Sera.[43] He was described as "Michelangelo, sculptor, from the garden," in a letter of 1494, about which time, it is now clear, he sculpted the monumental Hercules under Medici aegis.[44] Later the painter Sebastiano del Piombo wrote to him, "I know the pope's regard for you [he means Leo X, Lorenzo's son], and he speaks of you as if you were his brother, almost with tears in his eyes, because he has told me you were brought up [*nutriti*] together, and he makes it clear he knows and loves you, though everyone's afraid of you, even popes."[45]

To be sure, one longs for more detail and further precision here, for less Cinquecento and more late Quattrocento testimony. There is, however, nothing inherently unlikely in the mid-sixteenth-century tradition that several exceptionally talented young artists, Michelangelo included, worked closely with, and were encouraged by, Lorenzo and his circle in the Medici garden near San Marco. Moreover, to seek to persuade the reader that Lorenzo de' Medici had an expert and catholic knowledge and appreciation of what we know as the visual arts, that "with a coherent plan" he had begun a notable career as an artistic patron before his early death, is neither to indulge in hero worship—to become "infatuated" with what Norman Douglas once described as "the squabbles of microscopic Tuscan princelings and the hallucinations of neurotic monks and carvers of saints"[46]—nor to succumb to what has wittily been called "florentinitis,"[47] an almost terminal obsession with things Florentine.

The Aesthetic Education of Lorenzo

] 1 [

Lorenzo de' Medici himself, along with almost all of his fellow citizens, suffered from an absorption in, not to say obsession with, Florence and its traditions, past and present. He writes of "my Florence" and "my beloved city" in his early poem the *Simposio,* which evokes the familiar urban sounds of his upbringing in the Palazzo Medici, next to the family church of San Lorenzo and near to the sacred and civic heart of the city.[1] Lorenzo derived his very sense of scale from the experience of living beside the two grand buildings that had long dominated Florence's urban center. When forced by floods in the summer of 1464 to clamber up the high tower of the Medici villa of Cafaggiolo, he told his father that "we would have given the cupola [of the cathedral] or the tower of Palazzo Vecchio a run for their money" (Fig. 2).[2] These two civic monuments were to captivate him throughout his life. The young Virginia Woolf thought there was "something homely in [the Duomo's] appearance," and even more surprisingly, if rather appealingly, she compared this beautiful city nestled amid hills "to a great basket of white & brown eggs."[3] No such domestic images occurred to fifteenth-century Florentines. "I seem to have returned to Paradise," the goldsmith Marco Rustichi wrote in 1448 in the manuscript in which he has obligingly left us scores of sketches, unparalleled in their precision, of Florentine churches.[4] There is no reason to believe that even the skeptical Lorenzo de' Medici, whose youthful travels revealed to him the distinctive beauties of many other Italian cities, would have dissented from this artisan's sense that fifteenth-century Florence was a special place indeed despite,

or because of, the fact that the proud citizens of other Renaissance towns in Italy and elsewhere vociferously declared that they too lived in heavens on earth. Lorenzo's own house, the huge, rusticated Palazzo Medici, built by Michelozzo Michelozzi for Cosimo de' Medici in the late 1440s, was described as a terrestrial paradise by noble Milanese visitors whom the boy Lorenzo had helped to entertain there in 1459 (Fig. 3).[5]

To establish their uniqueness, Florentines pointed to their proud republican traditions, preserved since the early communal era despite an almost irresistible tendency on the part of self-governing councils elsewhere in Italy to succumb to princely authority. Some contemporary intellectuals argued—and have persuaded many historians to agree—that Florence's republican constitution and egalitarian ethos were essential preconditions for the growth of the literary and artistic movements that scholars call the early Florentine Renaissance. However one might "explain" the Renaissance—and since the Quattrocento itself historians have elaborated scores of explanations—the cultural achievements of the generation of Leon Battista Alberti, Donatello, Lorenzo Ghiberti, Filippo Brunelleschi, Masaccio, and others were and are unassailable. The Florentines themselves, intensely self-conscious and articulate, wrote descriptions of this first Renaissance that have retained their power to move, despite repetition ad nauseam. Alberti, after his return to Florence, expressed his feelings of wonder upon seeing the great cathedral dome designed by Brunelleschi (or "Pippo," as he familiarly called the architect), which seemed vast enough to shelter all Tuscany.[6] The merchant Giovanni Rucellai, Alberti's most important Florentine architectural patron, who grew up amid, and then contributed to, these stirring cultural events, later recorded his intense pride at having been born in Florence, the navel of the world, at precisely the right time. No Florentine had ever possessed Cosimo de' Medici's political acumen and authority, Rucellai enthused in his commonplace book, congratulating himself on the Medici marriage his elder son, Bernardo, had made. Giovanni described the Aretine humanist chancellor Leonardo Bruni, who had written the most celebrated eulogy of his adopted city, as the most learned man of his time, indeed of almost any time. As for Brunelleschi, who possessed "incredible genius and imagination" and had "rediscovered the old

Roman way of building," he was simply the greatest architect since antiquity itself.[7]

By the time Lorenzo was born, in 1449, his grandfather, Cosimo, who had dominated the city's politics for thirty years after he and his "party" or faction triumphed by constitutional means in September 1434, had begun successfully to graft onto the stock of an older tradition of civic pride a burgeoning belief that Florence's achievements in midcentury were largely owed to the Medici, a partisan proposition to which guidebooks still often subscribe. According to the family's apologists, Cosimo, his family, and his party had united and strengthened a city long given over to internal factionalism and threatened by hostile external powers, allowing its old civic culture to transform itself in emulation of the classical civilizations. Of course not all Florentines agreed: the Medici were the worms devouring the rose, the devils in Paradise indeed, according to their erstwhile friend Agnolo Acciaiuoli in 1465.[8] By the late 1450s some of Cosimo's other allies, long bound to him by the clientelist threads of loyalty he so expertly spun, had come to believe that the constitutional controls promoted by the regime of which they had been a part posed a threat to the republican institutions and civic culture inherited from their late-thirteenth-century ancestors. Such men also increasingly feared the dynastic ambitions of Cosimo and his family, made manifest in their building program. They moved against Piero di Cosimo in 1465–66, when the teenaged Lorenzo acted ably as his father's lieutenant in restraining their open aggression. In August 1466 the youth rode "armed to the teeth" into the Piazza della Signoria to proclaim the regime's triumph at a popular gathering to ratify new constitutional arrangements.[9]

Nor would modern scholars accept that the Medici "created" the Florentine Renaissance; rather, they would point out that Cosimo was only one of a number of important and innovative artistic patrons, especially during the crucial second and third decades of the fifteenth century, which witnessed the creation of so many of the classic early works of the movement. They would emphasize, moreover, that these original works of art were created by a whole, complex, urban society whose gifted and competitive artisans, artists, and intellectuals shared—and were in the process of further defining—a common civic culture with patrons who

were themselves a varied assortment of individuals (both famous and obscure), groups, and institutions.[10]

Still, by Cosimo's death in 1464 the Medici had assumed a dominance in Florentine society and politics to which no family had ever pretended. Cosimo was declared *pater patriae,* father of his country, immediately upon his death, and he became the object of an almost cultic veneration. Humanist exaggeration aside, Cosimo had indeed invested money, good taste, and energy in his great building program—the palace, the churches of San Lorenzo and San Marco, the country villas—and was not only a formidable statesman and diplomatist but also a consummate behind-the-scenes political manager, a *gran maestro,* as contemporaries had it. The young Lorenzo clearly admired his grandfather, though we know little about their personal relationship. In two early fragments Lorenzo echoed the widespread judgment that Cosimo was "the wisest of men . . . a most famous man and endowed with many and singular virtues." His grandfather had left the city "peaceful within and without, with grain in great abundance and happier than it had ever been."[11]

The youthful author of these words is sometimes portrayed as having been almost a playboy princeling before he accepted leadership of the regime, aged just twenty, in early December 1469. He himself wrote several years later of his reluctance to assume his father's political role because of his youth and the peril involved; it has been suggested that he lacked the diplomatic experience and knowledge of foreign affairs so crucial to Medici authority both at home and abroad. Lorenzo's adolescent years certainly seem to have about them a fairy-tale quality; the intimate correspondence of his *brigata* (company of friends) is full of allusions to music, dancing, storytelling, and lovemaking. There is the pathos of his doomed love for Lucrezia Donati, to whom many of his juvenile poems are addressed, a young married gentlewoman so compelling that Sigismondo della Stufa wrote to an absent Lorenzo in March 1466 describing how she looked as she left church: "[Y]ou never saw anything so beautiful, dressed in black and with her head veiled, stepping so gracefully that it was as if the very stones and walls should worship her as she passed. I will say no more, lest you be tempted by sin in this holy season."[12] The celebrated joust in which Lorenzo inevitably emerged the champion was

to follow in early 1469, in which year he was also married to a Roman noblewoman at a sumptuous wedding ceremony that went on for days. "O Magnificent Lorenzo, mirror of youth," one man addressed him in 1465.[13] Little wonder that the death of his father in late 1469 might appear to have prematurely slammed the door on a charmed, even feckless youth.

It is beyond doubt that the adolescent Lorenzo, fortunate enough to have the wealth with which to satisfy his many curiosities, had enjoyed himself during the 1460s, not least on his numerous journeys throughout Italy, to which we shall soon return. He had also displayed an occasional irresponsibility and even rebelliousness, in 1466 earning a telling rebuke from his devoted tutor, the priest Gentile Becchi: "You should take a harder look at yourself, esteem more those who esteem you; do not be tricked into situations by one of your 'leave it to me's.'"[14] The major themes of Lorenzo de' Medici's youth were hardly rebelliousness and fun-seeking, however. Indeed, his desire for pleasure and his occasional restlessness are best interpreted as understandable given the yoke of responsibility imposed on him by family and civic expectation, as well as self-inflicted because of his own striving nature. Urged on by his dynastic instincts and by family and friends and possessed of a competitive drive that stimulated his precocious intellect into action, Lorenzo realized early on that life was real and life was earnest and that given the recurrent illnesses of Piero, his father, in the 1460s and the intermittent death threats faced by all of his family, he needed to become another Cosimo as soon as possible.[15]

Lorenzo had acquired very little direct experience of diplomatic negotiation by the time he began to lead the regime Cosimo had founded. He had, however, traveled extensively in Italy, first visiting Milan, his family's powerful ally, for the marriage of Alfonso of Aragon and Ippolita Sforza in 1465. In the next year, en route to Naples "to visit His Majesty the King and associate with those lords," as his father expressed it,[16] he had an audience with the pope in Rome and deputized for Piero in the signing of a commercial contract. His extensive traveling in his teens constituted an apprenticeship in grasping the ways of the Italian courts and becoming acquainted with their leading lights, in testing himself in a world full of dissimulation and intrigue. "Be alert, . . . a man and not a

boy," his father had enjoined him before his first trip to Milan, "and make every effort to be both careful and clever in learning how to undertake even greater tasks, for this jaunt can show the world what you can do."[17]

A precocious learner with "a most supple intellect," according to the Milanese ambassador to Florence in May 1469,[18] Lorenzo was in fact more experienced in domestic politics than in diplomacy at the time. "Notwithstanding his being under age," as the enabling law admitted, he was elected to the powerful republican Council of One Hundred, in December 1466, possibly in recognition of the active role he had taken in defeating the anti-Medicean forces during the partisan crisis earlier that year.[19] At precisely this time he joined several of the lay religious confraternities, which were ubiquitous in Florence and throughout western Christendom. Fragmentary evidence suggests that his membership in these institutions, which were at once pious and political associations, allowed him to keep an eye on dissenters and to consolidate support for his father's regime, which is not for a moment to deny his own urbane religiosity. He was already emerging as a back-room political manager in another respect, receiving letters from would-be clients when he was only ten or so. His own first two surviving letters, of November 1460 and September 1461, are responses to such requests for political and other favors.[20] As Lorenzo was later to lament, he spent the rest of his life reading and writing letters and giving audiences to clients. Hardly yet the *maestro della bottega* he was to become, Lorenzo was nevertheless already an accomplished *gran maestro* in his own right at the time of his father's death. Despite his tender age, his assumption of authority in a regime dominated by mature and elderly men was smoother than some observers had expected because his family had carefully prepared the way and he had schooled himself with discipline and intelligence for the role.[21]

] 2 [

Very early in his arduous political and diplomatic apprenticeship Lorenzo began to cultivate his own intellectual interests and to seek to emulate his elders in their pursuit of the Medici family's cultural program. By about the age of fourteen he was writing respectable, if unoriginal, love poetry in the Petrarchan style—he so delighted in "the greater refine-

ment" of the composer Guillaume Dufay that in 1467 he had Antonio Squarcialupi ask the musician to set one of his poems to music—and interesting himself in the collecting and copying of expensive books. He was also adding to his family's notable collection of *anticaglie*—antique coins, medals, sculpture, and jewels—the beginning of a lifelong fascination with "anything precious and rare."[22] At the same time, Lorenzo began to serve, despite being technically underage, on the works committees (*opere*) that advised on the construction, adornment, and maintenance of Florence's ecclesiastical and communal buildings.

Lorenzo's precocious membership on these works committees and his early collecting of books and *objets d'art* were at once political and civic acts and expressions of aesthetic preference. It is beside the point, I would submit, to argue that "the central problem posed by Lorenzo's role as art-patron" is to decide whether Lorenzo was "sincerely preoccupied with the arts and with learning" or "[used] them as part of the process of political management by means of which he dominated Florence."[23] For Lorenzo and his contemporaries would not have distinguished, indeed could not have distinguished, between the world of the arts and politics in this way; they did not find it strange, questions of flattery and *amplificatio* aside, that a talented person might have a refined knowledge of both. For Quattrocento people, *arte* meant "skill," sometimes "cunning,"[24] or referred to a trade guild. It is an unavoidable anachronism to speak now of Lorenzo's passion for the visual arts. He would have said that he was an *intendente* (an expert or informed person) who loved architecture and *muraglie* (buildings), *anticaglie* (antiquities), and *scultura* (sculpture), although it has been suggested that in his refined and superior collector's sensibility we may find the germ of the idea of art for art's sake.[25] His skill—*arte*—as a political mediator informed and gave authority to his interventions in what we would call aesthetic or artistic matters, his lifelong involvement in which was almost inseparable from his role as a civic, dynastic, and factional leader.

Some of Lorenzo's earliest known contacts with artists had nothing directly to do with "art" at all; or, rather, it is probably futile to imply such a distinction. A letter of 1467 to Lorenzo from the painter Benozzo Gozzoli, who had of course frescoed the private chapel of the Palazzo

Medici in the preceding decade, was a standard, if elaborate, thank-you note for a Laurentian intervention on behalf of a wayward apprentice.[26] Fra Filippo Lippi wrote to the young Medici the next year tactfully refusing to interfere in an ecclesiastical election.[27] Lorenzo is here a patronal boss dealing with clients who happen to be famous painters, yet it is safe to say that he would have been acutely aware of their artistic prestige and of his elders' admiration of their work. Lorenzo was, I shall argue, a formidable Renaissance patron in the several Quattrocento and modern senses of that slippery word, in the definition of which European languages other than English are so much more precise than ours. Contemporaries called him *patrone,* "boss," and he enjoyed patronage rights *(ius-patronatus)* over a number of ecclesiastical foundations. He also exercised patronage of the arts in the modern sense *(mecenatismo)* and was a master of political patronage and clientage *(clientelismo).*[28]

Young Lorenzo's immersion in politics and in patronage in its several senses from his early teens on equipped him admirably for the major civic role he was to assume. From his mother, Lucrezia Tornabuoni, and his father, Piero, from his uncle Giovanni and his grandfather Cosimo, he inherited attitudes and patterns of behavior, some of which were enduring. These Medici had not cared to distinguish—even if they had possessed the vocabulary with which to do so—their celebrated patronage of the arts, especially architecture and sculpture, from the fulfillment of their civic duty to manifest magnificence, not to mention the collective compulsion to pursue their dynastic aims to which John Paoletti and other scholars have drawn our attention.[29] The family's obvious love of fine and expensive objects—books, coins, cameos, ancient sculptures—was almost impossible to disentangle from the prestige acquired by their acquisition. Their professional relationship with an architect such as Michelozzo Michelozzi, who worked extensively for them, was almost indistinguishable from their patronal friendship with him and his son, Niccolò, who became Lorenzo's secretary and confidant.[30] It is too easily overlooked that several apparently distinctive aspects of Lorenzo's concern for art and architecture owe a good deal not only to ancestral example but also to an already venerable civic tradition. The contemporary eulogist who after Lorenzo's death saw his magnificence in the con-

text of an older dynastic generosity toward a city that had created a Dante and a Petrarch at a time when, he might have added but wisely did not, the Medici were troublesome minor country gentlemen only recently established in Florence was certainly correct.[31] The classic modern account of Lorenzo as a distinctive, almost overrefined third-generation personality in the "typical rhythms of generations in a powerful family"[32] oversimplifies earlier Medici and, indeed, Florentine behaviors.

As a practitioner of artistic diplomacy, Lorenzo was elaborating upon Cosimo's example, and both men were taking upon themselves a role other civic leaders, as well as the Florentine republic itself, had exercised.[33] When in the 1470s the grandson began to act as an arbiter in matters of artistic dispute, he was assuming a role in which his father had been preeminent.[34] Although Piero di Cosimo had a more ornate and decorative taste in painting than his son was to develop, the two shared a passion for mosaics and for gorgeous manuscripts; witness Lorenzo's commissioning from the miniaturist Francesco d'Antonio del Chierico in 1476 the magnificent illuminated copy of works by Dante and Petrarch recently on display at London's National Gallery.[35] At home Lorenzo chose to surround himself to his dying day with expensive Flemish art, paintings on canvas collected so assiduously by his father in particular; it is not known whether he bought any for himself.[36] If the sculptor Bertoldo became Lorenzo's "household" sculptor[37] and Andrea del Verrocchio became a Medici "court artist,"[38] there are intriguing earlier references to artists associated domestically with Cosimo: the painter and sculptor Andrea d'Aquila[39] and the painter Giovanni Angelo da Camerino.[40] Lorenzo, as it were, inherited Verrocchio—enthusiastically, it must be said—from his elders, and toward the end of his own life Lorenzo employed the son, Filippino Lippi, of another artist beloved by them, Fra Filippo, whom he also honored in the cathedral at Spoleto.[41]

Giovanni di Cosimo, who in other respects was a role model for his nephew Lorenzo, was experienced at managing building programs and had a well-developed aesthetic *appetito* (taste), as a friend put it. Architectural historians agree that Giovanni's villa begun at Fiesole in the early 1450s had a strong stylistic influence on Lorenzo's later Poggio a Caiano (Fig. 4). Giovanni di Cosimo's architectural advice to Francesco Sforza

in 1456 might well have come from Lorenzo's pen decades later. Since the hospital the Sforza prince was planning to build in Milan would be "an undertaking of very great expense and importance, much honor and dignity," Giovanni wrote, "one should see many designs by different masters and should choose the best after careful scrutiny. And because here [in Florence] there are many extremely able masters, I have commissioned each of them to make a number of different models." Giovanni judged Bernardo Rossellino's model to be the best and said that "these days he is without equal."[42] It has been speculated that Lorenzo may have been inspired to undertake his several urbanistic schemes—and much else—by the example of his cultivated mother, Lucrezia, who pioneered an entrepreneurial project for commercial development in Pisa in the 1460s and 1470s.[43]

If one may be granted a little imaginative license, it is possible to suggest some of the ways in which Lorenzo might have absorbed these ancestral influences. Growing up in the new Palazzo Medici, into which the family moved when the boy was nine or ten, surrounded by the ancient and medieval treasures and modern sculptures and paintings accumulated by his ancestors, Lorenzo was constantly assailed by sensations at once physical and aesthetic. Opulent beauty was his birthright and, so to speak, his death rite. When he was a newborn, had his eyes been able to focus, perhaps Lorenzo's first sight would have been the sumptuous birth tray painted for his mother. Executed by Giovanni di ser Giovanni, Masaccio's brother, called "lo Scheggia," and now in the Metropolitan Museum in New York, it displays the coat of arms representing both the Tornabuoni and Medici families and the Medicean device of the diamond ring laced with feathers bearing the motto "SEMPER." With sure prescience, his parents had decided that the salver, which Lorenzo kept in his private rooms throughout his life, should also depict a Triumph of Fame.[44] Forty-three years later, in the Medici villa at Careggi, near Florence, he died contemplating a still more precious object. "Last of all he cast his eyes down," his friend Angelo Poliziano recorded, "and gazed upon the silver figure on the crucifix, which was superbly set in pearls and gems, and ever and anon he kissed it, and so he passed away."[45]

It is useless to pretend to know precisely what Lorenzo made of this

upbringing, of this almost relentless exposure to some of the most beautiful and precious objects his age knew. Very plausibly one can imagine him staring shortsightedly, aged ten, at Benozzo Gozzoli's team as it frescoed the new palace's private chapel, absorbing how the work was done and discussing with the master painter and his own family what we would call the iconography of this gorgeous and many-layered work.[46] The sharp-faced boy himself gazes back at us still from Gozzoli's masterpiece, but it would be absurd to guess what he is thinking (Fig. 5). In his youth Lorenzo met artists other than Gozzoli—in lay religious confraternities, among other places—and he surely visited artists' *botteghe,* as his peers certainly did when there was something novel to be inspected.[47] Perhaps he knew early on the author of his birth salver, "lo Scheggia," who was an acquaintance of his own later associate and friend, the woodworker-engineer Francione, which translates as "Big Frank." Piero de' Medici or conceivably Lorenzo himself had commissioned from this man, Masaccio's brother, a painting depicting Lorenzo's triumph in the joust of 1469, a huge and expensive work still to be found in the Palazzo Medici in 1492.[48] It is particularly easy to believe what one cannot prove, that the young Lorenzo frequented Andrea del Verrocchio's workshop, so fertile of talent and much favored by his family. There in the 1460s and early 1470s Lorenzo would have seen some of the most exquisite drawings ever created in Renaissance Florence, which was "almost synonymous with drawing."[49] In Andrea's workshop, we might surmise, Lorenzo came to understand the Florentine artisan obsession with the practice and power of drawing, to appreciate the central role of design (*disegno*) in the creation of beautiful objects in several genres. The very phrase *maestro di disegno* (design master) emerged during the decades when Lorenzo was young.[50] Giovanni Rucellai, who married into the Medici family and in his time was the most significant patron of architecture in the city after Cosimo, used the phrase twice in his commonplace book, to describe the goldsmith Maso Finiguerra and Antonio del Pollaiuolo.[51]

As has been recently observed, it is difficult to believe that the poet Lorenzo who so sensitively described his first love's beauty—"her skin a warm and living white . . . her face serious and without conceit, sweet and pleasing, without a trace of flightiness and commonness . . . her hands the

most beautiful Nature had ever wrought"[52]—would not have been appreciative of the incomparable woman's hands Leonardo da Vinci created in a drawing now at Windsor, would not have admired and learned from the portraits of women sketched by Leonardo's master, Verrocchio, such as the beguiling drawing now at Christ Church, Oxford.[53] Again, this can only be (reasonably informed) speculation, and I am not convinced enough by the claims of those historians who fill in the awkward silences in the documents by creating "inferred narrative"—"thought-experiments," as Natalie Davis has it[54]—to contemplate taking any further this attractive but perilous practice. Suffice it to say that Lorenzo's upbringing and his surroundings were such as to make it absolutely explicable that in his maturity he sat, as willingly as Cosimo, Giovanni, and Piero de' Medici had done before him, in a study replete with precious and beautiful objects—half treasure house, half sacristy;[55] that he became quite as keen to commission sculpture and construct villas as his ancestors had been; and that he became interested, too, in building on their achievement in an innovative and, given his temperament, competitive way. Just occasionally a flash of direct evidence shows that the youth was indeed caught up in all this Medici activity. It is telling that in the late summer of 1468, when the factor at the Medici villa of Cafaggiolo reported to Piero on building activity there, he at once added: "Lorenzo has the urge to level the piazza here in front of the villa. We will do what he says, and keep you informed."[56]

] 3 [

Young Lorenzo acquired his knowledge of and passion for building and sculpture in particular not only through dynastic example, by soaking up the family atmosphere, but in a way that may surprise those readers who are incurably romantic about his "magnificence." He did so as a member of numerous *opere,* those ubiquitous civic bodies to which scholars are now giving belated attention. Lorenzo first became an *operaio* in 1463, when he was just fourteen years old, replacing his uncle, Giovanni, on the works committee of the convent of Santa Brigida, which was under the protection of the Guelf Party. The humanist Bartolomeo Scala, a Medici client and chancellor of Florence, correctly regarded this precocious appoint-

ment as the start of a civic career, citing Matthew 6:33: "But seek first his kingdom and his righteousness, and all these things shall be yours as well."[57] What the boy did in this office we do not know, and it would certainly be foolish to imagine that he contributed much to its deliberations. However, we should not underrate this particular teenager's sharp receptiveness—he began writing respectable Petrarchan poetry at about this age—or the astute strategic sense of his Medici elders and their oligarchic friends, who put him in this and other civic magistracies to educate him in government and teach him the delicate art of pursuing dynastic and factional objectives by persuasion and, if necessary, by the application of subtle pressure. At once a good republican citizen, if somewhat young, and a rising star in the Medici dynasty, Lorenzo was soon appointed, in 1466, by the Mercanzia tribunal to the works committee responsible for commissioning the *Christ and St. Thomas* of Verrocchio. The teenaged Lorenzo was regarded, in the words of the document, as "capable and worthy" of replacing his busy and ill father.[58] This marvelous bronze sculpture took years to complete, and "the men who planned and directed work on [it] were Lorenzo de' Medici and his closest political allies."[59] Placed at the church of Orsanmichele, in the center of Florence, the sculpture was a major civic monument—the chemist-chronicler Luca Landucci remarked that it was "the most beautiful thing you could imagine and the finest head of the Savior that has existed"[60]—and it had a more private meaning for the Medici, one of whose patron saints was Saint Thomas (Fig. 6).[61]

In 1468 Lorenzo, aged just nineteen, was named one of a committee of fifteen "venerable citizens" and sixteen artisans—"the very best, most wise and knowledgeable" men—who were to offer "mature counsel and a complete scrutiny in arriving at the best and the most perfect conclusion" concerning the vexed issue of how to crown the Duomo's cupola with an immense bronze orb (*palla*), a commission that, after a false start, went to Verrocchio (Fig. 7).[62] The young Medici's role was not merely consultative, since the family bank was involved in the commission.[63] In the same year, he began a term of four years on the *opera* of the Servite church of the Annunziata, a Marian shrine of cultic importance to the Florentines in general and to the Medici family, whose houses were nearby.

Lorenzo de' Medici

Within this church the ruling family of Mantua, the Gonzaga, were building their controversial tribune.[64] Over the same period Lorenzo served as a canal official, and from 1469 on he officially sat on the building committee of the Guelf Party.[65]

It should be emphasized that Lorenzo continued to take such positions throughout his life despite his manifest reluctance to join republican magistracies other than those bodies crucial to his maintenance of authority, namely, the Council of Seventy, the Seventeen Reformers, the Accoppiatori, and the Monte officials. Though he would never sit on the Signoria as a prior or be a gonfalonier of company, he was later to become an *operaio* of the Palazzo Vecchio, which was the seat of government, the Franciscan establishments of La Verna and San Salvatore al Monte, the church of Santo Spirito, the confraternity of San Paolo, and other bodies. As one of the six *provveditori* of the Wool Guild for two decades after 1472, he was able to exert influence on the Opera del Duomo itself. Now, it must be admitted that the Medici leader was frequently absent from meetings of these *provveditori* and no doubt from those of other works committees to which he belonged.[66] Yet there can be little doubt that he was kept well informed about their deliberations and could influence them when he wished, not least because his colleagues on the more important committees were almost invariably his closest *amici* and partisans.

Lorenzo's intimate knowledge of the pool of sculptural talent available in Florence—expertise of which non-Florentines later availed themselves—must in part have been born of this association with the Opera del Duomo and its team of professional stonemasons and sculptors. When the duke of Milan asked Lorenzo in 1489 to suggest a sculptor who might execute the ambitious design for a Sforza funerary monument, for example, he replied, "I have turned over [the design] in my mind . . . and the result is that I do not find a master who satisfies me." He apologized for this Florentine "shortage and failing," but his severe judgment may not have been completely sincere—witness his admiration of the mature Verrocchio and Antonio del Pollaiuolo—or perhaps he meant that there were no up-and-coming young sculptors.[67] It is interesting to speculate that Giorgio Vasari's much later statement that Lorenzo had wanted Bertoldo to instruct young sculptors in his San Marco garden because

there was "in his time . . . to be found no such noble and celebrated sculptors as there were painters of the highest worth and fame"[68] may reflect some knowledge of this pessimistic reply to the Milanese lord, whatever its original meaning.

That Lorenzo also learned a good deal about organizing building operations, about dealing with master artisans and judging their architectural models and designs, we can glean from looking closely at his experiences as one of the republic's Canal Officials in 1468–72, 1474–76, and later. When it first emerged that Lorenzo had assumed this office in August 1468,[69] even before becoming leader of the regime, and long maintained his connection with it, one was intrigued to know why. Surely the Medici heir apparent, the exquisite connoisseur in-the-making of ancient *objets d'art,* had better things to do than to participate in this unglamorous magistracy of which almost no scholar seemed to have heard, although several contemporaries noted its establishment and mentioned its activities.[70] Why was the young Lorenzo mucking about not in boats but with canals?

Set up in 1458, the Canal Officials were charged with making the Arno navigable from Pisa to Florence itself, a truly ambitious scheme with obvious commercial and strategic implications for the city, which the architect and engineer Luca Fancelli later revisited in a letter of August 1487 to Lorenzo,[71] whose family, with its own economic interests in the Pisan countryside and galley trade, had clearly supported, if not created, the idea. It would bring "so much utility, magnificence and glory" to the republic, the enabling act stated.[72] Cosimo was one of the first officials, and even though the office was reserved for citizens over thirty-five years old, Lorenzo assumed the office ten years later, at age nineteen, probably to help maintain the momentum, since the anti-Medicean priorate of Niccolò Soderini had somewhat earlier canceled the scheme. According to the new legislation, Florence could do nothing "more worthy nor bring greater practical benefit, reputation, and honor" to the city and to Leghorn than by finishing the project, on which so much had already been expended for costly stone and marble.[73] By early 1467 the officials of this politically sensitive committee, which worked from a large house (with the notary of the Signoria itself acting as secretary),[74] had

changed their focus. They were now responsible for the still formidable task of excavating a canal between Pisa and Leghorn, as well as for the building, maintenance, and even provisioning and manning of the fortresses of those two maritime cities, where they also had a certain jurisdiction over navigation.[75] Later the Canal Officials were assigned the care of other major Florentine frontier strongholds such as Cortona and Sarzanello,[76] and even before the Pazzi war, of 1479–80 began, they were entrusted with "the general supervision of all fortresses" when it was decided that their repair and maintenance was of the greatest urgency after Giuliano de' Medici's assassination.[77]

Precisely what Lorenzo did as a canal official we cannot be sure. His older colleagues were certainly expected to travel around the Florentine domain gathering information and giving advice, at least until they obtained the dignity of knighthood,[78] and perhaps he occasionally joined in. On his way north in July 1469 he inspected the fortress of Sarzanella, with whose rebuilding he would be concerned in 1487, and pronounced it "a really good acquisition."[79] On his frequent trips to Pisa, a city he loved, he surely inspected the impressive fortifications reaching completion there, including the "great and worthy tower of Porto Pisano," singled out by Benedetto Dei as one of the major building projects of about 1470,[80] and met and talked with the same engineers and master builders with whom he was, we know for certain, to be so familiar in the next decade. In addition, during his travels and at home Lorenzo would have imbibed the experience and expertise of the class of Florentine citizens of which he was to become a remarkable example, the class that specialized, so to speak, in military engineering. The captain of the strategic fortress at Castrocaro thanked God in July 1471 that the architect Giuliano da Maiano had arrived there because the man in charge of works at Monte Pogguolo, "though a good master builder, has little imagination and less sense of design,"[81] a sophisticated judgment that Lorenzo de' Medici himself might later have articulated in praising this architect and military engineer with whom he became closely identified in the 1470s and 1480s.

Because the Canal Officials were, in the words of a law of 29 July 1472, "men with demonstrated experience in building," they were instructed

to oversee the urgent erection of the new fortress and tower, the Maschio, at Volterra, which the Florentines had reconquered shortly before.[82] During the early period of its construction Lorenzo apparently left the magistracy, although he did inspect work in progress in February of the next year, when he went to Volterra "to see those castles of ours," as a correspondent noted.[83] He was again a canal official in 1474, when the grim but beautiful structure, which is still a high-security prison, was judged to be "turning out worthily and almost impregnable" (Fig. 8).[84] It should come as no surprise that Lorenzo demonstrated as keen an interest in military architecture as other Florentine oligarchs traditionally had done. Moreover, despite his own lack of military prowess and his careful avoidance of martial metaphors to justify his family's dominance, as leader of the regime he cultivated an expertise matching that of other Italian rulers, such as the duke of Ferrara, Ercole d'Este, men from warrior dynasties who were quite as preoccupied as Lorenzo himself with strengthening the fortresses on their vulnerable frontiers.

The Florentine captain of Borgo San Sepolcro reported in detail to Lorenzo in early 1487 on the defenses of this frontier town since "[y]our Magnificence said to me before I left home that you would very much like to hear about the state of these moats."[85] It can be no coincidence that during his uninterrupted term as an *operaio* of the Palazzo Vecchio between 1487 and 1492 that office took over responsibility for all the fortifications at Pisa, Leghorn, Volterra, and Firenzuola and planned major works at Poggio Imperiale, not just for "honor and public safety," as the law said, but to safeguard Lorenzo and his regime.[86] In this capacity, perhaps, he was asked in 1488 by the king of Naples to send south a naval munitions expert, "mastro Ioanni," employed by the Florentine government.[87] The popular novel that has the young Lorenzo de' Medici urging Leonardo da Vinci to design a vicious new artillery piece is perhaps not so very far from the mark.[88] Lorenzo was becoming an acknowledged connoisseur of the military and defensive engineering, which he had first learned to admire as a juvenile canal official, at precisely the time, in the third quarter of the century, when engineer-architects were boldly responding to the growing use of siege artillery by creating a new

architecture of beautifully utilitarian structures whose rounded forms better withstood and deflected projectiles.[89]

Lorenzo was, I shall argue, at the very least a close observer of the process by which the new fortress of Volterra was designed in 1472. Lodovico il Moro, of Milan, expressed himself all the more pleased twelve years later, when it was reported to him that the design for his fortress at the strategically placed Casalmaggiore on the Po had been sent to Lorenzo after earlier discussion and "was also to your liking, and that you approved it."[90] In the same decade Lorenzo possessed the authority to ask of Ottaviano Ubaldini della Carda, his kinsman and Federigo da Montefeltro's close associate, "that he should send Siro the architect to Ferrara," a reference to the well-known military engineer Ciro Ciri, whom Lorenzo very likely had met during the siege of Volterra, when Ciri was in the pay of both the count of Urbino and the Florentines.[91] Later in the 1480s one finds Lorenzo in the thick of discussions concerning Florentine fortress design and construction. In the winter of 1490, according to a letter written by the magistracy of the Otto di Pratica, in charge of foreign policy, the prominent Florentine politicians Iacopo Guicciardini and Bernardo del Nero "met with Lorenzo de' Medici to plan how the new fortress at Pisa should be set in order and also how one might fortify and complete the tower that is on the other side of the Arno, facing the said new citadel."[92] Later in the same year Lorenzo and two colleagues went to Poggio Imperiale, on a hill outside Poggibonsi, south of Florence, toward Siena, "concerning the plan they have to transfer the inhabitants of Poggibonsi to that place, where they intend to construct a city encircled by walls," a description that reminds one of Alberti's dictum that "a Fortress is to be built like a little Town."[93] Lorenzo's architectural-cum-political education had borne fruit. And the down-to-earth master carpenters and builders with whom he had constantly come in contact during those early years—men such as Francione, Giuliano da Maiano, Domenico di Giovanni, nicknamed "the Captain," and, probably somewhat later, Giuliano da Sangallo—were to become the builders and in some cases the designers of the villas and churches of his maturity.

Vitruvius in ancient Rome and, long after him, the Quattrocento in-

tellectual Leon Battista Alberti discussed military devices and fortification in their theoretical treatises on architecture. Lorenzo's contemporaries likewise made little or no practical distinction between military engineers and architects—Filippo Brunelleschi is the outstanding case in point—and Lorenzo de' Medici would have learned a good deal about architecture and design while pursuing his political and dynastic career as a canal official and a member of works committees negotiating with experts in fortifications and hydraulics. He shared in a refined and knowledgeable way the passion, indeed awe, that contemporaries understandably felt for grand fortifications, the "divine" work of rulers, those "new and impregnable walls . . . of harsh, hard stone, not so much walls as steep mountains . . . a safe haven for its citizens, an expression of the fatherland's beauty which struck terror into its enemies," as the Neapolitan Iuniano Maio described his city's defenses in 1493.[94]

] 4 [

About 1473 Lorenzo somewhat disingenuously claimed that he had been reluctant to take on his father's public role in late 1469 "as it was contrary to my age, and on account of the great responsibility and peril it involved."[95] Danger there was, to be sure, but rather than being "singularly unprepared"[96] to assume leadership of the Medici faction, the young man had served a hard apprenticeship since his early teens. Not only did he sit on all sorts of committees other than *opere* but he trained as a behind-the-scenes political manager. The budding *gran maestro* was also sent on semiofficial missions to other states at a tender age, learning the diplomatic ropes during this introduction to Italian court society. By the time he was the unofficial leader of Florence, at twenty, Lorenzo had visited many of the major cities in Italy—Rome, Naples, Venice, Milan, Ferrara, Genoa, more than once in some cases—and dozens of smaller centers.

Piero, his father, feared that Lorenzo enjoyed these journeys rather too much. We can be sure, however, that the pleasure he took in them went beyond dancing in Milan with the accomplished Ippolita Sforza, whose lifelong friend he became, and indulging what his tutor called his taste for "fleshly things."[97] Despite "my old trials, shortsightedness, and lack of a sense of smell,"[98] Lorenzo loved to see and experience new

things, as his early sonnets reveal by their persistent travel motif, their references to suburban Rifredi and the more distant Volterra, Maremma, and Milan. One might suggest that he was training himself on these early journeys to be the "passionate sightseer" he was to become, if Bernard Berenson's self-description may be used without undue anachronism.[99] A friend reported of his first visit to Venice in 1465, en route to Milan, "I believe that in this place he has seen sights so magnificent and grand that they cannot be bettered, although at Milan he will find enough even more satisfying."[100] Lorenzo saw Bologna, Padua, Vicenza, Verona, Modena, and Ferrara in the course of this maiden journey, disrupting his schedule by staying longer than planned at the Estense court, at the duke's prompting and to his father's exasperation.[101] A mission south in the next year took him to Rome and then on to Naples, which "paradise of devils" he recalls in a sonnet, alluding to the verdant and carefully cultivated Neapolitan gardens, "the sunny landscape and sweet vapours of Paestum," though he apparently did not see the ruined Greek city for himself.[102] For reasons of security, the youth returned home through the Abruzzi, visiting Ancona.

This southern journey excited Lorenzo's antiquarian imagination. Precisely as Joseph Alsop wagered years ago, it can now be demonstrated that while he was still in his teens Lorenzo began collecting, as his near contemporary biographer Niccolò Valori later put it, "any beautiful and rare thing . . . with great diligence . . . old things . . . coins or other precious objects . . . vases, *intagli* . . . and stones."[103] At Aquila, in the Abruzzi, he had been given "certain silver and gold coins" by one correspondent, who wrote mentioning eighteen more since Lorenzo had expressed his enthusiasm for such things.[104] As early as November 1465 Lorenzo's uncle, Giovanni Tornabuoni, had been on the lookout in Rome for "some fine marble figure or coins" that might tempt his juvenile taste (none available was "worthy"), and friends and clients kept offering him treasures they had come across.[105] However, we do not learn at first hand what the boy made of the buildings, sculpture, and frescoes he must have seen on this and other early journeys; we cannot know if in Venice he early learned to love the veined marble, mosaics, and dazzling colors of that city. What is evident is his youthful hunger for seeing new places, evidenced by his desire

"to look at Lucca, and then . . . go to Pisa to visit and see our possessions," as he expressed it in requesting his father's permission to travel with friends when only fourteen,[106] and his firm insistence on visiting Genoa while returning home from Milan in the summer of 1469 despite his sick father's fears for him. (Piero apparently feared that Lorenzo might drown while swimming in the sea as much as he feared that he might be assassinated.)[107]

The youth was hardly alone in this predilection for seeing new places. It goes without saying that other Italian lords, gentlepersons, and artists looked incessantly, with more or less discrimination as the case may be, at what foreign cities had to offer. It has been argued that Duke Galeazzo Maria Sforza's visit to Mantua and to Florence in early 1471 inspired that Milanese prince to dream of commissioning frescoes and buildings similar to those he had admired, including a mausoleum for himself modeled on the Florentine Baptistery.[108] "I contrived as much as I could to go about looking at these worthy things of yours," Lorenzo's own Florentine friend Agnolo della Stufa informed the duke in July 1473, singling out the new hospital modeled on Florence's own, about which Giovanni di Cosimo de' Medici had earlier given advice.[109] By the time Ercole d'Este, duke of Ferrara, began his major urbanistic renewal, known as the Terra Nuova, in late 1492, he "had personally looked at the most significant contemporary examples of town planning" in all Italy, most of whose important buildings, old and new, he also knew at first hand.[110]

Lorenzo the passionate and increasingly discriminating artistic sightseer and *intendente* emerges most clearly from his more densely documented mature years, when his taste also came of age. A second journey to Rome in September 1471 enabled Lorenzo to inspect the ancient city's monuments with Leon Battista Alberti himself as guide. This delightful experience was remembered by Bernardo Rucellai—Lorenzo's brother-in-law, who himself became a formidable antiquarian—in his *De urbe Roma*. Alberti had dedicated his *Trivia* to the ten-year-old Lorenzo in 1459, but there is no direct evidence linking the two before this Roman holiday—during which the party engaged in learned dispute over the meaning of damaged inscriptions on ancient marbles, a subject that continued to engage Lorenzo.[111] "Much honoured" in Rome, Lorenzo brought

back to Florence "the two ancient heads, of Augustus and Agrippa, given me by the pope, and further . . . our dish of carved chalcedony purchased along with many other cameos and coins."[112] This so-called dish was the fabulous Tazza Farnese, the most precious of Lorenzo's prized possessions, valued at ten thousand florins in the Medici inventory made on his death (Fig. 9).[113] During the next two decades he pursued with an intensity that became white-hot by the later 1480s the quest begun in adolescence for rare and old pieces; witness his concern to acquire more of Pope Paul II's celebrated collection, his long and well-documented pursuit of Gonzaga treasures,[114] and his campaign, conducted through sometimes unscrupulous agents, including the dealer Giovanni Ciampolini, to extract antiquities from Rome in the last decade of his life, not always legally.[115]

By the end of his life Lorenzo de' Medici had in the Palazzo Medici one of the largest and most varied contemporary collections of antiquities, objects thought to be ancient, and unusual medieval or modern pieces. In the last category were choice pieces of Damascene metalwork, Chinese porcelain, Islamic ware, and majolica, including "huge vases, nothing like, and better finished than, anyone has seen" presented to Lorenzo by Sultan Qa'it-Baj in 1487, rarities that joined the ubiquitous modern arms and armor also listed in the famous inventory of 1492.[116] Apart from exquisite pieces inherited from his elders, such as the cameo depicting Noah and his family created for the court of Emperor Frederick II,[117] Lorenzo himself was presented with, or sought to buy, not only sculptures, architectural fragments, marble vessels, pottery, coins, hardstone vases, and cameos and intaglios but also apparent oddities, such as bronze nails from an ancient Roman galley.[118] When a statue thought to be of Plato was found in Pistoia, it was rushed to Lorenzo, so well known was his love of antique portrait busts in this subject town.[119] Several local, that is to say, Etruscan, antiquities were also to be found in his collection, and he actively pursued them.[120] In his bedchamber he had exquisite aubergine-colored glassware, as well as modern paintings, and his approval of still other contemporary creations was eagerly sought. The man from Faenza who presented him with what appear to have been eight pieces of ceramic painted fruit in June 1491 was keen to order "something beautifully fine" for him should the Medici connoisseur like them.[121]

The Aesthetic Education of Lorenzo

Lorenzo's Neapolitan contemporary Giovanni Pontano argued that a magnificent and diverse collection would bestow on its owner that air of "fascinating splendor" that was so desirable.[122] Giovanni Rucellai would have learned this had he eavesdropped on the courtly visitor to Florence who, reporting on the celebrations in June 1466 for the marriage of Giovanni's son to Lorenzo's sister, sneeringly described the merchant family as "extremely rich but extraordinarily ineffectual and lacking clothes, pearls, and jewels." (He also hinted that the Rucellai bridegroom might not be man enough to match Nannina de' Medici's vivacity.)[123] The Medici, on the other hand, gave away precious jewels and silver plate, antiquities and rare objects, as gifts to prominent people. Lorenzo's gift of a bronze horse's head to Diomede Carafa, of Naples, in 1471 is well known. The count thanked him effusively for this fine piece, which some modern critics believe to date from the Quattrocento, not antiquity.[124] Lorenzo graciously loaned treasures from his house to relations and friends for important occasions, carefully noting the details.[125] For the sake of display, he was willing to struggle under the weight of precious metal when going on diplomatic missions. Although he was only one of several Florentine ambassadors to the new pope in September 1471, Lorenzo departed, an awed contemporary witness tells us, "with thirty-five horses and seven mules and carriages, bearing 400 pounds of silver plate . . . a fine send-off to see."[126]

Most of Lorenzo's treasures were not only conspicuous but conveniently portable. He and other security-conscious Italian potentates knew this as surely as the northern European royalty they were seeking to emulate. When the Medici were expelled from Florence in late 1494, many of their treasures were spirited away for safe keeping by their partisans. The duke of Milan was desperate to know what had become of the "precious and portable things" from Lorenzo's study, "namely, his cameos, carnelians, coins, books, and similar fine things [zentileze]," not, he added significantly, the "marble objects."[127] Since Cosimo's time the family had been in the habit of displaying to visitors the heavier marble pieces, to be found both in the courtyard of the Palazzo Medici and in the garden of San Marco, and the smaller "fine things" in Lorenzo's quarters. Lorenzo continued the practice even after the Pazzi conspirators had angled for

an invitation to the *palazzo,* the easier to attack their hosts, by claiming a desire to see Lorenzo's "fine silver and jewels, coins and other noble things." In May 1490 Lorenzo instructed his eldest son, Piero, to make a distinguished Venetian visitor welcome by showing him everything in the garden and study: "He seems to me a knowledgeable person [*persona intendente*] who takes delight in seeing antiquities." Piero de' Medici replied, however, that "I do not think he understands much about sculpture but he did like a good deal what he heard about the coins and their age."[128]

Piero's reply clearly implies that the Medici father and son did understand and care about their treasures, in addition to grasping the portable prestige and financial security they also bestowed. His friends knew, as did Luigi Lotti, that "Lorenzo takes delight in rare things."[129] Lotti was referring to modern tapestries ordered by King Alfonso of Naples; Lorenzo owned scores of these labor-intensive objects.[130] On another occasion, in April 1490, Lorenzo praised majolica vases sent to him by a member of the Malatesta family, of Rimini, as "quite faultless and very much to my taste [*l'animo mio*] . . . because if the rarer the object the more precious it is, these vases are indeed dearer to me than if they were made of silver, being, as I said, most excellent and rare and a novelty to the rest of us here."[131] His peers also knew that Lorenzo had, in the Mantuan ambassador's words, an "appetite" for antiquities quite as insatiable as that of Isabella d'Este, who later inquired after four hardstone vases from Lorenzo's collection, all carved with his initials.[132] Lorenzo's taste, especially for gems, became so expert and so refined that the anxious desire of his correspondents to please so exquisite an appetite is still palpable in the surviving letters. One man knew that Lorenzo would be satisfied by a carnelian sent early in 1487, "so desired and with such hardship obtained." But the long quest itself—scores of letters were devoted to its pursuit—provided only part of the pleasure this connoisseur felt. The gem, "most beautiful" and "most skilfully made," had won the admiration of those other connoisseurs who had seen it, according to the writer. He added that Lorenzo had none "with such a variety of themes so perfectly finished."[133] Another of Lorenzo's agents described an engraved stone as "lovely and masterfully done, something you definitely have reason to want"; and in a rare instance the connoisseur's own appreciative words

have survived: "I have received the cameo I have so long coveted, which pleases me very much because it is in quite perfect condition; I am still more pleased at its unexpected arrival and even more delighted that your Lordship's diligent labour has put it my way."[134]

His correspondents knew that Lorenzo wanted pieces in mint condition, that he was unlikely to be interested in ancient coins "so worn down that hardly any inscriptions or images might be distinguished."[135] Pandolfo Collenuccio, a humanist scholar, simply assumed Lorenzo's studious interest in such beautiful and legible objects, especially if they were rare. Among the fifty or so antique medals Pandolfo had in his possession in 1491, "there are five among them that I do not believe Your Magnificence has," he wrote, sending on the select few with careful descriptions and comments on the inscriptions, including a footnote to Livy.[136] The distinguished classical scholar Angelo Poliziano certainly studied not only Lorenzo's old codices but also his collection of more than four thousand coins and medals, and artists as well as scholars such as he sought *all'antica* and mythological motifs in the Medici treasures. Direct visual quotations from ancient objects in Lorenzo's possession have been observed in works by Filippino Lippi and in a painting by Sandro Botticelli or a close follower, namely, the *Portrait of a Lady,* in Frankfurt, whose subject wears a Laurentian carnelian;[137] a *disegno* by Botticelli may also draw directly on a Medicean source. It has been plausibly suggested that several figures in Bertoldo's sculptural relief executed for Bartolomeo Scala's palace courtyard find their inspiration in Lorenzo's sculptural and gem collection.[138] Lorenzo's treasures have long been dispersed, and the vases aside, only a portion of the surviving pieces can be confidently identified as having belonged to him. It is therefore difficult, despite the existence of precious inventories, to gain a sense of the full impact of his collection and of his nurturing of artisans skilled in engraving and curating gems on contemporary artists and collectors. In the generation after his death, however, the fruits of his collecting were mentioned with awe as "most excellent and rare among this world's possessions."[139] This was clearly a grand and rare collection, worth literally a fortune, accumulated by an intelligent and discerning man who knew precisely what he was about.

Lorenzo's aesthetic curiosity was hardly confined, however, to antique *objets d'art.* His consuming appetite for this costly and elusive prey, perhaps for the exhilaration of the chase itself, may very well loom larger in the surviving evidence than it did in a life filled with other aesthetic interests, not to speak of a thousand and one other preoccupations. Nor should one argue that Lorenzo's collector's instinct somehow ran contrary to his feeling for contemporary artistic aspirations and achievements, which in the 1470s were focused increasingly on a fascination for the antique; hence the heightened interest that generation of artists manifested in collections such as Lorenzo's and his reciprocal absorption in this creative artistic moment.[140] The Roman correspondent who wrote eloquently to Lorenzo in 1489 of the discovery of "three beautiful little fauns on a small marble base, all three bound together by a great snake, which in my judgment are most beautiful, and even if they are silent they seem to breathe, to cry out, and defend themselves with certain wonderful gestures."[141] was praising the expressiveness of this ancient sculpture in a contemporary vocabulary, itself derived largely from classical sources, which Lorenzo would have recognized. Already, several generations of Tuscans had applied such naturalistic criteria to "modern" art after Giotto, a painter whose images, according to Filippo Villani, "agree so well with the lineaments of nature as to seem to the beholder to live and breathe."[142]

When traveling in northern Italy early in 1483 Lorenzo went out of his way to visit Mantua—"to see the city," as the Mantuans wrote—where he met Andrea Mantegna, whose already celebrated work was informed by a discriminating knowledge of ancient art. Francesco Gonzaga reported to his father: "Yesterday the magnificent Lorenzo de' Medici went about sightseeing. And today I went with him on foot to mass at San Francesco. From there His Magnificence took himself to Andrea Mantegna's house, where with great pleasure he saw some paintings by Andrea, as well as certain heads in relief and many other ancient things, which he appears to have enjoyed very much."[143]

Mantegna's painting was already known to Lorenzo, who in March 1481 had written the artist "a grateful letter, thanking him, etc., for the painting and work sent." This painting and possibly another piece were

evidently gifts sent Lorenzo, not works commissioned by him.[144] In return, Mantegna wrote in 1484 seeking Lorenzo's financial help so that he could complete his remarkable *all'antica* atrium house, which Medici presumably had seen being built, although what reply the painter's letter received we do not know.[145] Lorenzo's "great pleasure" in Mantegna's work, and perhaps in the northern Italian artistic tradition from which he came, was probably genuine. In his room in the Palazzo Medici, alongside the better-known works in the Tuscan tradition by Paolo Uccello, Piero del Pollaiuolo, and Fra Angelico, hung a painting bearing Medici heraldic insignia probably acquired by his father: a Saint Sebastian by Squarcione, surely Francesco (c. 1394–1468), Mantegna's Paduan master.[146]

Recent scholarship, while critical of the painterly talents and lack of personal integrity of this "notorious braggart,"[147] has accepted that there is nevertheless at least some substance in the local sixteenth-century tradition that Mantegna's master was "the most singular and outstanding teacher of all painters of his time."[148] Squarcione evidently taught Mantegna and others from collections of casts and drawings after the antique and after modern masters. By about 1455 this mediocre master had begun to describe his *bottega,* or workshop, and his collections there as a *studium,* a "place for study, a name that clearly indicates a change of emphasis from workshop to school."[149] This singular fact tempts one to put Ockham's razor aside for just a moment. During this Mantuan visit in 1483, might not Lorenzo have heard about, and been impressed by, the emergence of an already celebrated court painter, Mantegna, from a training that had pretensions to be as much academic and liberal as artisanal and mechanical? If so, might he not have grasped at that time how he and his artist friends could put to a novel use the Medici garden at San Marco, where by the 1480s ancient sculpture was accumulating?

Be that as it may, the circumstantial evidence is persuasive that while he was in Mantua in the late winter of 1483 Lorenzo looked hard and appreciatively at the major building campaign recently undertaken by the Gonzaga family, with Alberti as architect and Luca Fancelli as overseer. Mantua's transformation appears to have impressed other lords, and Lorenzo was, we shall learn, about to embark on his own ambitious program at home. He and Fancelli kept in touch during the Florentine

architect's long sojourn in Mantua, to which he had apparently first gone at Cosimo de' Medici's behest and whence Lorenzo was to summon him in the later 1480s. "And if Your Magnificence recalls, you said to me in Mantua that should I have need of you I should ask it of you," Fancelli wrote in 1487, referring perhaps to the visit of 1483.[150] Just two years later Lorenzo asked Fancelli to send him "a model of the church of San Sebastiano in Mantua," an unusual Albertian creation that stood, half finished, just across the street from the house Mantegna was seeking Lorenzo's financial help to build.[151]

At precisely this time, inspired in part by his Mantuan journey, one might well think, Lorenzo was continuing his self-education in Alberti's architectural theories, which had perhaps begun during his visit to Rome in 1471. He was reluctant to allow the duke of Ferrara to borrow a manuscript of Alberti's *De re aedificatoria (Ten Books on Architecture)* for long in early 1484 because, Lorenzo said, he "prized it much and often read it."[152] In September 1485 the first printed version of the work was being read aloud to him at the baths at San Filippo as it arrived in installments from the printer.[153] Lorenzo's close study of the *Ten Books,* which were not translated into Italian until the next century, remained an intensely elitist activity even though the Latin treatise was better known than Alberti's earlier *De pictura.*[154] In Florence the printed edition itself was scarce, judging by surviving inventories, although at least two people in Lorenzo's circle—Francesco Gaddi and Sigismondo della Stufa—owned copies by the end of the century.[155] There were also three versions of Vitruvius in Lorenzo's library, as well as a manuscript of Antonio Filarete's recent vernacular treatise on architecture, dedicated to Lorenzo's father, Piero. Lorenzo de' Medici never visited northern Europe, though he was once invited to go to see the "most beautiful and most magnificent" palace that his family had purchased in Bruges in 1466. One suspects that this Gothic structure would not have moved him, that had he visited Paris itself this young man brought up in early Renaissance Florence and devoted to Alberti's original revisiting of classical architectural theories would have agreed with Benedetto Dei's pungent observation that the French capital "was full of smells, ugly things and ugly buildings."[156]

In the early summer of 1490, traveling back from the baths via Mon-

tepulciano, in southern Tuscany, Lorenzo found himself with time on his hands as he waited to meet his daughter Maddalena. "As a result," he wrote, "I will go about having a look at some of these Sienese possessions, such as Pienza and Monte Oliveto, etc."[157] Lorenzo's desire to see Pienza is at once explicable. At his birthplace, the small rural town of Corsignano, Pope Pius II had several decades earlier begun to create, with the assistance of Florentine builders, a model Renaissance city in miniature, rationally planned and including what most scholars take to be a close but imperfect copy of Alberti's palace designed for the Rucellai in Florence a decade or so earlier.[158] It was about 1490 that Lorenzo again began to devote money and energy to his own urban schemes. As for the convent of Monte Oliveto, while it goes without saying that Lorenzo arrived several years too early to see the fresco cycle Luca Signorelli, an artist with whom he almost certainly was in touch at this time, painted at this great Benedictine house, there survives a delicious hint that what we call art was nevertheless discussed during Lorenzo's visit there in 1490. Two months later Lorenzo wrote to two gentlemen "concerning a marble Madonna, belonging to the friars of Monte Oliveto," which one of the recipients had apparently taken away. Whether Lorenzo wanted to get the marble sculpture back for the sake of the friars or for some purpose of his own is not known.[159]

The latter suggestion is not at all impossible. Already Lorenzo had acted high-handedly to acquire for himself a modern painting he coveted, the battle scene *The Defeat at the San Romano Tower,* one of Paolo Uccello's three expansive panels depicting this event to be found in Lorenzo's room in the Palazzo Medici upon his death. When the patrician Damiano Bartolini refused to surrender his half of the panel after his brother, Andrea, dutifully agreed to give up his half, Lorenzo sent his woodworker friend Francione and some assistants to seize it "against the said Damiano's will."[160] Little wonder, given the huge dimensions of these panels, that a small team commanded by an experienced woodworker-architect was needed to dismantle one of them. If this incident is at all characteristic of Lorenzo's modus operandi as a collector of modern painting, it explains why, when his son Piero asked in 1490 to buy from a Benedictine monastery what he took to be a painting "done by the

hand of Cimabue," the Medici youth was at once presented with the precious object as a gift, much to his delight but perhaps not to his surprise.[161] It is beside the point that modern scholarship attributes the work, an early-fourteenth-century two-sided panel depicting a Lamentation and Christ embracing the Virgin and Saint John that is now in the Fogg Museum at Cambridge, Massachusetts, to a less distinguished artist.[162] Dante had famously praised Cimabue as holding the palm in painting before Giotto snatched it from him,[163] and Piero di Lorenzo de' Medici, evidently eager to rescue the earlier painter from the oblivion into which he had fallen two centuries earlier, wanted to own this small golden panel, which does not strike the modern observer as more than a charming artisan piece; it certainly is not comparable to the anonymous Giottesque panel also depicting a Lamentation displayed nearby in the Fogg. He would have been encouraged to do so by several contemporary references, one of them by Cristoforo Landino, to Cimabue's pioneering role in the emergence of painting in Tuscany.[164]

It might be suggested that those fervent admirers of both Dante and Giotto, the Medici, were developing an appreciation of the historical tradition in Tuscan painting that had shaped the gifted artists of their own generation—Sandro Botticelli, Filippino Lippi, Domenico Ghirlandaio, and others—whom they so esteemed that they not only favored and employed them but also named them for posterity in the inventory of Medici possessions made upon Lorenzo's death. In that remarkable document dozens of works of art are matter-of-factly identified as "in Masaccio's hand," by "the hand of Sandro di Botticello," "by Desiderio [da Settignano]'s hand," and so on. Although the anonymous Madonnas and other images to be found in similar inventories still predominate, a number of Tuscan painters, from Giotto on, are so named.[165] Giovanni Rucellai had mentioned in his commonplace book the eleven famous contemporary artists whose works he owned, one of which, by Andrea Castagno, he may have "collected" after the artist's death rather than commissioned in the standard way. His precise list of about 1471 pinpoints a moment of transition—one of several such turning points, to be sure—in Quattrocento attitudes toward artists and their work, the beginnings of a cult of the artist, of the sense that great design ability and

high skill (*arte*) constituted "art," which became more diffused in Florence by the early sixteenth century.[166]

Doris Carl suggests that there were plans afoot in the 1480s for "an expansion of the 'famous men' program in the Florentine cathedral, three tombs in honor of artists being envisaged."[167] There is a good deal to be said for this proposal, and Lorenzo was central to the campaign. It may have been the Opera del Duomo that commissioned and paid for the commemorative bust of Giotto (and that of the organist Antonio Squarcialupi) installed toward the end of Lorenzo's life, yet Lorenzo was not without influence over this body, and his intimate Poliziano supplied Giotto's Latin epitaph after making six drafts.[168] (Lorenzo himself provided the Latin inscription on the memorial to Squarcialupi, who was very much a Medici creature.)[169] At this same time Lorenzo paid for the expensive marble tomb of Fra Filippo Lippi in the cathedral at Spoleto, having failed to persuade that city to restore the painter's bones to his homeland. As if to reinforce a sense of artistic lineage, the painter's son, Filippino, was commissioned to design the Spoleto monument, which bore the Medici arms and the Florentine heraldic lilies. Poliziano provided the inscription, in which the friar speaks, as it were, to the viewer, declaring that his art had surprised Nature herself by its ability to reproduce her works and acknowledging the generosity of Lorenzo, the grandson of his Medici patrons.[170] Lorenzo's attempts in the 1470s to repatriate the remains of Dante, similarly in vain, expressed an enduring Medici homage to the founder of Tuscan vernacular literature, much of whose verse the boy Lorenzo had learned by heart, or so Cristoforo Landino has him say in the *Disputationes Camaldulenses*.[171] At just the time the commemorative busts of Dante and possibly others were being planned and executed for the Duomo, Lorenzo also sought to have canonized—prematurely, as it transpired—his city's great Dominican archbishop in midcentury, Antoninus.[172]

This Laurentian desire to historicize and domesticate, as it were, Tuscan achievements in painting, literature, and even theology belongs to the late 1480s, when Lorenzo was actively engaged in building projects, in a continuing pursuit of rare antiquities, in commissioning contemporary artists, and in taking a lively, not to say proprietary, interest in the

artistic commissions of others. By this time his artistic appetite had become both a catholic and in several senses an educated one, embracing a love of both modern and Byzantine mosaics, which contemporaries associated with great wealth,[173] and of the small bronzes of Bertoldo, an interest in Etruscan as well as in Roman and Greek antiquities, a practical knowledge of avant-garde military architecture and a theoretical understanding of Alberti, a passion for ancient sculpture and *objets d'art* and an appreciation of the achievement of contemporary artists. Giovanni Tornabuoni wrote to his nephew in December 1484, as if to acknowledge this discriminating catholicity, that what he was sending him "is rather something fine and new [*bella modernità*] than ancient [*antica*]."[174]

It has been observed that Lorenzo's philosophical interests were similarly catholic, that his commitment to Neoplatonism has been exaggerated, given that he took the best Aristotelian scholarship more seriously than had been imagined.[175] In music, he both deeply appreciated the sophisticated polyphony of his northern European protégé Heinrich Isaac—in Lorenzo's own words at once "grave and sweet, skillful and full of ingenuity"—and himself practiced, admirably we are told by contemporaries, the popular Florentine art of improvised singing in public.[176] A serious patron of music who played several instruments, he was, however, an infinitely better poet than a musician, one of the best of his century. Lorenzo de' Medici was neither a poet who perforce involved himself in politics nor a politician who tinkered with poetry.[177] He was a consummate politician who wrote accomplished poetry in his spare time. To say this is not to be unduly influenced by Lorenzo's uncritical admirers, past and present. Contemporary poets such as Vincenzo Calmeta placed him firmly in the great vernacular tradition of Dante and Petrarch, into which Lorenzo had indeed self-consciously sought to insert himself by writing a commentary on his own sonnets.[178] His poetic abilities were easier to admire than to emulate, according to the contemporary Florentine literary figure Michele Verino, although, inevitably, he had his instant imitators.[179] This Medici poet wrote in almost every available vernacular genre—Petrarchan love poetry, bucolic verse, bawdy carnival songs, philosophical poems, burlesque parodies, poems in praise of Mary—and, to the despair of his modern editors, incessantly tinkered

with these creations, as if to demonstrate both his technical virtuosity and range and his ability to experiment. What was perhaps Lorenzo's last poem, written during his prolonged final illness, celebrates Christ's sacrifice on the cross.[180] After his death there was a heightened Florentine interest in his poetry, two of his familiars borrowing from his heirs in 1493 "the new miscellany of Lorenzo's compositions."[181]

Lorenzo de' Medici was a genuine intellectual with broad yet educated and discriminating tastes. In seeking to understand his aesthetic *appetito,* it is not particularly helpful to single out his indubitable greed for *anticaglie* or to dwell upon the passage in his *Comento,* the Dantesque commentary on his own poems, in which Lorenzo has been said to display conventional, even "old-fashioned" expectations and taste in painting:

> Because in my judgment three things make a perfect painting, namely, a sound foundation—either on a wall, on wood, on cloth (or whatever it might be)—upon which the picture unfolds; a master who perfectly understands both drawing and color; and, furthermore, that the subjects depicted be in themselves agreeable and pleasing to the eye. Since even if the painting should be absolutely accomplished, it might not be to the taste of the person obliged to look at it, given that some people most appreciate joyful subjects, such as animals, verdant foliage, balls, and celebrations, while others would prefer to look at battle scenes on land or sea, and similar harsh and warlike themes; still others landscapes, buildings, and perspective scenes; others again, something else quite different. Therefore one needs to add that if a painting is to be entirely pleasing, its subject matter must also be in itself delightful.[182]

This familiar interpretation rips the passage from its literary context and fails to understand its metaphorical sense.[183] It is a reading that also ignores the accumulating evidence of the writer's engagement with modern painting. Even so, Lorenzo insists in that passage that one choose "a master who perfectly understands both drawing [*disegno*] and color," that a painting must not only depict subjects that are "in themselves agreeable and pleasing to the eye" but also be in itself "delightful."[184] This is not so far from the Lorenzo revealed in other documents: the lover of refined and exquisitely made things, the searcher after the rarest and best of its kind,

who took delight, however, in the infinite variety of forms, ancient or new, in which excellence might manifest itself. What he found most laudable about the ancients, he told Frederick of Aragon when sending him a collection of Tuscan poetry, including his own, was that in those halcyon days every "distinguished and skillful creation of the human hand or mind" had been granted the highest recognition in both public and private.[185]

"Tastemakers are usually collectors," Susan Sontag suggested in her fictional portrait of Sir William Hamilton, and this was true of Lorenzo de' Medici.[186] His taste did not so much elevate the ancient world above the modern in some antiquarian way as seek to recreate and redefine the antique in contemporary terms and for modern purposes. Just as in the *Comento* he vehemently defended his own use of the Tuscan vernacular, pointing out that the revered Latin and Greek languages had been the living tongues of their own day,[187] Lorenzo loved and sought to contribute to the creation of modern architecture, sculpture, and painting conceived in an *all'antica* manner. What is love but a "hunger for beauty," an *appetito di bellezza,* he explained in the *Comento.*[188] When Italian lords asked Lorenzo which architect to employ; when Lodovico il Moro, contemplating a major sculptural project, several times asked Lorenzo to send "a master or two suitable for such a task";[189] when the Pistoian committee mentioned his "very complete understanding";[190] even when contemporaries apparently overpraised his knowledge of architecture, they were not being diplomatic or flatteringly deferential so much as they were acknowledging Lorenzo's "hunger for beauty," his educated and refined avant-garde taste.

They were also recognizing what Guicciardini called his "hunger for glory and excellence,"[191] and they were no doubt as conscious as Lorenzo himself of the public and political advantages of possessing a reputation for having an exquisite taste *all'antica* expressed in grand building programs and other commissions, as well as in the collection of rare and ancient things. While by the late 1480s Lorenzo, in a position of political strength, sought increasingly to impose his taste upon Florence, in the preceding decade, while consolidating his hold on the city, he had moved much more cautiously, restraining so far as he was able his twin appetites for beauty and for glory.

The Aesthetic Education of Lorenzo

❧ THREE ❧

The Temptation
to Be Magnificent, 1468–1484

] 1 [

Throughout his life contemporaries commented on Lorenzo de' Medici's impetuosity and the violence of his temper when he was crossed. In late July 1470, when his ally the duke of Milan was slow to ratify a peace treaty on which Lorenzo's survival within the city in part depended, he was reported by the Milanese ambassador to be "in a greater fury than I ever saw a man of his social condition."[1] He was also capable of self-mastery, learning to restrain himself precisely in these early months and years of his ascendancy, when he faced considerable opposition within and without the city. His assumption of authority in early December 1469 went more smoothly than some observers had expected, but in the first half of the next year, as he battled to secure the general Italian peace his regime needed, internal dissension on issues of foreign policy threatened to split it. The Medici family's traditional pro-Milanese stance was questioned by some of its powerful friends, who inclined toward a Neapolitan alliance. The elder statesman of the new regime, Tommaso Soderini, who belonged to this latter group, was widely regarded as seeking to undermine his young Medici protégé and replace him as leader. "Knightly leaders" such as Soderini, an outsider observed, seek "to bring Lorenzo down a peg."[2] Close Medici cousins were resentful of his new position, and exiled citizens plotted his downfall or assassination. A major revolt in provincial Prato in April 1470 was put down with bloody severity.[3]

Even friendly governments watched his performance with calculation. The Mantuan agent Bartolomeo Bonatto informed Ludovico Gonzaga on 14 June 1470 that "some say that this city is taking a republican path, acknowledging the authority of the Signoria in the Palazzo Vecchio. Not a soul goes to Lorenzo's house, and he stays there behind locked doors, seemingly interested only in mercantile affairs, and he goes to the palace only when invited."[4] In this moment of obvious crisis—if the Palazzo Medici was no longer a magnet for clients, then Lorenzo was losing his authority as *gran maestro*—the young leader chose to act with republican decorum. He must have been conscious of his extreme youth in a society accustomed to rule by mature men. Very early in his ascendancy, the Milanese ambassador reported that Lorenzo intended to govern so far as possible according to republican conventions, "cum più civiltà si potesse." About the same time he noted that "Lorenzo continues to act humbly and is behaving in such a way as to please the people, most of whom support him."[5] Later in the year, when this was no longer the case, Lorenzo continued to resist advice that he should forcefully assert himself within the city. The Ferrarese ambassador stated in late October that if Lorenzo did not abandon his pro-Milanese stance, he would have to "retake control of the regime by armed force, reorganizing it anew." Failure to do so, he concluded, "will allow the collapse of his tottering house."[6] Whatever his secret political ambitions, however corrosive his anger at opposition, Lorenzo devoted his abundant energy and critical intelligence to pursuing a careful diplomacy, pushing through constitutional reforms that strengthened his hold on the regime and cultivating friends and allies, old and new, with a persuasiveness his father Piero, according to some contemporaries, had increasingly failed to exercise.

Under close political scrutiny on all sides, Lorenzo was constrained to move quite as cautiously, and with due regard for republican and ancestral precedents, in his early activities as a patron of the arts. He was still learning, still serving his apprenticeship. It seems likely, nonetheless, that the young man who had already served on several works committees, watching important commissions mature, and had traveled widely in Italy, bringing home from Rome precious antiquities, the youth who in

1468 had been seized by a sudden impulse to create a *piazzetta* in front of his family's country seat, found it necessary to repress ideas and projects that were beginning to bubble to the surface. One wonders what emotions he felt in 1471 when the bronze ball, or *palla*, by Andrea del Verrocchio that he had helped to commission was put in place, crowning the Duomo amid popular jubilation and official self-satisfaction. The incumbent *operai* of the cathedral had their names recorded in an illustrated choir book, in which was inscribed the legend: "having completed the lantern of the cupola / the golden ball was placed above it / in the year of the incarnation of Our Lord 1471 and the twentieth day of June."[7] Several chroniclers record this Florentine sense of triumph; Leonardo da Vinci, then at work in Verrocchio's *bottega,* much later remembered the technical virtuosity required to secure so large an object on so lofty a structure (see Fig. 7).[8]

Lorenzo would have known that Cosimo's spectacular expenditure on architecture had not gone uncriticized within Florence despite the canny construction by friendly humanists of a defense of such "magnificence" as his, dedicated to pious and civic ends, one that had an early-fourteenth-century precedent in the Dominican justification (informed by Aristotle) of large Visconti expenditure "for the sake of the whole community [Milan]. . . ; as the Philosopher states in the *Ethics,* the common good has something in common with the good sacred to God."[9] While the Palazzo Medici was under construction in the late 1440s, one night someone splattered blood all over the entrance as a rebuke to Medici pretensions.[10] Even the family's generosity to ecclesiastical foundations such as the Badia at Fiesole, in which its apologists took such pride, was condemned by critics, who pointed to the almost sacrilegious arrogance implicit in the presence of the ubiquitous Medici *palle* (heraldic balls) on convent and church walls. They seemed "to manifest a lust for glory more than for divine veneration." What hypocrisy, the chronicler Giovanni Cavalcanti reports people as saying, made worse by building with other people's money, a charge later also made against Lorenzo.[11]

Throughout the fifteenth century, then, there persisted traditions critical of both vast expenditure on magnificence and the new *all'antica* styles in which it was made manifest. One Florentine gentleman who had

agreed in the 1470s to modification of his two-hundred-year-old house in order to oblige a neighbor who wished to refashion his own in the new style was outraged when as a result his ancient palace was "destroyed." The familiar phrase *nostra antichità* meant to such a man a revered ancestral property in what today would be called the Gothic style, not the new classicizing architecture preferred by his offending neighbor, who was, as it happens, Lorenzo's close friend Francesco Nori.[12] Historians and art historians on the whole prefer a triumphalist—Whig, as it were—view of the progress of the Renaissance style. A systematic study of the not insignificant number of criticisms of and resistance to it—opposition culminating in Girolamo Savonarola's attacks on worldly paintings, on liturgical vestments bedecked with coats of arms, and on the hypocrisy of *gran maestri* and tyrants who pursued temporal glory by supporting ecclesiastical foundations—would be very useful. Even Francesco Cegia, Lorenzo's major-domo, who after Lorenzo's death played so large a part in the preservation of the Medici collection of antiquities, was evidently unsettled by one such sermon in early 1496, two years after Piero de' Medici's flight. Impressed by the Dominican's assault upon tyrants and his insistence on the importance of good republican values, il Cegino, as he was familiarly known, wrote in his secret diary: "I would have praised all this had he not spoken vituperously about Cosimo de' Medici and his son Piero, saying things about them that I am sure are lies, above all about their building projects and their almsgiving, which made me think he spoke in anger as an enemy of the Medici house."[13]

There is reason to believe that the young republican politician was early, and remained, sensitive to this critical undercurrent. It is as if Lorenzo had listened to the advice the humanist Bartolomeo Platina put into the mouth of Cosimo in a fictional dialogue between the grandfather and grandson in his *De optimo cive,* of 1473–74, a copy of which he presented to Lorenzo. The young man must have liked the treatise because though he was normally as stingy toward unsolicited literary works as any other contemporary lord, he rewarded Platina with one hundred florins.[14] In this tract Cosimo explained to his grandson that to build a private palace after devoting oneself to public works was eminently defensible. Lorenzo, however, should discreetly devote himself to finishing

off and adorning the buildings begun by his ancestors, thereby "avoiding suspicion of lordly aspirations."[15] Perhaps for this reason it was almost twenty years before Lorenzo took up the bookseller Vespasiano da Bisticci's suggestion, made in November 1472, that he build the library about which the two had earlier spoken, a "project worthy of you since, without casting aspersions on your ancestors, I would hope this would be in no way inferior to anything of theirs." Why, Vespasiano added, Federigo da Montefeltro himself, the count of Urbino, and other famous men had praised the conception.[16]

Lorenzo's contribution in early 1471 to the public debate concerning the suitability of Leon Battista Alberti's model for the tribune of the Servite church of the Annunziata, under Gonzaga patronage, was also curiously muted, given that he was an *operaio* of that church and the son of a major benefactor. According to one contemporary source, Lorenzo may have shared the majority Florentine view that Ludovico Gonzaga's project begun at the site should be utterly demolished, allowing the Florentines to proceed "in a different manner and with another model."[17] Or it might be that he expressed public opposition because he did not wish to be seen as dissenting from the critical view of the project held by envious older men with whom he was struggling to cooperate politically; there is some evidence that Lorenzo, who would become an avid reader of Alberti, in fact thought the architect's central-plan solution a "beautiful thing," or so the well-informed Mantuan agent in Florence, Piero del Tovaglia, informed his master.[18] Whatever the case, when Ludovico Gonzaga, annoyed by what he described as the "swarm" of Florentine objections, threatened to withdraw from this dynastic commitment to a foreign church and spend his money in Mantua, Lorenzo, diplomatically professing ignorance of such aesthetic matters, hastened to advise the marquis on 21 May 1471 to proceed "precisely according to your own taste and desire."[19]

] 2 [

It was an undiplomatic act of Florentine violence, the conquest of rebel Volterra on 18 June 1472, that consolidated Lorenzo's position within his regime and the city, freeing him, or so it would seem, to get on with busi-

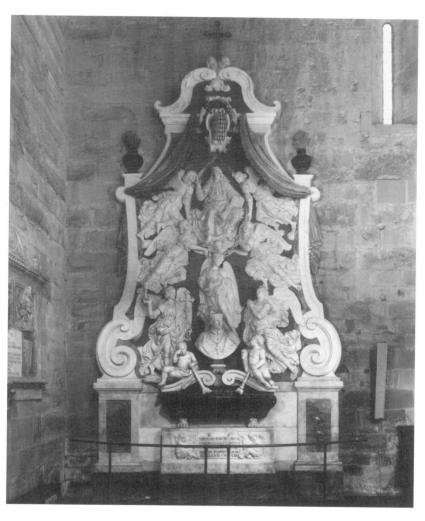

❧ *Figure 1* ❧
Andrea del Verrocchio, tomb for Cardinal Niccolò Forteguerri, Pistoia
(*Photo: Ralph Lieberman*)

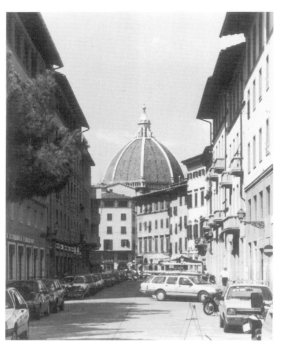

❧ Figure 2 ❧
Filippo Brunelleschi, cupola
of Florence Cathedral
(Photo: Ralph Lieberman)

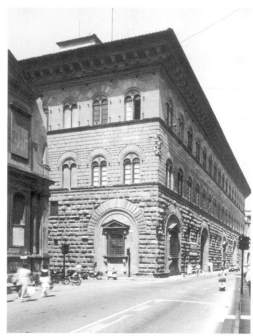

❧ Figure 3 ❧
Michelozzo Michelozzi, Palazzo
Medici, Florence
(Photo: Ralph Lieberman)

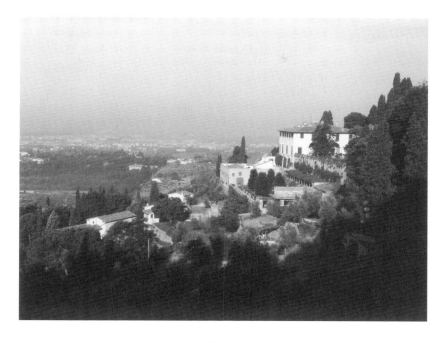

❧ *Figure 4* ❧
Villa of Giovanni de' Medici, Fiesole
(Photo: Ralph Lieberman)

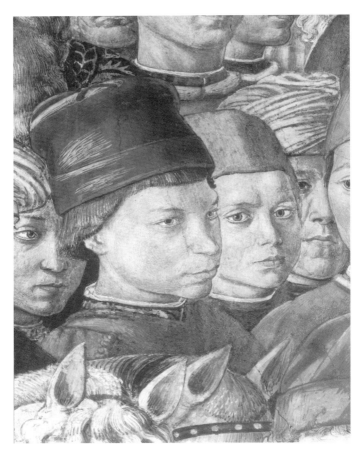

❧ Figure 5 ❦

The young Lorenzo, detail of fresco by Benozzo Gozzoli, Palazzo Medici, Florence

(Photo: Antonio Quattrone)

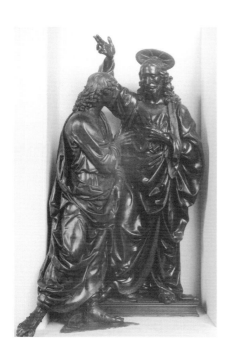

❧ *Figure 6* ❧
Andrea del Verrocchio,
Christ and St. Thomas,
church of Orsanmichele, Florence
(*Photo: Ralph Lieberman*)

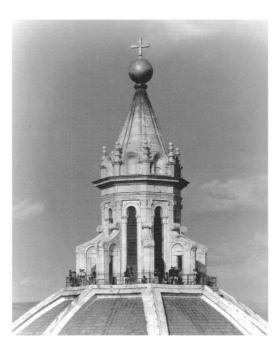

❧ *Figure 7* ❧
Andrea del Verrocchio,
bronze orb for the cupola
of Florence Cathedral
(*Photo: Ralph Lieberman*)

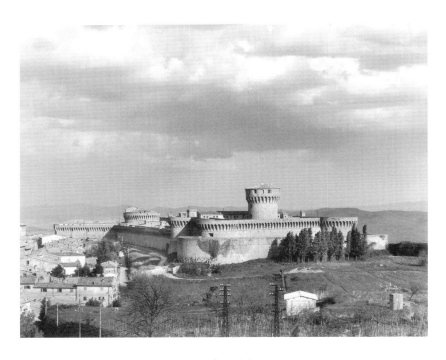

❧ *Figure 8* ☙
Fortress, Volterra
(Photo: Ralph Lieberman)

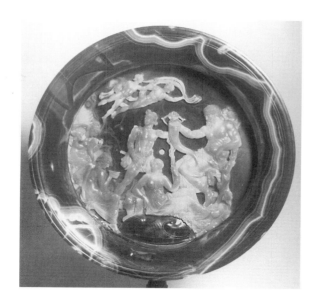

❧ Figure 9 ❧
Tazza Farnese,
Museo Archeologico
Nazionale, Naples
(Soprintendenza per i Beni
Archeologici delle province di
Napoli e Caserta, Naples)

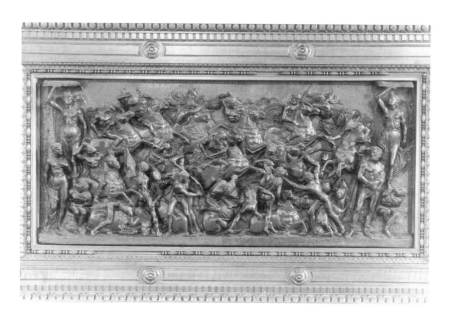

❧ Figure 10 ❧
Bertoldo di Giovanni, battle scene, Bargello, Florence
(Photo: Ralph Lieberman)

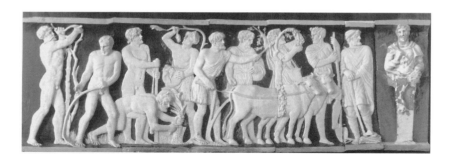

❧ Figure 11 ❧
Detail of frieze at the Villa of Poggio a Caiano
(Photo: Ralph Lieberman)

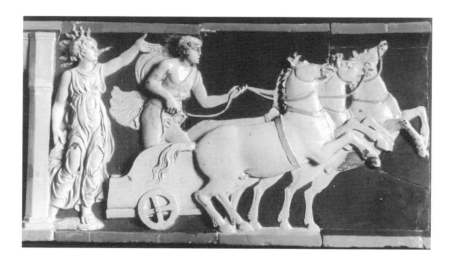

❧ Figure 12 ❧
Detail of frieze at the Villa of Poggio a Caiano
(Photo: Ralph Lieberman)

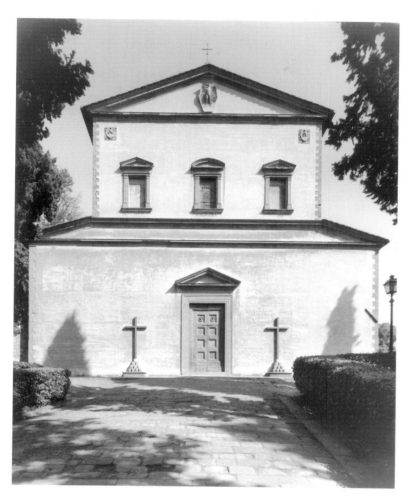

❧ Figure 13 ❧
Church of San Salvatore al Monte, Florence
(Photo: Ralph Lieberman)

❧ *Figure 14* ❧
Church and convent of Le Murate, Florence
(*Photo: Ralph Lieberman*)

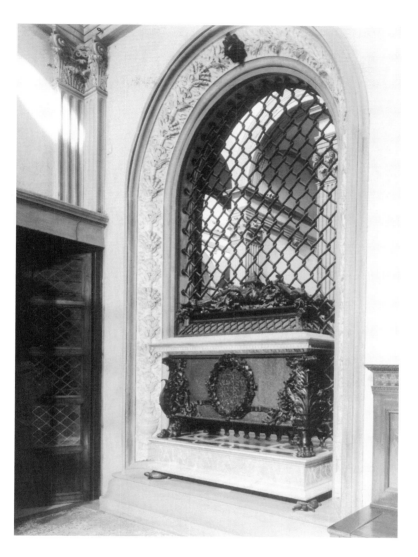

❧ *Figure 15* ❧
Andrea del Verrocchio, tomb for Piero and Giovanni de' Medici,
church of San Lorenzo, Florence
(Photo: Ralph Lieberman)

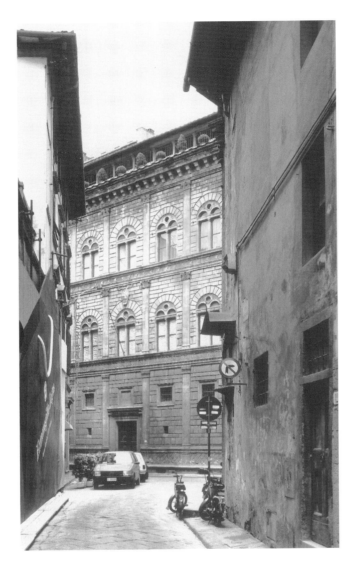

❧ *Figure 16* ❧
Leon Battisti Alberti, Palazzo Rucellai, Florence
(Photo: Ralph Lieberman)

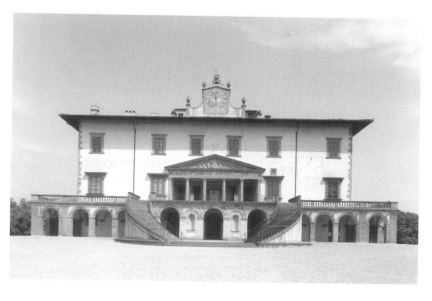

❧ *Figure 17* ❧
Giuliano da Sangallo, Villa of Poggio a Caiano
(Photo: Ralph Lieberman)

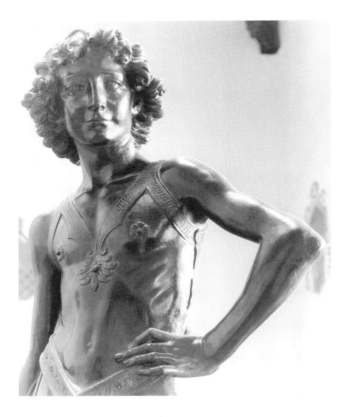

❧ *Figure 18* ❧
Andrea del Verrocchio, David, *Bargello, Florence*
(Photo: Ralph Lieberman)

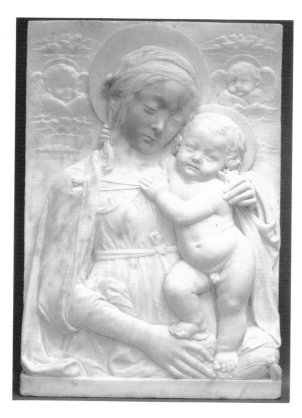

❧ *Figure 19* ❧
Benedetto da Maiano, Madonna and Child, *National Gallery of Art, Washington, D.C.*

(Samuel H. Kress Collection, National Gallery of Art, Washington, D.C.)

❧ *Figure 20* ❧
Giuliano da Sangallo, church of Santa Maria delle Carceri, Prato
(*Photo: Ralph Lieberman*)

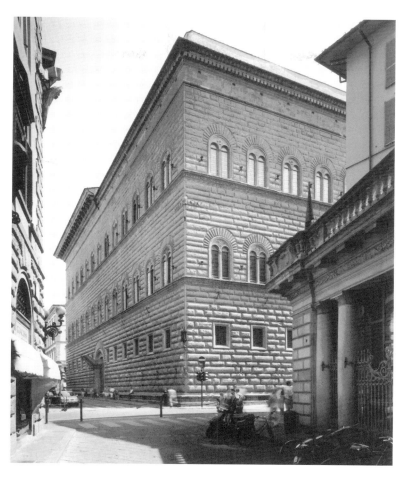

❧ Figure 21 ❧
Palazzo Strozzi, Florence
(Photo: Ralph Lieberman)

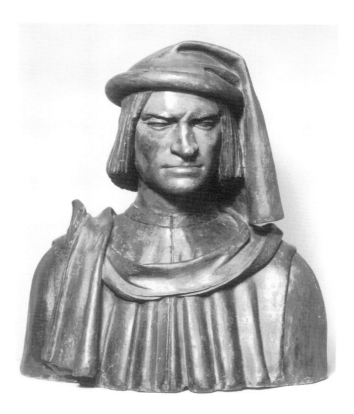

❧ *Figure 22* ❧
Portrait bust of Lorenzo, National Gallery of Art, Washington, D.C.
(Samuel H. Kress Collection, National Gallery of Art, Washington, D.C.)

❧ *Figure 23* ❧
Church of San Salvatore al Monte, Florence, interior
(Photo: Ralph Lieberman)

❧ Figure 24 ❧
Giuliano da Sangallo, church of Santo Spirito, Florence, sacristy
(Photo: Ralph Lieberman)

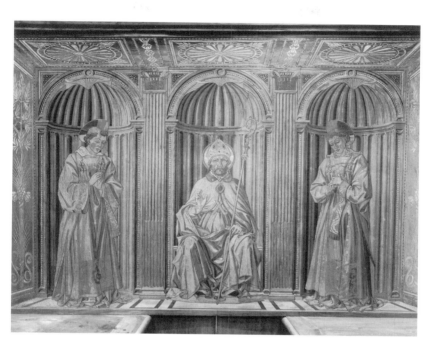

❧ Figure 25 ❧
Saint Zenobius, Florence Cathedral
(Photo: Ralph Lieberman)

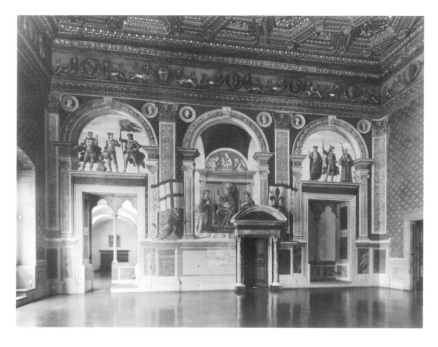

❖ *Figure 26* ❖
Sala dei Gigli, Palazzo Vecchio, Florence
(*Photo: Ralph Lieberman*)

❧ *Figure 27* ❧
Giuliano da Sangallo, Villa of Poggio a Caiano, façade
(Photo: Ralph Lieberman)

❧ Figure 28 ❧
Filippino Lippi, frescoes, Villa of Poggio a Caiano
(Photo: Ralph Lieberman)

ness other than merely surviving. It was after the war that he found the confidence, even, one suspects, the sheer leisure, to pursue the traditional patronal activities and artistic interests of his family, although he proceeded slowly. It has been remarked that Lorenzo wrote little or no poetry in the first troubled years of his leadership, taking up his pen again to write several autobiographical prose fragments and some poetic works only about 1473.[20] Precisely at this time he devoted copious time and resources to reviving the *studio,* or university, at Pisa, a project that continued to absorb him.[21] Moreover, the Volterran war of 1472, which needs to detain us for some time now, deepened Lorenzo's acquaintanceship with, if it did not introduce him to, several master woodworkers and builders who were soon to work with him. The conflict may also have further sharpened that interest in architecture and *disegno* born of his early works-committee experience and now maturing in the 1470s. Certainly, it was in the direct aftermath of the war that Lorenzo became active in the affairs of the Wool Guild, joining its special committee entrusted with administration of the Volterran alum resources, the struggle for the control of which had been a major cause of the revolt. This body became the office of the six *provveditori,* who exercised an extraordinary supervisory role over many aspects of the guild and of the Florentine cathedral in its care. Lorenzo's continuous membership on this committee until his death provided the constitutionally respectable modus operandi by which he brought influence to bear on the Opera del Duomo, which was itself central to the Florentine building and sculptural trades, providing basic materials such as timber from its extensive forests in the Casentino and marble from Carrara and training the generations of masters whose names, and even at times personalities, emerge from the detailed account books kept by that impressive mini-bureaucracy.[22]

Lorenzo was slow to seek a military solution to Volterra's revolt, finally deciding to do so when he was persuaded that his enemies were using, indeed stirring up, Volterran discontent to undermine Medici authority at home. Lorenzo and his closest partisan friends emerged from the conflict, which had gathered a good deal of popular support in Florence, with diminished reputations because of their alleged complicity in the violent sack of Volterra but with a securer grip on government. To be sure,

Lorenzo's role in the victory was almost studiously understated. He was, however, on the special committee *(balìa)* of twenty directing the war and apparently gained decisive influence among its members, many of whom were already his partisan friends. The state bureaucracy that ran the war was, or became, a thoroughly Laurentian one. The Twenty's chancellor was Lorenzo's own secretary, the ubiquitous Michelozzi, and the Florentine chancellor and Medicean Bartolomeo Scala was prominently in the wings. The bank of Giovanni Rucellai, whose son Bernardo was Lorenzo's brother-in-law, managed the huge war chest the commune had provided. Other Medici associates were actively engaged in assuring the siege's success. It was as if at Volterra Lorenzo were breaking in the bureaucratic and partisan team that would long be associated with his continuing ascendancy.[23]

On the military and engineering side, during the war the nucleus of a later Laurentian building and architectural team also emerged among the master carpenters and builders who spearheaded the successful siege against what was commonly regarded as an impregnable fortress. As Gino Capponi reported in a letter of early June, the besieging Florentine forces were supported by fifty master woodworkers led by four *capomaestri,* "and there have gone there as overseers Francione, el Maiano, e' Grasso di messer Luca [*sic*], all woodworkers, and the builder known as the Captain."[24] There are details concerning payments to Francione, Domenico di Francesco, "the Captain," and the more mysterious fat woodworker (e' Grasso, possibly Giovanni da Gaiole) in the records kept by the Twenty. "The Captain" turns up in the next year as a supervisor of the construction of the new fortifications at Volterra, in whose design Francione is usually assumed by scholars to have had a role.[25]

There appears to be no documentary confirmation that Francione had such a role. It seems very likely, however, that Francione, Giuliano da Maiano, and "the Captain" were all privy to the planning sessions for the new fortifications, just as they had orchestrated the siege, which was distinguished by its use of sophisticated earthworks and wooden towers and its deadly use of artillery. On the very day of the victory the Twenty noted that the Florentine general, Federigo da Montefeltro, had undertaken "to give some thought to the fortress and other matters pertaining to this

city's future security," valuable counsel from the greatest Italian military commander of the day.[26] A week later, the Mantuan ambassador informs us, the Twenty "have been about three hours" with Federigo, "and they have designed in what way they wish to construct a citadel and to fortify Volterra."[27] As we have seen, the Florentine republic quickly assigned the supervision of this major project to the Canal Officials, one of whom was Lorenzo de' Medici. He would have been at the very least an interested observer of the technical discussion between Federigo, the various Florentine and foreign military engineers, and his citizen elders on the Twenty who were more experienced than he in such bellicose matters. Even if Lorenzo was absent from this vital meeting of the Twenty, he talked intimately with Federigo at this time, according to one witness, remaining "alone with the count for a good while."[28] Federigo, the Italian prince with perhaps more money at his disposal for building and book collecting than any other, had been one of Lorenzo's godfathers and very likely became for him a figure to emulate.

If Lorenzo had not already known Francione and the others and appreciated their experience and ability before the siege of Volterra, he came to do so afterwards; since he was a *provveditore* of the Wool Guild from 1471 on, men such as Giuliano da Maiano and Francione, who worked for the Opera del Duomo, would have brought themselves to his attention. With several of these woodworker-engineers Lorenzo went on to have long friendships, employing them on projects of his own, dispatching them to other lords as part of his so-called artistic diplomacy, and protecting their everyday interests as any *gran maestro* did those of his clients.

It is time to assemble, as it were, the *dramatis personae* of Lorenzo's patronage over the next decade or so. A firm friend was Francione, that "famous woodworker," as Margaret Haines has described him, a much older man whom Lorenzo would first have heard of for his beautiful intarsia work at the Duomo, the Palazzo Vecchio, and church of the Annunziata.[29] He was regarded as one of Florence's most gifted "masters of perspective" by about 1470,[30] an artisan with the transferable design skills typical of the city's goldsmiths and woodworkers. Francione was at Colle in September 1479 to supervise repairs to that town's defenses dur-

ing the Pazzi war. His matter-of-fact report to Lorenzo begins without a preamble and uses the *voi* form at a time when many of Lorenzo's social peers addressed him far more formally. "I do not believe we will lose Colle in a year," the master artisan reassured the embattled Lorenzo.[31] When it appeared that this military engineer had been mortally wounded at the siege of Sarzana in mid-June 1487, Lorenzo, declaring that "the sorry matter of our Francione . . . has upset me so much that there are few people in this camp about whom I would feel more strongly if this had happened to them," ordered instant compensation to be paid to his family.[32]

Lorenzo cannot have opposed the appointment a year later of a "resurrected" Francione, "Big Frank," to the salaried post of military engineer to the republic, a distinction he shared with that other woodworker whom he had helped train, the man known as "il Cecca."[33] Celebrated by contemporaries and honored by Giorgio Vasari with a life of his own, Cecca seems, by the way, not to have been Lorenzo's intimate. Medici knew his value, however, declaring that "Piancaldoli was too costly" on hearing of the engineer's death during that campaign.[34] These military engineers lived dangerously. Lorenzo went on to write to and on behalf of Francione several times in the 1480s, entertaining him with other intimates on one occasion in 1485.[35] It was to this woodworker that Lorenzo turned when he wanted a painting forcibly removed from the house of its rightful owner.[36] Later in the 1480s, Francione worked with Lorenzo at the villa of Agnano and other sites, possibly neglecting his public duties as military engineer while doing so; there may even have been a gentle tug of war over him between the *maestro della bottega* and his oligarchic lieutenants.[37] If by this time Lorenzo nonetheless found more to admire in the emerging architecture of Giuliano da Sangallo—he championed the latter's model for the new fortress at Sarzana over Francione's and others' in 1488, and according to Vasari, Francione submitted a model for the villa of Poggio a Caiano only to see the younger man win the "competition"[38]—the new favorite had been the older Francione's partner, and Lorenzo's affection for "Francione nostro," as he characteristically called him, remained unaffected. Baccio Pontelli, another intarsia artist and military engineer with whom Lorenzo stayed in touch, found it appro-

priate when writing to Lorenzo in 1481 to sign himself "woodworker, disciple of Francione."[39]

In a letter to Alfonso of Aragon Lorenzo declared himself "displeased and much put out" by the death in Naples in November 1490 of another of the siege masters at Volterra, Giuliano da Maiano, "because he was very much my man."[40] A modern scholar has observed that Lorenzo's phrase expresses "more a certain inconvenience than pain,"[41] and yet the relationship between the two was an old one and remained an intimate one, Giuliano having been, in Luca Pacioli's words, "very close" to Lorenzo.[42] Giuliano, certainly with the painter Alesso Baldovinetti and probably with Maso Finiguerra, *maestro di disegno,* had been responsible for the brilliant wooden inlaid panel of Saint Zenobius in the new sacristy of the Duomo, under which the wounded Lorenzo was to shelter when attacked by the Pazzi and their supporters.[43] "The said master Giuliano is a most devoted servant of Your Magnificence and preaches your preeminent virtues," a cardinal to whom Lorenzo had recommended da Maiano as builder of his palace in the Marches assured Lorenzo in early 1478.[44] In April of the previous year Giuliano had been appointed architect of the Opera del Duomo—one historian has referred to the post as "something like city architect"—as part of a series of reforms behind which one can detect Lorenzo's influence.[45] Finding himself in Faenza, in the Romagna, later in 1477, the new appointee at the cathedral acted as a Florentine agent eager to report confidentially to Lorenzo "many matters concerning that regime."[46] Again, in the next decade Lorenzo came to prefer the much younger Giuliano da Sangallo for his own projects, but if it was in a sense a happy solution to dispatch the other Giuliano to Naples in response to the duke of Calabria's request in 1484 for Florentine architectural and engineering expertise, Lorenzo was hardly sending to this powerful prince a man whose talents he did not still admire. In May 1489 the ruler of Naples, expressing himself delighted with Medici's choice, showed a visiting Florentine his new "place [*villa*] . . . which Maiano had derived [*havea tracto*] from your model," as Lorenzo was informed,[47] an intriguing phrase implying that the older architect and his Florentine master in some sense collaborated still.

The Temptation to Be Magnificent, 1468–1484

Seemingly less familiar but still closely associated with Lorenzo was yet another of the master artisans at the siege in 1472. "The Captain," Domenico di Francesco, was a builder who had had considerable experience on the Roman building sites of Pope Paul II in the 1460s, knowledge of which may have recommended him to a man such as Lorenzo de' Medici. Domenico was, intriguingly enough, to be found at Poggio a Caiano not long after Lorenzo acquired the property, apparently directing the preliminary improvements to the site, including those drainage and other hydraulic works in which military engineers such as himself were expert.[48] Several of "the Captain"'s letters to Lorenzo, reports on fortifications mixed with letters recommending "a most experienced" builder and a very well known mercenary captain, survive from the time of the Pazzi war.[49] More formal and polished than the letters Lorenzo received from Francione, Bertoldo *scultore,* and, later, Giuliano da Sangallo, "the Captain"'s correspondence reveals that he was at his social ease with Florence's leading citizen—as one might expect of an ex-papal familiar—and accustomed to discussing professional matters with him, in part in Lorenzo's capacity as a canal official. "When I am there in Florence," he wrote from Borgo San Sepolcro, "I will tell Your Magnificence details concerning these constructions, both old and new, that are absolutely Your Magnificence's doing."[50] Impressed by a potential site at remote Valiano some months later, Domenico di Francesco wrote to Lorenzo: "And if Your Magnificence should want sent a design of what has been decided, or a model, tell me and I will do it willingly because this seems to me a place to take very seriously indeed, and you have to see it to know that."[51] Almost invariably called in Florentine documents "the builder" *(muratore),* Domenico is nevertheless described by Giuliano da Sangallo himself as an "architect," one of the six *architetturi* asked in 1486 whether the church of Santo Spirito should have three doors or four.[52] Da Sangallo did not like the advice the older man gave, but "the Captain," who had been described in Roman sources as "architetto de caxa,"[53] evidently had considerable experience and design skills; he was employed with Francione and others to construct the fortress at Sarzana in 1487,[54] and further research may well show him to have been active in Laurentian and still other Florentine building campaigns.

Lorenzo de' Medici

It is my suggestion, to refine an earlier point, that by mixing with such mature and experienced Florentine artisans, men of intelligence and critical spirit as Vasari tells us, skilled accountants of entrepreneurial temper,[55] Lorenzo de' Medici added a good deal to the knowledge of building and *disegno* that he was acquiring as an *operaio*. The sense of striving that pervaded these artisan workshops, which would have been instantly recognizable to a man as competitive as Lorenzo, emerges touchingly in a drawing of an apprentice, attributed to Maso Finiguerra in the 1460s, bearing the legend "I wish to be a good designer and I want to become a good architect."[56] The *maestro* of such artisans in a social and political sense, their protector and patron, Lorenzo was guided by these skilled men in their own catholic and overlapping fields of endeavor. He was not alone in this. That impressive Mantuan patron of architecture, Ludovico Gonzaga, when writing to the Florentine-born Luca Fancelli, was accustomed to ringing the changes on this theme, at times declaring himself the architect's master and at others confessing himself the disciple.[57] Poliziano, patently Lorenzo de' Medici's master in the classics, played with the conceit that he was Lorenzo's "client and pupil."[58] Somewhat later, in the remarkable double portrait painted by Filippino Lippi of himself and the patrician Piero del Pugliese, his "patron," the artist sought to demonstrate their friendship and equality.[59]

These examples should hardly surprise us unless we adhere to the myth of the magnificent patron as creator of all he or she commissions, including the artist himself. Scholars have pointed out that in Renaissance Italy the patron-client relationships between people of very different social status were more frequently reciprocal, if, inevitably, unequal, than we might expect, each side having something to offer and, just as importantly, something to withhold. This was as true of obscure peasants, on whom landlords often relied for paramilitary backing, as of modest citizens dealing with grandees who needed their electoral support. If Lorenzo de' Medici himself came increasingly to be described by his cronies as "il padrone," the boss, there worked on his Mugello estates a tenant farmer with precisely that nickname: "Domenico di Cenni, known as 'boss.'"[60] It has recently been suggested that in discussing Renaissance art patronage we should "supply a more dynamic, transactional model

that concentrates [less on hierarchy than] on the mutuality of the relationship and on the process," a point well developed in several contexts by other scholars.[61] Contemporaries, after all, referred to such clientelist ties as "friendships." Many of these associations lasted for decades and even survived several generations, although some were merely instrumental or limited to a single instance. There was both an ethical and a human dimension to Florentine *amicizia.* His creatures in a sense they may have been, but Lorenzo de' Medici owed much to the clever familiars, at once his clients and his friends, with whom he surrounded himself. If their peasant cousins might offer, or withhold, armed allegiance to the Medici, men such as Francione could put nothing less than their *arte,* their skill and genius, at his disposal. These men (they were overwhelmingly men) of the inner *bottega* of which Lorenzo was master were not only the artisan artists whom we have been discussing but musicians, scholars, and virtuoso odd-job men. Their very nicknames—"the Captain," "Big Frank," and so on—conjure up a masculine world of jocular familiarity despite marked social distinctions within the group, an atmosphere of intellectual collaboration created in a hothouse environment that might also breed competition and jealousy.

] 3 [

Some of Lorenzo's familiars became and remained more familiar than others. Take, for example, the intriguing "Francis the goldsmith," who is ubiquitous in Medici documents beginning in the late 1460s, when he emerges working for Lucrezia Tornabuoni as her Pisan agent, later serving Lorenzo himself as factotum. He is several times described, as if it were his title, as "Francesco orafo che fa i facti di Lorenzo" (Francis the goldsmith, who does Lorenzo's business).[62] This goldsmith later lived in Medici-owned houses, both in Florence and in the country; one of the Medici gardens near San Marco was known as "Francis the goldsmith's garden."[63] In the same year—1486—this obscure man held two high political posts: he was both a prior and a member of the feared police magistracy of the Eight. While he was a member of the latter, he and his colleagues, who included the partisan chancery official Giovanni Guidi, consigned a provincial prisoner to Lorenzo on the (judicially unsound)

grounds that "he should be dealt with by the person whom he had offended."[64] Like so many Florentine artisans, not to say Laurentian friends, Francesco had what we would call transferable skills. His name crops up with Francione's in 1481 as among the masters who inspected the possible site of a fortress at Poggio Imperiale,[65] and in 1491 he was asked for his advice on the question of completing the Duomo façade.[66] It was none other than Francesco who, acting for Piero de' Medici, sought to "buy" the painting by Cimabue in the possession of a Benedictine monastery,[67] and he turns up as the protagonist in a poetical exchange with another Medici familiar, Feo Belcari. We have very recently learned that Francesco was indeed a practicing goldsmith, so confirming Caroline Elam's suggestion that he had design skills.[68] It would be pleasant to speculate—and why should one not?—that the "Francesco..., orafo" who in 1468 sat on the committee responsible for commissioning the cathedral's bronze orb was none other than he.[69] If so, his most junior colleague was, of course, Lorenzo de' Medici. This would be an extremely early example of how intertwined Lorenzo's artistic and clientelist ties with his gifted artisan friends were. The artful Francesco, for all we know, played some role in the aesthetic education of the young politician to whose family he was so devoted.

Other close associates certainly did so. One such man with whom Lorenzo was early and long associated, both as a friend and as an artistic familiar, was the sculptor Bertoldo di Giovanni, born about 1440, who later in life would be installed in the Palazzo Medici, where he had a room to himself.[70] Bertoldo's acquaintance with Lorenzo dated from at least 1473, when we find him witnessing a notarial act "in the house of that magnificent man Lorenzo di Piero de' Medici."[71] When that house was rattled to its foundations by the Pazzi Conspiracy of April 1478, in which Giuliano died and Lorenzo was wounded, Bertoldo used his particular skills to uphold it. The well-known commemorative medal he quickly designed, bearing portraits of the two Medici with suitable epithets— Lorenzo's read "salus publica"—and vivid narratives in miniature of the violent event, was a visual counterpart all'antica to Angelo Poliziano's eloquent tract *Coniurationis Commentarium,* written almost as promptly on their stricken Medici master's behalf.[72] Bertoldo, by his own account a

pupil of Donatello's, did not emerge from the boot camp, as it were, of the Opera del Duomo's large team of stonecutters and sculptors. His only commission at the cathedral, two wooden angels to be placed above the organ, almost certainly came from on high through Lorenzo's influence in the Wool Guild.[73] It would seem that their friendship was, or became, a more personal (less institutional) alliance than, say, Lorenzo's with "the Captain" or even with Francione; witness the famous letter Bertoldo wrote to his friend in July 1479, full of mysterious, not to say garbled, allusions to the writer's abandoning his craft to take up cooking. This document, with its angrily elliptical references to one Luca Calvanese (possibly Bartolomeo Scala, for whom Bertoldo also worked) and its evocation of grilled songbirds eaten at the Acciaiuoli country estate of Montegufoni has still more secrets to yield. It may in part be written in the homoerotic double-talk so ubiquitous in Quattrocento Tuscany.[74] For our purposes, it reveals a joky intimacy, even intensity, between Medici and Bertoldo. The sculptor accompanied his young friend to the baths in 1485 together with assorted secretaries, musicians, and other household familiars.[75]

Lorenzo owned several small bronzes *all'antica* by "our Bertoldo,"[76] as he referred to him, and must have prized his friend's ability to execute works in this emerging sculptural genre, which was to become so fashionable in the next generation. Despite Bertoldo's mixed reputation with modern connoisseurs—his "tough, moody [and] dangerous"[77] small bronzes can repel as much as they attract—the vivid small battle scene now in the Bargello struck the late Sir John Pope-Hennessy as "an unassailably great work."[78] Lorenzo, who hung it over a fireplace in his quarters in the Palazzo Medici, was presumably of the same opinion (Fig. 10). The artist's domestic role in Lorenzo's life certainly provides a plausible context for the mid-sixteenth-century tradition that associates him with Lorenzo's sculpture garden at San Marco, where he is supposed to have been a curator-cum-restorer-cum-teacher. There is certainly an allusion in the record to Bertoldo's advising his Medici friend on newly found antiquities, such as the "ancient and beautiful" bronze unearthed in Siena in 1489. Further, a recently discovered document in which the young stonemason (*scarpellino*) Giovanni di Romolo di Tommaso Michi is described in the late 1480s as "working for Lorenzo, with Bertoldo the

sculptor" gives some sense of a small Laurentian team working on stone and marble as well as bronze, whether in the Palazzo Medici or the San Marco garden one cannot, of course, divine.[79] "Bertoldo the sculptor, who lives with him, has died at Poggio a Caiano of quinsy, much to the said Lorenzo's sorrow, because he loved him as much as any of his familiars," reported the notary of the Opera del Duomo, Bartolomeo Zeffi, in late 1491. He was "a most worthy sculptor, an excellent maker of medals, who along with the Magnificent Lorenzo made fine things," observed another contemporary, Bartolomeo Dei, at the time of Bertoldo's agonizing death.[80] Bertoldo's presence at the villa of Poggio in 1491, when building there was going on apace, lends weight to the much-repeated suggestion that he designed the terra-cotta frieze on its palatial façade (Figs. 11, 12).[81]

Is Bartolomeo Dei suggesting in this passage some creative collaboration between the two men, one in which Bertoldo had been as much the teacher as the disciple of his younger friend, a living link with Donatello's heroic generation? If so, the artistic and personal alliance that developed between Giuliano da Sangallo and Lorenzo, in part at the expense of older loyalties, was also perhaps this sort of "symbiotic relationship," as Linda Pellecchia has so well described the young Giuliano's earlier collaboration with Bartolomeo Scala.[82] Although Giuliano and, to a lesser extent, Bertoldo came from the Florentine workshop tradition, they may perhaps be regarded as increasingly Laurentian artists in a novel sense, at once more controlled by the *maestro della bottega* than were master artisans such as Francione (whom one associates as much with the bustling and chaotic world of republican committees and crowded workshops as with an emerging coterie of "court" artists) yet enjoying with him a closer creative and personal intimacy.

When Giuliano and Lorenzo met we do not know, although the opportunities and contexts for them to have done so abounded from at least the early 1470s on. The very young artisan worked in Florence with men known to Lorenzo—Francione, Giuliano da Maiano—on projects in which we may assume that the Medici leader, along with half the city, was interested. During the period 1465–72, when Giuliano was in Rome beginning to create his remarkable collection of architectural and other drawings after the antique, Lorenzo visited the city several times, most

significantly for our purposes in 1471 with Alberti, Bernardo Rucellai, and Donato Acciaiuoli. Upon his return to Florence this budding architect designed the very novel suburban "villa" of Scala, an antique-inspired small palace that "breaks with almost every tradition of Florentine domestic architecture." In seeking to revive Plinian and Vitruvian ideas of the ancient Roman *domus* within the walls of Florence in the 1470s, da Sangallo and Scala were, in Pellecchia's judgment, anticipating several architectural themes that matured in the next decade, when the Florentine chancellor's master, Lorenzo, would work so closely with Giuliano.[83]

Whatever his precise motive, Lorenzo in mid-1485 advised the works committee of Santa Maria delle Carceri in Prato to replace Giuliano da Maiano as architect of the proposed new church with da Sangallo, who went on to devote many years to the project; at the time da Sangallo was preparing a model of this or some other building for Lorenzo. More securely documented is the fact that in May of the next year Giuliano da Sangallo was confident enough of Lorenzo's professional respect and personal affection to request his intervention in the emotionally charged dispute over how many doors the façade of the church of Santo Spirito should have; however, Lorenzo did not act on his plea "not to let so beautiful a building be destroyed" by accepting the proposal to finish the building with three rather than four portals, why one cannot quite be sure.[84] If after the laying of even these first, secure stepping stones the path leading from one man to the other can still at times become unclear, there is enough firm ground to enable us to assume a growing and intimate collaboration. Through self-education and, one may suggest, close contact with men such as Lorenzo and Scala the expert artisan Giuliano had become a learned architect in whose house, a contemporary observed, were "various antique Roman objects."[85] Summoned by Pope Julius II in January 1506 to inspect on site a newly discovered Laocoön, the older Florentine, accompanied by Michelangelo, at once recognized that this was the ancient sculpture famously mentioned by Pliny.[86]

Lorenzo loved to surround himself with very intelligent people, all the more so, one suspects, if they were amusing, personally pliable, and devoted to him and to his dynastic interests. "Court" artists and intellectuals they may perhaps be called, yet it must be emphasized that these

men—the poet and philologist Angelo Poliziano, the poet Luigi Pulci, the musician Antonio Squarcialupi, and the artisans discussed above— were genuinely first-rate, and their contribution quite central to Lorenzo's life and achievements, which is not to go so far as the provocative description of Lorenzo as "to some extent . . . a committee."[87] Lorenzo did not nurture minor talents, however willing to praise, not to say fawn upon, him such satellites might have been. Despite Lorenzo's admiration for and support of the northern European composer Heinrich Isaac,[88] he would hardly have agreed enthusiastically with the Mantuan agent who advised his own master to employ Isaac rather than the celebrated Josquin Desprez: "[Isaac] is more companionable and will be more fertile of novelties. It is true that Josquin composes better, but when it suits him, not when he is required to, and he asks for a stipend of 200 ducats, where Isaac will work for 120."[89] Lorenzo, himself a poet who endlessly revised his work,[90] would have understood better the artistic temperament that Josquin displayed. He chose increasingly to be surrounded by creative people with a discerning or scholarly knowledge of antique sources, some of whom could be as difficult as they were devoted to him.

If the youthful Leonardo da Vinci, supremely talented and trained in Verrocchio's workshop, was indeed as close to Lorenzo in the 1470s as some scholars maintain on the basis of an early tradition, one wonders why he did not stay, or was not suffered to remain, in Florence after 1482 to become a Laurentian familiar—why, as the same source has it, Lorenzo instead dispatched him to Milan.[91] Perhaps, if these old stories are true, the answer is that Leonardo's temperament was more independent than that of, say, Bertoldo. Besides, Leonardo's interest in architecture, such as it was, largely postdated his Florentine years, the 1470s,[92] during which time Lorenzo's aesthetic energies had been largely directed to thinking about *muraglie*. Perhaps, too, Leonardo's tendency to see "the world differently from his contemporaries"—and his relative lack of interest in antique motifs[93]—made Lorenzo content to allow him to stay in Sforza Milan. Even so, in the mid-1480s Leonardo drew what is very likely a portrait sketch of a quite sprightly Lorenzo, as if to recall an earlier association.[94]

The Temptation to Be Magnificent, 1468–1484

This Laurentian team of collaborators was assembled in the 1470s—as a result, no doubt, of a series of coincidences and ad hoc decisions as much as of a conscious policy—and as his experience of and interest in building and design grew, Lorenzo's securer political position in the city after mid-1472 enabled him to begin to give expression to that knowledge. The Milanese ambassador, who even in early 1472 had been concerned about Lorenzo's growing arrogance (which in part meant the young man's increasing independence of Milanese advice), observed of him that he was "thinking to achieve more than even Cosimo and Piero had ever done, so far as I understand him."[95] It was perhaps a fairer assessment to say that Lorenzo was emerging, in the words of a confraternal document of the same year, as "first citizen of his republic."[96] As such, he began to take up and develop ideas and projects that had been close to the hearts of his ancestors, themselves the city's leading citizens.

"It is obvious," wrote the cleric Giovanni Capponi to Giovanni di Cosimo de' Medici in early 1461, "that all of your house have always been builders and improvers of pious foundations."[97] His Capponi kinsman Guglielmo was later to cede to Lorenzo perpetual rights over ecclesiastical property he coveted. The religious poet Feo Belcari had praised Cosimo as "a preserver of churches [*templi*] and holy places," which description Benedetto Dei footnoted, as it were, by reference to the elder Medici's "buildings and churches and monasteries and hospitals and churches [*sic*] and bridges and chapter[house]s and cloisters and sacristies and refectories and infirmaries."[98] Lorenzo died with a reputation for having maintained this ancestral tradition. He was "very rich and powerful, and most charitable," a Benedictine remembered: "he built churches and convents and especially at San Gallo, at Agnano in Val di Calci and at the Angeli in Florence."[99] At first Lorenzo took up this tradition more modestly, however, by expressing a reverence for ancestors and a pious dedication to the city's embellishment that any Florentine citizen could thoroughly understand. The very rich Filippo Strozzi was to articulate the same sense of priorities when writing to his brother, Lorenzo, in 1477. Since God had granted the Strozzi an abundance of worldly goods, Fi-

lippo said, in expending them "I want to be mindful of Him, first serving the church then one day moving on to ourselves."[100] As if following Platina's advice given to him in this decade, Lorenzo and his cousins continued with the reconstruction of the Medici parish church of San Lorenzo, designed by Filippo Brunelleschi for Cosimo, spending some 6,570 florins in the period 1477–81. It is not clear to what works there this large sum was devoted.[101] Within the church, Verrocchio had labored earlier in the decade at the tomb for Piero and Giovanni de' Medici "as worthily as we know how, to house their bones," as Lorenzo himself wrote. A splendid and unusual funereal monument, "one of the wonders of the world" according to a contemporary, it nevertheless expressed filial piety in a traditional sculptural genre.[102]

If Lorenzo had assumed at San Lorenzo the direct control of the project exercised by Cosimo, with the consent of the administrative district, or *gonfalone,* of which the church was a part, elsewhere, at the observant Franciscan church and convent at San Salvatore, high above the city near San Miniato, the young man duly acted behind the scenes, as his grandfather had also done there. The banker Castello Quaratesi had earlier given Cosimo the task of choosing the masters who would rebuild this conventual complex of which he was patron "because," in Castello's own words, "he understands these things better than I and will act in my best interests."[103] Lorenzo was later to exercise this sort of discretion on behalf of other patrons. Although the chronology and details of his role at San Salvatore are not clear, Riccardo Paciani has convincingly sketched in the outlines of the story. It may be untrue that, as a sixteenth-century tradition had it, in the mid-1470s Lorenzo had pressed the austere friars to rebuild a grander church for the sake of the city, for all that he does appear to have exerted an influence on the developing project toward the end of his life, when his coat of arms was to be found in a chapel within the church. It appears that he acquiesced in the Franciscans' decision in 1474 to construct the complex themselves, using friar-architects and "shunning in the said buildings every unnecessary grandeur and unusual ornamentation in dressed stone and paintings . . . that might lead to major transgressions of our rule."[104] In the 1470s Lorenzo was certainly the banker of San Salvatore and possibly an *operaio*—an office he

was to hold in the 1480s, when he sent a silver ex-voto to the church at a time of illness—satisfied to dispense sums "to be used for the said building campaign" (Fig. 13).[105]

Why Lorenzo declined to support even in this discreet way certain other pet projects of his grandfather's one cannot be sure. Very early in his career he expressed his regret to the duke of Milan that he was unable to favor the Badia at Fiesole as his ancestors had done.[106] More than twenty years later, when he was consumed by a frenzy for building, he seems to have ignored the pointed request of that foundation's prior, Matteo Bossi, that he "now when the greatest prosperity favours you . . . set to work and complete our building under a beneficent star and with the aid of our benefactor Jesus Christ."[107] It may well be that even early on Lorenzo felt an almost irresistible urge to strike out on his own, however decorously, whenever permissible. If so, his modus operandi was modest to the point of anonymity, as emerges when one considers his earliest known independent support for an ecclesiastical foundation, the largest and most prestigious female convent in the city.

After the Benedictine house of Le Murate in the quarter of Santa Croce suffered a damaging fire in 1471, Lorenzo helped finance the rebuilding from mid-1472 on, spending the large sum of five thousand florins, according to a sixteenth-century conventual tradition, on kitchens, dormitories, improvement of facilities, and the construction of a "loggia with four columns surmounted by a balcony."[108] Interestingly, Lorenzo's first fiscal intervention at Le Murate seems to have been as a representative of the commune, dispensing civic funds by means of a complicated mechanism, but the foundation's redoubtable abbess, Madonna Scolastica Rondinelli, reminded her "sweet son" in a letter of 17 May 1472 that he had also committed "your own money."[109] Giuliano, Lorenzo's brother, was to donate part of a garden to the convent in 1475.[110] Even so, this remained decent and anonymous Medicean generosity. According to the grateful mother superior, Lorenzo himself had insisted—shades of Cosimo's critics—that at Le Murate neither his "heraldic arms nor anything else should reveal what God alone knew and had given."[111] How anonymous and workaday the new architecture of the convent was we cannot say,[112] nor is it known by whom it was designed and built. The

documents tell us nothing, and the conventual buildings, until very recently serving as a maximum-security prison, were radically transformed in the nineteenth century. It is tempting to speculate, however, that Lorenzo may have taken an early aesthetic interest in this, his first known architectural intervention, and that some older, experienced friend, such as Francione or "the Captain," took a hand in the project (Fig. 14).

What we may be sure of is that by retiringly supporting a strict observant foundation such as Le Murate—and Lorenzo went on consistently to favor the more rigorous religious houses[113]—he had increased his reputation for piety (if we assume that the news would have gotten out) and gained for himself and the Medici the prayerful support of Florence's largest female convent. The young Medici leader knew as well as any contemporary nun that a convent's collective prayers possessed the energy of two thousand horses.[114] Both his newly widowed mother and Lorenzo himself were, in their different ways, devout Christians. It was precisely in the early 1470s that Lucrezia Tornabuoni emerged not just as a pious benefactor of the poor, devoted to the Marian cult and Florence's patron saint, John the Baptist, but as a saintly figure herself, increasingly revered by the populace. By 1472 an ex-voto of Lucrezia was to be found in the Duomo itself, despite prohibitions against placing such figures there, kneeling before a painting of the Medici saints, Cosmos and Damian, as if to mediate between the family on earth and its heavenly patrons. So lifelike and impressive was the image that a Medici client wished to reproduce it in a church in Ancona to please Lucrezia's elder son.[115] The Medici regime was a holy one, a *governo santo,* the family's apologists insisted. If Florence's republican government had always been considered as in a sense sacred, and the Palazzo Vecchio sacrosanct, then the republic's leading family both sought and increasingly had bestowed upon it a reputation for being a *beata stirps,* a holy dynasty.[116]

Dynastic considerations were inseparable, then, from the Medicean piety expressed in the family's support of ecclesiastical foundations. The district around the church of San Lorenzo was the very heartland of the Medici faction and of the lineage itself, which numbered scores of men and women almost all of whom supported Lorenzo's branch. After 1465, however, Piero de' Medici acquired absolute *iuspatronatus* over the

ancient church itself, which rivaled the Duomo in prestige and wealth. No one but the Medici had the right to bury their dead in the church proper, a prohibition that separates the basilica of San Lorenzo from other great Florentine churches;[117] at Santa Croce, for example, there is a profusion of floor tombs whose occupants enjoy a certain postmortem freemasonry, if not sociability. However traditional Cosimo's floor tomb at San Lorenzo was in form, it was made of white marble and porphyry and placed before the main altar, holding the church together, so to speak. Paolo Giovio later observed that Cosimo "had an entire church as his gigantic sepulchre."[118] By constructing a tomb for their uncle and father there in the early 1470s Lorenzo and Giuliano expressed piety in traditional terms, but by having Verrocchio display their names prominently in *all'antica* lettering on this stylistically daring monument made of costly materials they were forging a new vocabulary of magnificence (Fig. 15).[119]

Lorenzo eventually was able to do more or less as he wanted with San Lorenzo and its canons, who spoke the plain truth when in July 1479 they acknowledged his authority "not only in building walls and constructing buildings but in choosing persons who can satisfy the needs of the parish and church."[120] Just as Lorenzo de' Medici exercised patronage in several senses in his parish church, he sought to do so even at Le Murate, despite the more appropriate anonymity of his intervention there. By his financial support of the Benedictine nuns, by courting Madonna Scolastica Rondinelli, who had close family connections with anti-Medicean citizens, Lorenzo was gaining a foothold in a quarter, Santa Croce, that had traditionally been hostile to the Medici and their faction, concentrated as it was in San Lorenzo and the quarter of San Giovanni. Another benefactor of Le Murate at this time was Antonio di Bernardo Miniati, the public official in charge of the funded debt, whose partisan allegiance to Lorenzo earned him the hatred of the populace, by whom he was killed upon Piero de' Medici's expulsion from the city in late 1494. Le Murate, whose first major benefactors had been members of the pro-Medicean Benci family, was to remain identified with Lorenzo, his heirs, and his party for many decades to come, as Savonarola knew.[121] An image of Lorenzo—an ex-voto, surely, not a painting—later existed in the conven-

tual church, from which Piero Soderini removed it during the period when he was gonfalonier for life, between 1502 and 1512.[122]

Soderini, whose republican government was committed to a policy of public support for the arts, was no doubt reacting to the unmistakable political dimension of Lorenzo's pious donation to Le Murate. Lorenzo and other Medici had carefully placed ex-voto images of themselves, many of them life-size and some of silver, at strategic sacred sites throughout Florence and beyond.[123] Just as many Medici arms and inscriptions were expunged by the republican regime after 1494, so might an imposing votive figure of Lorenzo, charged with religious power, demand removal. Lorenzo's descendants, restored in 1512, proceeded to put back religious and civic images associated with his regime and to destroy those of Soderini's government.[124]

] 5 [

More politically confident by the mid-1470s, Lorenzo felt able to interest and involve himself openly in public programs, increasingly to identify himself and his family not only with ancestral projects but with the embellishment of the republic at large, all the while continuing to blur the distinction between the advancement of Medicean dynastic pretensions and the dutiful fulfillment of a rich citizen's obligations to Florence. He earned widespread praise for his support of the university at Pisa, to the planning of which he gave his close attention. The Milanese ambassador reported in October 1473 that Lorenzo would not leave Pisa "before the studio is opened."[125] For the rest of his life Lorenzo was regarded by friends as "having the authority essential to the university's existence."[126] This was also an "extraordinarily happy" period of the young Lorenzo's life—several letters of 1476 refer to his skylarking on festive trips away from Florence—when he again began to compose poetry, as well as to express this renewed *joie de vivre* by pursuing with fresh energy his other aesthetic interests, often in collaboration with the artisan friends of whom we have been speaking.[127]

The city's great Duomo quickly claimed his attention. His participation in the Wool Guild's affairs as one of the committee of the six *provveditori* gave a proper republican context to Lorenzo's personal enthusi-

asm for the competition announced in 1476 to complete the façade of the cathedral. In August of that year Lorenzo requested through his secretary Michelozzi, who was also chancellor of the Wool Guild from 1475 until his master's death, that an official of the Opera del Duomo "measure the church's façade" and send him the details. Bertoldo the sculptor also took part in this process. The scheme was, the then *capomaestro* of the Duomo wrote to Lorenzo, "the best and most honorable undertaking around," and manifestly Lorenzo was caught up in the excitement.[128]

This is not to say that the competition for the façade of the Duomo was Lorenzo's idea. He was hardly the only Florentine citizen aware that Alberti's beautiful marble façade for Santa Maria Novella was nearing completion, thanks to the munificence of Giovanni Rucellai, whose name was to be incised across the Dominican church in elegant *all'antica* lettering, or that the Franciscans at Santa Croce were taking a renewed interest in its unadorned *facciata,* whose completion the Florentine government argued in 1476 would render that church among Italy's most beautiful.[129] Several public documents from this period speak of the duty of "that most religious people," the Florentines, "to honor and magnificently enhance the divine cult,"[130] an official sentiment Lorenzo found it both politically convenient and personally congenial to endorse.

Nothing came of this particular competition at the cathedral, in part, at least, because there was such a shortage of ready money at the Duomo and other building sites that workers' wages were being cut at a time when food and other shortages distressed the city at large.[131] (No Florentine church façade other than that of Santa Maria Novella was to be completed in the Quattrocento.) Whatever Lorenzo's role in conceiving the scheme, he and his friends in the Wool Guild were evidently vexed by its failure. For whatever reason—the general economic conditions, the "unsteady" decision-making procedures—the 1470s were not the Opera del Duomo's finest hour. Several other proposals, such as the major project to construct a new choir, went unrealized; only the creation of liturgical manuscripts and vestments flourished.[132] By July 1477 the six *provveditori,* including Lorenzo, had been entrusted with the task of reforming elections of persons to the consulate of the guild to ensure that hand-picked men of energy and good judgment were chosen to lead

it. The account-keeping of the Opera del Duomo was also criticized in this period, during which Giuliano da Maiano was elected architect to the cathedral, charged "with the general care of the building and construction of the church";[133] whether the criticism was justified is not clear. A little later, Lorenzo and the other *provveditori* were given the task of reviewing elections to the Opera itself. It was a matter of urgency, the legislation declared, that in this office "there should always be among the *operai* someone who has some understanding of building and of the matters pertaining to it."[134]

The electoral technique devised by the six *provveditori* to ensure this outcome mirrored precisely that by which the Medici and their friends had controlled communal appointments. Under the new dispensation, certain extraordinary payments made to artists and others by the Opera had to be approved by the guild consulate and the six *provveditori*. It was according to this last procedure that Lorenzo and his colleagues were several times to disburse monies to artists very close to him, including Bertoldo, Giuliano da Sangallo, and Domenico Ghirlandaio.[135] It was as if—or is this again to discard Ockham's razor?—Lorenzo and his close associates had within the space of a year not only engineered the appointment to the Opera del Duomo of an architect of whom they approved, Giuliano da Maiano, but also reformed the consulate and ensured that one of the two *operai* elected each year would be friends of Lorenzo's who had experience in the management of architectural projects.

In the event, the first *operaio* drawn under the new dispensation on 1 January 1478 was none other than Roberto Lioni, one of the Wool Guild's *provveditori* and among Lorenzo's most loyal political lieutenants.[136] In a number of decisions made by the Opera from that time on, Laurentian influence, or that of such close associates, can be suspected if not precisely detected, for example, when the Opera gave the sculptor Matteo di Iacopo permission in 1480 to work with Andrea del Verrocchio in completing the *Christ and St. Thomas*[137] or when, ten years later, two sculptors were granted leave to labor for Lorenzo's uncle, Giovanni Tornabuoni, in the church of Santa Maria Novella.[138] Lorenzo was at this time insinuating himself and his allies into the affairs of the Florentine cathedral, on which he went on to maintain an increasingly steady gaze. Almost cer-

tainly he was also interesting himself during the 1470s in the campaign to redecorate and beautify the Palazzo Vecchio, paving the way for his explicit and documentable role there as an *operaio* after 1479.[139]

The beautification of the city itself, the straightening of streets and the provision of ample piazzas where citizens might socialize and from which they might view Florence's public monuments, not least the Duomo and the Palazzo Vecchio, had been since the late thirteenth century an essential part of the republican program, though judgments differ as to whether this was a more or less ad hoc process, guided by very general principles of beauty and civic utility, or the imposition on the citizens by an oligarchic elite of a "planning code," ordered and rational, that reinforced visually and, as it were, subliminally the power and majesty of the state.[140] Lorenzo, who was not only a student of Alberti's treatise but from a family of past masters at supporting, in order to appropriate, civic and republican concerns and procedures, found such urbanistic themes irresistible. In the early 1460s the diarist Alamanno Rinuccini had pointed out that large patrician building projects were dispossessing the populace of its housing at a time when the population had begun to grow after a century of recurrent plague.[141] The Florentine authorities knew in 1474 what demographic historians have since rediscovered: "how our population by God's grace . . . has much increased both in the city and the countryside."[142]

Legislation of that year proposed solving the housing shortage by offering tax breaks to builders, an acceptably public-spirited context for Lorenzo's acquisition in 1477–78 of considerable land along the Via dei Servi and the Piazza SS. Annunziata on which to build houses for rental. Since at precisely this time the Florentine government was also concerned about unemployment and food shortages, to support such projects was to offer work to the populace, a "very great help to poor men," as Vespasiano da Bisticci had written of Cosimo's earlier building program.[143] It is arguable that Lorenzo's urbanistic schemes for this, his native area of the city, stretching from the Palazzo Medici to the Sangallo gate, were already taking shape.[144] A pertinent document of early January 1478, to which none other than Francione and Giuliano da Maiano gave their expert assent, argued that as a consequence of Lorenzo's build-

Lorenzo de' Medici

ing program at the Annunziata "the piazza would be regularized, and would become more beautiful and more embellished," a consummation devoutly to be wished for according to a recent critic of this famous space's radical lack of symmetry.[145] Elam speculated with exemplary caution that Lorenzo might also have been planning to create in the remodeled piazza a loggia to mirror Brunelleschi's portico at the hospital of the Innocenti. If this were true, commented Manfredo Tafuri, who remained unduly skeptical, then Lorenzo's was indeed a precocious idea informed by a humanistic conception of rational urban planning.[146]

Not so unthinkably precocious, surely. We must allow that Trecento Florentines had devised rational principles of urban planning. Moreover, in Lorenzo's Florence there already existed an impressive, if small-scale, exemplar of the making over of an urban precinct according to Quattrocento principles: again a Rucellai project, the enclave at once private and public that Alberti and others had created in the parish of San Pancrazio for Giovanni Rucellai. The original piazza, cut by a major thoroughfare, had been expanded to offer a better view of Giovanni's palace, with the beautiful façade that so moved the contemporary architect Antonio Filarete, and to accommodate an elegant loggia, in which the whole Rucellai clan was to celebrate its unity and prosperity.[147] For Bernardo Rucellai's wedding to Lorenzo's sister Nannina, in June 1466, the entire piazza had been covered by a ceiling depicting the heavens, under which the guests had feasted and danced for days. Lorenzo de' Medici was there, dressed in newly acquired Milanese finery, and he may well have had eyes for something other than the many aristocratic young women present in this elegant urban space (Fig. 16).[148]

One may suspect that the young Lorenzo de' Medici was not unimpressed by Giovanni Rucellai's achievements as a builder and public benefactor, second only to those of his own grandfather and reaching their high point in the late 1460s and early 1470s. Despite being, as Palla Strozzi's son-in-law, a potential enemy of Cosimo's regime, Giovanni had with patience and subtlety pursued a brilliantly original building campaign, wooing the Medici and entering into the city's good graces by his tasteful munificence while remaining loyal to the memory of his exiled Strozzi kin. In his elegant Albertian town house he had gathered

beautiful objects created, as he expressly said, by the best (*miglori*) masters in Italy.[149] To be sure, Lorenzo de' Medici would have regarded as risibly inadequate—philistine and naively apolitical—the undereducated Giovanni Rucellai's dictum that man is born to do two things, "to procreate and to build."[150] He might have found more acceptable, especially for Florentine public consumption, another of the statements Giovanni confided to his diary, a sentiment informed by the banker's secondhand acquaintance with the ideology that Hans Baron dubbed republican "civic humanism": that he had joyfully pursued his building program and other generous acts "because they redound in part to the honor of God and the city and to the memory of me."[151]

] 6 [

The "me" part of Rucellai's statement was last but hardly least for both men. One cannot escape the impression that during this period Lorenzo, while working within republican conventions, was also laying more ambitious personal and dynastic plans; witness his abortive project to have his brother, Giuliano, made a cardinal as part of what one might call the Medici's self-beatification strategy. This had been another dynastic dream, Lorenzo in 1472 mentioning "how long it has been our family's desire to have a cardinal in its ranks."[152] Many years later, after much effort and expense, an extremely youthful Giovanni di Lorenzo attained the purple, causing his father to call it "the greatest achievement ever of our house."[153]

Houses in several senses were early and always on Lorenzo's mind. In June 1474 he acquired for well over six thousand florins the estate of Poggio a Caiano, ten miles west of Florence on the road to Pistoia. Its owner, none other than Giovanni Rucellai, had already created a flourishing agricultural enterprise there, among other improvements planting numerous mulberry trees. Giovanni had also renovated the estate's *casa da signore,* presumably a fortified manor house in the traditional style, which had belonged to his exiled father-in-law, Palla Strozzi. There can be no doubt that Lorenzo intended his already improved new estate to be profitable, just as his housing schemes in Florence were to provide rental income. He began at once to acquire further property around it,

Lorenzo de' Medici

defending his lands against flooding from the river Ombrone as part of the elaborate improvements supervised by the experts in pastures and hydraulics, including Domenico "the Captain."[154] In the summer of 1477 Lorenzo prevailed upon the city of Prato to allow him to appropriate certain ecclesiastical lands that bordered on his own meadows, an early example of Lorenzo's contriving to have public institutions serve his private interests.[155]

Lorenzo's first project at Poggio—the construction of a handsome dairy farm, *cascina*, beginning in August 1477—would not have offended republican sentiments, however, while it still attracts the respectful attention of architectural historians. Lorenzo and his associates took the *cascina*, with its four towers and large internal pond for raising fish, very seriously; much mentioned in the correspondence of the period, it quickly became a showplace. Lucky the cow to have Lorenzo as her master. The factor, whose singularly inappropriate nickname was Malherba (meaning "rampant weed"), "received us with delight and showed us everything," Francesco Baroni wrote in the spring of 1486 about a visit by some foreign notables. "The cow barn's garden is well kept, and where it has been sown and put in order it is like a freshly barbered mane in the Venetian style."[156] Antonio Marchetti, the Pistoian canon and close Medici friend who supervised the construction, had been loathe to allow the foundations to be laid without Lorenzo's being present: "But Your Magnificence not being here, as I had hoped, we've postponed it till you are present or let us know we are to proceed without you," he wrote in late April 1477, adding that it would be "nice [*buono*]" if Lorenzo were present "at least at the start."[157] There are constant references to the stocking of the farm with fine milk cows, often brought from Lombardy, information that Lorenzo clearly wanted to hear amid the countless pieces of news brought to his attention every day. "There have been born two more calves, a female and male," he was told in December 1477, "which will be baptized Belfiore after the spot where the *cascina* stands."[158]

Although Lorenzo was not to build a villa *ex novo* at Poggio until the late 1480s, even the story of the dairy farm suggests that this profitable estate had captured more than his commercial imagination, not least because an absorption in such model farms was not disdained by such

landed magnates as the duke of Milan himself.[159] From the very beginning Lorenzo and his family visited the estate at Poggio constantly. "I am to go to the country, and I will go more willingly to Poggio than anywhere else, and I will have the children with me," Clarice Orsini, who had been brought up in the baronial houses of her noble Roman kin, wrote to her mother-in-law when recuperating from an illness in mid-1480.[160] An inventory of that year reveals that the remodeled old house, "Ambra," was both capacious and comfortably furnished—one man had jokingly described the estate as "Poggio City"[161]—and yet from the very moment of its acquisition Lorenzo may have entertained still grander ambitions for the site. That it had belonged to the proud Palla Strozzi, whose descendants never accepted Medici ownership, may have added a certain frisson for Lorenzo. Palla's grandson, Bardo Strozzi, was to take the view as late as 1496 that Poggio, "la nostra antichia," was not Medici property that could be sold forcibly to strangers after Piero de' Medici's expulsion.[162] Poggio a Caiano also fits Alberti's description of the ideal villa site; Alberti had advised gentlemen to have two country houses, one near the city and the other more rustic. This second villa, he wrote in words that owe something to Pliny the Younger's description of his Umbrian house in his letters, should stand "pretty high, but upon so easy an Ascent, that it should hardly be perceptible to those that go to it, till they find themselves at the Top, and a Large Prospect opens itself to their View."[163] Anyone who has visited Poggio a Caiano will recognize how uncannily apt this description is. A curious note, urgent and elliptical, written to Lorenzo by Bernardo Rucellai just six days after Lorenzo acquired Poggio from Giovanni Rucellai suggests that the two young men had excitedly been discussing some architectural project, perhaps building villas in the air.[164] The villa Lorenzo eventually built there was a "most sumptuous" one, Guicciardini was to observe (Fig. 17).[165]

During this happy time devoted to an intense cultivation of his own ideas and sensibility Lorenzo began to acquire a useful reputation for "artistic" expertise. The private became the public seamlessly throughout his life. In his letter of late May 1474 Bernardo Rucellai had deferred to his brother-in-law's superior right to exercise *arbitrio,* judgment, in the architectural debate in which the two young men were apparently en-

gaged, almost certainly with the site at Poggio in mind, if not literally in view. Despite the modesty topos deployed by this gifted young antiquarian, he was perhaps genuinely willing to acknowledge Lorenzo's superior architectural knowledge: "The balconies and circular galleries, together with those gardens on the loggias, make me hasten to send you my design. . . . If you find something that offends you, consider it done by an unlearned man and in a moment of delirium. And if it seems to you obscure, and in need of comment, you shall be the judge, because I am sending it to you just as I found it."[166]

Lorenzo was already caught up not just in architectural ideas but also in modern sculpture and, almost certainly, pace most critics, in contemporary painting. Conventional, to be sure, was his early assertion, after Petrarch, that anyone who could truthfully depict the face and virtue of his beloved would have to be a "Phidias, Polyclitus and Praxiteles," by reputation the best ancient Greek artists.[167] It has been proposed, however, that he commissioned from Piero del Pollaiuolo the portrait of Galeazzo Maria Sforza that was found in his study upon his death at the time of the Milanese duke's visit to Florence in 1471,[168] at which time, by the way, a Ferrarese medalist who had been in contact with his father paid Lorenzo the compliment of sending him a gift of a silver medal portraying the duchess, promising to send an image of the duke later.[169] Medici's taste for such things was becoming known. Between 1472 and 1475 Lorenzo acquired the garden at Piazza San Marco, building there a pleasure house, or *casino,* where later in the decade a religious play was performed. Whether there was also antique sculpture there so early and whether the young Leonardo da Vinci frequented it in the 1470s, as one near contemporary tradition has it, we cannot be sure, but the site was to become so closely identified with the Medici that it was sacked upon their expulsion in 1494.[170]

Leonardo's master in that "nursery of exceptional talents,"[171] the workshop of Andrea del Verrocchio, maintained his close artistic relationship with Lorenzo at this time. Andrea's distinctive nickname, "True eye," was first recorded in 1467, about the time his association with the Medici can also be documented. His *bottega* certainly created the banner borne by one of Giuliano de' Medici's entourage at his joust in 1475;

Leonardo's hand has been detected in parts of his master's brilliant preliminary drawing now in the Uffizi.[172] Leonardo's collaboration in Verrocchio's tomb for the Medici elders in San Lorenzo has also been proposed.[173] According to Vasari, Andrea himself restored ancient sculpture for the Medici, as Bertoldo and others were to do in the next decade.[174] It would surely have been Lorenzo himself—hardly his father—who commissioned from Verrocchio, as early as the late 1460s, a painted portrait of the younger Medici's beloved Lucrezia Donati, which cannot now be identified. Surely this "wooden frame within which is the head of Lucrezia Donati," mentioned in the well-known list of works done for the Medici for which the artist was not paid,[175] was the same "small painting [*tavoletta*] in which a woman was depicted" at the foot of which Lorenzo composed one of his early love sonnets addressed to Lucrezia, a self-conscious reference by the young poet to Petrarch's poems about Simone Martini's portrait of Laura.[176] It is poignant indeed now to discover that in October 1495 Lucrezia's son, Niccolò Ardinghelli, bought from the Medici estate for twenty-three large gold florins "a figure or image or painting of his mother," almost unbearably poignant to think that Lucrezia Donati, who was to live another six years, may have wanted for herself this image commissioned by her Medici lover of thirty years earlier.[177] In 1476 the Medici brothers Lorenzo and Giuliano took the highly unusual step of selling Verrocchio's bronze *David* to the Signoria for 150 florins, surely not because they disliked it or needed the money but in order to contribute to "the ornamentation and beauty and indeed magnificence" of the Palazzo Vecchio, where this politically charged figure, representing the victory of virtue over vice, was placed outside the Sala dei Gigli (Fig. 18).[178] The sculptor's intimate and long association with the Medici is captured by Vasari's story, which we have no reason to doubt, that together with the waxworker Orsino Benintendi he made the votive images of Lorenzo placed in several Florentine churches after Lorenzo survived the Pazzi Conspiracy of 1478.[179]

Non-Florentines began to admire Lorenzo's taste in sculpture, which must have been formed within the context of his early association with Verrocchio and perhaps Bertoldo and of his appreciation of Antonio del Pollaiuolo, whose *virtù* Federigo da Montefeltro had praised to him in a

letter of May 1473. From this last artist the young Medici probably commissioned the bronze *Hercules and Antaeus* in the same decade.[180] Although it is not true that Lorenzo called Antonio Florence's "premier artist" in 1489, in later years he did write to and on behalf of the artist and discussed antiquities with him. For his part, Pollaiuolo declared after Lorenzo's death that "I have always been attached to that [Medici] house."[181] Lorenzo possessed a marble Madonna so prized by Ginevra Bentivoglio, the wife of the de facto lord of Bologna, that she wanted a copy made quickly as a wedding present in April 1473. As it happened, the maker of such copies was already engaged on a project for Lorenzo, whom Ginevra then asked to release the man. The piece should be, her agent insisted, "as large as possible . . . the marble should be as white and fine as can be and worked precisely in the style of Lorenzo's."[182] As Verrocchio was currently employed by Lorenzo and Giuliano de' Medici in creating the tomb for Piero and Giovanni de' Medici in San Lorenzo, the reference may be to him. Andrea's workshop was prolific in making and reproducing such pieces, some of which survive.[183] Whoever had created Lorenzo's prized marble sculpture, however, we may be reasonably confident that it resembled the Madonna and Child now in the National Gallery at Washington, an assured, refined work from the 1470s securely attributed to Benedetto da Maiano (Fig. 19).[184]

As early as 1473, this vignette suggests, Lorenzo's was the taste to follow in at least one Italian center; his was the right to dispose of the talents of a Florentine master working for him. In the early summer of 1478 Lorenzo informed the lord of Faenza that he was sending "Zanobi dalla Parte, the master builder, as requested."[185] Already in this decade he was, literally, a palatial broker, acquiring the new Boni palace for his Martelli neighbors and allies in 1475 and, almost certainly, engineering his partisan friend Francesco Nori's acquisition of the older palace of Alberto di Zanobi.[186] Also in the 1470s, at Poggio a Caiano and elsewhere, he was laying the foundations, metaphorically if not literally, for a number of his own future activities.

How precise and fully worked out a campaign he had to become a major supporter of the arts is not clear. The historian's hindsight can lend a spurious order to a more chaotic, lived reality. His intentions are difficult

to divine, too, because insofar as Lorenzo was indeed methodically determined to break new ground—in politics or anything else—he was compelled to do so by adopting the paradoxical procedure of appearing to follow in his ancestors' footsteps, by exercising finesse and a certain self-deprecation in order to mask that impulsiveness and that will to dominate on which contemporaries comment. He had the subtlety in abundance to pursue such a course. It was remarked that, like Cosimo, on occasions he spoke little and elliptically, that he probed others' intentions with facetious irony.[187] Piero del Tovaglia, long the Florentine agent of the marquis of Mantua, reported to his master in 1474 that Lorenzo often joked to him that he knew that his fellow citizen "would not care if Florence were put to the sack if the house of Gonzaga thereby prospered."[188] One thing is certain: about 1473, when he began his family *ricordanze,* Lorenzo was privately thinking hard about how much money—an "incredible" 663,000 florins—his ancestors had spent since 1434 on "building projects [*muraglie*], alms and taxes (without mentioning other expenses)." He was "delighted" to conclude, while recognizing that others might disagree, that this was money "well spent . . . having greatly enhanced our status."[189]

There are hints, moreover, that in his first decade in authority Lorenzo was not only establishing a reputation for refined taste but also devising a modus operandi for his own later building projects, beginning to make what has been called his "impulsive yet devious interventions in the lives of his contemporaries,"[190] becoming adept at negotiating bargains or special arrangements—usually dealing with people and institutions obligated to him—when acquiring property or privileges. Giovanni Rucellai, who was in severe financial difficulties by that time, recorded in his tax return of 1480 that he had found it "necessary to arrange ways and means" of selling his beloved Poggio a Caiano to his son-in-law in 1474 because the Medici brothers "desired the said estate."[191] The old man was not, one may infer, well pleased, despite his genuine admiration for his Medici in-laws. Giovanni was compelled to acknowledge the younger man's authority, however, just as the Pistoian committee three years later was to defer to Lorenzo's "quite complete understanding" of sculptural models by Verrocchio and Piero del Pollaiuolo and of patronal politics as well.

Lorenzo and the Florentine Building Boom,

1485–1492

]1[

Tuscany may have been "the fountain of architects," in Federigo da Montefeltro's phrase,[1] but toward the end of the 1470s, after two or three decades of major palace construction and other monumental works, not much building was being done in Florence. "There was much more construction before than now," observed the Opera del Duomo as early as 1475.[2] Florence could not contribute financially to the campaign against the Turks, Lorenzo himself argued in July 1477, "because in truth, given the times, our city . . . is not in a position to do so."[3] Unemployment was high, and essential food supplies were scarce. The Turkish threat and a period of plague coincided with increasingly tense political conditions within the city, leading up to the Pazzi Conspiracy of April 1478.[4] This ugly event, in which Giuliano de' Medici died, threw Lorenzo badly off balance. A personal and dynastic blow to the wounded Lorenzo, it embroiled his city in a dangerous, almost ruinous war with the papacy and Naples. Economic conditions about 1480 continued to be very bad as a result; if even half of the citizen complaints concerning war damage submitted to the tax officials in that year were true, many estates south of the city had been devastated by foreign troops. The mercenary captain Rodolfo Gonzaga observed in the late summer of 1478 the destruction of "many fine palaces belonging to citizens, to such an extent that much damage has been and is being done."[5]

For the first half of the next decade Lorenzo and his regime were pre-

occupied with the prolonged negotiations over the conditions for peace and then with further warfare in Italy, this time the War of Ferrara. At home Lorenzo's position was more precarious in the early 1480s than was once thought, for all that his opponents were beginning to describe him as having a tyrannical authority and his personal diplomacy in going to Naples to negotiate a peace won him praise. "Light of our city," according to legislation passed just after the Pazzi Conspiracy,[6] his reputation nevertheless flickered, and on several occasions his life was at risk. "I am not Florence's lord [*signore*], just a citizen with a certain authority," he found it necessary to write even to his close ally Pierfilippo Pandolfini in November 1481.[7] If this was a somewhat disingenuous formulation, still it was only by intense concentration that Lorenzo stabilized domestic politics by engineering decisive constitutional changes, such as the creation of a Council of Seventy, to the advantage of his regime but at considerable cost to his own health. It is from the early to mid-1480s that one begins to hear persistent reports, in both Florentine and foreign correspondence, of Lorenzo's being ill and often bad-tempered.[8] In his own letters there are several well-known outbursts from the year 1485 against his political intimates, whom he accused of lacking judgment and even fidelity, and apparently against politics itself. "Get these petitioners off my back," he ordered in the spring of 1485, "because I have more letters from would-be Priors than there are days in the year and I am resolving not to want everything my way and to live what time I have left as peacefully as possible, as those old fellows of ours have done, and see how they are both old and wise."[9]

There are other expressions of a vehement weariness with urban politics at this time, when reading about architecture increasingly captured Lorenzo's imagination, and it has been argued recently that after 1478 he more or less abandoned his more ambitious plans for patronage in ungrateful Florence to turn to farming and to villa-building in the country.[10] The mounting evidence seems to suggest otherwise. For the reasons rehearsed above, Lorenzo postponed the execution of all of his well-laid plans, whether in the country or in the city, until the very late 1480s, until that period of "extraordinary happiness" for Florence—after the capture of the frontier fortress of Sarzana in 1487—recorded by Niccolò Machi-

avelli and others.[11] If there were also by about 1490 portents of radical disturbance that dismayed some observers, most of Lorenzo's contemporaries would have agreed with Iacopo Giannotti, who, writing to Benedetto Dei after witnessing the celebrations for Saint John the Baptist's day in 1491, exclaimed that "never was there so noble a sight; Florence is unique in the world."[12] At this time, in an extraordinary burst of creativity and expenditure, Lorenzo began most of his buildings and several sculptural and painting commissions associated with them. At the same time, he sought to exert an almost supervisory role over the Florentine building boom, which contemporaries agree was under way by the end of that decade, as a period of economic difficulties, including food shortages, gave way to one of abundance that lasted until the mid-1490s.[13]

The conditions were at last right for Lorenzo. His political and personal reputation at home and abroad burgeoned at this time. The Ferrarese chronicler Ugo Caleffini described him at his death as "Florence's top man and the leading untitled man in Italy."[14] By early in the next century Lorenzo's name had become a byword for strong, informal, civic authority among the warring factions of Friuli, where such a presence was so needed.[15] During his lifetime Gabriele Ginori, a Florentine holding office in a foreign state, had sought Lorenzo's permission to include the Medici escutcheon alongside his own on a public building.[16] Much more remarkably, the Lombard captain of Florence in 1492, Gian Galeazzo Trotti, recorded that date on his painted terra-cotta coat of arms by explicit reference to Lorenzo's life span—Trotti's tenure of office had been forty-three years after Lorenzo's birth—a rare compliment with startling implications for Lorenzo's stature in some contemporary eyes.[17]

Among the Florentines themselves Lorenzo had become the "boss," *padrone*, or "boss of the shop" to his intimates, while classical scholars described him variously as Caesar among his leading citizens and "leader of the Senate." Lorenzo was, others implied, the personification of a young philosopher-prince.[18] His authority in this republic—so "powerful in war and peace," wrote Alessandro Cortesi in 1487, that it towered "over other cities as a cypress over other trees"[19]—was formidable although not absolute. No one was "to write to anyone outside Florence—whether ambassadors . . . or private citizens—about anything concerning

the regime or any public matter," wrote one of Lorenzo's secretaries in July 1491, "and these were the words that came from the mouth of the Magnificent Lorenzo."[20] His closest associates now felt emboldened to act indefensibly in Lorenzo's defense. When, in May 1490, several subjects of the king of Naples were captured on suspicion of plotting against Medici's life, leading citizens whom the shocked Ferrarese ambassador termed his "closest relations and friends"—including Bernardo Rucellai and Niccolò Michelozzi, whom we have met in sunnier contexts—subjected the captives, who were in the end to be released, to savage and prolonged secret torture.[21] Their leader was maimed by some eighteen turns of the rope, during which torment his interrogators asked no precise questions but "merely demanded that he reveal what he knew."[22]

The object of this solicitude was by now accustomed to disposing of other citizens' palaces as if the renewing "Renaissance" fabric of the city itself were already his further to alter and mend. The palace of the disgraced Pazzi went to his counterpart in Bologna, Giovanni Bentivoglio. When he fell out with his Martelli neighbors, in whose name he had bought the new Boni palace in 1475, Carlo Martelli denounced Medicean meddling in the matter in his secret diary. Carlo was not able to live in the palace and had to declare a huge fictitious debt to his own brother, he declared in 1494, "because the tyrant Lorenzo de' Medici prevented me, by making an unjust demand, from being able to take possession of the house and my belongings."[23] Others, however, were positively eager to seek Lorenzo's interference. Bartolomeo Scala, who admitted that he "owed everything" to Lorenzo and his ancestors, was content to draw up a will giving the younger Medici the authority to do with his last arrangements and property what he willed, and he was not alone in so doing.[24] Some years earlier a man who claimed membership in the patrician Nerli family had bequeathed two farms to "my godfather Lorenzo di Piero di Cosimo de' Medici and his heirs . . . and this to ensure that neither Lorenzo nor his sons quickly forget me."[25]

If the money to build had been lacking earlier—and historians have often argued that Lorenzo's supposedly poor showing as a patron may be explained in part by the fact that the family bank was faltering[26]—he had certainly found the means, in several senses, by the late 1480s. As peren-

nially short of ready money as any Italian lord, he was busy raising large sums throughout the 1480s. The four thousand ducats he received in 1486 from the acrimonious sale of the Palazzo Medici in Milan—an affair he followed with minute attention—he ordered sent to him personally, not to his bank, "because in truth I've some need of it."[27] After 1487, when he was allied to Pope Innocent VIII by marriage, Lorenzo had much readier access both to money and ecclesiastical patronage, but then, as he wrote a year later, "how many holes I have to fill."[28] Contemporaries as various as Francesco Guicciardini and Piero Parenti charged that he filled those holes by diverting public funds for his personal purposes, using trusted agents such as Antonio di Bernardo Miniati, the official in charge of the state debt. To what degree and in what sense this charge against Lorenzo was true is the subject of a technical historiographical debate during which, in my judgment, Alison Brown has won more ground than she has lost. Brown, who years ago pointed out that the plenary fiscal and other powers granted to a special magistracy on which Lorenzo sat, the Seventeen Reformers, favored his interests during the 1480s, is surely right in continuing to insist that it was suspiciously anomalous that Lorenzo "was heavily in debt to the commune by the time of his death without losing office," that both the sources of his income and what moderns would call his tax status "remain surprisingly opaque."[29] Those contemporaries who summarily hanged Antonio Miniati upon the downfall of the Medici and gravely harassed other Laurentian creatures certainly purported to believe that such Medici agents had embezzled public moneys, presumably with their master's knowledge if not at his instruction.[30]

One can be sure, however, that as the 1480s went on, Lorenzo used his new influence at the papal curia, as well as his growing authority at home, to persuade ecclesiastical and other institutions to sell or lease him at favorable terms property he needed for his building campaigns, for he was later accused on several sides of failing to honor such agreements. The stonemasons' guild claimed that its property had been acquired for Lorenzo's wife neither legally nor for a just price, "as was the custom in similar cases concerning the family and house of the said Lorenzo."[31] He had "begun to build contrary to what was right and against the said monastery's interests and without the said apostolic authority and with-

out paying a penny," the Cistercians at Cestello were to argue.[32] It is true that there was a widespread desire after 1494 greedily to extract every possible penny from the fallen Medici. As the sons of one of Lorenzo's agents, Francesco Cambini, recalled, they had refused their father's inheritance "so as not to have to struggle with desperadoes, or be the prey of the cops [*birri*] . . . and because of the house of Medici's departure, every man was saying 'Gimme, Gimme.'"[33] Whether or not Cambini had been as hardworking and upright as his sons believed, the charges against Lorenzo himself must be taken seriously, so persistent and so detailed are they. We know, for example, that in July 1482, as the result of a decision of the Seventeen Reformers, he had recently gained access to more than nine thousand florins, with which his father had been obliged to build a "great inn" to accommodate visitors to Florence, an undertaking inherited from Castello Quaratesi that neither Piero nor his elder son honored. A near-contemporary critic of this act of omission observed that not long after receiving the sum, "Lorenzo was himself spending a much greater quantity on building in different places."[34] On his death, according to a Ferrarese chronicler's implausible report, Lorenzo "was worth more than a million ducats; so it was said."[35] However he got it, the money was there, or the means could be found, for Lorenzo de' Medici to begin seriously to challenge his grandfather's reputation as a builder and patron in the late 1480s.

] 2 [

The period after 1478–80 during which, perforce, he bided his time and began to accumulate the physical resources he needed was, we may surmise, one of mounting frustration for so impatient a man. It was deeply ironic that at this very time Pope Sixtus IV contemplated compelling him to have the Florentines construct the last building in the world Lorenzo de' Medici would have consented to erect: a chapel to commemorate the anti-Medici ecclesiastics who had participated in the martyrdom (or so half of Florence would have said) of his brother, Giuliano. It was almost with envy that at this same time Lorenzo congratulated the communal government of Arezzo on its new resolve "to complete the building [of the cathedral], a truly laudable, pious and holy design."[36] As if somehow

to express privately his acquisitive desires and to foreshadow his deepening interest in, and identification with, classical Rome's golden age, early in the year after the Pazzi Conspiracy he commissioned from a scribe, almost certainly Neri Rinuccini, a precious manuscript, the *Scriptores Historiae Augustae,* now to be found in the State Library of Victoria in its original binding. Portraits of Roman emperors and empresses crowd this sumptuous manuscript, which bears Laurentian insignia and the motto "le tens revient"; several marginal glosses appear to be in Angelo Poliziano's hand.[37] Over the next few years, also as if to contain his impatience in a creative way, Lorenzo began to study more intensively ancient treatises on agriculture and villas (a theme to be taken up in the next chapter), as well as Leon Battista Alberti's *De re aedificatoria,* completed about 1452.

The contemporary who wrote after a visit in 1486 that "in Florence I found the said [all'antica] architecture very much on the increase, especially since the Magnificent Lorenzo de' Medici began to take pleasure in it,"[38] was not observing a recent Laurentian conversion to architecture; rather, he was referring to the heightened, learned concentration of a man, unwell and approaching forty, eager to execute long-laid plans both in town and country. As Lorenzo observed during this period, "[W]hen I am much involved in one thing, I am loathe to tackle others."[39] Thinking about architecture had become his particular delight, an almost voluptuous pleasure, as Filarete had written. Some years before, in June 1481, Lorenzo had written to thank Francione's disciple, Baccio Pontelli, "for the design sent of the duke of Urbino's house," Giuliano da Maiano and Niccolò Michelozzi having passed on his request.[40] Pontelli had sent detailed measurements "so that Your Magnificence should now have everything and will see room by room what has been done and what it will take to furnish the said house."[41] Other designs and models were sent to him in this period, including a plan requested from Luca Fancelli of Alberti's church of San Sebastiano in Mantua, that architect's "most tantalizing building fragment" in the words of a distinguished scholar.[42] Presumably Lorenzo did not share the perplexed judgment of Federigo Gonzaga, who was not certain whether the building was intended to be a church, a mosque, or a synagogue.[43]

Lorenzo and the Florentine Building Boom, 1485–1492

This quite practical absorption in architectural models surfaced vividly, if enigmatically, in September 1485, when Lorenzo instructed Michelozzi in the concluding paragraph of a letter to "press, at once kindly and insistently, Francis the goldsmith in my room, because I have so taken this matter to heart that I am not able to think of anything else day or night. Remind Giuliano da Sangallo to hurry up with my model, and Alberto Villani with the crayfish, about which you will hear."[44] It is quite possible that these two sentences are unconnected, so leaving unsatisfied our curiosity as to what Francis the goldsmith was doing that so excited Lorenzo. Even so, there is clear evidence in the passage that Giuliano da Sangallo was working on a model that also preoccupied Lorenzo, and at a time when he was eager to ensure that his estate at Poggio a Caiano was provided with freshwater crustaceans. Perhaps Lorenzo seriously thought, in this year of recurrent illness, that he might die before even beginning the projects he was nurturing. His sickness "has taken me to Saint Peter's gates," he observed during a period of convalescence.[45] Illness, often accompanied by violent pain, was rarely to leave Lorenzo during the rest of his life. If he could sometimes joke about his trials—he told Giovanni Lanfredini in August 1489 that "my having been ill these days with some leg pain means I have not written to you; though the feet and tongue are far apart, one can still get in the way of the other"—he reportedly shouted with pain on other occasions.[46] Hence Lorenzo's sense of urgency in the late 1480s, all the stronger for his lifelong conviction, informed by Tuscan poetic conventions, that the delicate rose should be plucked before it became a heap of faded petals.

The cause of Lorenzo's excitement in the autumn of 1485 was more likely the project to build the church of Santa Maria delle Carceri at Prato, not his program for the villa at Poggio a Caiano, where, we now know, construction proper started some years later. The design of the church was assigned to Giuliano da Sangallo on 10 October, only weeks after Lorenzo's note, despite Giuliano da Maiano's having been awarded the commission by the Pratese authorities some months earlier. A circumstantial case has been mounted for Lorenzo's having engineered this change of architects for a project of which the city of Prato, not he, was in every other sense the patron. According to a contemporary chronicler,

Lorenzo de' Medici

❧ 86 ❧

Lorenzo certainly backed da Sangallo's smaller, more compact design, but new evidence suggests that his several interventions in 1484–85 may have been as much those of a trusted arbiter between conflicting Florentine governmental and local Pratese demands as they were those of an interloper determined to have his own way at any cost.[47] This is not to say that he did not relish the opportunity to intervene. Lorenzo shared his own mother Lucrezia's special devotion to the mother of God. When, in Landucci's words, "absolutely everybody went" to Prato to witness the Marian miracles occurring at this sacred site—which quickly inspired a devotional literature in the vernacular[48]—Lorenzo would not have been reluctant to exert his aesthetic as well as his political influence by allowing his new favorite the opportunity to create the most beautiful building possible in this restless subject town important to the Medici and their regime (Fig. 20).

It has been pointed out that in August Lorenzo had asked Luca Fancelli in Mantua to send him "a model of [Alberti's] church of San Sebastiano," with its centrally planned interior at once grand and intimate. Rudolph Wittkower years ago remarked on the exquisitely Albertian spirit of Santa Maria delle Carceri, one of the first centrally planned churches in Italy, a distinguished descendant, it has also been pointed out, of Brunelleschi's new sacristy for the Medici at San Lorenzo.[49] Lorenzo continued to exercise at least occasional influence on the project. In September 1485 he had one of the *operai* stay with him in Florence for two days "concerning the building," and some three years later "his most courteous letters" persuaded the church's building committee to quarry stone from a particular source. Meanwhile, his clerical uncle, Carlo de' Medici, the protonotary of Prato, played a role as prominent as it was ambiguous in the proceedings at the old castle-prison. Santa Maria delle Carceri retained these Medicean associations. The waxen votive images of two Medici popes, including Lorenzo's son Leo X, so devoted to completing his father's architectural projects, were soon to be prominently displayed there.[50]

As he pored over architectural designs and models, both his own and others', Lorenzo was preoccupied with study of Alberti's *De re aedificatoria*, an authoritative manuscript text of which Leon Battista's cousin, Ber-

nardo Alberti, had presented to him about 1480. He had reluctantly parted with it when Ercole d'Este of Ferrara requested a loan in March 1484,[51] and when the superb *editio princeps* of the treatise began to emerge from the press a year later, Lorenzo took away with him to the baths those quires already printed. Since the book was read aloud to him every day, his secretary wrote urgently to Florence on 11 September requesting that the remaining portions be rushed to the country to keep pace with him. Lorenzo, despite his distaste for the new printed books, was evidently enjoying this not so leisured rereading of an edition dedicated to "patrono suo" by Poliziano himself.[52] In this mid-September reading he was stalled in the middle of book 6, which begins so stirringly with Alberti's discussions of the history of architecture and of how beauty might be defined; hence, perhaps, his eagerness for more.[53] To this rereading of Alberti, Lorenzo—"the patron Alberti never had" in Gabrielle Morolli's striking phrase—brought a more sophisticated knowledge of Latin language and literature than was possessed by Ercole d'Este, to whom the treatise was read aloud a little later by the scholar Matteo Maria Boiardo, and an understanding and experience of architecture at least as well grounded as the Ferrarese duke's. In September 1488 Boiardo offered to gloss for Ercole those parts of Alberti's work he did not understand; whether he was referring to the difficulty of its polished Latin or to its technical vocabulary is not clear.[54] If Lorenzo too were in need of such assistance, one of the first classical scholars of the period, Poliziano, was by his side to provide it.

It has even been implied by scholars, on the basis of a passage in Luca Pacioli's *De divina proportione*, written not long after Medici's death—"Concerning architectural models he was very quick off the mark, as I was informed by someone who with his own hands consigned to his intimate familiar, Giuliano da Maiano, one for the worthy palace known as Dogliuolo [the villa of Poggioreale] in Naples"[55]—that Lorenzo himself may have made architectural models. This suggestion should be neither uncritically accepted nor dismissed out of hand. A contemporary remarked in a private letter in December 1489 that Ercole d'Este, who had asked for details concerning Filippo Strozzi's recently begun palace in Florence,

took "great pleasure in building and in making designs [*fare disegni*]" (Fig. 21).[56] The idea that the Ferrarese duke was himself an architect has found a vigorous champion in one recent scholar—Ercole's wife, too, once addressed him as "optimo architecto [excellent architect]"—and Ludovico Gonzaga's claims to be a "principe architetto" seem completely established by recent scholarship.[57] There are several examples of other Florentine citizens' making architectural models or designs, sometimes very amateurishly, to be sure.[58]

Whatever the case, there is no need at all to argue that Lorenzo's own hands shaped the prototypes of the innovative buildings with which his name is associated to concede that the judgment of his near-contemporary biographer, Niccolò Valori, that he possessed a thorough practical as well as theoretical knowledge of architecture—that he especially loved the antique—is not far-fetched.[59] His collection included several fragments of ancient architecture, for example, a door and frieze.[60] All his life Lorenzo had been inspecting building sites in one capacity or another, and he visited his own projects in the late 1480s almost compulsively, inspecting the foundations and everything else. When he was prevented from turning up in person, his agents sent him pages of detailed information about progress. Professional engineers and builders such as Luca Fancelli wrote to Lorenzo as if to a colleague—if not quite as they might to a practicing architect, then as to a man deeply conversant with the various activities in which engineer-architects engaged, including hydraulics. Fancelli's letter of 1487, which is a quite technical revisiting of the plan hatched in Piero de' Medici's day to make the Arno navigable by construction of a canal, begins by explaining that the writer is in Milan to inspect the cupola of the cathedral, whose repair "will not be accomplished without difficulty, since this building lacks both a sound structure and due proportion [*sanza osa e sanza misura*]."[61] This remark, intriguingly enough, is somehow reminiscent of the much earlier observation, provoked by expert French despair at the ad hoc methods of the Lombard builders engaged in the construction of this flamboyant Gothic cathedral, that "ars sine scientia nihil est," that "practical experience without theoretical knowledge amounts to nothing."[62] A number of scholars take in-

creasingly seriously the proposition that Lorenzo's was an informed and lively participation in both the conception and the execution of his own and some other buildings.[63]

Lorenzo's preferred architectural collaborator by about 1485 indubitably was Giuliano da Sangallo, whose remarkable talents, born of the Florentine artisan tradition and his own youthful archaeological study of ancient ruins, are not diminished but rather contextualized by this proposal that the two worked in partnership, as Andrea Palladio and Giangiorgio Trissino were to do in the Veneto in the next century. During this creative period Lorenzo thrust Giuliano and his models forward whenever possible, thereby exacerbating the sense of rivalry among his architectural advisers. (The rivalry was even more pronounced in his literary entourage, whose internecine quarrels could be spectacular; witness the cleric Matteo Franco's description of Luigi Pulci as a "louse clinging to the Medici balls,"[64] an obscene play both on the poet's name [*pulce* is Italian for "flea"] and on the double meaning of the *palle,* pawnbroker's balls, on the Medici coat of arms.) We can reasonably infer that by the last half of the 1480s there existed quite (if not such) a spirit of rivalry, perhaps even bitterness, between the two Giulianos, da Maiano and da Sangallo. While denying himself the title "architect" in his letter of May 1486 to Lorenzo—perhaps an act of mock modesty, or a compliment to his master—the younger man felt confident enough of his judgment and of Medici's benevolence forcefully to condemn the older Giuliano da Maiano for his supposedly arrogant role in the rejection of Brunelleschi's four-door model for Santo Spirito, begging Lorenzo to intervene "so that so beautiful a building is not allowed to be ruined."[65]

On 2 May 1488 Giuliano da Sangallo was appointed to replace Giuliano da Maiano as cathedral architect because the older man was alleged to be too distracted to do the job properly. However, da Sangallo resigned just three days later, and da Maiano resumed the position.[66] What role, if any, Lorenzo played in this obscure tug of war one cannot say. Perhaps he did not approve of, or had second thoughts about, the younger architect's appointment to the Duomo at precisely the time when his own architectural plans were about to be realized. For the sake of the king of Naples, he was willing in December 1488 to dispatch Giuliano da

Sangallo there with "the plan of a model of a palace which the Magnificent Lorenzo de' Medici sent to King Ferdinand," but the young architect was back within several months after receiving a warm southern welcome. Indeed, it was presumably to keep da Sangallo in Florence for himself in the future that Lorenzo informed Alfonso of Naples upon the death in December 1490 of Giuliano da Maiano, who had been employed in Naples on Medici's advice, that the latter was irreplaceable: "Having thought carefully about all this city's architects, I have not found—nor is there—one I judge to have the aforesaid Giuliano's ability [*sufficienta*]."[67] *Sufficienta* means general ability rather than ingenuity or genius—it almost patronizes with mild praise—and Lorenzo went on to recommend the similarly reliable and experienced Luca Fancelli, a very good architect but hardly a great one, to the Neapolitan prince.[68]

There existed, one can speculate, a special intellectual affinity between Lorenzo and da Sangallo, each of whom very well understood, indeed shaped, the other's architectural ideas. When Piero di Lorenzo de' Medici sent a model of Poggio a Caiano made by Giuliano da Sangallo to Lodovico il Moro in October 1492, it was his opinion that "from the master himself Your Excellency will understand still better the mind and intention of Lorenzo."[69] To argue that Lorenzo de' Medici was deeply interested in and knowledgeable about architecture is not to take too literally the humanist rhetoric on the subject, nor is it to claim that he had an architectural *oeuvre*, although we can perhaps speak, as one scholar has done, of a "Laurentian architectural manner." Still less is it somehow posthumously to insult Giuliano. Lorenzo was not an educated architectural genius whose lofty ideas the artisan-engineer Giuliano da Sangallo merely executed. Nor did Sangallo play Mansard to Lorenzo's Louis XIV, trapping the French king, as Saint-Simon had it, into ambitious architectural projects that Louis foolishly believed were his own creation.[70]

<div align="center">] 3 [</div>

"The city and countryside were virtually renewed and beautified," the Baldovinetti chronicler wrote of the new building boom contemporaries agree started "about 1490."[71] Florentines listed dozens of civic, ecclesiastical, and private projects into which so much money was poured that

skilled craftsmen were in short supply and some patrons were ruined. The atmosphere in Florence must have resembled that of Ferrara, itself experiencing a boom, as described by the Bolognese writer Giovanni Sabadino degli Arienti: "[E]verywhere the air was full of that holiest of sounds, master builders hammering stone and a horde of sculptors working at marble of all sorts to embellish buildings both civil and ecclesiastical; and on all sides resounded the shouting for more stone and more mortar."[72] During 1489 the Florentine government passed laws giving financial assistance to a number of ecclesiastical foundations "for building and adornment" in a more sustained and even systematic spirit than was usual.[73] No less than one hundred florins per week was paid to the numerous workmen at the Palazzo Strozzi, begun in July 1489, a mighty project that several contemporaries single out as beginning the boom.[74]

Lorenzo did not create this outburst of civic energy, which, as Iacopo Giannotti enthused in a letter of 22 September 1489 to Benedetto Dei thanking him for sending his current list of "worthy building projects," "very much redounds to the honor of that republic; may God allow their peaceful completion, and in due course may the present and future citizens be able to do even better."[75] He made, however, very substantial contributions, direct and indirect, and in a sense sought to shape and control this energy. While Luca Landucci mentions the Palazzo Strozzi first in his account, every other project he lists was either Lorenzo's own commission or one in which he played a role, usually as an *operaio* or member of a works committee. The apothecary gives special mention to Lorenzo's Poggio a Caiano, "where he has commenced so much that is lovely, for example, the dairy farm, lordly things [*cose da signori*]."[76] The longer lists of Baldovinetti and Benedetto Dei include a number of projects that can be variously associated with Lorenzo, even when he goes unnamed; Machiavelli was later both explicit and accurate in listing Lorenzo's initiatives.[77] Medici's role was lordly in another respect: he sought not only to orchestrate the boom but also to impose on it whenever he could the architectural repertoire he and Giuliano da Sangallo were establishing. Guicciardini comments on how citizens commissioning works of art vied with each other to please Lorenzo;[78] like Augustus in Suetonius's *Lives of the Caesars,* Lorenzo "often urged other prominent men to adorn the city

with new monuments."[79] According to Lorenzo Strozzi, his father, Filippo, had had to trick "he who ruled [*chi reggeva*]"[80]—Lorenzo de' Medici—into approving the rusticated palace design Strozzi himself desired. One wonders who tricked whom, since, however much Lorenzo de' Medici may have admired the belligerent grandeur of Filippo's palace, the authorship of which is disputed, it almost certainly expressed a taste he would have found too conservative by about 1489.

Even at the height of his political power Lorenzo as architectural patron proceeded more decorously in the city than in the countryside, which is not to say that he practiced a form of self-renunciation in Florence, as Manfredo Tafuri put it,[81] that he was an architectural Jack in the city and an Ernest in the *contado,* freely to adapt Oscar Wilde. His second scheme for urban renewal, the creation of the Via Laura connecting the Servite church of the Annunziata with the church of Cestello and the construction of numerous houses for rental, was represented to the Florentine public as a public-spirited response to "the shortage of houses in the city and the existence of vacant land on which suitably to build," as it was put in legislation of May 1489 granting tax breaks to would-be builders.[82] Several contemporaries comment on the scarcity of houses and the desirability of "rendering the city more beautiful with new buildings,"[83] and Lorenzo's initiative won their notice. His aim, a notarial document tells us, was "to make the city larger and more beautiful . . . as his ancestors had done [*more maiorum*]." However, this last phrase has been described as "self-consciously classical," lending a certain grandeur to an otherwise modestly traditional statement of the sort other lords were making to justify their projects.[84]

In undertaking the scheme Lorenzo was, after all, responding to enabling legislation for the formulation and passing of which he and some of his closest political collaborators were at least in part responsible. Apparently, no other private citizen so quickly took advantage of the new law, and at least one of the several public institutions that built houses from 1489 on was, shall we say, sensitive to Lorenzo's wishes. It was the six *provveditori* of the Wool Guild, with Lorenzo present, who urged that body to take action during the same year.[85] Government legislation specifically favored Lorenzo's urban initiative. On 27 July 1491 the Coun-

cil of One Hundred, noting that "the construction of a very beautiful street"—the Via Laura—required that the street frontage of an institution managed by the Guelf Party be realigned, instructed the party to find the money to do so when requested "by he who has ordered the new street to be made."[86] There was no need to supply the name. Two days later Lorenzo was explicitly excused certain taxes by the Seventeen Reformers because the Via Laura would be "for the public honor and universal good."[87] Without doubt many contemporaries agreed, even Giovanni Cambi, no Medici friend, praising the complicated arrangement by which the Bankers Guild was to receive for charitable purposes the rental from some new houses to be built by Lorenzo to honor an earlier bequest by, it happens, Giovanni di Cosimo de' Medici. A little earlier Giannotti had reported more generally to Dei that "the city is healthy, prosperous and blissful; the building works go ahead."[88]

Private interests were here being served in the name of the common weal, however, although to be fair to Lorenzo, he was almost always careful in his letters to acknowledge the distinction in principle between the public sphere and his private concerns (specialità, as he called them),[89] while seeking to persuade himself and others that in practice the two often—increasingly one might think—overlapped or coincided. The Via Laura project, which a scrutiny of the technical evidence has suggested was probably designed by Giuliano da Sangallo, "may have been more extensive than previously thought."[90] There is now a consensus that Lorenzo's plans for this area did not include the construction of the megalomaniacal "villa for the city . . . a grand palace surrounded by Babylonian-like gardens" depicted in the celebrated da Sangallo drawing in the Uffizi.[91] This drawing certainly belongs to the early Cinquecento and was perhaps a hastily thrown together conception of about 1515 created for the visit of Lorenzo's son Pope Leo X to Florence. It shows Lorenzo's new streets, however, so invoking his urbanistic vision for this Medicean area of the city. For a private Florentine citizen to begin about 1490 to undertake, with public subsidies, an urbanistic renewal of a sort the republic itself had traditionally managed—and in the quarter of the city dominated by his family and faction—does express in architectural terms

a confident dynastic authority and may foreshadow grander political pretensions.

If Lorenzo's was an apparently modest and public-spirited urbanistic initiative, other Italian lords soon took notice of his example, or so it would seem. Indeed, they were often able to pursue their own schemes with more vigor, not to say ruthlessness, than the Medici leader himself had been able to do before his premature death in early April 1492. There were, of course, papal precedents for what Lorenzo had in mind, and he was surely aware of them: Nicholas V's plans for a *renovatio Urbis* a generation earlier (about which Domenico "the Captain" might well have apprised Lorenzo) and Pius II's successful transformation of Pienza, the "model" city Lorenzo certainly inspected in 1490.[92] A great soldier of the older generation and Lorenzo's godfather, Federigo da Montefeltro, had already created at Urbino what Baldassare Castiglione later described as "not a palace but what appears to be a city in the form of a palace," as the Medici leader knew since he had asked to see plans of Federigo's masterpiece in June 1481.[93]

Among his contemporaries, however, a still youngish Lorenzo may have offered inspiration even to long-established rulers with a commitment to architecture and urbanistic renewal. Giovanni Bentivoglio, whose unofficial role as leader of the oligarchic regime in Bologna most resembled Lorenzo's in republican Florence, had since the 1460s worked in a piecemeal way on the renewal of his ancestral quarter in that city, where the impressive palace begun by his predecessor, Sante Bentivoglio, stood. The Bolognese leader's more concerted and studied attempt to make the city, in Arienti's phrase, more "polished, charming, and beautiful"[94] came in the 1490s, when, it has been suggested, Giovanni had before him the urbanistic examples set first by Lorenzo and then by Ercole d'Este of Ferrara and Lodovico il Moro of Milan.[95] The latter, who took control of Milan in 1494, devoted his considerable energies in that decade to continuing his urbanistic renewal at rural Vigevano, including the marvelous piazza that has so caught the imagination of architectural historians. "It is no longer Vigevano but a new city," a contemporary observed.[96] As for Ercole d'Este, ruler of Ferrara from 1471 to 1505 and "the most prolific

builder" of the Italian Quattrocento,[97] he did not begin his admittedly much more ambitious construction, within grandly expanded fortifications, of an entire new urban quarter—spacious and ordered, with wide streets and piazzas lined with palaces, churches, and houses—until some months after Lorenzo's death.[98]

It is intriguing that Ercole had visited Florence in the very week Lorenzo lay dying (the latter was too ill to receive the duke, not that the two appear to have felt much personal affinity) and had inspected churches—the Annunziata and San Gallo—in the district the Medici family had been transforming for decades. The pious prince also visited two other "Laurentian" sites, the church of Santo Spirito, whose new sacristy had just been designed by Giuliano da Sangallo with Lorenzo's approval, and the convent of Le Murate, where Lorenzo had twenty years earlier modestly begun his career as an architectural benefactor. The duke went on at once to Siena and Pienza.[99] While the need to defend his city, above all from Venice, was paramount in Ercole's mind, he sought as well to beautify and, in Arienti's phrase, "to modernize" Ferrara.[100] Like Pius II before him at Pienza, Ercole encouraged his courtiers to build grandly in the Herculean Addition and himself commissioned churches and religious houses there. He emulated Lorenzo—how consciously we can only speculate—in also creating more modest housing within the Terra Nuova, for purposes of rental and to provide rewards for clients.[101] It would seem that in some respects at least Lorenzo led the urbanistic way in his generation. It cannot be ruled out that had he lived as long as his grandfather and assumed an even firmer authority over Florence in the twenty-odd years that lease of life would have granted him, scholars might now talk of a Laurentian quarter in Florence as they do of Ferrara's Herculean Addition. This said, it is very doubtful, indeed unthinkable, that the unmartial Lorenzo would have contemplated erecting in San Giovanni a gigantic equestrian monument of himself such as the condottiere-prince Ercole planned for the grand Piazza Nuova in Ferrara.[102]

For even in his period of firm ascendancy Lorenzo exercised a "subtle reticence" when it came to self-portraiture,[103] in keeping with the careful ambiguity about himself he cultivated in other respects. He was, after all, an almost unique specimen of an anomalous species: the princely re-

Lorenzo de' Medici

publican, the republican prince. Comparatively few contemporary portraits of him survive, and fewer still that one may be reasonably sure he himself commissioned: Bertoldo's Pazzi medal, for example, where he appears as a near martyred patriot, or the long vanished life-size votive images demonstrating his piety. (Several well-known surviving terracotta images of Lorenzo, more or less contemporary, may depend upon such waxen prototypes, including the Washington bust [Fig. 22]).[104] The leading Medici indubitably appears in several paintings for which friends of his paid—most famously in Domenico Ghirlandaio's fresco for Francesco Sassetti in the church of Santa Trinita—and there have been "sightings" by art historians in other contemporary works, most of them almost as unconvincing as claims by tourists to have seen that extinct carnivorous marsupial, the Tasmanian tiger.[105] How Lorenzo's image came to be inserted into other families' commissions—did he insist on this tribute to him?—one cannot say for certain. Perhaps the best-known "contemporary" image of Lorenzo de' Medici, the almost brutal painted terracotta bust in the National Gallery at Washington, may descend from a late Quattrocento prototype but is itself almost certainly several decades younger.[106] None of this means, however, that Lorenzo was genuinely self-effacing. Rather, in a still republican city-state where citizen portraits and portraits busts belonged to a genre that, only recently emerged, obeyed strict rules of decorum, he chose to advertise himself, his authority, and his aesthetic taste in other ways, such as public-spirited support of urbanistic renewal.

It was in early pursuit of a grand urban plan, one might suggest, that Lorenzo put such expense and energy into the construction of the church and monastic house of San Gallo, his one major ecclesiastic commission and the only one of his projects to be nearing completion at his premature death. The consuls of the Silk Guild and their colleagues in charge of the Hospital of the Innocenti justified their alienation in 1489 of a small farm that became a conventual garden by arguing that their benefactor was Lorenzo, whose purchase of the property had been a pious act done "for the good of the said hospital and for the honor of God and the benefit of all the city of Florence and its citizens."[107] This ecclesiastical complex stood just outside the San Gallo gate, the principal northern

entrance to Florence, pointing straight into the quarter of San Giovanni, on which Lorenzo and his ancestors had lavished such architectural care. At the beginning of a major ceremonial route, Lorenzo's church—and it was very much his—as it were ushered distinguished visitors into the city. They first experienced the Medicean district—the Annunziata, San Marco, the Palazzo Medici, San Lorenzo—before arriving at its republican center. A secretary in the Palazzo Vecchio, Bartolomeo Dei, nephew and correspondent of the chronicler Benedetto, told the story succinctly in a letter to his uncle of 21 August 1488: "Here they are commissioning and building a new monastery and most beautiful house of religion outside the San Gallo gate . . . belonging to the Austin friars; and Lorenzo de' Medici is paying the lion's share of the expense and is the inspiration [*auctore*] behind the building, together with our ser Giovanni [Guidi], with the help and for the sake of the reputation of a fine and excellent preacher, fra Mariano Barbetta, head of the convent."[108]

This Fra Mariano da Gennazzano, whose eloquent preaching even the hypercritical Poliziano admired, spoke of Lorenzo "with praise divine," a Bolognese remarked, esteem that contemporaries tell us was reciprocated.[109] A Franciscan source preserves the tradition that the destruction of a smaller church on the site, containing relics, was bitterly resisted by that order and the parish to no avail so determined was Lorenzo to go ahead even at his own expense. He also provided the friars with a small farm to be used as their garden but neglected to pay the vendor.[110] It is interesting that an official document of 1493 granting financial aid to the new church of San Gallo claimed that Lorenzo had paid for it "entirely."[111] No doubt the intention was to underline Lorenzo's pious munificence, but perhaps I may be forgiven for suggesting that the reference also reveals that his ability to finance and influence architectural projects without dipping into his own purse was widely recognized. It was a very unusual though not unique way of describing a patron's relationship to a building to say that Lorenzo was its "author." The use of this magisterial word may imply that Lorenzo was both entrepreneurially and creatively involved in its construction; architectural historians almost unanimously attribute its design to Giuliano da Sangallo.[112]

There is little more to be said about this. The church itself, of which

several plans may survive, was destroyed in the siege of 1530, and although its attribution to da Sangallo is accepted by scholars, no strictly contemporary document links Giuliano's name to it, despite Giorgio Vasari's explaining the architect's surname by reference to the building.[113] From the start, however, the project aroused the enthusiasm and envy of observers, confirming that its design was strikingly novel. Ercole d'Este, that formidable builder, was reported to be "very satisfied" with it in April 1492, his ambassador adding that this "is a site just right for an architect and I never saw anything more polished and sumptuous." The Ferrarese diplomat wondered whether Fra Mariano would now bother to visit the headquarters of the Austin friars in Ferrara "because there is no greater difference between them [the Florentine and Ferrarese establishments] than between Paradise and some other place; I am not referring to a garden but to what appears to me a landscape endowed with every refinement." The new conventual library, he added, was "finished as if made from silver."[114]

Lorenzo's respect for the polished humanistic learning of the Austin friars may explain his patronage of the convent, as well as his marked predilection for observant religious orders. Lorenzo, Giovanni Pico della Mirandola, and other learned men met there as in a Christian academy, according to Niccolò Valori.[115] The prior of San Gallo was, moreover, Lorenzo's client in a political sense. The two men were so close that Lorenzo could secretly ask Fra Mariano to preach on a delicate public issue. Fra Mariano once declared himself dedicated to Medici "lovingly as a son and reverently as a servant," and his convent was to remain a Medicean stronghold.[116] The "ser Giovanni" who collaborated in the building campaign in 1489 was the top Florentine bureaucrat Guidi, "that scandalous and pernicious man," according to a contemporary, and Lorenzo's loyal tool in the managing of elections and the diversion of public funds into his master's hands.[117] It was at the San Gallo complex that there gathered in early March 1492 the distinguished ecclesiastical retinue that was to escort the newly elected cardinal Giovanni de' Medici, accompanied by "the flower of the citizenry," on his solemn procession into Florence.[118] Lorenzo, "far and away our first citizen," according to one contemporary,[119] and a politician and dynastic leader who greatly

admired *all'antica* architecture, which conferred an ancient prestige on its *auctor,* was hardly practicing self-denial by his pious patronage at the church of San Gallo.

According to a Benedictine chronicler, Lorenzo also built at the churches of Santa Maria degli Angeli and Agnano at this time. The former may have been the church of that name in Assisi, where in the 1470s he indeed ordered the repair of the fountains commissioned by his grandfather. If it was the Florentine Santa Maria degli Angeli, as the Benedictine actually says, it is not evident that he did anything more than take an academic interest in Brunelleschi's unfinished project for the Scolari oratory there, of which Giuliano da Sangallo did, however, prepare a drawing.[120] As for the church on his estate at Agnano, we do not know what, if anything, he accomplished there. The small surviving structure yields no clues, though a Quattrocento loggia that forms part of the complex warrants investigation by architectural historians.[121] Nor is recent speculation that Lorenzo commissioned Giuliano da Maiano to construct Santa Maria del Sasso near Bibbiena, an attractive church built, to be sure, in the 1480s and decorated with Medici arms at that time, convincing.[122] In yet another case, without further evidence one does not know quite what to make of some intriguing information recently found in the archive of the church of San Lorenzo. Giuliano da Sangallo certainly participated in the clearing out of the charnel house under this Medici foundation in 1491, a task ordered by Lorenzo himself at his own expense and requiring an entrance to be constructed for the passage of material. However, to argue as Howard Saalman and others have done that this humble work constitutes a "building fragment" of a Medici dynastic mausoleum—Lorenzo's precocious anticipation of what was to become the Medici new sacristy—seems to squeeze more from an admittedly juicy fact than at present seems reasonable.[123]

Content, it would seem, to construct and pay for the polished and sumptuous church at San Gallo, Lorenzo otherwise expressed his passion for ecclesiastical architecture *all'antica,* his desire to beautify Florence and its territories to his own and the city's glory, by intervening in others' projects in his last few years. He frequently did so as an *operaio,* a traditional republican role that he exercised, however, in an increasingly

insistent, not to say imperious, way. It has been persuasively suggested that Lorenzo's architectural ideas influenced the second campaign, begun about 1490, at San Salvatore al Monte, where for some years he had been an *operaio*. An older, more austere generation of Franciscan architect-friars having died, Lorenzo was freer to express an "*all'antica* delineation of a 'severe' version, one without ornamentation, of Laurentian magnificence."[124] The names of both Giuliano da Sangallo, and the architect nicknamed "Cronaca," have been associated with this late Laurentian phase at San Salvatore (Figs. 13, 23).

Be that as it may, one can quite firmly document Lorenzo's direct and masterful intervention, with Giuliano da Sangallo, in the construction of the sacristy at Santo Spirito, the principal church of the quarter south of the Arno, which was undergoing reconstruction after a fire in 1470. Its *opera* decided on 14 August 1489 that "the sacristy should be built in such a way, and according to the model, that Lorenzo di Piero di Cosimo had had Giuliano da Sangallo make." This was to be an "octagonal design with tribunes in the shape of the [Florentine] baptistery," which should be followed more or less as Lorenzo thought.[125] Just after Lorenzo's death in April 1492, da Sangallo was asked by the *opera* "whether he understood the wishes of Lorenzo concerning what was still to be done in the sacristy."[126] Manifestly, the design decisions were Lorenzo's and Giuliano's, yet the former was not even on the Opera of Santo Spirito at the time he commissioned the model, though he had joined this body, long dominated by five great local families, by late 1490. He was indeed one of the *operai* who persuaded the Florentine government in December of the next year to give further public funds to "bring to perfection" Santo Spirito "by completing the new sacristy, worthy embellishment of the said church" (Fig. 24).[127]

Santo Spirito, like San Gallo an Augustinian foundation, had always been sustained by the public funding that was also forthcoming after the fire of 1470. Well before 1489, however, Lorenzo had been able to bring influence to bear on the *opera* he was later to join, such as in May 1481, when that body ordered the coats of arms "of the People and Commune of Florence" to be removed from Santo Spirito's façade, where they had been placed by explicit command of the Florentine government to ac-

knowledge its recent financial support, and put "in an honorable place to satisfy the men of the Company of the Pigeon and at the request of that most worthy man, Lorenzo di Piero de' Medici."[128] Lorenzo had been a member of that religious confraternity, which met in the church, since 1467, and many of his closest patrician allies—the Guicciardini, the Capponi, and others—came from the quarter of Santo Spirito and had been directly involved in the reconstruction of its major religious site.[129] At the church of Santo Spirito, Lorenzo de' Medici was both making his personal and dynastic presence felt outside of his ancestral district and using his aesthetic clout to perfect a communal church.

More indirectly still, not as an *operaio* of the Duomo but as one of six *provveditori* of the Wool Guild, did Lorenzo concern himself in a crucial way with the ornamentation of the republic's cathedral itself. The consuls of the guild, prompted "again and again by some of the city's leading citizens," decided on 12 February 1490 that the *opera* should attend to the cathedral's façade, which was not only unfinished and deteriorating, they argued, but "without any architectural rhyme or reason [*sine aliqua ratione aut iure architecture*]."[130] Many scholars have detected Lorenzo's classicizing taste, his recent eager rereading of Alberti, in that last phrase. And he was certainly one of the citizens and artists who at a meeting a year later pronounced judgment on the various models and designs for the façade, although it is not true that he himself submitted a design. The first of the handful of speakers deferred at once to Lorenzo's "very great architectural expertise," whereupon he, praising all the entries, advised postponement of a decision to allow mature reflection.[131] Later in 1491 Luca Fancelli was appointed architect to the *opera* "by these Florentine lords, especially the Magnificent Lorenzo,"[132] and he at once set about designing a model for the façade. The *opera* claimed that in electing Fancelli it had consulted "citizens most expert and learned in architecture,"[133] and those scholars are surely right who have proposed that Lorenzo had decided that Luca was the best available architect for the Duomo (Giuliano da Maiano having died in Naples in October 1490), especially since his own Giuliano da Sangallo was precisely then preoccupied with several of Lorenzo's private projects, Poggio a Caiano and the church at the San Gallo gate above all.[134] Lorenzo had dominated this process at the

cathedral by his singular combination of aesthetic prestige and political clout. The meeting of citizens and artists included some of his oldest political allies, such as his uncle Giovanni Tornabuoni, Ruggiero Corbinelli, Antonio Taddei, and Bartolomeo Scala. Among the artists were Francione, Filippino Lippi, Domenico Ghirlandaio, and Botticelli, all of whom were currently working with and for him. An almost contemporary tradition insisted on Lorenzo's personal passion for this façade project, his *invenzione,* as Vasari called it.[135]

Lorenzo also looked within the cathedral at this time, intent upon enriching and making more beautiful a vast interior that, informed contemporaries remarked, lacked embellishment.[136] In Alberti's treatise Lorenzo would have read that as grave and simple as the interior of a "temple" should be, it was also to be as "handsome and elegant as possible."[137] Lorenzo focused upon the main chapel, dedicated to Saint Zenobius, Florence's first bishop and a civic hero for whom Lorenzo had a special devotion. Wounded and afraid, Lorenzo had found shelter under the civic saint's image just after the murder of his brother in the cathedral on 26 April 1478 (Fig. 25).[138] In a very unusual decision in March 1491 the Wool Guild gave not only the *opera* but also the six *provveditori* the task of "decorating the said chapel in however and whatever manner they chose."[139] Lorenzo was therefore present when, two months later, the embellishment of the chapel, including the precious mosaic works he so loved, was entrusted to artists whom he had already personally employed: the Ghirlandaio brothers, Botticelli, and the miniaturist Gherardo.[140] The beginning of this mosaic work was duly noted by Tribaldo de' Rossi in his diary, as if to agree with Alberti's opinion that mosaics were an eminently dignified medium to render a church interior more handsome.[141]

Lorenzo was increasingly a republican *operaio* with a difference. Even so cautious a scholar as the late Nicolai Rubinstein proposed that it was probable that his taste was reflected in the decoration of the Palazzo Vecchio's Sala dei Gigli, where Medicean themes mingle with civic ones. Another scholar has argued that his influence there was "real but indirect" (Fig. 26).[142] On other occasions, when he was not on the *opera* of the communal palace, Lorenzo was permitted to make decisions, as when in May 1483 Domenico Ghirlandaio was commissioned to paint an altar-

piece for the chapel of the Signoria of that "quality and that manner and form as should seem good to, and please, the Magnificent Lorenzo di Piero di Cosimo de' Medici."[143] When Lorenzo was actually in office—in 1479, 1486, and 1488–92—he might undertake a magisterial role. After the *opera* of the Palazzo Vecchio assumed control of the fortifications at Poggio Imperiale and Firenzuola in September 1488 and of most other Florentine fortifications by early 1491, Lorenzo took a particular responsibility for several major projects. Among these was the construction of the fortress-city near Poggibonsi, described by Tribaldo de' Rossi as intended to be "a very strong citadel, with a precinct," in the design of which Lorenzo took a personal interest, while his family firm acted as banker to the undertaking.[144] His brief included questions of garrisoning: "[The Otto di Pratica] decided as below . . . , according to a note in Lorenzo de' Medici's hand," an official document of 1489 concerning the appointment of castellans to Florence's fortresses baldly states.[145]

While on the *opera,* Lorenzo must also have strongly supported the construction in 1491 of a stone *rialto,* or raised bridge, connecting the Palazzo della Signoria and the Loggia dei Lanzi. Or so we may infer from the fact that after the expulsion of the Medici the Signoria chose to order its dismantling—that "the palace may not be disfigured on its sides"—on the very day it commanded that the legend "Pater Patriae" be removed from the tomb of Lorenzo's grandfather, and this despite the anti-Medicean Piero Parenti's praising the "great convenience and beauty of the bridge."[146] It is as telling that the *opera* of the Palazzo Vecchio was among those top magistracies in which Piero di Lorenzo had replaced his dead father by a law promulgated on 13 April 1492, as several contemporary letter writers were quick to note.[147] For Lorenzo and his family at least, the quintessentially republican office of *operaio* of Florence's seat of government was becoming quasi-hereditary.

As both powerbroker and aesthete Lorenzo had a pervasive authority in these years; at the very least, his influence and prestige were such that powerful Florentines felt compelled to act as if it were. Twice after 1485 he served as the middleman in Giuliano Gondi's acquisition of the site for his grand urban palace, whose design has always been attributed to none other than Giuliano da Sangallo.[148] As if in tribute, a headless mar-

ble statue dug up there in April 1490 "was taken," Dei tells us, "to the Magnificent Lorenzo de' Medici's garden,"[149] to the Palazzo Medici if not to the San Marco sculpture garden. Whatever game of cat and mouse Filippo Strozzi and Lorenzo played during the designing of the Palazzo Strozzi in the late 1480s, Lorenzo indubitably assisted Strozzi to acquire part of the site from the Medici family's Tornabuoni kinsmen and was named the executor responsible for finishing the building in Filippo's will. Strozzi and Lorenzo were at best ambivalent about each other.[150] It appears from a passing reference in a letter that about 1490 Lorenzo, the *padrone,* sought to make even his friend Niccolò Michelozzi spend more on some country building project or other than his secretary felt able to afford. It was essential, their common friend Filippo da Gagliano advised an embarrassed Michelozzi, that he should "understand [Lorenzo's] opinion and either take his advice or be in a position to justify himself."[151]

This Laurentian concern with what one might consider other people's business penetrated into the Florentine dominion, certainly into Prato (the Santa Maria delle Carceri project) and Pisa and just possibly into the church of the Madonna in Pistoia. Lorenzo had always loved Pisa and its environs as if they were an extension of Florence itself, not to say of Medici territory. In the early 1470s he had been more active in refounding the university there than in pursuing his own building projects. When in the late 1480s the *studio* officials began a campaign in Pisa, constructing a new residential building with lecture halls for the university and largely destroying the old grain market—so arousing Pisan anger—Lorenzo was kept closely informed by trusted local agents such as Bernardo Pulci and Francesco Cambini, even though he was not himself one of the *studio* officials at this time.[152] He would also have heard about the project's progress from Antonio di Bernardo Miniati, whose correspondence with Cambini mentions the financial arrangements several times.[153] Whether or not it was true, as one man wrote, that this "Sapienza was advised and inspired" by Lorenzo[154]—he had certainly been the major force behind the university's renewal in the early 1470s—the *studio* officials were told in January 1489 that "the Magnificent Lorenzo deigned to come and see your model and the site, on which he expounded with wise words and arguments, and he seems very pleased. And besides he wanted to exam-

ine the designs of the new grain piazza, which satisfied him as much as the other things."[155] A year later, when some rooms were already finished at the Sapienza—"a fine and worthy building," according to the Florentine authorities—Lorenzo revisited Pisa "and made it very clear that he was most pleased because he said that up to this point there is no defect and you are making it so beautiful that it should immensely please anyone and without doubt it should proceed."[156]

] 4 [

This all sounds very masterful, yet Lorenzo did not live long enough, even had political and economic conditions in Florence and Italy remained favorable after 1494, to shape his city and its fabric as he wanted to do. Like several of the Florentine building projects Lorenzo began or took a supervisory interest in, this Pisan undertaking was unfinished at his death—work on it was stopped in August 1492—and has left almost no trace. It took centuries more for the Duomo façade to be completed, and then by public and patriotic action in the nineteenth century, not by Medicean fiat. Nor was the chapel of Saint Zenobius ever to glow with the mosaic work Lorenzo loved. The very magistracy through which Lorenzo had penetrated into the cathedral's affairs—the six *provveditori* of the Wool Guild—was summarily abolished on the expulsion from Florence of his son Piero in late 1494.[157] The Medici arms were removed from a chapel in the church of San Salvatore al Monte and from other places.[158] So great was the animosity toward Lorenzo's distinguished protégés that the effigy of the musician Antonio Squarcialupi in the Duomo, with its Latin epitaph composed by Medici himself, was erased by the Wool Guild "as if it had never been there."[159] This is in effect also true of the church of San Gallo, almost finished by 1492, which for strategic reasons the Florentines deliberately destroyed, not without a certain partisan pleasure, one may speculate, during the siege in 1530, when the exiled Medici and their imperial allies slowly strangled the city into submission. There is more to be seen of the fortress-city at Poggio Imperiale, near Poggibonsi, which Lorenzo helped design toward the end of his life. Monumental fragments still survive, and from the air its impressive outline—like some cumbersome missile, pointed at one end—emerges clearly. Still,

not long after Lorenzo's death the site was described as "almost abandoned and without a master [*padrone*]."[160]

Lorenzo had signally failed to do in Florence what Augustus had achieved in Rome, at least according to a phrase of Suetonius much plagiarized by Renaissance Italian eulogists of princely building programs: "found [a Rome] built of brick and left it in marble."[161] In fact, despite his rhetorical good intentions, the first emperor's old Rome apparently remained "a town of narrow, twisting lanes and enormous, shapeless, and far from fireproof buildings."[162] For Lorenzo's part, it was not for want of trying that he failed in Florence, as if he agreed with the thoughts Robert Browning was to put into the mind of Andrea del Sarto in his poem of the same name: "Ah, but a man's reach should exceed his grasp, Or what's a heaven for?" Contemporary critics quickly realized this and put a stop to a number of his ambitious projects upon his death and later, after Piero's exile. Such opponents sensed how strong his desire was to be Florence's cultural *padrone,* how concentrated his ambition to become not only a major builder himself but the principal arbiter of civic elegance in a city replete with experts. It is as irresistible as it is idle to speculate upon how much more Lorenzo might have achieved had he lived as long as his grandfather, how coherent a vision of a Florentine urban *renovatio* he might have nurtured.

There are tantalizing hints that despite the catholicity of his private taste, which could embrace Flemish painting and Chinese porcelain, Lorenzo might have felt a growing frustration in the last decade of his life with Florence's public confusion of inherited and emerging architectural and sculptural styles, that he desired, however unrealistically, to create in his beloved city the classically inspired harmony, proportion, and beauty, about which he had read in Alberti's pages and that he had seen and handled in his friend Giuliano da Sangallo's architectural designs and models. Did Lorenzo even occasionally daydream of a Florence, or at least a Medici quarter of San Giovanni within his native city, that more resembled the so-called ideal cities depicted in a striking series of anonymous Italian paintings perhaps produced in the 1470s than it did the stylistically polyglot reality, an old and many-layered town full of curving streets and culs-de-sac, Gothic barnlike churches and unfinished façades, dis-

tinguished by solemn, massive late medieval sculpture forced to cohabit with slim and muscular early Renaissance figures?[163] Lorenzo does not seem to have found sympathetic that architectural mixture of old and new, of late medieval forms and classical elements, quite consciously favored by other contemporary builders, such as Ercole d'Este and Giovanni Bentivoglio, both in town and in country. It is inconceivable that, even after the Pazzi plot, when he became more than ever security-conscious, Lorenzo contemplated doing what Bentivoglio was to do after the Malvezzi conspiracy against his regime in 1488: to protect himself, Bentivoglio erected next to his new palace a Renaissance version of the dizzy family towers built centuries before, several of which still dominate the Bolognese cityscape.[164]

Medici surely agreed in 1491, if the phrase was indeed not his own, that the unfinished façade of Florence's cathedral, on which a scattering of monumental late Gothic figures as it were crouched at the base, while above them hovered empty spaces begging to be filled, was "without any architectural rhyme or reason."[165] He cannot have dissented from, if he did not initiate, an extraordinary decision made in February 1487 by his colleagues and friends on the Opera of the Palazzo Vecchio, namely, to break with republican precedent by allowing the members of this body to hold uninterrupted office for five years. This decision was made, quite explicitly, to ensure some continuity in what today would be called artistic policy since, the enabling legislation states in dignified language reminiscent of passages in Alberti's architectural treatise, aesthetic tastes so differ that in the decoration of the seat of republican government "no final touch has been put to it and [the Palazzo Vecchio] seems part old and part new."[166] Lorenzo then rejoined the newly constituted *opera,* remaining on it until his death.

In so many respects more the creation of Renaissance Florence than (as his apologists have it) its creator, Lorenzo de' Medici was not alone in this growing aesthetic instinct for stylistic order, uniformity, and simplicity. At precisely this time, as Jill Burke has recently drawn to our attention, more modest contemporaries were seeking to reorganize and redecorate church interiors in a more uniform and harmonious fashion.[167] Lorenzo's desire was, however, to articulate this contemporary

aesthetic grandly and publicly, perhaps to persuade all Florence, to adapt Alberti's phrase, "to put on almost a new face."[168] The official words of a provision passed by the Signoria just after Lorenzo's death preserved for citizens, and for us, a whiff of this largely unrealized ambition. As one would expect of "the first man of our city . . . the grandson of Cosimo, *pater patriae,*" Lorenzo had throughout his life taken every opportunity "to uphold, exalt, adorn, and celebrate" the city as part of his selfless labors on its behalf.[169]

There was opposition to Lorenzo's aesthetic labors, selfless or otherwise, as there was to his political tactics, and he remained sensitive to it. Some Pisan citizens resented the dismantling of a traditional civic space to make way for the new university building; members of the Franciscan order on several occasions appear to have resisted his architectural plans.[170] Other builders too suffered criticism. Filippo Strozzi's great palace struck at least one pious contemporary as a vainglorious tempting of Providence, as his death before its completion patently demonstrated.[171] Such opposition to monumental building was not unknown in princely states such as Ferrara and Milan, whose rulers could more openly assert their taste and magnificence than could Lorenzo de' Medici, let alone Filippo Strozzi, in still republican Florence.[172] Moreover, within his own coterie of intimates aesthetic debate appears to have continued in the late 1480s, and on occasions Lorenzo allowed his judgment to be overruled, or at least he found it politic to defer to his friends' opinions. In an intriguing incident in 1488 Lorenzo explicitly championed an alternative model for the new fortress already begun at Sarzana—he and others argued that the design of Giuliano and Antonio da Sangallo could be implemented more quickly, more cheaply, and more effectively—only to have the Florentine magistracy concerned, full of Laurentian friends though it was, insist that Francione and the other masters should proceed with their original, "more spacious" design.[173] Even if Lorenzo remained convinced that his young favorite's model was better than that of his veteran friend "Big Frank," he intervened no further.

Such arguments among lay experts were common. In late 1490 there had been so much dispute over how the maritime fortress of Vada, south of Leghorn, was to be built that Lorenzo and his colleagues on the Opera

of the Palazzo Vecchio (to whom the Otto di Pratica had yielded authority in the matter) decided—imprudently, one might have thought—to proceed urgently with the foundations "and then to choose what will go on top and how it will be arranged."[174] A history of protracted disputes within the Opera of the Palazzo Vecchio itself, on which Lorenzo sat for many years, may well explain the unusual decision in 1487 to prolong that magistracy's tenure of office. If so, Lorenzo afterwards remained attentive to differences of aesthetic judgment among his colleagues, who included learned men of decided taste such as his brother-in-law Bernardo Rucellai; Rucellai, as it happens, became increasingly critical of Lorenzo's political actions as time passed and was also competing with him for antique pieces. There could be spirited debate among Lorenzo and his *principali*, as contemporaries described the other leading citizens, on all sorts of diplomatic and public issues, and Lorenzo did not inevitably prevail, or at least he did not always choose to win. In a fascinating if obscure addendum to a letter Lorenzo wrote in December 1489 to perhaps his most trusted political ally, Pierfilippo Pandolfini, he commented about another dear friend, the partisan bureaucrat Giovanni Guidi:

> I believe that ser Giovanni must have written to you that those drawings [*disegni*] we had done in the Camera dell'Arme [a principal ground floor room of the Palazzo Vecchio] are not turning out to be as opulent [*si grassi*] as he desired them, and some are almost unacceptable. I am telling you this so that you will not think the responsibility should be mine because I would not want it thought that I had changed my mind. So if ser Giovanni writes to you declaring otherwise, he will be saying the opposite of what he said to me.[175]

The passage may not even refer to works of art, but, to be sure, it illustrates the dynamics within Lorenzo's *brigata,* or inner circle. Lorenzo at once aspired to be, but wisely refrained from quite becoming, Florence's undisputed arbiter of elegance. There were too many other interests and opinions, friendly and otherwise, to take into account, too many Florentine sensitivities to avoid ruffling. Alberti had written, in another context, of how difficult it was for even a rich man to build the palace of his

dreams in the city, where "your Neighbour's Wall, a common Gutter, a publick Square or Street, and the like, shall all hinder you from contriving it just to your own Mind,"[176] the truth of which the banker Giovanni Rucellai had learned from hard experience while struggling decades earlier to persuade even his paternal kinsmen to sell him property he needed to erect his *palazzo* on the Via Vigna Nuova.[177] This was not the case, however, in the country, Rucellai's architect added, "where you have as much Freedom as you have Obstruction in Town."[178]

It was in the countryside, indeed, above all at Poggio a Caiano, Spedaletto, and Agnano, that Lorenzo found that untrammeled architectural, almost psychological freedom in the mid- to late 1480s. It was into these villas and estates that he channeled aesthetic and political energies almost undiluted by concerns for republican decorum, partisan rivalry, and oligarchic consensus. To be sure, by villa-building he pleasured and delighted himself, again to paraphrase one of his favorite books of this period, Alberti's *De re aedificatoria*.[179] But as much as he sought to leave behind, briefly, the cares and complexities of Florence, his sights were in several senses still fixed firmly on the city he had left. From the countryside, from the classicizing villa of Poggio a Caiano, which so awed his contemporaries, it was Lorenzo's intention to assert a cultural and political authority, informed by ancient precedents and undertones, over Florence itself.

Lorenzo, "Fine Husbandman"
and
Villa Builder, 1483–1492

] I [

Lorenzo de' Medici was not only accomplished at letters and at architecture, according to Cristoforo Landino, who knew him well, but also "a fine husbandman [*bonus agricola*]."[1] If the humanist scholar intended to pay Florence's leading citizen a compliment duly steeped in classical associations—Lorenzo as austere Roman *paterfamilias*, never happier than when tending his vines and observing with an expert eye the unfolding of the agricultural year—he did so with some justification. In a sense Lorenzo was born and remained a countryman. Centuries before his birth the Medici had come from the beautiful and isolated upland valley of the Mugello, in the Apennines north of Florence, and they maintained extensive rural properties there, and control of much ecclesiastical patronage, throughout the Renaissance period. Lorenzo spent long months of his youth at Cosimo's great fortified manor house, Cafaggiolo, where during the summer of 1468 he and his brother, Giuliano, were reported to be having "an ecstatically good time . . . fowling and hunting."[2] Throughout his life he remained a dedicated rider and racer of fine bloodstock and devoted to hunting.[3]

Most Florentine families, patrician and otherwise, sought pleasure and a renewal of their roots by regularly visiting the farms and villages of the countryside whence their ancestors had come to the city. These pil-

grims went at Christmas and at Easter and stayed for weeks at a time during the intolerably hot Tuscan summer and early autumn. There is no better description of the workings of this citizen instinct than Lorenzo's own. "It was the month of April," he wrote in his *Comento,*

> when, as is the usual custom in our city, men and their families linger willingly and at ease in their delightful country villas because, just as the first flush of youth is the best of the ages of man, this is the most beautiful time of the year; moreover, there are so many amenable and refined places of resort close to our city that even were it not a matter of custom, men would betimes be enticed to leave behind their personal and public cares and enjoy a touch of country leisure.[4]

These rural resorts were also productive working farms, and the Florentines, Lorenzo among them, never forgot that not only their daily provisions of oil, grain, wine, and fuel but much of a family's wealth and social status came from its landed possessions. As Lorenzo Strozzi put it when discussing the matter with his brother, Filippo, country estates should yield "a certain pleasure [*diletto*]" but also "financial return and convenience."[5] When he was only fifteen years old, Lorenzo de' Medici was kept closely informed about grain prices at Cafaggiolo by the factor there, Francesco Fracassini, a man with whom he went on to enjoy a long relationship, yet another of the familiar Francescos by whom Lorenzo was surrounded.[6] Such land agents fed Lorenzo information about his estates, pages of it at a time, throughout his career. It is often implied by scholars that only as a mature man, in poor health and weary of public life, did Lorenzo retreat, as it were, to the delights of farming and of the countryside and to the consolation of villa-building there. On the contrary, like so many Italian urban patricians, Lorenzo de' Medici was from the start as much a countryman as a citizen, one whose attitudes toward life and aesthetic tastes were formed in the mountains of the Mugello as well as in the squares, council chambers, and palaces of Florence.

The masterpiece among his nature poetry may well be the so-called *Ambra,* probably written toward the end of his life and inspired by the *locus genii* of his beloved villa of Poggio a Caiano, but he had experimented

Lorenzo, "Fine Husbandman" and Villa Builder, 1483–1492

earnestly with bucolic and pastoral verse from his teenage years on.[7] Long before his almost obsessive villa-visiting in the late 1480s, Lorenzo had gone regularly to Medici houses other than Cafaggiolo. He was often at the suburban villa of Careggi, where he chose to die. He seems to have added paintings and furnishings to this substantial house reconstructed by his grandfather; there has also been speculation that the palace's upper open loggia, which appears to have been a late addition, was his doing.[8] According to an inventory of 1482, there was a room "known as Lorenzo's" in the novel villa his uncle Giovanni di Cosimo de' Medici had commissioned above Florence at Fiesole in the 1450s, "a most beautiful building and view," as a contemporary tells us.[9] It is easy to imagine Lorenzo surveying the city below from his kinsman's pleasure house and repeating with ironic enjoyment Angelo Poliziano's joke that Cosimo used to say that he preferred his house and estates at remote Cafaggiolo to Fiesole "because everything he saw from it was theirs, which was not true of Fiesole."[10]

Thanks to recent research by Amanda Lillie, we now understand very well these Florentine attitudes toward the land and toward country houses during the Quattrocento, the very practical agricultural concerns of men and women determined for profit, pleasure, and reasons of family piety to stay put, whenever possible, on the estates and in the houses of their ancestors. They vastly preferred renovating or making additions to old towers, castles, and manor houses to building grandly *ex novo*. Even the immensely rich Filippo Strozzi, who, like Lorenzo de' Medici, was a determined and ambitious rural improver, chose to develop ancestral estates. His most daring villa, Santuccio, which incorporated classical features new to Florentine rural architecture in the 1480s, was not constructed *ex novo* and retained an older tower. Very few villa builders and agricultural improvers in Florence's golden age of classical humanism gave any thought to Pliny the Younger's letters, in which he described his several villas with loving and minute brushstrokes, or to other solemn Latin evocations of Arcadian bliss.[11]

Lorenzo, however, a "bonus agricola" who heard the traditional call of the land quite as clearly as Strozzi and others, chose increasingly to answer its siren tones in a new way. Toward the end of his life he was

building furiously and expensively at several rural sites. Two of his villas were new, stylistically innovative creations, and all were built on estates that Lorenzo himself had acquired. Not only were these extensive possessions without Medici associations but they were far from the ancestral lands of Lorenzo's lineage. Perhaps the first indication we have of Lorenzo's breaking the citizen mold, or, rather, of his redefining in a singular and influential way what it was to be a Florentine landowner and villa builder, is the more refined and learned absorption in rural pursuits he demonstrated from at least the early 1480s.

] 2 [

The two copies of Pliny's letters in Lorenzo's library,[12] with their detailed descriptions of his several villas—one near Ostia, another in the Umbrian countryside—surely did not go unread at a time when we know that Lorenzo and his circle were contemplating these themes in the early 1480s. His friend Bernardo Pulci, Luigi's brother, published in early 1482 an influential collection of translations of classical bucolic poetry, several of them dedicated to Lorenzo himself,[13] and during the next two years Poliziano lectured on Virgil's *Bucolics* and *Georgics* at the university.[14] From 1482 to 1486 the poet-philologist also wrote and published his own Latin pastoral poems, collectively known as the *Silvae*. One of the four, *Ambra*, refers explicitly to Lorenzo's devotion to that "all-sustaining estate" of the same name at Poggio a Caiano;[15] all reveal Poliziano's careful reading of the standard classical treatises on agriculture, several of which, including Columella's very practical *Res rustica*, he had borrowed from Lorenzo's library during 1482.[16] Poliziano's students Piero and Giovanni di Lorenzo de' Medici were reading Virgil's *Bucolics* during the early autumn of 1485, appropriately enough amid the running waters and lush fields of Poggio celebrated poetically by their tutor in the same year.[17]

"I gather that every day you take more pleasure in agriculture [*della agricultura*]," Bernardo Rucellai had written to Lorenzo from Milan on 20 January 1483 in a personal postscript to a letter devoted to diplomatic business, "a neglected source of happiness [adding in Latin] than which none is worthier of a free man."[18] On the face of it this is a more or less conventional statement that echoes an adage Bernardo would have read

in his father, Giovanni's, commonplace book: "the agricultural life is a blessed source of unrecognized happiness."[19] Very likely the Florentine banker had found the general idea in some late medieval compendium or other. The thirteenth-century Bolognese writer Piero de' Crescenzi had quoted Cicero's *De officiis* to this effect in his widely circulated *Liber ruralium commodorum.*[20] If the Ciceronian passage was an almost platitudinous aside, the notion that agricultural pursuits possessed a special dignity was central to Columella's *Res rustica.*[21] The two Rucellai add to this classical topos the emerging Quattrocento idea that the pleasures of the agrarian life have been somehow underestimated. Lorenzo de' Medici had perhaps come to agree, as his brother-in-law seems to have sensed in his Milanese letter, which surely refers not just to Lorenzo's long-established love of country life but also to some fresh spurt of enthusiasm for things bucolic. There is always the possibility that Bernardo's is a sly allusion to some rustic love affair of Lorenzo's; Francesco Guicciardini later reported on his nocturnal visits to Bartolomea Nasi's country villa in that decade.[22] It is more likely, however, that this is a reference to a new and intense Laurentian involvement, at once scholarly and emotional, in the themes on which Poliziano was then lecturing and writing, a reference to something Lorenzo was reading.

In January 1483 Lorenzo was perhaps engrossed in Columella's long and earnest treatise, which Angelo himself had been perusing a little before. A more attractive version of the tenth book, which treats in verse of the rhythms of the horticultural year, was dedicated to Lorenzo by the Ferrarese scholar Curio Lancellotto Pasi in that very year.[23] It is also possible that at that time there had come into Lorenzo's hands part of the Florentine Michelangelo Tanaglia's *De agricoltura,* some of which can be dated to about 1483. This verse treatise in the vernacular assured its reader that "nothing befits the free spirit more than the cultivation of the soil."[24] Tanaglia, an antiquarian and collector whose poem draws on the obvious classical sources, had been recommended to Lorenzo by none other than Bernardo Rucellai some years earlier.[25] In whichever treatise on agriculture—ancient or modern—he was reading in early 1483 the sophisticated Lorenzo was very likely more engaged by descriptions of the pedestrian minutiae of the agricultural round than one might think.

Like the country-born Virgil himself,[26] he knew a good deal about rural pursuits. Lorenzo's agents reported to him incessantly on every detail concerning his own estates—the plantings, the yields, the floods—and his poetry, above all the late poem describing a flood at Poggio a Caiano, as well as his prose, reveals a careful attention not only to natural but also to horticultural phenomena. "I have planted so many mulberries at Poggio," he wrote to Gentile Becchi in April 1489 in a passage that may recall his ex-tutor's protective care when he himself was vulnerable, "that I have learned that when they are tender and young only a stout and thick stake can defend them from the wind."[27]

Just as absorbing, however, must have been the insistence Lorenzo found in the agricultural literature, ancient and modern, that to master nature and reap her bounty was not only a free and noble vocation but much more so—according to Columella—than the practice of commerce, the law, or even the military arts: "If good men are to shun these pursuits and their kind, there remains . . . one method of increasing one's substance that befits a man who is a gentleman and free-born, and this is found in agriculture."[28] How much more noble the pastoral life was when a grand villa crowned a gentleman's estate, as Michelangelo Tanaglia himself was to make clear in his slightly later dedication of *De agricoltura* to Alfonso of Naples. This dedication mentions the palace outside Naples designed for the king by Giuliano da Maiano on Lorenzo's advice—"thy magnificent and splendid habitation with its fine architecture"[29]—of which King Charles VIII of France said in 1495 that it was so full of beautiful and singular things that it lacked only Adam and Eve "to make of it an earthly paradise."[30] Bernardo Pulci had described the Medici leader in his collection of translated bucolic verse as "Lorenzo, shepherd, who pastures his flocks and herds on the banks of the Arno,"[31] a shepherd-king, we will suggest, who at this time was seeking to further strengthen his control over the city of Florence by redefining himself as a noble countryman.

If he had not already been building villas in the air when he bought the estate of Poggio a Caiano, with its villa "Ambra," in 1474, Lorenzo's head was certainly full of architectural fantasies by the summer of 1483. A contemporary reported that desirous of acquiring the Vallombrosan

country estate of Pitiana, during a visit there Lorenzo "spent much time with architects [*architectori*] designing new rooms, meadows, fish ponds and vineyards, with many olive plantations and various fruit trees." His aim was nothing less than to transform "not only the palace itself but to civilize the whole nearby hill by various designs . . . [*disegni alla civile*]."[32] The Vallombrosan monks successfully resisted Lorenzo's pressure, at once subtle and high-handed, and their spokesmen went on to record for posterity their displeasure with what they called Lorenzo's "tyrannical" tactics.[33] Just three years later he was to find an infinitely more complaisant churchman, Guglielmo Capponi, who granted him the extensive ecclesiastical estates of Spedaletto and Agnano in the Volterran and Pisan countrysides.

By 1486 Lorenzo was positively land-hungry. The year before, he had been compelled to cede to his close Medici cousins by way of compensation for monies owed them Cafaggiolo, with its sixty-seven farms and old associations and with what one Laurentian client called the finest house between Florence and Paris.[34] Nowhere does Lorenzo record the sense of loss or anger he surely felt on this distressing occasion, which is not to say that he might not also have experienced some fugitive sense of excitement that his being forced to give up the ancestral house in the Mugello freed him to build afresh on lands he himself had acquired and had begun to shape in his own image. Whatever Lorenzo felt about the loss of Cafaggiolo, he now moved with such speed and energy into other parts of the Tuscan countryside that we can be certain that his deepest feelings and ambitions were engaged.

There is a strong fifteenth-century warrant for the still familiar argument that Lorenzo's villa- and estate-building in several senses constituted a retreat to the land, a quest for pleasure, for better health, and for safe, if undramatic, returns on capital investments. The strictly contemporary explanation, of which Lorenzo could hardly have disapproved, was provided by Poliziano in his 1485 poem *Ambra:* his master and friend "chose the villa Ambra at Poggio a Caiano . . . as a place to relax away from his civic duties." To this one might add Lorenzo's own insistence in the *Comento* that city cares and responsibilities, including the patronage of urban architecture, were inimical to the amorous muse best cultivated

in sweet meadows.[35] Implicit in this insider's account is the understanding that throughout the 1480s Lorenzo was often seriously ill and badly in need of quiet and recreation, not least in 1485 itself, when he was forced to convalesce at the mineral baths for weeks on end. In the next generation there surfaced another, much repeated explanation the precise origins and genealogy of which are not evident, although one suspects that its source was Medicean propaganda designed to elevate the family's social status. The Vallombrosan critic of Lorenzo's attempts to acquire the estate of Pitiana explained his land hunger as the result of a business downturn, as we would say: "Foreign trade having been interrupted, [Lorenzo] began to concentrate upon landed estates."[36] In his *History of Florence* Niccolò Machiavelli was more explicit, anticipating modern scholarship in his emphasis on how poorly managed the Medici bank was in Lorenzo's time: "In his commercial affairs, [Lorenzo] was very unfortunate, from the improper conduct of his agents . . . To avoid similar inconvenience, he withdrew from mercantile pursuits, and invested his property in land and houses, as being less liable to vicissitude."[37] Close to this account is the biographer Niccolò Valori's, which asserts that Lorenzo "came to hate the mercantile life" and to recognize "how useful and delightful is agriculture, and not unworthy of some prince."[38]

The Medici bank was certainly in trouble during this period, as a classic study and subsequent research have shown, and the profit motive was, to be sure, at least as important to Lorenzo as it was to his patrician contemporaries, who invested heavily in land even when they did not withdraw from trade and banking. Florentine aristocrats characteristically kept mixed investment portfolios throughout the period.[39] All of Lorenzo's villas, even Spedaletto, which was principally a hunting lodge and conveniently located close to health-giving mineral springs, were situated on working estates into which he poured a good deal of capital for drainage and other improvements. Lorenzo's everyday correspondence has as one of its major themes the acquisition of both tracts and parcels of land and their subsequent development. On 4 June 1477, to take only one of numerous examples, he received an urgent letter from his Pistoian agent, the canon Antonio Marchetti, informing him that some meadows

recently acquired from the city of Prato for the estate at Poggio had been mismeasured in haste, to Lorenzo's disadvantage.[40] Some time later, these meadows having been irrigated, Marchetti reported that "the water does the job splendidly and will do so even better when the ditches are reinforced."[41] The maintenance and administration of rights to pasturage in the Pisan Maremma and elsewhere were also constant preoccupations of Lorenzo and his several factors and agents.[42]

Further expert study of Lorenzo's agricultural enterprises might well support my impression that at times he took commercial advantage of his personal ascendancy over Florence's regime and its bureaucrats during the city's political and military advance in the 1480s into the Lunigiana area, north of Pisa, where the Florentine fortresses of Sarzanello and Pietrasanta were to be found. At least suggestive of a certain merging of Florentine public with Laurentian private interests is a letter of 14 July 1490 written by Antonio di Bernardo Miniati, Florence's top financial bureaucrat, to the city's customs official in Pisa, Francesco Cambini; and there are many similar letters that are as intriguing as Antonio's handwriting is difficult. The one friend of Lorenzo's carefully instructed the other as to how their lord's right to ship grain into the Lunigiana should be protected, in collaboration with Girolamo Pilli, a Medici land agent: "And this is Lorenzo's business, and therefore you must exercise every possible diligence."[43] Presumably the public official Cambini, who later described Lorenzo as "more than a father,"[44] followed the writer's advice.

The Medici were among the Tuscan leaders expanding the commercial cultivation of olives at this time, recognizing, in the words of a contemporary Sienese document, that olive oil was with grain, meat, and wine "one of the four basic necessities for human life." This statement was no cliché. A Florentine father solemnly warned his son, living in Brittany, about the dangers of a diet that combined butter and wine, while grudgingly conceding that "where oil cannot be found butter can be consumed."[45] Despite the heavy investment involved in establishing groves, which took years to reach maturity, Lorenzo himself was responsible for the planting of thousands of olive trees on his estates in the Pisano, including Agnano.[46] He also established mulberry plantations for the prop-

agation of silkworms, although he was not quite the pioneer in this lucrative enterprise that a contemporary eulogist claimed he was: the thousands of mulberry trees on Lorenzo's own estate of Poggio a Caiano had been planted by the previous owner, Giovanni Rucellai.[47] A Spanish visitor aptly described this model estate about 1520 as "a pleasure house bringing in fine profits."[48]

Among these productive olive groves and mulberry plantations Lorenzo also sought and found relaxation and pleasure. It was reported in June 1488 that having been cooped up in Florence for two months, he had gone to Montepaldi "to take a breath of air and to get away from many tangled affairs."[49] He would also have visited this very recently acquired estate south of Florence because Francione and other builders were working there about this time, and Lorenzo enjoyed looking at buildings in progress.[50] We read that in August Montepaldi "is now habitable," though there was still work to be done.[51] This little-known villa, set among extensive farms and still very much in existence today, was described in 1492 as "a house or rather palace." Though simply enough furnished, Montepaldi possessed numerous rooms, loggias, vaults, and courtyards, including a chamber for Lorenzo himself and accommodation for the secretaries and bodyguards (staffieri) who accompanied him even when he was on vacation.[52]

Without doubt, Montepaldi's new owner hoped to find better health by also taking the waters at his Spedaletto estate and elsewhere, at those rustic Stations of the Cross that punctuated what Mario Martelli has described as the via crucis of his wanderings from the mid-1480s on.[53] Foreign diplomats were as obsessed in their correspondence with Lorenzo's poor health and his peripatetic habits as were Lorenzo and his circle. To read the Milanese ambassadorial reports of 1487–92 is to discover an almost nomadic Lorenzo, on the move between Bagno a Morba, Spedaletto, Agnano, Poggio a Caiano, Bagni di San Filippo, Careggi, Loggia de' Pazzi, and other places.[54] One Florentine correspondent promised him in May 1486 to write only when necessary "so that with as little disturbance as possible you can enjoy some leisure and benefit from the waters."[55] When he found himself at Spedaletto, every day riders brought Lorenzo flasks of health-giving water from his mother's favorite source,

due south at Bagno a Morba.[56] In a loving letter of July 1489 the near invalid assured his little daughter, Contessina, who had been worried about his illnesses, that "these waters [at Spedaletto] go on doing me wonders, so that, with God's grace, I hope to return as well as ever I was."[57]

In his last, increasingly desperate weeks, as his health seesawed, to the consternation of scores of Lorenzo watchers, we witness his almost pathetic faith in the curative powers of architecture enjoyed in country air. In late February 1492 Lorenzo planned a trip to Poggio a Caiano and Montepaldi "to take the air somewhat, and for recreation, as it appears . . . the doctors agree."[58] Although it was conceded that the air at Careggi was preferable to that at Poggio a Caiano,[59] the month before his death found Lorenzo dreaming, in bitter spring weather, of journeys to Poggio and Agnano, where the building teams were hard at work.[60]

] 3 [

Passionately fond of both rural pleasures and profit, patently desirous of relieving, if not curing, his physical ailments by spending time in the fresh air, in his building campaigns in the country Lorenzo was seeking to express still other feelings and desires, to achieve still other objectives. There was, one suspects, the urge to refashion himself and his immediate family, to transform himself and his descendants from Florentine citizen-bankers–cum–Mugello countrymen into learned landed gentlemen who, like ancient Roman patricians, from their villas molded and domesticated their vast estates as they sought to shape and control the republican politics of the city. Lorenzo's aesthetic and political imagination was captured by this ancient vision in the 1480s, when he not only built or transformed a number of country houses in Tuscany but dreamed of creating still others. There are two unrealized villa or palace projects, marked "the Magnificent Lorenzo," among Giuliano da Sangallo's sketchbooks.[61] Lorenzo certainly was businesslike in acquiring and managing his estates. The impulse to do so, however, expressed his quintessentially political nature, his dynastic drive to dominate republican Florence more thoroughly than his ancestors had been able, or perhaps wanted, to do.

In his several outbursts of 1485 Lorenzo indeed declared himself both tired of the odious routine of patronal politics and dissatisfied with his

lieutenants' loyalty, and he did this at a time, it is true, when his convalescent mind was certainly building villas in the air. These private complaints hardly amounted to a serious denunciation of politics, however, which he continued to practice in the very act of apparent renunciation. Lorenzo de' Medici did not become apolitical when he stayed in the country, for he continued to conduct civic and patronal business there. Official and private letters, scores of them, followed him like heat-seeking missiles during his journeys from country house to country house, from one bathing station to another. While he insisted at times that only the more important letters be sent on to him in the country, when necessary he was an assiduous rural correspondent.[62] Lorenzo knew very well that however much he may have wished it, to be away from Florence for too long spelled danger—"because my friends' love and trust cease when I go more than ten miles away from there"[63]—which meant that he had to keep his finger on the distant city's sometimes erratic pulse. And when he was in the Tuscan countryside, in no way could he disappear without a trace. Florentine and foreign observers charted his every movement in detail and duly reported *in extenso* to their respective masters. He also saw foreign dignitaries in his country houses, if the need arose, and it would be naïve to think that his new villas were not intended, in Leon Battista Alberti's words, to "receive Strangers handsomely and spaciously." Poggio a Caiano became a staging post for eminent visitors approaching Florence. According to Giovanni Pontano, a lord should furnish his villas splendidly "so as not to leave the impression that he has passed from sunlight into shadow when from time to time he must withdraw from civic duties."[64]

The very placing of the Laurentian villas expressed a clear and, in the Florentine context, novel political strategy. The contemporary churchman who asserted that economic motives informed Lorenzo's rural enthusiasms also let slip, without comment, the important remark that he sought to acquire villas "around Florence on all sides."[65] If this was indeed his intention, Lorenzo did not quite succeed. After the loss of Cafaggiolo in 1485 he had no seat in the northern Mugello region, though he retained other connections with this ancestral territory. Nor, after his failed attempt to possess Pitiana, near Vallombrosa, did he have a villa to

the mountainous east of the city, in or toward the Casentino district. Otherwise, however, one can speak of a strategic positioning of mainly new Medici country houses around Lorenzo's home city. Just as the Sforza of Milan and the Estensi of Ferrara had multiple country residences and traveled almost incessantly between them, so too did Florence's principal citizen. Just outside of Florence, to the west, was Cosimo's villa of Careggi, which Lorenzo often visited and showed off to visitors. In the environs of the city there was another retreat, of which we know little, at Grassina.[66] Further south lay Montepaldi, which was near the important fortified town of San Casciano. To the southwest, in the almost lunar landscape of lower Tuscany, was the villa and hunting lodge of Spedaletto. Lucrezia Tornabuoni had loved this wild countryside, where the mineral baths she developed at Bagno a Morba were situated, and she passed this enthusiasm on to her elder son, who went on visiting the area after her death in 1482.[67] From Spedaletto's high tower Lorenzo could espy not only the abundant game but Volterra, with its towered fortress rebuilt after the Florentines had won back this rebellious city at such cost to both parties in 1472. A supposedly impregnable fortress, Volterra was the key to Florence's southwest frontier. That victory against Volterra had also firmly established Lorenzo's position in the regime and the Arno city for the first time.

Across from Spedaletto, toward Pisa, the great port city purchased by Florence in 1406, Lorenzo developed extensively the agricultural interests in which his and other Florentine families had been investing for most of the century. Lorenzo had several estates around Vico Pisano, Buti, Calci, and Fucecchio, and he owned an iron mine, as well as substantial houses, in the area.[68] His overlordship was not undisputed. To the outrage of the local authorities, in 1472 some dissident covered the Medici coat of arms in the main square of Fucecchio with human excrement, and it was rumored after the Pazzi Conspiracy that there were plots against Lorenzo in these towns and in Pisa itself.[69] In 1486 he acquired Agnano, which commanded a view of Pisa and the Tyrrhenian Sea from its position in the foothills above the Pisan plain. While Poliziano pictured Lorenzo reading at leisure there and enjoying the sea view from the pine woods his master had ordered planted at Agnano,[70] the Pisans, many of

whom were not reconciled to Florentine rule and who were soon to revolt, would have known that Florence's master was also gazing intently at them. The views from Poggio a Caiano, which stands between Pisa and Florence on the highway to the subject town of Pistoia, were almost as fine. From what Donato Giannotti described in 1533 as "this magnificent building," its owner could survey, as Giannotti also pointed out, Florence itself, as well as Prato and Pistoia.[71] Prato, long part of the Florentine state, had rebelled briefly against the Florentines in the first difficult year of Lorenzo's ascendancy and merited watching.[72] As for faction-ridden Pistoia, it was, as Antonio Marchetti said to Lorenzo, "the second eye of your dominion," not only a potential trouble spot but a major source of support for Lorenzo and a focus, therefore, of his political and social patronage.[73]

It is striking that all of Lorenzo's new villas, including Montepaldi, which still offers astonishingly long southern views of hills and valleys,[74] conformed to Alberti's prescription that a gentleman's country house should not only be clearly visible to passersby but also "have a View of some City, Towns, the Sea, an open Plain, and the Tops of some known Hills and Mountains."[75] Lorenzo's villas were there to be seen and marveled at and to provide a magnificent vantage point from which their owner could survey the lands and towns—Florence itself, in the case of Poggio a Caiano—subject to that city and to the Medici regime. His intention was not to subdue citizens and provincials by force of arms, to cow them into submission from crenellated castles preserving the not-too-distant memory of feudal, magnate, authority. Though Spedaletto retained a medieval tower, Lorenzo's villas were not fortified, unlike those of other contemporary Italian lords and, indeed, of most other Florentine aristocrats. Lorenzo's very life was at risk at Poggio a Caiano, his bodyguards may have believed, because its civil and open architecture offered him no physical protection.[76] (Duke Cosimo I later found it necessary to surround the villa with a fortified enceinte.) Rather, Lorenzo's aim was to win over the Florentines and all Tuscany by the prestige and authority invested in *all'antica* architecture. He surveyed rather than dominated half of Tuscany from these classicizing villas, with their wide and brilliant views. From these latter-day watchtowers–cum–pleasure

houses he made his presence felt among towns that in the past had revolted against Florentine rule and in some cases were to do so again. His frequent journeys between his villas, accompanied by bodyguards and in some cases shadowed by considerable forces of men in case of trouble, remind one of the characteristic country progressions of the Sforza, Gonzaga, and Estensi dynasties, indeed of some northern European Renaissance king keeping a wary eye on his domain.[77] These subject cities were not quite the territorial jewels in a crown Lorenzo had yet to assume, but the very act of benign surveillance was intended to make them so.

] 4 [

The Laurentian villa-building campaign dates from about 1486 on but was long and carefully prepared. The site at Poggio a Caiano had been acquired when Lorenzo was a very young man, in 1474.[78] Some ten years later he entered into negotiations with the master of a chivalric religious order, Guglielmo Capponi, to gain possession of several estates in his charge. This branch of the Capponi family had occupied the mastership of Altopascio, near Lucca, for several generations after 1445. More pliant creatures of the Medici than their proud Capponi cousins descended from Gino and Neri di Gino, these ecclesiastical Capponi had early accommodated Giovanni di Cosimo de' Medici's wishes concerning land he held around Fucecchio,[79] the area in which Giovanni's nephew, Lorenzo, displayed a renewed interest in the early 1480s, when several agents and friends, including Bernardo Rucellai, were active there on his behalf.[80] Lorenzo must have approached Guglielmo Capponi concerning his desire to have Spedaletto and Agnano early in 1486. In a letter of 23 March addressed to "my magnificent patron," the master of Altopascio explained that Spedaletto's boundaries could indeed be expanded and asked Lorenzo whether the arrangement he proposed accorded with "the conception Your Magnificence had revealed." The extra lands Lorenzo required at Agnano could be found by persuading a certain man to cede them, he added. These estates, Capponi concluded, would provide "all in all fresh air most conducive to your good health."[81] The deal was concluded on 8 May 1486 by a personal agreement that was the prelude to a very long and complex legal document of 23 August. For the com-

paratively small sum of sixty florins per annum and the surrender to the Altopascio order of certain Medici lands at Fucecchio, Lorenzo and his direct male descendants received in perpetual lease the properties "in the *contado* of Volterra and of Pisa known under the name of Spedaletto and Agnano, and other lands pertaining to Altopascio." The arrangement had papal approval, and it was understood that if Lorenzo's direct line were extinguished, the estates, together with any improvements, should return to Altopascio.[82]

A later Capponi master of Altopascio tried to exert this right of repossession.[83] Lorenzo, however, with three sons in 1486 and possessed, one suspects, of a confident sense of the virility of his line, began almost at once to improve Spedaletto and then to build Agnano, as if they would belong to the Medici race forever. He visited Spedaletto very soon after its acquisition,[84] no doubt to take the waters of Bagno a Morba but very likely also to discuss the building works, which despite some difficulties were well under way by May 1487. In that month Antonio Berlinghieri wrote from Volterra to Niccolò Michelozzi that he had been talking to some master builders "working on the magnificent Lorenzo's Spedaletto" who had gone into town to inspect the new fortress at Volterra, which Lorenzo and his colleagues had helped design fifteen years earlier. All was going smoothly, according to these experienced men, though closer questioning by Berlinghieri revealed that one Piero Pitti, apparently the building supervisor, was very unpopular. Since builders always complained about their boss, he would have ignored this opinion, Berlinghieri added, save that the laborers on the site also "said that if [Pitti] had charge of this estate things would not turn out well and that he was always threatening to strike and kill them."[85] What Lorenzo did with this alarming information one does not know. Building must have already been far advanced, however, as in that same month a list was drawn up of household furnishings to be sent to Spedaletto.[86] In the words of a contemporary document, by 1487 the "palace [*palatium*] known as the Hospital of Saints Ippolito and Cassiano" was fast becoming "a new gentleman's palace [*palazzo da signore*] attached to the hospital."[87]

The new house, with its regular shape, internal courtyard, and deep entrance hall, must have been dignified and comfortable, if not grand.

Lorenzo, "Fine Husbandman" and Villa Builder, 1483–1492

What remains has apparently been somewhat altered. Set several miles from Volterra in still quite remote country, Spedaletto was not intended to make a daring architectural statement. It gained the muted approval of a foreign visitor in September 1487, who informed the pope that no neighboring house "was worthier of Lorenzo."[88] No architect's name is associated with Spedaletto's design, although two years after the building activity there Simone del Pollaiuolo, called "Cronaca" (a well-known younger Florentine architect who was to work on several Laurentian projects after Lorenzo's death), was recommended by Lorenzo to the factor of Spedaletto. Possibly he had earlier contributed to the project, or perhaps some other master builder was entrusted with it.[89] There is still much to learn concerning the men who worked for and with Lorenzo at his several villa sites. According to a near contemporary, for example, the very competent architect Lorenzo da Monte Aguto "was responsible for many of the late Magnificent Lorenzo de' Medici's buildings," yet so far as I know, no other source confirms this confident remark.[90]

The hospital's medieval tower remained an integral part of the small complex, perhaps to acknowledge (as Filippo Strozzi did at his villas) the pious ties and associations of the site and almost certainly to serve as a place to watch for game, as did the towers of Ercole d'Este's villas in the Ferrarese countryside.[91] Although Lorenzo did do business at Spedaletto, meeting the papal nuncio, Giacomo Gherardi, and then the bishop of Volterra there in the autumn of 1487, one's impression is that if any of his villas was a genuine retreat, it was this hunting lodge near Volterra.[92] The surrounding lands, to this day wooded and hilly, were hardly very productive, as Niccolò Valori conceded, while emphasizing the agricultural improvements the new owner had made and the amenities therefore offered to the local inhabitants (whose humble interests Lorenzo did in fact pursue, as his correspondence shows).[93] At Spedaletto Lorenzo was not so much the gentleman farmer, however, as the hunter who needed exercise and entertainment, the near invalid who craved the mineral waters his mother had prized. In late May 1489 the Ferrarese ambassador reported Lorenzo's going there "for some days . . . to drink the thermal waters, as he also did last year." There are other references in the last five years of his life to Lorenzo's going to Spedaletto for his health (e.g.,

for more than two weeks from late August 1491 "for his gout's sake").[94] The villa's 1492 inventory reveals that it was well stocked with hunting equipment, for example, a variety of nets for capturing birds and wild boar.[95]

In the rainy late September of 1490 Lorenzo, having inspected building works at Agnano, decided, in the words of a friend, "to stay some carefree days" at Spedaletto.[96] By then, among the villa's delights for Lorenzo must have been the now lost fresco cycle including "The Forge of Vulcan," which he commissioned there presumably in late 1487–88, after building had been completed and the house had been made habitable. Unlike a suburban villa such as Careggi, Spedaletto had almost no portable devotional images or works of art.[97] Instead Lorenzo chose to have the *sala grande* and the external loggia frescoed, setting to work what has been described as "almost an official team" of artists, most of whom had earlier painted in the Sistine Chapel in Rome, probably at Lorenzo's suggestion, and later in Florence's Palazzo Vecchio: Sandro Botticelli, Filippino Lippi, Domenico Ghirlandaio, and Perugino.[98]

Through these earlier commissions, as well as by other means, Lorenzo already knew most of these men, and he had had professional contacts with them. If there is no surviving documentation of a personal relationship with Ghirlandaio (who, however, painted a sympathetic portrait of Lorenzo for Francesco Sassetti), firm, if indirect, evidence exists of Lorenzo's corresponding with both Lippi and Botticelli.[99] While it cannot be demonstrated that the latter's *Primavera* was commissioned by Lorenzo himself, and Lorenzo's cousin and namesake now seems its probable patron, the great mythological painting (the precise subject of which continues to exercise the forensic skills of numerous scholars) finds its literary and imaginative inspiration in Florentine circles very close to the Medici leader, whether its subject is the portrayal of love or the triumph of rhetoric. Two other works by Sandro are named as being in Lorenzo's possession at his death.[100] It is almost as if at Spedaletto Lorenzo de' Medici were deliberately pitting one great modern master among his favorites against another. He was, after all, the most competitive of men, as his contemporaries observed; Isabella d'Este, not without competitive instincts herself, wrote of his mania for horse racing that "he is always

wanting to win, by one means or another."[101] Perhaps the Lorenzo who so coveted the battle scenes by Paolo Uccello that he appropriated them for the walls of his room in the Palazzo Medici wished to see these artists struggling against one another at Spedaletto, like the protagonists of some heroic battle between nude supermen engraved by another of his preferred artists, Antonio del Pollaiuolo. This appears to be how one Milanese interpreted the commission at Spedaletto in a celebrated comparison, sent to Lodovico il Moro, of the respective merits of these four masters (Botticelli with his "virile air," Filippino with his "sweeter" manner, and so on): "they have all worked at the Magnificent Lorenzo's Spedaletto, and it is not clear who holds the palm."[102]

These paintings were destroyed in the early nineteenth century. Had they survived, even in the damaged state of the dancing nudes painted somewhat earlier by Antonio del Pollaiuolo for the Lanfredini family villa at Arcetri,[103] without doubt it would be harder to deny, as many scholars still do, that Lorenzo de' Medici's artistic taste extended to, indeed easily embraced, the best and most experimental of modern painting. He had come to appreciate Filippino Lippi, for example, as deeply as Cosimo had appreciated the painter's father. The two corresponded in the late 1480s, when Lorenzo ordered a Roman antiquarian "to show the heads and other things to Filippino."[104] The artist was commissioned by Cardinal Oliviero Carafa in 1488 to paint his chapel in Santa Maria sopra Minerva in Rome after "agreements made with Filippo the painter at your [Lorenzo's] behest," and afterwards one of Lorenzo's agents reported on how diligently Lippi was working.[105] Given Lorenzo's recommendation, the Neapolitan prelate declared to another Florentine, he would have preferred Filippino to Apelles or all the artists of ancient Greece, those fabled names the young Lorenzo himself had earlier delighted in recalling.[106] The Spedaletto paintings by Filippino and others, which according to Giorgio Vasari constituted a great mythological cycle that included "the story of Vulcan, in which many nude figures are at work with hammers making thunderbolts for Jove,"[107] demonstrated the secular taste shared by the Medici and their Lanfredini friends, who found it both appropriate and delightful to decorate a private house in the country with classical and mythological, often erotic scenes despite the more

conservative and pious taste displayed in country houses by most contemporaries.[108]

It is very easy to comprehend why a student of Luca Signorelli has been tempted to speculate recently that his now lost and always mysterious *Court of Pan*, if indeed it was commissioned by or offered to Lorenzo about 1490, as Vasari tells us and current scholarship plausibly suggests, may have found itself at Spedaletto.[109] This much-praised "canvas depicting some naked gods," a pagan *sacra conversazione* held amid a classical landscape suffused with bucolic eroticism and a melancholic sense of ancient loss, would surely have pleased Lorenzo the rural lover, pastoral poet, and villa builder.[110] Whatever his relations with the gifted painter from Cortona, it needs to be emphasized that on the first occasion when Lorenzo de' Medici was able to carve out a significant new space of his own, he very quickly filled it with paintings by very different contemporary masters, thereby creating at Spedaletto a sort of miniature gallery of modern art for his private delectation.

There is no reference in the surviving documents to painted cycles at Spedaletto's sister villa at Agnano, overlooking Pisa. Built *ex novo,* the villa may not have reached the advanced stage necessary for the execution of such in situ decoration when Lorenzo died, although by then the emerging structure was lived in by the agent Girolamo Pilli,[111] and presumably the owner found it habitable on his frequent short visits. By 1492 a number of rooms were already supplied with devotional images and furnished in what appears to have been a rather utilitarian fashion.[112] Lorenzo's plans for Agnano were, however, more ambitious than those for Spedaletto and took commensurately longer to put into effect. The whole beautifully situated estate was itself to be a carefully wrought work of art. As the transformation of Spedaletto drew to a close during 1487, Lorenzo in his systematic way had turned toward Agnano, where at the request of the ubiquitous Francesco *orafo* the Olivetans granted him land of theirs early in that year. They had little choice: "I don't dare contradict him," wrote a senior cleric, adding that Lorenzo must be satisfied "one way or another." Lorenzo wrote to his agents concerning Agnano's affairs in several letters of late 1488 and early 1489, at which time Giovanni Cambi was to send "two hundred ducats for Agnano."[113] Lorenzo himself wrote

of his affection for the monks whose church formed part of the estate and of his determination to favor their interests.[114]

It is clear from correspondence that by the summer of 1489 extensive building and agricultural work on the gardens and the estate itself were fully under way, as if to prepare for the villa that was soon to be embedded there like some precious stone. There is much talk of the digging of ditches and channels—Valori later commented on the elaborate drainage schemes implemented at Agnano, presumably on the flat marshy land below the villa site proper[115]—and of the builders, who "have constructed the courtyard portal as instructed" and other works.[116] Lorenzo took his usual direct interest in progress, Girolamo Pilli mentioning to him in a letter of late August 1489 "that channel they were building when you were here." The laborers had also dug up a large "basin [*pila*]," he continued— an antiquity, perhaps—which Pilli had thought might be placed "at the mouth of the channels, where it was decided to put the fountain; should you wish it."[117] A garden and grounds were already emerging. Cambi reported in May 1489 that "the mulberries are doing fine." "Wild boars have devastated a field of grain," he was forced to concede a month later, "near the hermitage where we planted the cherry and apple trees."[118]

Agnano, sheltered in foothills above the Pisan coastal plain, still enjoys a salubrious microclimate, of which Lorenzo and his agents were determined to take advantage. He called for "citrus plants for Agnano" in the autumn of 1489;[119] it is probably reasonable to suppose that the various exotic plants and fruits brought by Giuliano, "your Magnificence's gardener," from the duke of Calabria's gardens a little earlier had been destined for this benign, indeed noble place.[120] The grounds were to include a vast rabbit warren, or rather walled enclosure—a *conigliera*—possibly similar to the rabbit house that was to be found in the hunting park of the Visconti dukes, behind the Porta Giovia castle in Milan, in the 1460s. Francione had been asked to turn his multifarious skills to this undertaking at Agnano, which would require hundreds of meters of walling. Having measured the proposed site of the rabbit enclosure in August 1489, the woodworker-architect declined for technical reasons to continue "before you [Lorenzo] look at it again."[121]

Judging by the fact that construction was begun in the midwinter of

1489–90, when bad weather was inevitable, there must have been an urgency on Lorenzo's part to build the villa of Agnano. He was informed on 2 January 1490 that "at Agnano they are continuing with the foundations, and only the loggia toward the garden remains to be built."[122] However, Giovanni Cambi went on, he and "Master Peter the builder" believed that the measurements for this last section were not accurate, and they awaited Lorenzo's coming. Two weeks later Lorenzo learned from the factor, Girolamo, that "the house's foundations are all built to ground level . . . precisely according to the measurements you left," save for the columned loggia area, concerning which the mistaken calculation had been made.[123] This mishap had apparently caused a halt in the work, since according to Cambi in a letter of 6 January, "nothing new has happened at Agnano." He added that Piero di Gino Capponi, a leading Florentine politician and distant cousin of the Altopascio Capponi, had dined there "and was very pleased" with what he had seen.[124]

Lorenzo himself wanted to spend some days there in the next month, as his friend Filippo da Gagliano reported to Michelozzi on 20 February.[125] The main structure of the building was going up fast in the changeable spring weather, or so we may assume from Lorenzo's request of 20 April 1490 to Guglielmo Capponi that the master of Altopascio "concede certain timber for Agnano to Gratiadio."[126] This *maestro,* Graziadio di Gherardo da Pescia, with whom Lorenzo had been acquainted as early as 1474, was very possibly in charge of the building site, where he would have worked with "Master Peter the builder," mentioned above (surely the "Master Peter woodworker" apparently still resident at Agnano in 1492).[127] The first-named man is hardly likely to have been responsible for the architectural design of this creation *ex novo*—two drawings for which exist in the Uffizi collection—this "house, or rather gentleman's palace, built according to the model," as it is described in the Medici inventory of 1492.[128] More likely, Francione's creative contribution went beyond planning the impressive rabbit enclosure at the Pisan site, to which he was attending in August 1489. Cambi had informed Lorenzo on 21 May that "Francione has never returned from Sarzana, and so the work you demanded of him at Agnano has not been completed," at least a reference to hydraulic and building works on the grounds of the

estate.[129] We know that in the following months Francione was several times absent from the fortress site at Sarzana, much to the anger of Florentine authorities.[130] When he arrived at Agnano in August 1489 he was in effect "moonlighting"—his official job was as communal engineer—and dedicating his expertise to Lorenzo's interests. The engineer-architect who had submitted a design for the site of Poggio a Caiano might well have concerned himself with the model for the villa at Agnano.

Lorenzo's personal interest in the project remained intense, and a furious pace was kept up. The Milanese ambassador wrote home on 11 September 1490 that Lorenzo was riding toward Pisa "to visit his estates, and they say that he will be there about fifteen days."[131] He certainly inspected Agnano, where, da Gagliano told Niccolò Michelozzi, "they are building fast."[132] It is perhaps to late 1490 that we can assign an interesting list dated only 13 December detailing "what I left to be done at Agnano": extensive work on walls, doors, windows, and so on.[133] During the next year, Lorenzo continued to urge on his lieutenants there, interesting himself in every detail. The factor at Agnano was commanded in early August "to send for Graziadio and have him design the house for the oil press, and to begin to lay the foundations, etc."[134] When that agent apparently became disaffected, an ill and impatient Lorenzo demanded in a letter of 25 January 1492 "that [the factor] should stop complaining to Lorenzo all the time and get on with his job."[135]

Lorenzo's younger son, Giovanni, knew how much Agnano mattered to his father, whom he joined there on a visit early in December 1491.[136] The young cardinal seems to have kept an eye on the project for his ailing father, regretting early in the next year that "I can write nothing about Agnano because I have not been there for a while on account of the bad weather."[137] Despite all of the attention given the project, the villa itself was not, in the words of a contemporary document, "entirely finished" in 1494,[138] when it and the estate at Spedaletto passed into the hands of Francesco Cybo, the husband of Lorenzo's daughter Maddalena, to repay a debt, the underlying intention perhaps being to preserve the estate from avaricious hands after the expulsion of the Medici.[139] The nucleus of the house—vaults, courtyards, loggias, a number of rooms—already existed in April 1492. If the present structure, completed in the next century,

bears any resemblance to the Laurentian "model" mentioned by a contemporary source, Lorenzo's Agnano was indeed to be an imposing country house, a "palace"[140] set amid new outbuildings and gardens, including a huge fishpond, which still survives, on a flourishing estate comprising extensive pastureland and farmland. Such carefully wrought and exotically planted grounds enhanced a villa's splendor, according to the expert opinion of the Neapolitan humanist and diplomat Giovanni Pontano, referring, however, to "those . . . [villas] built not in country style but with city magnificence."[141] Agnano was a cardinal undertaking on which, as Cambi had earlier observed to Lorenzo himself, "we are, as you know, continually spending."[142]

<div align="center">] 5 [</div>

Lorenzo's spending on the estate at Poggio a Caiano had been considerable since its early acquisition, and it would increase when villa construction began much later. The number and scale of the gradual improvements mentioned in the Medicean correspondence and other sources make this clear, though no account books survive to provide precise figures such as those we have for the great Palazzo Strozzi. First came massive hydraulic works, the construction of embankments, dikes, and canals to control and channel the river Ombrone, very likely under the supervision of the engineer Domenico "the Captain." He wrote to Lorenzo from Poggio in the spring of 1476 informing him that the canal expert from Viterbo had arrived and been shown "all the waters . . . and where they have to be directed. Now he says he wants to speak personally with Your Magnificence, so tell me whether we should come to you or await you here."[143] This was perhaps the first of many visits to Poggio by specialists variously described as "water masters" and "meadow masters,"[144] and Lorenzo continued to oversee their labors. His advice was sought, for example, in an agent's letter of early 1489 duly reporting on work on the dikes and the planting of thousands of mulberry plants and pine trees.[145] These necessary, prosaic hydraulic works Poliziano compared to the mighty achievements of ancient Roman villa builders.[146]

The new owner went on acquiring other lands in the area during the 1470s, while awaiting the outcome of a complicated legal process that by

1479 had given him in installments possession of the entire estate purchased from Giovanni Rucellai five years earlier. Just as Lorenzo appears to have put pressure on the older man to sell in 1474, despite Bernardo Rucellai's youthful protestations to the contrary,[147] Medici went on consistently to use all the authority he could muster to consolidate and perfect the estate, or *possessione,* as he and contemporaries called it, which patently mattered to him earlier, and more, than any other. The commune of Prato felt compelled in 1477 to grant him by public decree certain ecclesiastical property he coveted there.[148] Fourteen years later the Florentine magistracy of the Seventeen Reformers, with Lorenzo himself present, decided that since a small house at Poggio a Caiano belonging to Florence "would be useful to Lorenzo di Piero de' Medici without detriment to the commune," he should have it in perpetuity on payment of due compensation.[149] Lorenzo at once assumed the role of protector of his people at Poggio, as if to demonstrate his mastery of his new possession. He extended his patronage as well to the Pistoian ecclesiastic Marchetti, a Medici partisan who also acted as Lorenzo's middleman in the district.[150] Early on he also intervened on behalf of humble men from the area. He wrote a letter in support of "the brother of the gardener at Poggio" to the *podestà* of Prato in August 1484.[151] When some of his employees at the diary farm wounded a man from the Pistoian mountains two years later, Lorenzo in a sense took responsibility by assuring the injured party of his displeasure and offering help.[152]

Lorenzo and his immediate family visited and stayed at Poggio almost from the moment of its acquisition. Upon immediate receipt on 30 May 1474 of the informal note from Bernardo Rucellai agreeing to surrender the possession, he inspected the site in a state of high excitement with this brother-in-law, or so we may infer from circumstantial evidence indicating that the two young men had an animated conversation about the site's possibilities.[153] Lorenzo's first firmly documented visit was about 19 July,[154] and for the rest of his life he was drawn to this perfect site for a villa like some lover possessed. The late summer of 1482 found him extremely reluctant to return to the city from Poggio "and have all Florence in my house to no end."[155] So ill in the late summer of 1491 that he

could barely speak, Lorenzo was nevertheless borne there "on a litter, being unable to ride."[156] Clarice Orsini and their children shared Lorenzo's love of "Poggio City," staying there—often with Lucrezia Tornabuoni, who had a room of her own[157]—in the large, older country house once owned by Palla Strozzi and renovated at considerable cost by Palla's son-in-law Rucellai.

In the years 1476–80 this substantial house was made more comfortable by the new Medici owners, as a comparison of two inventories of those years reveals. By the latter date the villa was quite well stocked with paintings and books. Lorenzo could refresh old memories with classic vernacular works by Dante, Petrarch, and Sacchetti. If he wanted a new bestseller, the master of Poggio had only to reach for a printed copy of the *Morgante*, written by his boyhood friend Luigi Pulci.[158] His bedroom in the country also contained an image of Christ's head and "a plaster cast of a boy and maiden going to bed," which was not of particular value, as a later document tells us.[159] A variety of pleasures abounded, then, at Poggio a Caiano. Beginning in April 1477 the handsome new dairy farm gradually emerged from its foundations, to the satisfaction of several witnesses. Contemporaries also admired the beautiful milk cows fortunate enough to be housed there, most of which had been brought to Tuscany from Milan by drovers (as many as a hundred head in August 1489 alone).[160] The *cascina* also accommodated more exotic guests, such as the Barbary sheep Lorenzo received as a gift from the Turkish sultan in 1487.[161]

The duke of Calabria wrote in April 1486 that he had heard that Lorenzo "is creating an estate *ex novo*,"[162] whereupon the prince sent thirty of his finest working bullocks—those superb white oxen one still very occasionally sees laboring with such ponderous dignity in Italian fields—to do the plowing. There had already been a considerable force of men at work at Poggio in the latter part of the preceding year, which has persuaded several scholars that not just an estate but the villa *ex novo* had already been begun by 1485.[163] It is often assumed that Lorenzo's excited mention of "my model" in a letter of September of that year refers to the design for Poggio. Just as likely, however, Lorenzo was concerning him-

self with the design for the church of Santa Maria delle Carceri in Prato, a commission only a little later withdrawn from Giuliano da Maiano and assigned to Giuliano da Sangallo.[164]

This is not to deny, in the absence of clinching evidence either way, that by 1485 Lorenzo was thinking quite practically about the new villa he had probably been dreaming of building on the gentle hill at Caiano since his joyous acquisition of Rucellai's house there years before. Poliziano's poem written as from Poggio in November 1485 does not say that "Lorenzo my glory, glory of the muses" had begun to "build the roofs of a villa which will last forever" but rather implies that he would soon be doing so.[165] There was almost certainly still nothing substantial to see in May 1486, when a detailed account of Poggio written by the Medicean intimate Francesco Baroni said no more than that some distinguished visitors had been impressed by the fertile charms of the fields and gardens and by the elegant dairy farm, where "thirty-four cows suckle so beautifully."[166] If this was the case, perhaps preliminary work on the foundations began sometime between mid-1486 and fairly early in 1487: an undated letter written by the poet Michele Verino (who was dead by the end of May 1487) states firmly that "the structure is not yet begun, but the foundations are laid."[167]

It is conceivable that this Latin poet, Lorenzo's near neighbor at Poggio, was recording a sober observation of physical fact, for the foundations for this huge building would not have been built in a day. One suspects that he was exercising a certain imaginative license, however, since Lorenzo, his architect, and the building team waited another three years before vigorously pursuing the erection of that noble structure about which Poliziano had already prophesied in 1485. Luca Landucci implied that 1489–90 was the crucial time; it is not even out of the question that one can be completely precise about the date and time of commencement. According to the very late testimony of Donato Giannotti, Lorenzo's villa proper was begun at 6:00 A.M. on 12 July 1490, the philosopher-priest Marsilio Ficino having declared this the auspicious moment. This last detail need not surprise us: Filippo Strozzi's urban palace in Florence had been begun just one year before in a similarly formal, astrologically determined manner.[168] Moreover, a letter of very early Septem-

ber 1490 has been discovered in which Lorenzo's kinsman and agent in Rome, Nofri Tornabuoni, wrote quite matter-of-factly to him that he was more than ever keen to seek out antiquities "since you said to me that you had begun building the palace at Poggio."[169] Whenever in 1490 construction began, this was the year in which contemporaries spoke unambiguously of rapid progress there. Less than two weeks after Tornabuoni wrote, another of Lorenzo's friends, Filippo da Gagliano, let Michelozzi know that "at Poggio they are building vigorously, and you never saw anything so beautiful. It is taking shape, and already it seems a thing apart."[170] Progress was such that when, in May of the next year, several Milanese ambassadors visited Poggio, they reportedly were to greet the emerging building "with stupefaction as much as admiration," one of them declaring that "he had never expected to see such a thing. This building project so far seems to them very much yours [Lorenzo's], and a fine start and appropriate for that estate" (see Fig. 17).[171]

Lorenzo's frequent visits in this period, despite his ill health, were surely made to see for himself what progress had been made and to urge on the builders. He took as close a supervisory interest in the villa as George Washington was to demonstrate during the building of Mount Vernon, about which the president found time away from his official duties to write long letters of instruction.[172] Large quantities of material were being consumed at Poggio and at Agnano. Twice in 1491 Lorenzo's colleagues among the *provveditori* of the Wool Guild voted him the right, despite prohibitions to the contrary, to cut timber from the Casentino forests entrusted to that body, some 450 wagon loads in all.[173] The construction was being paid for directly from capital, which must have been considerable, or so Filippo da Gagliano seems to inform us in an obscure passage in which, after saying how quickly Poggio a Caiano was progressing in September 1490, he adds that "one wants to see it [finished?] quickly, and before Strozzo will do so, which will happen if [Poggio] continues to be financed from capital."[174]

Lorenzo's friend implies here that Medici was in architectural competition with Filippo Strozzi in 1490, just as their two families had long been and were to remain political rivals, despite a recent entente. Other contemporaries agreed. Ercole d'Este, when sent the detailed plan of Fi-

lippo Strozzi's new town palace by another Strozzi in 1489, was quoted as exclaiming, "[I]t will be prouder [or more arrogant, *più superba*] than Lorenzo's" (see Fig. 21).[175] This was probably a reference to Lorenzo's Florentine house, Cosimo's palace built in the 1440s, but it is not inconceivably an allusion to Lorenzo's project for Poggio, a princely undertaking that was hardly a secret in Florence and Italy at large by that date. A passage in the correspondence of Ugolino Verino regrets Filippo Strozzi's death in 1491, not least because his monumental palace was left unfinished. Verino goes on to express his fear that the project might not now be pursued with genuine enthusiasm, despite Strozzi's testamentary insistence that this happen. Since we know from other evidence that Lorenzo de' Medici was named the executor charged with completing the palace, and since Verino alludes to the perils of revealing to his correspondent why he felt the great enterprise might stall, he may well have been implying that Lorenzo would deliberately thwart Filippo's dying wishes. Marvelous villas were all very well, the scholar Verino further added with explicit reference to Poggio, but he would have preferred to see a fine library any day![176] Unless these contemporaries misread the signs, the ultracompetitive Lorenzo, whom Filippo had had to dupe, according to Strozzi's son, in order to obtain his permission to build the rusticated urban palace of his dreams, was now spurred on by Strozzi's example, as well as by his own mortal fears, to finish the villa of his own architectural fantasies.

Lorenzo's disappointment at losing this race against time, despite Filippo Strozzi's predeceasing him, was captured by Piero Parenti, the contemporary chronicler who reported that on his deathbed Lorenzo told his intimates that one of the three things he most regretted was not "having seen the loggias of his building at Poggio finished."[177] All the same, the progress in the last eighteen months of Lorenzo's life had been remarkable, given the grandeur of the conception and the complexity of its execution. It was reported to the tax officials that by 1495 Poggio was "a large habitation, or rather palace, a third of which has been finished according to the existing model; and of the remaining two-thirds, all the foundations are in place, and part of the walls, with loggias and porticos around, and outside a balcony and stairways."[178]

The last of Lorenzo's building projects, the villa at Poggio a Caiano had most engaged his mind and heart, not to speak of his purse. And as faithfully completed and decorated in the second and third decades of the next century by his son Pope Leo X this striking building best expressed Lorenzo's taste and his ambition to create in and around Florence a cultural program "in which the ancient Roman and Tuscan traditions were merged together and transformed."[179] Into its conception Lorenzo put architectural ideas he had long pondered as he talked to familiars such as Francione and Giuliano da Sangallo, visited other Italian cities, pored over other lords' designs, and read in Alberti's treatise and the ancient agricultural literature. Together with da Sangallo, whose design for Poggio a Caiano may owe something to his study of the remains of the so-called palace of Maecenas in Rome, by the late 1480s Lorenzo was ready to design and erect a villa that, even as it emerged from its foundations, struck contemporaries as not only admirable and beautiful but "a thing apart," to repeat Filippo da Gagliano's description.[180] Vasari's later account of the villa's creation rings more or less true in the light of such considerations. Having commissioned "several models from Francione and others," Lorenzo "had Giuliano make a model of what he himself had in mind, which was in form so very different and diverse from the others, and so close to Lorenzo's fancy [capriccio], that he had work started on it at once as the best of all."[181] According to Piero di Lorenzo de' Medici, it was the architect Giuliano who was best able later to explain, with the help of a model, his father's "mind and intention" concerning Poggio a Caiano.[182]

We are able to speculate what was "a thing apart" about the design of Poggio a Caiano. The Milanese ambassadors stupefied by Poggio in late 1491 made the interesting remark that "if the lord Lodovico [il Moro] could see these things, he would not be pleased with what he [himself?] has done."[183] It was perhaps Lorenzo's intention to express in the countryside so decided an architectural taste for, in the Neapolitan humanist Giovanni Pontano's words, "city magnificence [quello (stile) magnifico di città],"[184] which it was thought would attract Lodovico il Moro's attention, for just after Lorenzo's death he asked to see a model of the villa. Even in the city most Italian lords, including Lodovico himself, still lived

in and built town houses, many of them painted, which were at once forbidding and defensible; and Milan was particularly conservative in this respect. The formidable new urban palaces of most Florentine patricians were, with some notable exceptions, such as those of the Rucellai and the Boni, still rusticated, conveying to contemporaries a stony and monumental authority. Cosimo de' Medici's own palace of the 1440s, for all that scholars regard it as a pioneering example of civil architecture, could still serve as a sturdy refuge from which missiles might be launched at attackers in troubled times.[185] In nearby Bologna the Bentivoglio had followed Cosimo's example by carving out a grand palace amid the urban confusion. A crenellated structure with a richly adorned and painted façade, the Palazzo Bentivoglio was "very beautiful . . . in the style of a fortress [*rocca*]," in one later contemporary's words.[186]

Not even in the countryside did Lorenzo choose to build in the Florentine version of this style, evocative as it was of an older, seigneurial authority based on military power. He was mindful, surely, of Alberti's observation that tyrants, not private citizens, built fortresslike houses with battlements and towers.[187] It was Lorenzo and Giuliano da Sangallo's distinctive achievement to design for the thoroughly rustic site of Poggio a Caiano a civil and urbane building as different as could be from some northern Italian lord's castle or from Cosimo de' Medici's Cafaggiolo, described in a document of 1468 as "a great fortresslike dwelling surrounded by a walled moat, with barbicans and two towers."[188] The "Ambra" at Poggio a Caiano, which Lorenzo had bought from Giovanni Rucellai in 1474, must have been such a fortified manor house; examples are to be found in the frescoes of Benozzo Gozzoli in the Palazzo Medici and in the more fantastic landscapes of Maso Finiguerra's "Florentine Picture-Chronicle."[189]

As well refurbished as this substantial mansion was, and as endowed with prestige by the famous Palla Strozzi's ownership, there was no possibility that when he judged the time to be right Lorenzo would resist his long-nurtured desire to impress his own architectural and political personality upon this remarkable site. When it had outlived its usefulness the old Strozzi-Rucellai villa of "Ambra" was allowed to decay as it was replaced by the grand and original edifice that became a direct model

for several sixteenth-century villas.[190] Poggio was to remain so much the type of the classicizing Italianate villa, expressive of some noble pastoral dream, that its remote, not to say illegitimate, descendants flourish still in those parts of the New World where Italians have settled; witness the monumental houses with porticoed façades built in the suburbs of eastern Melbourne by Italo-Australians wishing to proclaim their new prosperity while insisting upon their roots in an ancient rural society to which, in fact, their ancestors had been largely peripheral except as humble laborers and herdsmen.

Lorenzo had come to recognize that his grander "agricultural" pursuits were, in Valori's phrase, "not unworthy of some prince." He would have agreed with his biographer that his new villa at Poggio, perfectly expressing his passion for architecture "as close to the antique as possible," "so to speak stood for and rivaled an ancient magnificence."[191] Several other comments already quoted reveal this vivid contemporary sense that Poggio came as a revelation, that it conveyed more than a hint that its builder was making some new and significant statement, informed by a sense of "ancient magnificence," about how he saw his position in the Tuscan world and how he wished to be envisaged by others. "This is the work of a king. . . . Kingly, Lorenzo, is your house . . . and your kingly mind is in everything," wrote the unctuous poet Naldo Naldi.[192] While it was not unusual to refer to grand buildings as "royal"—the early-fifteenth-century chronicler Gregorio Dati had briefly described the Florence of his day as full of "kingly palaces"[193]—Naldi's relentless repetition of this theme is striking. Other contemporaries found Laurentian Florence itself regally overawing. A Paduan visitor thought the newer Renaissance palaces there fit for Jupiter and the gods.[194] One of them, Filippo Strozzi's town house, was "a royal and massive building [*mole regale*]," wrote an appreciative Ugolino Verino.[195]

If, however, the Florentine Verino was picking up Horace's reference, in *Odes* 2.15, "to "princely piles [*regiae moles*]," the Latin poet's intention had not been laudatory. Horace was criticizing the building by his Roman contemporaries of great pleasure houses, with porticos "measuring . . . tens of feet," in a shrinking countryside that was thereby despoiled. In earlier, better times, he lamented, "private estates were small, and great

was the common weal."[196] In the Latin poet's pejorative sense Lorenzo's Poggio was indeed "a princely pile," invasive of the countryside over which it lorded, built by a man whose family was gradually insinuating itself into republican political space at the expense of the commonweal. The villa's design, a brilliant application by Giuliano da Sangallo of an ancient and public architectural vocabulary to a private citizen's country house, expressed this emerging dynastic claim to supreme authority within the republic.

Possibly Lorenzo found the justification for his architect's doing so in the pages of one of his copies of Vitruvius's *Ten Books on Architecture,* where the Roman theorist sanctions the use by powerful men of public and grand architecture in their private dwellings.[197] Modern architectural historians agree with Naldi that the villa of Poggio a Caiano is "kingly." Poggio's architecture "returns to ultimately imperial models," in one analysis, to "more urbane characteristics of building," such as the very balconies and circular galleries first mentioned in Bernardo Rucellai's excited note to Lorenzo of early June 1474.[198] The possibly first use of a tympanum on the villa's façade must have struck contemporaries, it has been argued, as clear evidence of "the princely and imperial character of the building and its patron."[199] Across that façade, bright against the sober grey, stood out the painted terra-cotta frieze depicting classicizing metaphors of Medici rule and other dynastic themes, such as the regeneration of nature and the return of the Golden Age.[200] If scholars disagree radically about when and by whom the frieze was executed, there is more or less a consensus that Bertoldo *scultore,* who died at Poggio in very late 1491, at the peak of the building campaign, designed it with a pellucid sense of the ruling passions of his beloved Lorenzo de' Medici— "Laurent agriculteur," in André Chastel's phrase, "along with [whom he] made fine things" (Fig. 27).[201]

This princely pile was not obviously threatening, however, and its antique aura, as well as the disarming capacity it still has to take one's breath away, as it seems somehow to hover above the hill to which it is so firmly attached, deeply impressed contemporaries. At Poggio, Lorenzo and Giuliano da Sangallo had managed to create an urbane and magnificent villa that simultaneously addressed Florentine civic sensibilities

and sensibilities and made Medicean intentions acceptably manifest. Poggio's architecture at once reassured Lorenzo's fellow republican citizens of his unbellicose and civic inclinations, reinforced his (deserved) reputation as a cultivated and learned country gentleman steeped in the classics, and gave subtle notice to all Tuscany of his ambition to have the Medici join the ranks of Italy's princely and royal families. The young Medicean leader who had been sensitive to republican sentiment in the 1470s and who in maturity still proceeded with a certain high-handed sense of decorum in Florence itself was at Poggio a Caiano using architectural sign language, as it were, to communicate from the countryside his future political and dynastic ambitions in the city and in princely Italy at large.

] 6 [

There were other such signs abroad, and contemporaries were able to read them. Lorenzo, for one thing, was developing a sharper interest not only in ancient history—which, he told Ercole d'Este in 1486, while in pursuit of a copy of Dio's *Roman History,* gave him "pleasure and consolation"[202]—but also, almost certainly, in the shaping of his own family's historical image. If he did not take up the humanist Francesco Filelfo's offer of 1477 to write for his "exaltation . . . your 'Florentine History,'"[203] he was surely aware some years later that two men close to him, Alessandro Cortesi and Francesco Baroni, were gathering archival materials touching on the recent Medici past. The Medicean circle was at least contemplating the compilation from chancery documents of a historical work in praise of his family, if not of Medici himself. It is telling that in 1484–85, just after Bartolomeo Scala and his Florentine chancery had news of the work, Cristoforo Landino, at Lorenzo's behest, translated into Tuscan for Lodovico il Moro Giovanni Simonetta's recent *Commentaries on the Deeds of Francesco Sforza,* which exalted the writer's patron-employer in a partisan, not to say propagandistic, manner by the careful and novel use of the Milanese archives.[204]

In the same period Lorenzo was accelerating his collecting of antiquities, his searches for old and rare manuscripts. He gave as much attention to his book collecting as to politics, a learned contemporary ob-

served with admiring exaggeration.[205] One of his greatest regrets on his deathbed was not to have seen his "marvellous Greek and Latin library done." As if to tease the earnest modern scholar, this contemporary testimony[206] leaves unclear whether he was referring to an actual (marbled?) library under construction or to his well-known and burgeoning collection of books and manuscripts. Some of the greatest triumphs of Lorenzo the antiquarian came in this last period, for example, when in late 1487 he purchased in Venice the precious Roman carnelian of Apollo, Marsyas, and Olympus, which was later valued at one thousand florins and much copied.[207]

To own such rare and valuable objects, which most contemporaries believed possessed magical and sacramental powers, to keep them hidden safely away from curious proletarian eyes within the Palazzo Medici, while occasionally condescending to display them to a few distinguished visitors, was itself a decidedly magnificent, not to say princely, way of behaving. Late medieval kings and nobles had formed such ambitious collections, and contemporary monarchs and popes pursued them. While Lorenzo without doubt enjoyed and prized his precious objects in the scholarly spirit that had animated collectors in the previous century,[208] the preeminent lineage of his Tazza Farnese had just as much appeal for Poliziano and perhaps for him. This extraordinarily delicate and costly object had been previously owned by Emperor Frederick II before passing into Persian hands, after which Alfonso I of Aragon, Ludovico Trevisan, and then Pope Paul II had possessed it. What had formerly been owned by kings and pontiffs, the Laurentian poet boasted, "now belongs to Lorenzo, splendor of the Tuscan city."[209] Lorenzo's princely contemporaries in Italy, tortured by their own "insatiable hunger for ancient things," as Isabella d'Este was to say, in their turn sought to possess objects made even more prestigious by the fact of Lorenzo's having owned them. "They are rare and lordly objects," Francesco Malatesta wrote to Francesco II Gonzaga of four hardstone vases, "which the late, magnificent, Lorenzo de' Medici held very dear." The vases, Isabella d'Este was informed, were inscribed "with capital letters bearing Lorenzo de' Medici's name."[210]

The legend "LAU.R.MED.," or variations of it, can be found on many

objects owned by Lorenzo, usually the most precious, the hardstones and gems, as well as in manuscripts he commissioned. No other contemporary collector allowed this dangerous practice, which, even in the hands of a skilled craftsman,[211] risked defacing or even breaking rare and priceless objects. When Lorenzo began to order these acts of "desecration," as a distinguished modern scholar of hardstones has described them,[212] and what contemporaries thought of them we hardly know. Nor is there consensus on what the R represents, despite support for the reading "R[ex]" (King) or "Rex paterque" (King and father), Horace's description of Maecenas.[213] Enough contemporaries saw Lorenzo's collection to allow one to rule out the argument that by its use he was claiming in secret a supreme title to which he could not pretend in public.[214] So far as one knows, he never called himself "prince" let alone "king," although admiring friends such as Gentile Becchi and Michele Verino occasionally conferred on him the former title in an allusive way.[215] But in contemporary usage the word *princeps* itself could refer to the leading citizen of a republic. The Venetian doge was in this sense styled a prince; Giovanni Bentivoglio acted, in the words of an inscription, as "prince of the Bolognese senate."[216] When he was elected Florence's first gonfalonier of justice for life in 1502, Piero Soderini was several times called the city's *princeps*.[217]

Until a more convincing explanation appears, the late Ruth Rubinstein's suggestion that the placing of the mysterious R between two sets of three letters on various Laurentian objects reveals the connoisseur Lorenzo's nice sense of symmetry retains an elegant simplicity.[218] That is hardly the end of the matter. Not the use of the R so much as the unparalleled act of inscribing his own name on these often ancient and delicate objects, however exquisitely and carefully, betrays Lorenzo's cultural and political ambitions perhaps more clearly than do any other of his actions, including his creation of Poggio a Caiano. Lorenzo may not have called himself a king, but to collect such royal and venerable objects, to seek to possess them forever by autographing them, as it were, in dignified classical lettering—an action that Pliny reports was regarded as a "violation" by some of his own contemporaries—was a quintessentially high-handed activity.[219] It was also a way of insisting on his and his dynasty's intention to lay contemporary claims to an ancient authority, of associating his

Lorenzo, "Fine Husbandman" and Villa Builder, 1483–1492

family's noble present with an even grander past, just as Poggio's striking architecture sought to do. Among his contemporaries, only Bernardo Rucellai offered an explanation for his brother-in-law's astonishing temerity in putting at risk fragile objects so revered by their generation, an explanation with an almost unimpeachable authority: "Witness the letters inscribed on the gems themselves, displaying the name of Lorenzo, whose carving he charged to be done for his own sake and that of his family, as a future memorial for posterity of his royal splendor."[220]

In the last decade of his life Lorenzo acted increasingly as if he were Augustus as described by Suetonius, almost as if he had had a privileged preview of Augustus's *Res gestae,* which was, however, not rediscovered until the next century.[221] Perhaps in the 1480s he talked with Poliziano about his emerging "image." Suetonius was a favorite historian of this Greek and Latin scholar, who had suggested that Augustus was Florence's Roman founder.[222] Medici asserted his authority in Florence subtly and allusively as the first Roman emperor had done: by his own public and private building programs and his encouragement of others' munificence; by his solicitude, as father of the fatherland, for his social inferiors; and by his reticent refusal to accept titles such as lord *(dominus).*[223] So pervasive was Lorenzo's influence, however, that his critics agreed with Piero Parenti that "he ran the regime [*stato*] as if he were no less than its lord [*signore*],"[224] that, in the words of his confessor, "from God, and from Lorenzo his minister, we receive everything."[225] It is not out of the question that Alamanno Rinuccini, as hostile a witness as only an ex-friend or ex-lover can be, was right in claiming that Lorenzo was biding his time until he was forty-five and legally eligible to be head of state. Then, as gonfalonier of justice he would "take over the republic"[226]—Giovanni Cambi uses the phrase "declare himself titular ruler"[227]—and become duke of the Florentine republic, its duly appointed *princeps* indeed.

If this was his intention, Lorenzo's cultural program was a highly intelligent paving of the way, a seamless weaving together of his deepest aesthetic and political impulses. While biding his time, why further offend his enemies, not to mention his patrician friends, by claiming titles that were still anathema to Florentines of all sorts? Why tempt republican providence by commissioning grand portraits of himself and fresco cycles

glorifying his dynasty, as did his northern Italian princely peers and as his son, Leo X, was to do at Lorenzo's own Poggio a Caiano, or by collecting antique images of Augustus, despite his closet interest in that powerfully ambiguous figure?[228] Better to have his contemporaries infer his superior, even quasi-regal status from their admiring contemplation of Poggio, redolent of some ancient glory, from their awed half-knowledge of those treasures locked within the Palazzo Medici, those almost sacred relics that Lorenzo now possessed as no one before him had done by virtue of having had his name inscribed upon them. Better still, let others confer upon this man whom one contemporary described as possessing an "imperial spirit [*cesareo animo*]" the position he would not yet claim for himself. Even before his death, images of Lorenzo, who even the republican Piero Parenti admitted was the greatest citizen Florence had ever had,[229] began to appear in other men's collections. The medal with Lorenzo's likeness made by Niccolò Fiorentino was to be found in the study of that remarkable friar, Franceschino da Cesena, in 1489. Early in the next century the Florentine Cosimo Bartolini kept a portrait of Lorenzo, reverently it seems, in a drawer or small box.[230] The great collector was himself being collected.

There is still something very poignant about the contrast between what Lorenzo was in the process of claiming for himself and his dynasty and what he achieved in his lifetime: "Between the idea And the reality, Between the notion And the act, Falls the shadow."[231] From his youth burdened by a sense of life's transience, he knew the near impossibility of gathering rosebuds while ye may; he came to feel saddened, as Piero Parenti tells us, by dying, in the words of another contemporary, "at an age when he might have expected to enjoy a longer life,"[232] when he might have hoped to see his many cultural and political projects completed. Perhaps the most sympathetic reading, to modern eyes at least, of Lorenzo de' Medici's insistence on inscribing his name on objects at once fragile and ancient is that by doing so he was expressing an impossible longing for permanence and continuity, for eternal union with an inevitably lost world. It is true that he lived to enjoy briefly the hunting lodge at Spedaletto and its paintings, and the church at San Gallo was very near completion in 1492. Otherwise, his favorite schemes were

Lorenzo, "Fine Husbandman" and Villa Builder, 1483–1492

unfinished, and he did not even live long enough to see begun the frescoes at Poggio a Caiano, soon to be painted by one of his favorite artists, Filippino Lippi (Fig. 28).[233] He was at least spared the knowledge that after his death several of his projects, like Lippi's cycle, were to be neglected or even abandoned and destroyed.

The pathos of all this struck Giovanni de' Medici, who as Pope Leo X vigorously sought to revive his father's dynastic dreams, above all at Poggio a Caiano itself. During his triumphant visit to Florence in 1515 the Medici pope, entering from the south, first saw near the church of San Felice in Piazza a Roman arch depicting "the image of his father Lorenzo, bearing the legend: 'This is my beloved son,' at which sight he wept copious tears." The old Medicean claims to be a holy dynasty here reached an audacious, metaphorical high point. At the family church of San Lorenzo Leo found depicted another giant image, this time of his father's namesaint, Saint Laurence, "so realistic that it seemed almost alive." The legend directly addressed the distinguished visitor, reminding him that his ancestors had built this beautiful church and begging him to complete its façade, another Laurentian and Medicean project never to be completed, despite many attempts.[234]

Between the desire and the consummation falls the shadow, indeed, which has caused many scholars to underrate or even denigrate Lorenzo de' Medici as amateur and patron of art. He died so young, however, even by Renaissance standards, that to compare him with his grandfather, as Francesco Guicciardini and subsequent historians have done, is odious. Full of intelligence and ambition, as a patron he planned, indeed achieved, more than we have been taught, and he brought to all of his aesthetic pursuits—and they were many—a taste at once educated, discriminating, and catholic. That taste he sought to share with, at times impose upon, his contemporaries, in the same way and for the same reasons that he pulled ever tighter at the city's political strings. Florence was his and his family's city, Lorenzo was coming to believe by the late 1480s, and just as he was increasingly responsible for its diplomacy and government, so too was its embellishment both his business and his delight.

Republicans, now as then, can take a certain perverse satisfaction in the fact that Lorenzo de' Medici died too young to become titular prince

Lorenzo de' Medici

of Florence, if that is indeed what he intended for himself. There is a certain satisfying irony, too, in the contemplation that it was communal and republican Florence, with its artisan-artists, its ubiquitous works committees, its citizens expert in architecture and sculpture, that in a sense fashioned Lorenzo de' Medici, the Magnificent, more successfully than he himself was able, for all his appetite for beauty and glory, to refashion and make over the city. And yet one must acknowledge, if not regret, that Lorenzo's early death deprived us of a Florence made even more beautiful by his encouragement of excellence in all the arts, by his educated taste for "polished and sumptuous" architecture.

Notes

ABBREVIATIONS

AB	*Art Bulletin*
ASF	Archivio di Stato, Florence
ASI	*Archivio Storico Italiano*
ASM	Archivio di Stato, Milan
ASMan	Archivio di Stato, Mantua
ASMod	Archivio di Stato, Modena
BM	*Burlington Magazine*
BNF	Biblioteca Nazionale, Florence
Corp. relig. soppr.	Corporazioni religiose soppresse sotto il Governo Francese
JWCI	*Journal of the Warburg and Courtauld Institutes*
MaP	Archivio Mediceo avanti il Principato
MKIF	*Mitteilungen des Kunsthistorischen Institutes in Florenz*
Notarile Antecos.	Notarile Antecosimiano
Provv., Reg.	Provvisioni, Registri
RQ	*Renaissance Quarterly*
RS	*Renaissance Studies*

CHAPTER ONE. INTRODUCTION: THE MYTH OF LORENZO

1. Citizens of Pistoia to Lorenzo de' Medici, 11.iii.1477, published in C. Kennedy, E. Wilder, and P. Bacci, *The Unfinished Monument by Andrea del Verrocchio to the Cardinal Niccolò Forteguerri at Pistoia* (Northhampton, Mass., 1932), 78–79. Translations are mine unless otherwise indicated. The original text of translated passages is usually given only for unpublished documents. All dates have been changed to modern style.

2. Letter of 17.iii.1477, in ibid., 79: "et chonosciamo che chome persone poco experte volavamo dare juditio di quelle cose di che non avavamo molto experientia."

3. A. Butterfield, *The Sculptures of Andrea del Verrocchio* (New Haven, Conn., 1997), 137–57; P. L. Rubin and A. Wright, *Renaissance Florence: The Art of the 1470s* (London, 1999), 154–55, with a colored image of the model. See also F. Falletti, ed., *I Medici, il Verrocchio e Pistoia: Storia e restauro di due capolavori nella cattedrale di S. Zeno* (Leghorn, 1996).

4. Quoted in S. J. Milner, "Rubrics and Requests: Statutory Division and Supra-

Communal Clientage in Fifteenth-Century Pistoia," in *Florentine Tuscany: Structures and Practices of Power,* ed. W. J. Connell and A. Zorzi (Cambridge, 2000), 312–32 (324). See also idem, "Lorenzo and Pistoia: Peacemaker or Partisan?" in *Lorenzo the Magnificent: Culture and Politics,* ed. M. Mallett and N. Mann (London, 1996), 235–52; and W. J. Connell, *La città dei crucci: Fazioni e clientele in uno stato repubblicano del '400* (Florence 2000), esp. 91–101, 144–47.

5. I am grateful to Stephen Milner for allowing me to read his unpublished paper "Unfinished Business: Verrocchio's Forteguerri Monument and the Politics of Patronage," in which he discusses the complicated political context of the commission in the light of newly discovered documents.

6. E. H. Gombrich, "Renaissance and Golden Age," *JWCI* 24 (1961): 306–9 (308), describing Cosimo de' Medici.

7. F. W. Kent, "Patron-Client Networks in Renaissance Florence and the Emergence of Lorenzo as 'Maestro della Bottega,'" in *Lorenzo de' Medici: New Perspectives,* ed. B. Toscani (New York, 1993), 279–313 (281). For a notable case in 1472 of Lorenzo as arbiter between members of the Spinelli family over a disputed will, see P. Jacks and W. Caferro, *The Spinelli of Florence* (University Park, Pa., 2001), 258–59, 350.

8. Niccolò Machiavelli, *Istorie fiorentine,* ed. F. Gaeta (Milan, 1962), 576.

9. For these and other contemporary descriptions, see F. W. Kent, "'Lorenzo . . . , amico degli uomini da bene': Lorenzo de' Medici and Oligarchy," in *Lorenzo il Magnifico e il suo mondo,* ed. G. C. Garfagnini (Florence, 1994), 43–60.

10. Benedetto Coluccio, quoted in P. Foster, *A Study of Lorenzo de' Medici's Villa at Poggio a Caiano,* 2 vols. (New York, 1978), 1:526.

11. Cristoforo Landino, quoted in E. B. Fryde, *Humanism and Renaissance Historiography* (London, 1983), 132 n. 78.

12. Filippo Redditi, *Exhortatio ad Petrum Medicem,* ed. P. Viti (Florence, 1989), 11.

13. Harvard School of Business Administration, Baker Library, Selfridge Collection, no. 226, Lorenzo to Piero Alamanni, 12.vi.1491: "sappiate questi Redditi sono amici di casa mia gran tempo è." See also Viti's edition of Redditi's *Exhortatio,* vii–lvi, 89–131.

14. Christine de Pisan, *Le Livre des fais et bonnes meurs du sage Roy Charles V,* ed. S. Solente, 2 vols. (Paris, 1936–40), 2:37. On the myth of Lorenzo, see most recently M. M. Bullard, *Lorenzo il Magnifico: Image and Anxiety, Politics and Finance* (Florence, 1994), esp. pt. 1.

15. J. K. Galbraith, *Ambassador's Journal: A Personal Account of the Kennedy Years* (New York, 1970), 535–36.

16. Francesco Guicciardini, *Storie fiorentine dal 1378 al 1509,* ed. R. Palmarocchi (1931; reprint, Bari, 1968), 81.

17. See M. Wackernagel, *The World of the Florentine Renaissance Artist* (1938), trans. A. Luchs (Princeton, N.J., 1981), chap. 7; A. Chastel, *Art et humanisme à Florence au temps de Laurent le Magnifique* (Paris, 1961), esp. the introduction; and E. H. Gombrich, "The Early Medici as Patrons of Art," in *Italian Renaissance Studies,* ed. E. F. Jacob (London, 1960), 279–311. See more recently Bullard, *Lorenzo il Magnifico,* esp. 30–31, and J. Kirshner's review in *Speculum* 71 (1996): 138–40; E. Welch, "The Year of Lorenzo," *Art History* 17 (1994): 658–63; and C. Hope, "In Lorenzo's Garden," *New York Review of Books,*

24 June 1999, 65–68. For recent scholarship more willing to grant Lorenzo's interest in contemporary art and his active role as its patron, see below, n. 47.

18. T. Tuohy, *Herculean Ferrara: Ercole d'Este, 1471–1505, and the Invention of a Ducal Capital* (Cambridge, 1996), 20–21.

19. D. Abulafia, *Frederick II: A Medieval Emperor* (Oxford, 1988), esp. chap. 8.

20. This point was well made by E. Borsook, "A Florentine Scrittoio for Diomede Carafa," in *Art, the Ape of Nature: Studies in Honor of H. W. Janson*, ed. M. Barasch, L. Freeman Sandler, and P. Egan (Englewood Cliffs, N.J., 1981), 91–96. In discussing his brother Lorenzo's Neapolitan chapel, Filippo Strozzi affirmed that "di simi[le] chosa sai hognnuno à chontentare il gusto suo" (Filippo Strozzi to Lorenzo Strozzi, 12.xii.1478, published in E. Borsook, "Documenti relativi alle cappelle di Lecceto e delle Selve di Filippo Strozzi," *Antichità Viva* 9 [1970]: 3–20, quotation on 15); see also A. Lillie, "Florentine Villas in the Fifteenth Century: A Study of the Strozzi and Sassetti Country Properties," 2 vols. (Ph.D. thesis, University of London, 1986), 1:292–93, for other Strozzi uses of *gusto*. The Strozzi were also quite as interested as the Medici in importing Eastern ceramic ware (M. Spallanzani, *Ceramiche orientali a Firenze nel Rinascimento* [Florence, 1978], esp. chap. 1).

21. See ASF, Compagnie religiose soppresse da Pietro Leopoldo, 1287, book 1 (unfoliated), begun 1.iii.1494 (there is a *volgare* version of this document in book 2, fols. 191r–192r). For this proposal, see C. Acidini Luchinat, "Gli artisti di Lorenzo de' Medici," in *"Per bellezza, per studio, per piacere": Lorenzo il Magnifico e gli spazi dell'arte*, ed. F. Borsi (Florence, 1991), 190–91; and idem, "San Lorenzino in Piano," in *L'architettura di Lorenzo il Magnifico*, ed. G. Morolli, C. Acidini Luchinat, and L. Marchetti (Milan, 1992), 116–17.

22. G. O. Corazzini, *Ricordanze di Bartolomeo Masi, calderaio fiorentino, dal 1478 al 1526* (Florence, 1906), 17. See also *The New Cambridge Modern History*, vol. 1, *The Renaissance, 1493–1520*, ed. D. Hay (1957; reprint, Cambridge, 1975).

23. Francesco Guicciardini, "Elogio di Lorenzo de' Medici," in *Scritti politici e ricordi*, ed. R. Palmarocchi (Bari, 1933), 227. Maffei is paraphrased in Fryde, *Humanism and Renaissance Historiography*, 131. See also Bartolomeo Cerretani's statement that Lorenzo "amava e valenti et gl'unichi in ogni artte" (Bartolomeo Cerretani, *Storia fiorentina*, ed. G. Berti [Florence, 1994], 186).

24. F. W. Kent, "Lorenzo de' Medici, Madonna Scolastica Rondinelli e la politica di mecenatismo architettonico nel convento delle Murate a Firenze (1471–72)," in *Arte, committenza ed economia a Roma e nelle corti del Rinascimento (1420–1530)*, ed. A. Esch and C. L. Frommel (Turin, 1995), 353–82, and below, chap. 3.

25. F. W. Kent, "Lorenzo de' Medici at the Duomo," in *La cattedrale e la città: Saggi sul Duomo di Firenze, atti del VII centenario del Duomo di Firenze*, ed. T. Verdon and A. Innocenti, 3 vols. (Florence, 2001), 1:341–68.

26. P. Foster, "Lorenzo de' Medici and the Florence Cathedral Façade," *AB* 63 (1981): 495–500; L. W. Waldman, "Florence Cathedral: The Façade Competition of 1476," *Source* 16 (1996): 1–6.

27. P. Barolsky and W. E. Wallace, "The Myth of Michelangelo and Il Magnifico," *Source* 12 (1993): 16–21, quotation on 18; Ascanio Condivi, *Vita di Michelangelo Buonar-*

roti, ed. G. Nencioni with essays by M. Hirst and C. Elam (Florence, 1998), 11. See also P. Barolsky, *Michelangelo's Nose: A Myth and Its Maker* (University Park, Pa., 1990). Charles Hope, "In Lorenzo's Garden," concedes that the story of the library "seems to be true," while remaining a school-of-sculpture skeptic.

28. Vespasiano da Bisticci to Lorenzo, 26.xi.1472, published in G. M. Cagni, *Vespasiano da Bisticci e il suo epistolario* (Rome, 1969), 159. The bookseller refers to "quel sito di quella libreria ch'io ho ragionata altra volta colla Magnificentia Vostra," without specifying where it might be built.

29. K. Weil-Garris and J. F. D'Amico, *The Renaissance Cardinal's Ideal Palace: A Chapter from Cortesi's De cardinalatu* (Rome, 1980), 105 n. 40. At least some of these references to a library might possibly refer to the "bellissima libreria" full of rare and priceless books Guicciardini says Lorenzo created at his new church of San Gallo, begun in 1488 ("Elogio," 227). See also Fryde, *Humanism and Renaissance Historiography,* 138–39; and N. Rubinstein, "Lay Patronage and Observant Reform in Fifteenth-Century Florence," in *Christianity and the Renaissance,* ed. T. Verdon and J. Henderson (Syracuse, N.Y., 1990), 63–82 (73–74).

30. Foster publishes two letters of 1490 from Giovanni Cambi in Pisa to Lorenzo mentioning that "[g]l'altri marmi per la libreria non sono per anchor venuti" and, later, that "[l]i marmi furon presi, che per la vostra libreria veniroro" (*Study,* 1:525 n. 710). At a seminar at Johns Hopkins University in October 1999, Elena Calvillo made the point that *marmi* might mean sculpted pieces (see, e.g., Marino Sanuto, *I diarii di Marino Sanuto* [Venice, 1892], 35, 387).

31. Giovanni Lascaris, dedicatory letter to Piero de' Medici, quoted in E. Piccolomini, "Delle condizioni e delle vicende della libreria medicea privata dal 1494 al 1508," *ASI,* 3d ser., 19 (1874): 101–29, quotation on 105: "iam semistructa."

32. O. Merisalo, ed., *Le collezioni medicee nel 1495: Deliberazioni degli ufficiali dei ribelli* (Florence, 1999), 9, document dated 22.i.1495. See also V. Branca, "Poliziano e la libreria medicea di San Marco," in *Miscellanea A. Campano,* in *Medioevo e Umanesimo* 44 (1981): 167–87.

33. The document is quoted in M. Hirst, "Michelangelo in Florence: 'David' in 1503 and 'Hercules' in 1506," *BM* 142 (2000): 487–92. Hirst explicitly links this passage with Condivi's allusion. More generally, see Hirst's "Michelangelo and His First Biographers," *Proceedings of the British Academy* 94 (1996): 63–84, and his introduction to Condivi's *Vita.* It is perhaps not beside the point that the cathedral's works committee sold Giuliano da Sangallo thirteen hundred pounds of white marble in August 1489 (Archivio dell'Opera del Duomo, Florence, II, 21, 7, fol. 101). See now the further evidence concerning marble stockpiled, as it were, in the Palazzo Medici in F. Caglioti, *Donatello e i Medici: Storia del "David" e della "Giuditta,"* 2 vols. (Florence, 2000), 2:441–42, 448–49.

34. The document is cited in Foster, *Study,* 1:526 n. 710, and published in I. Ciseri, *L'ingresso trionfale di Leone X in Firenze nel 1515* (Florence, 1990), 136.

35. In reaction to works such as E. Barfucci's *Il giardino di San Marco* (Florence, 1940) and, more generally, his *Lorenzo de' Medici e la società artistica del suo tempo,* 2d ed. (Florence, 1964), A. Chastel, "Vasari et la légende médicéenne: L'école du jardin de Saint Marc,"

in *Studi Vasariani* (Florence, 1952), 159–67, established the skeptical tradition, which many scholars still accept. Bullard, *Lorenzo il Magnifico,* writes of "the apocryphal school for young artists" (4; cf. 8). For the contrary view, see, above all, C. Elam, "Lorenzo de' Medici's Sculpture Garden," *MKIF* 36 (1992): 41–84, which supersedes L. Borgo and A. H. Sievers, "The Medici Gardens at San Marco," ibid. 23 (1989), 237–56. See also J. D. Draper, *Bertoldo di Giovanni: Sculptor of the Medici Household* (Columbia, Mo., 1992), 62–75; P. L. Rubin, *Giorgio Vasari: Art and History* (New Haven, Conn., 1994), 202; and P. Joannides, "Michelangelo and the Medici Garden," in *La Toscana al tempo di Lorenzo il Magnifico: Politica, economia, cultura, arte,* ed. R. Fubini, 3 vols. (Pisa, 1996), 1:23–36. L. Fusco and G. Corti, *Lorenzo de' Medici, Collector and Antiquarian* (New York, 2004), chaps. 4, i, ii, and 5, i, ii, review the fragmentary evidence concerning where Lorenzo's ancient sculpture might have been displayed in the garden of the Palazzo Medici and in the garden near San Marco and the near impossibility of matching sculpture mentioned in the documents with surviving pieces; see also L. Beschi, "Le sculture antiche di Lorenzo il Magnifico," in Garfagnini, *Lorenzo il Magnifico,* 291–317. See also P. Barocchi, ed., *Il giardino di San Marco: Maestri e compagni del giovane Michelangelo* (Milan, 1992). J. H. Beck, *Three Worlds of Michelangelo* (New York, 1999), is an engaging but overimaginative recreation of the young Michelangelo's relationship with Lorenzo; see also M. G. Pernis, "The Young Michelangelo and Lorenzo de' Medici's Circle," in Toscani, *Lorenzo de' Medici,* 143–61.

36. J. Hankins, "The Myth of the Platonic Academy of Florence," *RQ* 44 (1991): 429–75; idem, "The Invention of the Platonic Academy of Florence," *Rinascimento,* 2d ser., 41 (2001): 3–38; J. K. Cadogan, "Michelangelo in the Workshop of Domenico Ghirlandaio," *BM* 135 (1993): 30–31.

37. L. Steinberg, "The Michelangelo Next Door," *ARTnews,* April 1996, 106.

38. K. Weil-Garris Brandt, "A Marble in Manhattan: The Case for Michelangelo," *BM* 138 (1996): 644–59; J. D. Draper, "Ango after Michelangelo," ibid. 139 (1997): 398–400; K. Weil-Garris Brandt, "More on Michelangelo and the Manhattan Marble," ibid., 400–404; M. Hirst, "The New York 'Michelangelo': A Different View," *Art Newspaper* 7, no. 61 (1996): 3; A. Landi, "Michelangelo," *ARTnews,* April 1996, 104–5; W. E. Wallace, "They Come and Go," ibid., 107–9; K. Weil-Garris Brandt, C. Acidini Luchinat, J. D. Draper, and N. Penny, eds., *Giovinezza di Michelangelo* (Florence, 1999), reviewed well by S. J. Campbell in *RS* 14 (2000): 362–66. However, D. Heikamp has recently argued that the Archer "belongs to the world of later Tuscan mannerism" ("The Youth of Michelangelo: The New York *Archer* Reconsidered," *Apollo* 151 [2000]: 27–36, quotation on 34), while J. Beck regards it as a modern fake ("Connoisseurship: A Lost or a Found Art? The Example of a Michelangelo Attribution: 'The Fifth Avenue Cupid,'" *Artibus et Historiae* 37 [1998]: 9–42).

39. P. Godman, *From Poliziano to Machiavelli: Florentine Humanism in the High Renaissance* (Princeton, 1998), 3.

40. Quoted in F. A. D'Accone, "Heinrich Isaac in Florence: New and Unpublished Documents," *Musical Quarterly* 49 (1963): 464–83 (473); F. W. Kent, "Heinrich Isaac's Music in Laurentian Florence" (forthcoming).

41. D. A. Brown, *Leonardo da Vinci: Origins of a Genius* (New Haven, Conn., 1998).

Notes to Page 8

42. Leonardo da Vinci, *Scritti*, ed. C. Vecce (Milan, 1992), 227. For past discussion of this much-cited fragment, and a novel interpretation, see C. Pedretti, "L'era nuova con Leonardo," in *1492: Un anno fra due ere: Saggi*, by J. Le Goff et al. (Florence, 1992), 227–67 (258–65), and idem, "li medici mi crearono e desstrussono," *Achademia Leonardi Vinci* 6 (1993): 173–84.

43. W. E. Wallace, "How Did Michelangelo Become a Sculptor?" in *The Genius of the Sculptor in Michelangelo's Work*, ed. D. L. Bissonnette (Montreal, 1992), 151–67 (152–53); idem, "Michael Angelvs Bonarotvs Patritivs Florentinvs," in *Innovation and Tradition: Essays on Renaissance Art and Culture*, ed. D. T. Anderson and R. Eriksen (Rome, 2000), 60–74. The wide genealogical distance between the parties can be traced in L. Passerini, *Genealogia e storia della famiglia Rucellai* (Florence, 1861), tables 4 and 16. P. Barolsky, "The Mysteries of Michelangelo: Michael Hirst and J. Dunkerton, *Making and Meaning: The Young Michelangelo*," *Source* 14 (1995): 37–40, agrees that "Michelangelo did indeed work in these gardens" (38), though he remains skeptical about the larger claims made by the sixteenth-century biographers. See also Hope, "In Lorenzo's Garden."

44. The reference of 1494 is published in G. Poggi, "Della prima partenza di Michelangiolo Buonarroti da Firenze," *Rivista d'Arte* 4 (1906): 33–37 (34). Caglioti, *Donatello e i Medici*, 1:262–65, has now produced evidence confirming earlier speculation by C. Elam and M. Hirst concerning the Medici provenance of this youthful work.

45. Sebastiano del Piombo to Michelangelo, 27.x.1520, in *Il Carteggio di Michelangelo*, ed. P. Barocchi and R. Ristori (Florence, 1967), 2:252–53, a passage Michael Hirst first brought to my attention years ago. For a very recent, and balanced, assessment of what we know about the young Michelangelo's relations with Lorenzo, see R. Hatfield, *The Wealth of Michelangelo* (Rome, 2002), 145–51, 230.

46. N. Douglas, *Siren Land* (1911; Harmondsworth, 1948), 239. Chastel, *Art et humanisme*, 14, denies that with Lorenzo we see "l'action d'un patronage cohérent." On the patron as connoisseur, see, however, A. Thomas, *The Painter's Practice in Renaissance Tuscany* (Cambridge, 1995), chap. 11; and D. Kent, *Cosimo de' Medici and the Florentine Renaissance: The Patron's Oeuvre* (New Haven, Conn., 2000).

47. V. Iliardi, "The Visconti-Sforza Regime of Milan: Recently Published Sources," *RQ* 31 (1978): 331–42, quotation on 342. A vital step in the reconsideration of the extent of Lorenzo's interest in architecture and urbanism was taken by C. Elam, "Lorenzo de' Medici and the Urban Development of Renaissance Florence," *Art History* 1 (1978): 43–66. See also R. Pacciani, "Modi della committenza d'architettura del Magnifico," in *Lorenzo il Magnifico*, ed. F. Cardini (Rome, 1992), 155–70. Patricia Rubin has recently made the detailed case for taking a more optimistic view of Lorenzo's interest in and patronage of the arts: Rubin and Wright, *Renaissance Florence*, chap. 2. After completing this manuscript, I read with admiration and in almost complete agreement Riccardo Pacciani's "Lorenzo il Magnifico: Promotore, fautore, 'architetto,'" in *Il principe architetto*, ed. A. Calzona, F. P. Fiore, A. Tenenti and C. Vasoli (Florence, 2002), 377–411, the best account so far of its subject. See F. Borsi, "Lorenzo il Magnifico e le arti figurative," *Nuova Antologia* 3 (1991): 395–403, for an earlier statement of this emerging (consensual is too strong a word [see n. 17, above]) position, as

well as the essays Borsi edited in *Per bellezza, per studio, per piacere,* some of which claim too much for Lorenzo, however, on too little evidence. For a smaller, companion volume in English, see C. Acidini Luchinat, ed., *Renaissance Florence: The Age of Lorenzo de' Medici, 1449–1492* (Milan, 1993). The brief analyses of M. Hollingsworth, "Lorenzo de' Medici: Politician, Patron, and Designer," *Apollo* 135 (1992): 376–79, and F. Ames-Lewis, "Lorenzo de' Medici Quincentenary," ibid. 136 (1992): 113–16, also began to depart from the then prevailing view.

CHAPTER TWO. THE AESTHETIC EDUCATION OF LORENZO

1. Lorenzo de' Medici, *Simposio,* ed. M. Martelli (Florence, 1966), 101.

2. Lorenzo de' Medici to Piero de' Medici, 23.ix.1464, in Lorenzo de' Medici, *Lettere,* vol. 1, *1460–1474,* ed. R. Fubini (Florence, 1977), 13.

3. V. Woolf, *A Passionate Apprentice: The Early Journals, 1897–1909,* ed. M. A. Leaska (London, 1990), 396.

4. Marco Rustichi, quoted in W. Cohn, "Un codice inedito con disegni di Marco di Bartolomeo Rustichi," *Rivista d'Arte* 32 (1957): 74.

5. R. Hatfield, "Some Unknown Descriptions of the Medici Palace in 1459," *AB* 52 (1970): 232–49 (233). See now D. Kent, *Cosimo de' Medici and the Florentine Renaissance: The Patron's Oeuvre* (New Haven, Conn., 2000), chap. 12.

6. Leon Battista Alberti, *On Painting and On Sculpture,* ed. and trans. C. Grayson (London, 1972), 32–33. For the historiography on "civic humanism" and the Florentine Renaissance, see most recently J. Hankins, ed., *Renaissance Civic Humanism: Reappraisals and Reflections* (Cambridge, 2000), esp. the introduction (1–13).

7. Giovanni Rucellai, *Giovanni Rucellai ed il suo Zibaldone,* vol. 1, *Il Zibaldone Quaresimale,* ed. A. Perosa (London, 1960), 61; see also 60–62, 120–22.

8. F. W. Kent, "'Un paradiso habitato da diavoli': Ties of Loyalty and Patronage in the Society of Medicean Florence," in *Le radici cristiane di Firenze,* ed. A. Benvenuti, F. Cardini, and E. Giannarelli (Florence, 1994), 183–210 (198). For Cosimo, see N. Rubinstein, *The Government of Florence under the Medici, 1434–94* (Oxford, 1966); A. Brown, *The Medici in Florence: The Exercise of Language and Power* (Florence, 1992); F. Ames-Lewis, ed., *Cosimo "il Vecchio" de' Medici, 1389–1464* (Oxford, 1992); and Kent, *Cosimo de' Medici.*

9. A Sienese observer, quoted in Rubinstein, *Government of Florence,* 164 n. 4.

10. Kent, *Cosimo de' Medici;* F. W. Kent, "'Be rather loved than feared': Class Relations in Quattrocento Florence," in *Society and Individual in Renaissance Florence,* ed. W. J. Connell (Berkeley and Los Angeles, 2002), 13–50.

11. Lorenzo de' Medici, quoted in F. W. Kent, "The Young Lorenzo, 1449–1469," in *Lorenzo the Magnificent: Culture and Politics,* ed. M. Mallett and N. Mann (London, 1996), 1–22 (9), from which essay the following pages draw. A. Rochon, *La Jeunesse de Laurent de Médici (1449–1478)* (Paris, 1963), remains indispensable.

12. Sigismondo della Stufa to Lorenzo, quoted in I. del Lungo, *Gli amori del Magnifico Lorenzo* (Bologna, 1923), 45.

13. ASF, MaP, XXIII, 27, Francesco d'Antonio to Lorenzo, 6.v.1465: "O magnifico Lorenzo, spechio degli altri giovani."

14. Gentile Becchi to Lorenzo, 26.ix.1466, published in M. Martelli, "Il 'Giacoppo' di Lorenzo," *Interpres* 7 (1987): 103–24, quotation on 104 n. 4.

15. Kent, "Young Lorenzo," 7–10; R. Fubini, "Ficino e i Medici all'avvento di Lorenzo il Magnifico," *Rinascimento*, 2d ser., 24 (1984): 3–51, esp. 20.

16. Piero de' Medici to Filippo Strozzi, 20.vii.1465, in Alessandra Macinghi negli Strozzi, *Lettere di una gentildonna fiorentina del secolo XV ai figliuoli esuli,* ed. C. Guasti (Florence, 1877), 456. See also N. Rubinstein, "Lorenzo de' Medici: The Formation of His Statecraft," in *Lorenzo de' Medici: Studi,* ed. G. C. Garfagnini (Florence, 1992), 41–66.

17. Piero de' Medici to Lorenzo, 4.v.1465, in Lorenzo de' Medici, *Lettere,* 1:14.

18. Milanese ambassador to the duke of Milan, 16.v.1469, in ibid., 41.

19. The quotation is from Rubinstein, "Lorenzo de' Medici: The Formation of His Statecraft," 44 n. 5. On Lorenzo's role in the crisis, see M. A. Morelli Timpanaro, R. Manno Tolu, and P. Viti, eds., *Consorterie politiche e mutamenti istituzionali in età laurenziana* (Milan, 1992), 28.

20. Lorenzo de' Medici, *Lettere,* 1:3–6. For his confraternal life, see Kent, "Young Lorenzo," 15–17.

21. Kent, "Young Lorenzo," 21–22; F. W. Kent, "Patron-Client Networks in Renaissance Florence and the Emergence of Lorenzo as 'Maestro della Bottega,'" in *Lorenzo de' Medici: New Perspectives,* ed. B. Toscani (New York, 1993), 279–313.

22. On Lorenzo's collecting, see Niccolò Valori, *Vita di Lorenzo de' Medici,* ed. E. Niccolini (Vicenza, 1991), 104, and below, chap. 2. Squarcialupi's letter is quoted in F. A. D'Accone, "Lorenzo the Magnificent and Music," in *Lorenzo il Magnifico e il suo mondo,* ed. G. C. Garfagnini (Florence, 1994), 259–90 (270–71). A letter from Antonio Masi to Lorenzo dated 5.xi.1466 concerns "dua Giosopi molto belli" that one "ser Chiricho" had been too slow in copying (ASF, MaP, XXI, 45). Several years later Lorenzo commissioned "uno ptolomeo di minii" (L. Morozzi, *Le carte archivistiche della Fondazione Herbert H. Horne* [Milan, 1988], 55–56).

23. J. Hook, *Lorenzo de' Medici* (London, 1984), 120. And see now the powerful contrary case mounted by Dale Kent for the patronage of Lorenzo's grandfather in *Cosimo de' Medici.*

24. M. M. Bullard, *Lorenzo il Magnifico: Image and Anxiety, Politics and Finance* (Florence, 1994), 69, 72, 97–98.

25. E. H. Gombrich, "The Early Medici as Patrons of Art," in *Italian Renaissance Studies,* ed. E. F. Jacob (London, 1960), 279–311, esp. 310–11. For *intendente,* see M. Hollingsworth, "The Architect in Fifteenth-Century Florence," *Art History* 7 (1984): 385–410 (391–92).

26. Benozzo Gozzoli to Lorenzo, 4.vii.1467, published in D. Cole Ahl, *Benozzo Gozzoli* (New Haven, Conn., 1996), 279.

27. Fra Filippo Lippi to Lorenzo, 1.ix.1468, published in J. Ruda, *Fra Filippo Lippi: Life and Work* (London, 1993), 41, 545. The request by the queen of Naples that he allow two marble tombs manufactured in Florence for a Neapolitan client to leave the city duty-free, dated 16.ix.1489, addresses Lorenzo as a political boss rather than as a connoisseur (G. Milanesi, ed., *Nuovi documenti per la storia dell'arte toscana dal xii al xv secolo* [Florence, 1901], 155). And then there is the letter of 21 September (no year given) writ-

ten to Lorenzo by the client himself, the count of Terra Nova, in ASF, Carte Strozziane, I, 3, fol. 140r, mentioning the "due tavule de cone de' marmi, cum due sepulture, che fo fare in quessa città de Florenza per la ecclesia de Santa Maria Monte Oliveto de Napoli."

28. See esp. G. Ianziti, "Patronage and the Production of History: The Case of Quattrocento Milan," in *Patronage, Art, and Society in Renaissance Italy*, ed. F. W. Kent and P. Simons (Oxford, 1987), 299–311, esp. 299–300; and Kent, *Cosimo de' Medici*, 8.

29. J. Paoletti, " . . . 'ha fatto Piero con volontà del padre . . . ': "Piero de' Medici and Corporate Commissions of Art," in *Piero de' Medici "il Gottoso" (1416–1469)*, ed. A. Beyer and B. Boucher (Berlin, 1993), 221–50; S. McKillop, "Dante and *Lumen Christi*: A Proposal for the Meaning of the Tomb of Cosimo de' Medici," in Ames-Lewis, *Cosimo "il Vecchio" de' Medici*, 245–301.

30. Kent, *Cosimo de' Medici*, 175–77; M. Ferrara and F. Quinterio, *Michelozzo di Bartolomeo* (Florence, 1984). Niccolò Michelozzi's career and his relationship with Lorenzo deserve a systematic monograph; meanwhile, see N. Isenberg, "Censimento delle lettere di Niccolò Michelozzi," *Giornale Italiano di Filologia*, n.s., 13 (1982): 271–91; and idem, "Una corrispondenza inedita di Niccolò Michelozzi: L'assedio di Città di Castello raccontato dal segretario laurenziano," *Esperienze Letterarie* 10 (1985): 139–61.

31. Aurelio Bienato, *Oratio in funere Laurentii de Medicis Neapoli habitu* (Milan, 1492). See also P. Pirolo, ed., *Lorenzo dopo Lorenzo: La fortuna storica di Lorenzo il Magnifico* (Milan, 1992), 55–56.

32. Gombrich, "Early Medici as Patrons of Art," 304. See also Kent, *Cosimo de' Medici*, 287–91. Dale Kent's book now provides the most exhaustive analysis of the Medicean context in which Lorenzo grew up.

33. C. Elam, "Art and Diplomacy in Renaissance Florence," *RSA Journal* 136 (1988): 813–26. For examples of the Signoria's writing on behalf of artists, see Milanesi, *Nuovi documenti*, 93–94, 143–44.

34. For examples of Piero as arbiter, see A. Chiappelli, "Un nuovo documento sul Pesellino," *Rivista d'Arte* 6 (1909): 314–19 (316); Milanesi, *Nuovi documenti*, 111; and E. Borsook, "Two Letters concerning Antonio Pollaiuolo," *BM* 115 (1973): 464–68.

35. P. L. Rubin and A. Wright, *Renaissance Florence: The Art of the 1470s* (London, 1999), 131–33. See, generally, L. Gnocchi, "Le preferenze artistiche di Piero di Cosimo de' Medici," *Artibus et Historiae* 18 (1988): 41–78; F. Ames-Lewis, "Art in the Service of the Family: The Taste and Patronage of Piero di Cosimo de' Medici," in Beyer and Boucher, *Piero de' Medici*, 207–20; and E. B. Fryde, "The Library of Lorenzo de' Medici," in *Humanism and Renaissance Historiography* (London, 1983), 159–225.

36. P. Nuttall, "The Medici and Netherlandish Painting," in *The Early Medici and Their Artists*, ed. F. Ames-Lewis (London, 1995), 135–52; Kent, *Cosimo de' Medici*, 262–64; D. Wolfthal, *The Beginnings of Netherlandish Canvas Painting: 1400–1530* (Cambridge, 1989), 17–19.

37. J. D. Draper, *Bertoldo di Giovanni: Sculptor of the Medici Household* (Columbia, Mo., 1992).

38. A. Butterfield, *The Sculptures of Andrea del Verrocchio* (New Haven, Conn., 1997), 2.

39. Nicola Severino wrote to Cristoforo Felici in June 1458 that Andrea d'Aquila

was Donatello's disciple "et allevossi molti anni in Fiorenza in casa di Cosmo" (published in G. L. Hersey, *The Aragonese Arch at Naples, 1443–1475* [New Haven, Conn., 1973], 69; see also 60).

40. Giovanni da Camerino, on whose letter to Cosimo see Kent, *Cosimo de' Medici*, 342, received a letter dated 17 March (no year given) from a merchant in his hometown addressed to "Zuvanni dipintore da Cam[erino] in Fiorença in casa di Cosimo" (ASF, MaP, IX, 565). See, above all, F. Zeri, *Due dipinti, la filologia e un nome: Il maestro delle Tavole Barberini* (Turin, 1961), 92–97, which discusses the painter's relations with Giovanni di Cosimo.

41. Kent, *Cosimo de' Medici*, 333–37. See also below, chap. 5.

42. Giovanni's advice of 25.vi.1456 is in R. Magnani, *Delle relazioni private tra la corte Sforzesca di Milano e casa Medici, 1450–1500* (Milan, 1910), vii. His later judgment is published in F. Caglioti, "Bernardo Rossellino a Roma: I Stralci del carteggio mediceo (con qualche briciola sul Filarete)," *Prospettiva* 64 (1991): 49–59 (50). On Giovanni's villa at Fiesole, see A. Lillie, "Giovanni di Cosimo and the Villa Medici at Fiesole," in Beyer and Boucher, *Piero de' Medici*, 189–205; and idem, "The Humanist Villa Revisited," in *Language and Images of Renaissance Italy*, ed. A. Brown (Oxford, 1995), 193–215; more generally, see J. Paoletti, "The Banco Mediceo in Milan: Urban Politics and Family Power," *Journal of Medieval and Renaissance Studies* 24 (1994): 199–238; and V. Rossi, *L'indole e gli studi di Giovanni di Cosimo de' Medici* (Rome, 1893). Francesco Sassetti refers to "l'apetito tuo" in his letter of 16.v.1450 from Geneva to Giovanni describing a richly decorated bed canopy and backing sent for the latter's approval (ASF, Carte Strozziane, I, 3, fol. 60r; see also ibid., fol. 57r, Sassetti to Giovanni, 29.i.1460).

43. A. Lillie, "Lorenzo de' Medici's Rural Investments and Territorial Expansion," *Rinascimento*, 2d ser., 33 (1993): 53–67 (61–62). See also F. W. Kent, "Sainted Mother, Magnificent Son: Lucrezia Tornabuoni and Lorenzo de' Medici," *Italian History and Culture* 3 (1997): 3–34.

44. On this much-discussed work, see most recently J. M. Musacchio, "The Medici-Tornabuoni *Desco da Parto* in Context," *Metropolitan Museum Journal* 33 (1998): 137–51; and L. Bellosi and M. Haines, *Lo Scheggia* (Florence, 1999), 10–11, 54, 89.

45. For this deathbed scene, see C. Acidini Luchinat, *Tesori dalle Collezioni Medicee* (Florence, 1997), 11. This crucifix does not appear to be among the precious objects listed in M. Spallanzani and G. Gaeta Bertelà, eds., *Libro d'inventario dei beni di Lorenzo il Magnifico* (Florence, 1992). For the translation of Poliziano's letter, dated 18.v.1492, see John Burchard, *The Diary of John Burchard of Strasborg*, trans. A. H. Mathew (London, 1910), 416.

46. Cole Ahl, *Benozzo Gozzoli*, chap. 3; Kent, *Cosimo de' Medici*, 339–41 and chap. 13.

47. See the examples assembled in F. W. Kent, "Lorenzo di Credi, His patron Iacopo Borgianni, and Savonarola," *BM* 125 (1983): 539–41.

48. Bellosi and Haines, *Lo Scheggia*, 54; for this painter and Francione, see 57, 62.

49. E. Cropper, ed., *Florentine Drawing at the Time of Lorenzo the Magnificent* (Bologna, 1994), ix; Rubin and Wright, *Renaissance Florence*, are eloquent about this rich workshop tradition and about Verrocchio's influence within it when Lorenzo was growing up (76–120).

50. A. Wright, "Antonio Pollaiuolo, 'Maestro di Disegno,'" in Cropper, *Florentine Drawing*, 131–46; see now L. Syson and D. Thornton, *Objects of Virtue* (Los Angeles, 2001), esp. chap. 4. On Verrocchio's workshop and its influence, see Rubin and Wright, *Renaissance Florence*, 150–89; see also P. Adorno, *Il Verrocchio* (Florence, 1991); and Butterfield, *Sculptures of Andrea del Verrocchio*.

51. Wright, "Antonio Pollaiuolo," 131–46; Rucellai, *Giovanni Rucellai*, 1:24.

52. Lorenzo de' Medici, *Comento de' miei sonetti*, ed. T. Zanato (Florence, 1991), 175. For this observation, see Rubin and Wright, *Renaissance Florence*, 188–89.

53. Leonardo's drawing is discussed and illustrated in Rubin and Wright, *Renaissance Florence*, 188–89. For the Oxford drawing, see J. Byam Shaw, *Drawings by Old Masters at Christ Church Oxford*, 2 vols. (Oxford, 1976), 1:36, 2:plate 8.

54. N. Z. Davis, *The Return of Martin Guerre* (Cambridge, Mass., 1983), 38.

55. C. Franzoni, "'Rimembranze d'infinite cose': Le collezioni rinascimentali di antichità," in *Memoria dell'antico nell'arte italiana*, ed. S. Settis (Turin, 1984), 1:299–360 (307–9).

56. ASF, MaP, XVI, 273, Francesco Fracassini to Piero de' Medici, 26.viii.1468: "Lorenzo à voglia di spianare la piaza qui dinanzi a Chafaggiolo; farassi quello dirà e voi n'arete aviso." The factor had just above written, "Attendo allo spaccio di quesste muraglie," adding that "e tabernacholi si faranno sichondo l'ordine vostro." The poet Naldo Naldi praised Piero's villa garden at this precise time (M. Martelli, "Le elegie di Naldo Naldi," in *Tradizione classica e letteratura umanistica: Per Alessandro Perosa*, ed. R. Cardini et al. [Rome, 1985], 1:307–32 [331–32]), when Cafaggiolo is described as being "chon piaza grande dinanzi" (quoted in P. Nanni, *Lorenzo agricoltore* [Florence, 1992], 30).

57. Bartolomeo Scala to Lorenzo, 31.xii.1463, in Bartolomeo Scala, *Humanistic and Political Writings*, ed. A. Brown (Tempe, Ariz., 1997), 10. Lorenzo either continued to hold this office or took it up again toward the end of his life, since his son Piero replaced him as chair in April 1492 (A. Brown, *The Medici in Florence: The Exercise of Language and Power* [Florence, 1992], 122 n. 70). I failed to find archival records concerning this works committee's activities. Kent, *Cosimo de' Medici*, esp. 29–30, discusses the Florentine *opere* and earlier Medici participation in them. More generally, see M. Haines and L. Riccetti, eds., *Opera* (Florence, 1996).

58. The document is quoted in A. Butterfield, "Verrocchio's *Christ and St. Thomas*: Chronology, Iconography, and Political Context," *BM* 134 (1992): 225–33 (233).

59. Ibid., 229; Butterfield, *Sculptures of Andrea del Verrocchio*, chap. 3.

60. Luca Landucci, *Diario fiorentino dal 1450 al 1516*, ed. I. Del Badia (1883; reprint, Florence, 1969), 45.

61. Paoletti, " . . . 'ha fatto Piero'"; Kent, *Cosimo de' Medici*, 197–200.

62. The document, dated 19.i.1468, is published in C. Guasti, *La cupola di Santa Maria del Fiore* (Florence, 1857), 112.

63. D. A. Covi, "Verrocchio and the Palla of the Duomo," in *Art, the Ape of Nature: Studies in Honor of H. W. Janson*, ed. M. Barasch, L. Freeman Sandler, and P. Egan (Englewood Cliffs, N.J., 1981), 151–69.

64. ASF, Tratte, 915, fol. 19r–v (for his tenure in 1476–83, see fol. 166r). See also

B. L. Brown, "The Patronage and Building History of the Tribuna of SS. Annunziata in Florence," *MKIF* 25 (1981): 59–146; and Kent, *Cosimo de' Medici*, 202–10.

65. Lorenzo had stood in for his father in the office as early as 1465 (A. Brown, "The Guelf Party in Fifteenth-Century Florence," *Rinascimento*, 2d ser., 20 [1980]: 41–86 [67 n. 2]; ASF, Capitani di Parte Guelfa, numeri rossi, 9, fol. 79r). For Lorenzo and the Canal Officials, see below, this chapter.

66. F. W. Kent, "Lorenzo de' Medici and the Duomo," in *La cattedrale e la città: Saggi sul Duomo di Firenze, atti del VII centenario del Duomo di Firenze*, ed. T. Verdon and A. Innocenti, 3 vols. (Florence 2001), 1:341–68. On Lorenzo's membership in the *opera* of the Palazzo Vecchio, see M. Hegarty, "Laurentian Patronage in the Palazzo Vecchio: The Frescoes of the Sala dei Gigli," *AB* 78 (1996): 264–85; and on San Salvatore and Santo Spirito, see below, this chapter and chap. 4. For La Verna, see ASF, Arte della Lana, 234, fol. 31v, an act of 9.iv.1492 replacing Lorenzo by his son Piero; see also P. Saturnino Mencherini, ed., *Codice Diplomatico della Verna e delle SS. Stimate di S. Francesco d'Assisi* (Florence, 1924), which does not, however, mention Lorenzo in this role, nor when he first assumed the office. Recorded as an *operaio* of San Paolo in 1474, he held the office, apparently more or less continually, until his death (Lorenzo de' Medici, *Laude*, ed. B. Toscani [Florence, 1990], 108–111).

67. Lorenzo to Piero Alamanni, 8.viii.1489, published in L. Fusco and G. Corti, "Lorenzo de' Medici on the Sforza Monument," *Achademia Leonardi Vinci* 5 (1992): 11–32 (17), where the whole context is discussed.

68. Giorgio Vasari, quoted in Draper, *Bertoldo di Giovanni*, 65.

69. ASF, Tratte, 903, fol. 160v; 915, fol. 140r. Lorenzo's older colleagues included Medici stalwarts with whom he was to work all of his life, such as Bernardo del Nero and Antonio di Bernardo Miniati.

70. Giovanni Cambi, *Istorie*, vol. 20 of *Delizie degli eruditi toscani*, ed. I. di San Luigi (Florence, 1785), 363; Bayerische Staatsbibliothek, Munich, Benedetto Dei, "Memorie Storiche," fol. 126r; Marco Parenti, *Lettere*, ed. M. Marrese (Florence, 1996), 108, 113, 227, 229.

71. Luca Fancelli, *Luca Fancelli—architetto: Epistolario Gonzaghesco*, ed. C. Vasic Vatovec (Florence, 1979), 60–62.

72. ASF, Balìe, 32, fol. 1r, August 1458: "di quanta utilità, magnificentia et gloria"; see also ibid., 29, fols. 17v–18v, 26.viii.1458. For the context, see M. E. Mallett, *The Florentine Galleys in the Fifteenth Century* (Oxford, 1967), 16–17; and idem, "Pisa and Florence in the Fifteenth Century: Aspects of the Period of the First Florentine Domination," in *Florentine Studies*, ed. N. Rubinstein (London, 1968), 403–41. R. D. Masters, *Fortune Is a River* (New York, 1998), sheds no light on these early attempts to engineer the Arno's course.

73. ASF, Balìe, 32, fol. 16r–v, April 1466: "non possa fare alcuna cosa più degna nè che maggiore utilità, reputatione ed honore sia." See also P. C. Clarke, *The Soderini and the Medici* (Oxford, 1991), 106; and G. Pampaloni, "Nuovi tentativi di riformi alla costituzione fiorentina visti attraverso le consulte," *ASI* 120 (1962): 521–81 (526–32). ASF, Balìe, 32, fol. 11r, mentions the age qualification.

74. ASF, Balìe, 32, fol. 2r.

75. Ibid., fols. 17r–18v, January 1467. For the officials' jurisdiction over navigation, see ASF, Provv., Reg., 166, fols. 121r–122r, 8.viii.1475, and fols. 200v–201v, 25.i.1476.

76. ASF, Provv., Reg., 166, records legislation concerning their varied activities. For more information, see ASF, Notarile Antecos., 5029, fols. 94v–95r, 11.viii.1474, and fols. 135v–136r, August 1480; ASF, Provv., Reg., 162, fols. 84r–85r, 26.vi.1471, and 163, fols. 185v-186r, 9.ii.1473; and G. Gaye, *Carteggio inedito d'artisti dei secoli xiv, xv, xvi,* 3 vols. (Florence, 1839), 1:564, 567, 568. This magistracy deserves a detailed study to clarify its role. Its jurisdiction over canals and fortifications seems to have been shared from time to time with other bodies, such as the Sea Consuls at Pisa and the Five Fortress Officials; about 1477 the Canal Officials and the Ten Officials of the Arno seem briefly to have merged. See ASF, Balìe, 32, fols. 39v–40r, 7.vi.1477; ASF, Consiglio del Cento, Registri, 2, fol. 11r–v; and M. E. Mallett, "The Sea Consuls of Florence in the Fifteenth Century," *Papers of the British School at Rome* 27 (1959): 156–68 (161). The relevant materials for such a study include ASF, Ufficiali delle Castella, 27. See also F. W. Kent, "A Letter of 1476 from Antonio di Tuccio Manetti mentioning Brunelleschi," *BM* 121 (1979): 648–49; and D. Lamberini, "Giuliano da Maiano e l'architettura militare," in *Giuliano e la bottega dei da Maiano,* ed. D. Lamberini, M. Lotti, and R. Lunardi (Florence, 1994), 11–27.

77. ASF, Provv., Reg., 169, fols 14r–15r, 2.v.1478: "la cura generalmente di tutte le forteze."

78. ASF, Balìe, 32, fol. 11v, 7–8.viii.1465. New officials were to be appointed to replace those recently knighted "siché non sarebbe conveniente che andassino di qua e di là sollicitando tale opera come già ànno fatto" See also ibid., fol. 15r.

79. "[Lorenzo] andò a vedere Serzanello, che gli parve considerato dalla Rocca tucto buono acquisto," according to Gentile Becchi's testimony of 18.vii.1469 to Clarice, Lorenzo's wife, in A. Fabroni, *Laurentii Medicis Magnifici Vita,* 2 vols. (Pisa, 1784), 2:56. Several early letters to Lorenzo concerning rural fortifications suggest that he was active in this office: ASF, MaP, XXIII, 16, Felice Attavanti to Lorenzo, 19.ii.1466; ibid., XXI, 81, Council of Firenzuola to Lorenzo, 30.viii.1468.

80. Bayerische Staatsbibliothek, Munich, Benedetto Dei, "Memorie Storiche," fol. 116r: "la gran torre del Porto Pisano degno."

81. Gaye, *Carteggio,* 1:243–44: "viene costà Mo Zanobi, come quello che è buono maestro di murare, ma à pocha fantasia e meno disegnio."

82. ASF, Balìe, 32, fol. 31r: "tale opera si commetta a huomini pratichi di muraglia, e che n'abbino fatto pruova." The officials had "interamente la cura del detto cassero overo cittadella di Volterra e sue apartenenze e muraglie di quelle e similmente la cura del racconciare le mura di Volterra."

83. Officials from Castronovo wrote on 26.i.1473 to Lorenzo of his intention "a vedere queste nostre castella" (ASF, MaP, XXIV, 75). On Lorenzo's visit to Volterra, see Lorenzo de' Medici, *Lettere,* 1:379 n. 3; and E. Insabato and S. Pieri, "Il controllo del territorio nello stato fiorentino del XV secolo: Un caso emblematico: Volterra," in Morelli Timpanaro, Manno Tolu, and Viti, *Consorterie politiche e mutamenti istituzionali in età Laurenziana,* 177–211 (210–11).

84. ASF, Balìe, 32, fol. 36v, August 1475: "riescie una degna cosa e luogho quasi

inexpugnabile." Lorenzo was elected to the office on 26.iii.1474 and renewed for two further years (ASF, Tratte, 904, fol. 71v). He is recorded as absent from a meeting held in Bernardo del Nero's house on 11.viii.1474 (ASF, Notarile Antecos., 5029, fols. 94v–95r).

85. ASF, MaP, XXXIX, 497, Guglielmo Altoviti to Lorenzo, 13.iii.1487: "Vostra Magnificenza mi disse avanti partissi di chostì avesti charo intendere questi fossi a che termine sono." Provincial officials commonly reported to Lorenzo concerning fortifications and troop movements (P. Salvadori, *Dominio e patronato: Lorenzo de' Medici e la Toscana nel Quattrocento* [Rome, 2000], 126–30).

86. ASF, Consiglio del Cento, Registri, 3, fol. 62r, 21.i.1491: "che et l'honore et la sicurtà publicha ne segua." Other legislation reveals the authority exerted by the Opera del Palagio: ASF, Provv., Reg., 180, fols. 2v–3r, 8.iv.1489; ibid., 181, fol. 48r–v, 1.ix.1490.

87. ASF, MaP., XXXXV, 124, King Ferdinand to Lorenzo, 13.i.1488; see also Gaye, *Carteggio*, 1:284.

88. M. Woodhouse and R. Ross, *The Medici Gun* (London, 1975).

89. J. Hale, *Renaissance Fortification: Art or Engineering?* (London, 1977); D. Lamberini, "Architetti e architettura militare per il Magnifico," in Garfagnini, *Lorenzo il Magnifico,* 407–25. See also L. Masi, "Nuove risultanze della ricerca d'archivio per la storia dell'architettura militare fiorentina nel Quattrocento: Brolio, Colle Val D'Elsa, Firenzuola e Poggio Imperiale," *Architettura: Storia e Documenti* 112 (1987): 97–111. Filippo Redditi, for one, recognised Lorenzo's military-architectual expertise (Filippo Redditi, *Exhortatio ad Petrum Medicem*, ed. P. Viti [Florence, 1989], 11, 46).

90. Bernardo Rucellai to Lorenzo, 6.iii.1483, published in P. C. Marani, *L'architettura fortificata negli studi di Leonardo da Vinci* (Florence, 1984), 17–18, and now discussed at enlightening length in idem, "Leonardo e Bernardo Rucellai fra Ludovico il Moro e Lorenzo il Magnifico sull'architettura militare: Il caso della Rocca di Casalmaggiore," in *Il principe architetto*, ed. A. Calzona, F. P. Fiore, A. Tenenti, and C. Vasoli (Florence, 2002), 99–123.

91. Lorenzo de' Medici, *Protocolli del Carteggio di Lorenzo il Magnifico per gli anni 1473–74, 1477–92,* ed. M. del Piazzo (Florence, 1956), 214, 25.xi.1482. On Ubaldini della Carda, see Lorenzo de' Medici, *Lettere*, vol. 5, *1480–1481*, ed. M. Mallett (Florence, 1989), 133 n. 8. For Ciri, see G. Campori, "Gli architetti e gl'ingegneri civili e militari degli Estensi dal secolo XIII al XVI," *Atti e Memorie delle RR Deputazioni di Storia Patria per le Provincie di Modena e Parma*, 3d ser., 7 (1883): 1–69 (40–41, 61–62). Payments by the Florentines to "Sirro e Monchetto, ingiegnieri del signiore chonte d'Urbino" are recorded in ASF, Balìe, 35, fol. 68r, 31.vii.1472.

92. ASF, S. Maria Nuova, 1254, fol. 51r, to Francesco Cambini, 23.iv.1490: "si trovorono con Lorenzo de' Medici a disegnare come s'havessi ad rassettare la cittadella nuova di Pisa et così in che modo si havessi ad fortificare et finire la torre che è dall'altro lato di Arno rincontro a decta cittadella nuova." The letter continues by asking Cambini to send the "modello o disegno." Four days later he was asked to reproduce the design if he did not have the original, since he was known to have grasped "tal ordine" (ibid., fol. 607r).

93. ASM, Archivio Sforzesco, 312, Branda da Castiglione to the duke of Milan, 4.xi.1490: "per lo designo che hanno facto de trasferire li habitatori de Pozibonzi in quello loco [Poggio Imperiale], dove intendino farli edificare una terra et cingerla de muro"; Leon Battista Alberti, *Ten Books on Architecture*, ed. J. Rykwert (London, 1965), 88. A provision of 20.ix.1488 had given the Operai del Palagio, of whom Lorenzo was one, authority over Poggio Imperiale and Firenzuola (ASF, Provv., Reg., 179, fol. 55v). See also L. Masi, *La fortezza di Poggio Imperiale a Poggibonsi* (Poggibonsi, 1992); idem, "La fortificazione di Poggio Imperiale," *Annali di Architettura* 1 (1989): 85–90; and also L. Pescatori, "Note storico-tipologiche sulle fortificazioni di Poggio Imperiale," in *L'architettura di Lorenzo il Magnifico*, ed. G. Morolli, C. Acidini Luchinat, and L. Marchetti (Milan, 1992), 222–27. For Lorenzo's advice concerning the new fortress at Sarzana going unheeded in 1488, however, see below, chap. 4; and F. Buselli, "Fra Sarzana e Sarzanello," *Necropoli* 6–7 (1969–70): 61–68.

94. Iuniano Maio, *De maiestate*, quoted in B. Croce, "Vedute della città di Napoli nel Quattrocento," in *Annedoti di varia letteratura*, 2d ed. (Bari, 1953), 1:267–73 (269–70).

95. Lorenzo de' Medici, quoted in Kent, "Young Lorenzo," 2.

96. Rubinstein, "Lorenzo de' Medici: The Formation of His Statecraft," 44.

97. Gentile Becchi, quoted in Martelli, "Il 'Giacoppo' di Lorenzo," 104 n. 4. For the dancing in Milan, see E. Southern, "A Prima Ballerina of the Fifteenth Century," in *Music and Context*, ed. A. Dhu Shapiro (Cambridge, Mass., 1985), 183–97.

98. Lorenzo to Iacopo Guicciardini, 2.vii.1483, in Lorenzo de' Medici, *Lettere*, vol. 7, *1482–1484*, ed. M. Mallett (Florence, 1998), 284.

99. B. Berenson, *The Passionate Sightseer* (London, 1966).

100. ASF, MaP, XVII, 446, Alessandro Martelli to Piero de' Medici, 4.v.1465: "Credo in questa terra per alchune cose abbi visto sì grande e magnifiche, che non possa migliorare, benché a Milano troverà assai cose di più contento."

101. Piero de' Medici to Lorenzo, 11.v.1465, in Fabroni, *Laurentii Medicis Magnifici Vita*, 2:52.

102. Lorenzo de' Medici, *Tutte le opere*, ed. P. Orvieto, 2 vols. (Rome, 1992), 1:239. For the journey south, see Lorenzo de' Medici, *Lettere*, 1:18–20.

103. Valori, *Vita di Lorenzo*, 104–5; J. Alsop, *The Rare Art Traditions* (New York, 1982), 390; L. Fusco and G. Corti, *Lorenzo de' Medici, Collector and Antiquarian* (New York, 2004), doc. 217.

104. ASF, MaP, XXIII, 62, Lorenzo Biliotti to Lorenzo, 15.vi.1466: "io vi detti certe medagle d'ariento et d'oro." See also Fusco and Corti, *Lorenzo de' Medici, Collector*, doc. 7 and chap. 1, i, for this early period.

105. Giovanni Tornabuoni to Lorenzo, 16.xi.1465, in ASF, MaP, XXIII, 32: "qualche buon fighura di marmi o medage." Francesco Stagnesi wrote from Rome on 13.vi.1467 that since "quando voi fosti qui mi parve vi piacesse quel ramo di medage vi donai," he was sending on another medallion (ibid., 134). On 13.vi.1469 Iacopo di Bongianni, in Bologna, wrote enthusiastically of "una chosa per quanto n'intendo, e anche per altro giudizio, degna et bella, d'un chamaino" (ibid., XX, 499). For the first two letters, see also Fusco and Corti, *Lorenzo de' Medici, Collector*, docs. 4, 8.

106. Lorenzo to Piero de' Medici, 24.vii.1463, in Lorenzo de' Medici, *Lettere*, 1:7.

107. See Lorenzo de' Medici, *Lettere*, 1:47.

108. S. Eiche and G. Lubkin, "The Mausoleum Plan of Galeazzo Maria Sforza," *MKIF* 32 (1988): 547–53; G. Lubkin, *A Renaissance Court: Milan under Galeazzo Maria Sforza* (Berkeley and Los Angeles, 1994), 105–6.

109. ASM, Archivio Sforzesco, 285, Agnolo della Stufa to the duke of Milan, 14.vii.1473: "m'ingegnai d'andar veggendo delle cose vostre degne il più potetti, et intra l'altre vidi in Milano il nuovo spedale facto fare dalla felicissima memoria del vostro Illustrisimo padre, che mi parve veramente cosa degna di tanto auctore."

110. T. Tuohy, *Herculean Ferrara: Ercole d'Este, 1471–1505, and the Invention of a Ducal Capital* (Cambridge, 1996), 291.

111. For Alberti's *Trivia* and Lorenzo, see G. Mancini, *Vita di Leon Batista Alberti*, 2d ed. (1911; reprint, Rome, 1971), 369–70. For the 1471 visit, see A. Grafton, *Leon Battista Alberti* (London, 2000), 248, 253, 258; and L. Barkan, *Unearthing the Past* (New Haven, Conn., 1999), 31. Many years later, in 1488, Lorenzo lent his support to the project shared by Alessandro Cortesi and Fra Giocondo to copy inscriptions in Naples, "epigrammata antiqua" (Alessandro Cortesi to Francesco Baroni, 5.vii.1488, in F. Pintor, *Da lettere inedite di due fratelli umanisti [Alessandro e Paolo Cortesi]* [Perugia, 1907], 25–27). For Lorenzo's interest in inscriptions, see Fusco and Corti, *Lorenzo de' Medici, Collector*, chaps. 4, ii, 5, i, 6, i, and doc. 213.

112. Lorenzo de' Medici, "Ricordi," published in W. Roscoe, *The Life of Lorenzo de' Medici*, 10th ed. (London, 1902), 427. See also Fusco and Corti, *Lorenzo de' Medici, Collector*, doc. 204 and chap. 1, ii.

113. J. Beck, "Lorenzo il Magnifico and His Cultural Possessions," in Toscani, *Lorenzo de' Medici*, 131–42 (140). See now the analysis of Fusco and Corti in *Lorenzo de' Medici, Collector*, chap. 5, iv.

114. C. M. Brown with L. Fusco and G. Corti, "Lorenzo de' Medici and the Dispersal of the Antiquarian Collections of Cardinal Francesco Gonzaga," *Arte Lombarda* 90–91 (1989): 80–103; D. S. Chambers, *A Renaissance Cardinal and His Worldly Goods: The Will and Inventory of Francesco Gonzaga (1444–1483)* (London, 1992), esp. 119–21. N. Dacos, A. Giuliano, and U. Pannuti, eds., *Il tesoro di Lorenzo il Magnifico: Le gemme* (Florence, 1973), and D. Heikamp and A. Grote, eds., *Il tesoro di Lorenzo il Magnifico: I vasi* (Florence, 1974), remain indispensable. See now Syson and Thornton, *Objects of Virtue*.

115. L. Fusco and G. Corti, "Lorenzo de' Medici's Collection of Antiquities," *Studi Italiani di Filologia* 10 (1992): 1116–30; idem, "Giovanni Ciampolini (d. 1565), a Renaissance Dealer in Rome and His Collection of Antiquities," *Xenia* 21 (1991): 7–46; idem, *Lorenzo de' Medici, Collector*. See also V. Arrighi, "Per una biografia di Luigi Lotti, cancelliere ed agente di Lorenzo il Magnifico," *Interpres* 15 (1995–96): 407–21 (414–15); and M. M. Bullard and N. Rubinstein, "Lorenzo de' Medici's Acquisition of the *Sigillo di Nerone*," *JWCI* 62 (1999): 283–86.

116. Piero da Bibbiena to Clarice Orsini, undated, quoted in M. Spallanzani, *Ceramiche orientali a Firenze nel Rinascimento* (Florence, 1978), 56–57; Fusco and Corti, *Lorenzo de' Medici, Collector*, doc. 87; M. Scalini, "The Weapons of Lorenzo de' Medici," in *Arts, Arms, and Armour: An International Anthology*, ed. R. Held (Chicago, 1979), 1:13–29.

117. Rubin and Wright, *Renaissance Florence*, 137; Fusco and Corti, *Lorenzo de' Medici, Collector*, chaps. 4, xi, 5, iii, and doc. 17.

118. For the bronze nails, see Giovanni Antonio to Lorenzo, August 1488, published in Gaye, *Carteggio*, 1:286; and Fusco and Corti, *Lorenzo de' Medici, Collector*, doc. 97.

119. Valori, *Vita di Lorenzo*, 104. For verification of the story, see Fusco and Corti, *Lorenzo de' Medici, Collector*, chap. 2, ii. See also K. Fittschen, "Ritratti antichi nella collezione di Lorenzo il Magnifico ed in altre collezioni del suo tempo," in *La Toscana al tempo di Lorenzo il Magnifico: Politica, economia, cultura, arte*, ed. R. Fubini, 3 vols. (Pisa, 1996), 1:7–22.

120. A. Chastel, "L''Etruscan Revival' du XVe siècle," *Revue Archeologique*, 1 (1959): 165–80. C. Braggio, *Antonio Ivani: Umanista del secolo XV* (Genoa, 1885), 18–19, cites a search for Etruscan remains around Luni in 1474, to which one may add a letter of 15.iii.1474 from Mico Capponi, captain of Sarzana, to Lorenzo agreeing to help Ivani search for "alchuna medaglia" (ASF, MaP, XXX, 147; see also Fusco and Corti, *Lorenzo de' Medici, Collector*, doc. 14 and n. 1, and for Lorenzo's Etruscan objects, ibid., docs. 115, 210, 221, 227). See also J. R. Spencer, "Volterra, 1466," *AB* 48 (1966): 95–96; G. Cipriani, *Il mito etrusco nel rinascimento fiorentino* (Florence, 1980); and J. Martineau, ed., *Andrea Mantegna* (London, 1992), 453.

121. Battista da Cavina to Lorenzo, 4.vi.1491, published in P. Berardi, *L'antica maiolica di Pesaro del XIV al XVII secolo* (Florence, 1984), 44 n. 55. See also Syson and Thornton, *Objects of Virtue*, 194, 215–16.

122. Giovanni Pontano, "Il Trattato dello Splendore," in *I trattati delle virtù sociali*, ed. F. Tateo (Rome, 1965), 276–77; see also 272–73.

123. ASMan, Archivio Gonzaga, 1100, fol. 276r, Antonio Ricavo to Ludovico Gonzaga, 8.vi.1466: "oggi manda P[iero] de' Medici la figlia a marito al figlio di Giovanni Rucellai, richissimo ma fievoluzo et debile di veste, perle e gioye. Forse potrà esser contenta. D'altre cose non so come si chiamerà satisfacta. Non gli sarà grascia, essendo molto delicato et essa gagliardissima e viva." Antonio's judgment on the Rucellai had been more favorable at the time of the betrothal (ibid., fol. 6r, Antonio Ricavo to Ludovico Gonzaga, 27.xi.1461).

124. Hersey, *Aragonese Arch*, 72, publishes Carafa's thank-you letter of 12.vii.1471; see also ibid., 53ff., and E. Borsook, "A Florentine Scrittoio for Diomede Carafa," in Barasch, Sandler, and Egan, *Art, the Ape of Nature*, 91–96. For recent discussions, see L. Beschi, "Le sculture antiche di Lorenzo il Magnifico," in Garfagnini, *Lorenzo il Magnifico*, 291–317 (293–94); L. V. Borrelli, "Uno dono di Lorenzo de' Medici a Diomede Carafa," in Fubini, *La Toscana al tempo di Lorenzo il Magnifico*, 1:235–52; and Fusco and Corti, *Lorenzo de' Medici, Collector*, chap. 4, ii, and doc. 10.

125. See Lorenzo de' Medici, *Protocolli*, 226, 284, 316; ASF, Guardaroba Medicea, I, fols. 2r ff., knowledge of which manuscript I owe to David Rosenthal.

126. BNF, II, II, 127, Ricordi di ser Giusto d'Anghiari, fol. 99r–v: "E tra gl'altri [ambassadors], il Magnifico Lorenzo de' Medici andò con molte magnificenze, chè menò cavalli 35 and 7 muli co'carriaggi e portò circa 400 libbre d'arienti, chè gli veddi incassare io, bacini, miscirobbe, scodelle e piattelli e altre vasa d'ariento. Fu bello apparato il vederli partire." See now Giusto Giusti d'Anghiari, "I giornali di Ser

Giusto Giusti d'Anghiari (1437–1482)," ed. N. Newbigin, *Letteratura Italiana Antica* 3 (2002): 41–246 (169).

127. Lodovico il Moro to Giovanni da Castiglione, 17.xi.1494, published in B. Buser, *Die Beziehungen der Mediceer zu Frankreich während der Jahre 1434–1494* (Leipzig, 1879), 348. See now Fusco and Corti, *Lorenzo de' Medici, Collector,* doc. 168.

128. Lorenzo to Piero de' Medici, 9.v.1490, published in I. del Lungo, *Florentia* (Florence, 1897), 289 n. 1. His son's reply of 10 May is in Fabroni, *Laurentii Medicis Magnifici Vita,* 2:378. See also Fusco and Corti, *Lorenzo de' Medici, Collector,* docs. 136, 137. Piero Parenti mentions the Pazzi plan in his *Storia fiorentina,* vol. 1, *1476–78, 1492–96,* ed. A. Matucci (Florence, 1994), 15. There are many other examples of the Medici thus displaying their treasures, too many to cite here; see above all Fusco and Corti, *Lorenzo de' Medici, Collector,* chap. 6, iii.

129. Luigi Lotti to Niccolò Michelozzi, 28.iv.1487, published in *Nuovi documenti per la storia del Rinascimento,* ed T. de Marinis and A. Perosa (Florence, 1970), 61. See also Fusco and Corti, *Lorenzo de' Medici, Collector,* doc. 76.

130. J. Shearman, *Raphael's Cartoons in the Collection of Her Majesty the Queen and the Tapestries for the Sistine Chapel* (London, 1972), 11–12.

131. Lorenzo de' Medici, letter of 14.iv.1490, published in Berardi, *L'antica maiolica di Pesaro,* 42–43 n. 40 (see also Fusco and Corti, *Lorenzo de' Medici, Collector,* doc. 134); Rubin and Wright, *Renaissance Florence,* 323.

132. See below, chap. 5; C. M. Brown, "'Lo insaciabile desiderio nostro de cose antique': New Documents on Isabella d'Este's Collection of Antiquities," in *Cultural Aspects of the Italian Renaissance,* ed. C. H. Clough (Manchester, 1976), 324–53; and Fusco and Corti, *Lorenzo de' Medici, Collector,* doc. 66.

133. Luigi Lotti to Niccolò Michelozzi, 2.ii.1487, published in de Marinis and Perosa, *Nuovi documenti,* 60. For this gem of Phaethon, see Fusco and Corti, *Lorenzo de' Medici, Collector,* chaps. 3, i, 4, xi, 6, iii.

134. The first quotation is from Nofri Tornabuoni to Lorenzo, 4.vi.1491, quoted in Bullard, *Lorenzo il Magnifico,* 128. For Lorenzo's letter of 17.x.1489 to Niccolò Franco, see ASF, MaP, XXXXIII, 75: "ho ricevuto el cammeo de me già tanto desiderato, el quale per essere in gram perfectione me è suto molto charo; per essere venuto in tempo che non lo aspectavo, molto più charo; per essere venuto per opera et diligentia della Signoria Vostra, charissimo." See also Fusco and Corti, *Lorenzo de' Medici, Collector,* docs. 124, 151.

135. ASF, MaP, XXX, 139, Antonio Ivani to Lorenzo, 14.iii.1474: "Delatae sunt plures, verum ita corrose ut neque litterae neque vix imagines cernerentur." See also Fusco and Corti, *Lorenzo de' Medici, Collector,* doc. 14.

136. Pandolfo Collenuccio to Lorenzo, 22.vi.1491, in Pandolfo Collenuccio, *Operette morali, poesie latine e volgari,* ed. A. Saviotti (Bari, 1929), 299–300. Hence Poliziano's comment to Lorenzo of 20.vi.1491 on a beautiful ancient vase that "credo non ne habbiate uno sì bello *in eo genere*" (Angelo Poliziano, *Prose volgari inedite e poesie latine e greche edite e inedite,* ed. I. del Lungo [Florence, 1867], 81). See also Fusco and Corti, *Lorenzo de' Medici, Collector,* doc. 154.

137. Fusco and Corti, *Lorenzo de' Medici, Collector,* chaps. 4, ix, 5, i, 6, ii; J. Nelson and

P. Zambrano, *Filippino Lippi: Catalogo completo,* 2 vols. (Milan, forthcoming). My thanks to Jonathon Nelson for allowing me to see in typescript the relevant section of his, the second, volume: *Filippino Lippi e i contesti della pittura a Firenze e Roma (1488–1504).* For the "Botticelli," see C. Dempsey, *The Portrayal of Love* (Princeton, 1992), 132. See also R. Rubinstein, "Lorenzo de' Medici's sculpture of Apollo and Marsyas: Bacchic Imagery and the Triumph of Bacchus and Ariadne," in *With and Without the Medici: Studies in Tuscan Art and Patronage, 1434–1530,* ed. E. Marchand and A. Wright (Aldershot, 1998), 79–105, esp. 83–85. Rubin and Wright propose a possible Medicean quotation in a drawing by Botticelli in *Renaissance Florence,* 87, 334–35.

138. Draper, *Bertoldo di Giovanni,* 220–53.

139. Francesco Gonzaga's description of 5.ii.1526 to Federico II Gonzaga, quoted in C. M. Brown, "Isabella d'Este e il mondo greco-romano," in *Isabella d'Este: La primadonna del Rinascimento,* ed. D. Bini (Mantua, 2001), 109–27 (124). See also idem, "I vasi di pietra dura dei Medici e Ludovico Gonzaga vescovo eletto di Mantova (1501–1502)," *Civiltà Mantovana,* n.s., 1 (1983): 63–68. Artists who were involved in Lorenzo's collecting of antiquities were the metalworker Michelangelo da Viviano (see Lorenzo de' Medici, *Protocolli,* 195, 418), the gemcutter Giovanni delle Corniuole, and the hardstone cutter Pier Maria Serbaldi (see Fusco and Corti, *Lorenzo de' Medici, Collector,* chap. 6, ii, and docs. 158, 269). There is no evidence that Lorenzo was directly responsible for the Florentine law passed on 27.viii.1477 in favor of the master gemcutter Piero di Neri Razzanti (ASF, Provv., Reg., 168, fols. 99v–100r); see also Fusco and Corti, *Lorenzo de' Medici, Collector,* chap. 6, n. 44.

140. Rubin and Wright, *Renaissance Florence,* 254. See now Syson and Thornton, *Objects of Virtue,* esp. chap. 3.

141. Luigi Lotti to Lorenzo, 13.ii.1489, published in Gaye, *Carteggio,* 1:285. See also Fusco and Corti, *Lorenzo de' Medici, Collector,* doc. 110 and a related letter by Tornabuoni, doc. 109.

142. Filippo Villani, quoted in P. L. Rubin, *Giorgio Vasari: Art and History* (New Haven, Conn., 1994), 296.

143. Francesco Gonzaga to his father, Federico, 23.ii.1483, published in P. Kristeller, *Andrea Mantegna* (Berlin, 1902), 541; see also Fusco and Corti, *Lorenzo de' Medici, Collector,* doc. 165. The flurry of activity in Mantua after Lorenzo announced his desire to visit the city is described in several letters published in E. Tedeschi, *Alcune notizie fiorentine tratte dall'Archivio Gonzaga di Mantova* (Badia Polesina, 1925), 25–30; see also the discussion by C. Vasic Vatovec, "Lorenzo il Magnifico e i Gonzaga: Due 'viaggi' nell'architettura," in Fubini, *La Toscana al tempo di Lorenzo il Magnifico,* 1:73–102. For Lorenzo's also having a political motive for going out of his way, see M. E. Mallett, "Lorenzo de' Medici and the War of Ferrara," in Toscani, *Lorenzo de' Medici,* 249–61 (esp. 253–54).

144. Lorenzo de' Medici, *Protocolli,* 136. See also C. Elam, "Mantegna at Mantua," in *Splendours of the Gonzaga,* ed. D. Chambers and J. Martineau (Milan, 1981), 15–25; and R. Lightbown, *Mantegna* (Oxford, 1986), 120ff., 462–63.

145. Andrea Mantegna to Lorenzo, 1484, published in G. Milanesi, "Lettere d'artisti italiani dei secoli XIV e XV," *Il Buonarroti* 2, fasc. 4 (1869): 77–87 (86–87);

see also E. E. Rosenthal, "The House of Andrea Mantegna in Mantua," *Gazette des Beaux-Arts* 60 (1962): 327–48. Mantegna had visited Florence in the summer of 1466 (Lightbown, *Mantegna,* 96–97), at which time he may have met members of the Medici family.

146. Spallanzani and Gaeta Bertelà, *Libro d'inventario,* 12. The work is described as "di mano dello Squarcione." There was also a Judith and Holofernes, "opera d'Andrea Squarcione," in the "schrittoio degli anelli" (ibid., 51), which scholars generally take to have been by Mantegna (*Francesco Squarcione: "Pictorum gymnasiarcha singularis,"* ed. A. De Nicolò Salmazo [Padua, 1999], 77, 111).

147. C. Bambach Cappel, "On 'La testa proportionalmente degradata'—Luca Signorelli, Leonardo, and Piero della Francesca's *De Prospectiva Pingendi,*" in Cropper, *Florentine Drawing,* 17–43 (40–41). See also the entry on Squarcione in *The Oxford Companion to Art,* ed. H. Osborne (Oxford, 1970), 1088–89; and Martineau, *Andrea Mantegna,* 94–99.

148. Martineau, *Andrea Mantegna,* 95.

149. Lightbown, *Mantegna,* 18. See also F. Ames-Lewis, *The Intellectual Life of the Early Renaissance Artist* (New Haven, Conn., 2000), 57–60.

150. Luca Fancelli to Lorenzo, 12.viii.1487, in Fancelli, *Luca Fancelli,* 60. "Lucha scarpellino," for whom Piero di Cosimo de' Medici requested a leave of absence from Ludovico Gonzaga on 30.vi.1462 (ASMan, Archivio Gonzaga, 1085, 42), was surely Fancelli. See, generally, H. Burns, "The Gonzaga and Renaissance Architecture," in Chambers and Martineau, *Splendours of the Gonzaga,* 27–38.

151. Lorenzo de' Medici, *Protocolli,* 333, 1.viii.1485.

152. C. M. Rosenberg, *The Este Monuments and Urban Development in Renaissance Ferrara* (Cambridge, 1997), 128–29. Lorenzo indeed sent Ercole d'Este a manuscript to be copied (see the imperfectly transcribed letters in A. Cappelli, "Lettere di Lorenzo de' Medici conservate nell'Archivio Palatino di Modena," *Atti e Memorie delle RR Deputazioni di Storia Patria per le Provincie di Modena e Parma* [sez. di Modena] 1 [1863]: 267–68; see also Antonio da Montecatini in ASMod, Cancelleria Ducale, Estero, Ambasciatori [Firenze], 3A, 22.iii.1484 and 19.iv.1484).

153. M. Martelli, "I pensieri architettonici del Magnifico," *Commentari* 17 (1966): 107–11; see also below, chap. 4.

154. C. Grayson, "The Composition of L. B. Alberti's 'Decem Libri De Re Aedificatoria,'" *Muenchner Jahrbuch der Bildenden Kunst* 2 (1960): 152–61; idem, "Un codice del *De Re Aedificatoria* posseduto da Bernardo Bembo," in *Studi letterari: Miscellanea in onore di Emilio Santini* (Palermo, 1955), 181–88; C. Hope and E. McGrath, "Artists and Humanists," in *Cambridge Companion to Renaissance Humanism,* ed. J. Kraye (Cambridge, 1996), 161–88 (165–68).

155. C. Bec, *Les Livres des Florentins (1413–1608)* (Florence, 1984), 202, 321; A. F. Verde, "Libri tra le Pareti Domestiche," *Memorie Domenicane,* n.s., 18 (1987): 1–225 (133). Manfredi informed Ercole d'Este on 11.iii.1484 that Alberti's book "non si trova facto a stampa e anche pochi che lo habii: et chi lo ha, non la vole dare" (ASMod, Cancelleria Ducale, Estero, Ambasciatori [Firenze], 3A).

156. For Lorenzo's books see E. Piccolomini, "Delle condizioni e delle vicende della libreria medicea privata dal 1494 al 1508," *ASI,* 3d ser., 20 (1874): 51–80 (55,

72–73). Lorenzo loaned the Filarete manuscript for copying in early 1483 (Lorenzo de' Medici, *Protocolli*, 229). Dei's comment is published in M. Pisani, *Un avventuriero del Quattrocento: La vita e le opere di Benedetto Dei* (Città di Castello, 1923), 22. See A. Grunzweig, *Correspondance de la filiale de Bruges des Medici* (Brussels, 1931), 1:xxv, for the invitation to the Bruges palace, which Tommaso Portinari described to Piero de' Medici as "lla più bella e lla più magnificha di questa terra" (ASF, MaP, XII, 314, 4.iii.1466).

157. ASF, MaP, XVIII, 32, Lorenzo to Piero di Lorenzo, 13.vi.1490: "Et in questo mezo, andrò veggiendo alcuni luoghi intorno de' signori Senesi, come è Pienza et Monte Uliveto etc."

158. See C. R. Mack, *Pienza: The Creation of a Renaissance City* (Ithaca, 1987); A. Tönnesmann, *Pienza: Städtebau und Humanismus* (Munich, 1990); N. Adams, "The Construction of Pienza (1459–1464) and the Consequences of *Renovatio*," in *Urban Life in the Renaissance*, ed. S. Zimmerman and R. F. E. Weissman (Newark, 1989), 50–79; and C. L. Frommel, "Pio II committente di Architettura," in Calzone et al., *Il principe architetto*, 327–60. See also J. Onians, *Bearers of Meaning: The Classical Orders in Antiquity, the Middle Ages, and the Renaissance* (Princeton, 1988), 185–89.

159. Lorenzo de' Medici, *Protocolli*, 420–21. I can find no object corresponding to this description in Spallanzani and Gaeta Bertelà, *Libro d'inventario*.

160. O. Merisalo, ed., *Le collezioni medicee nel 1495: Deliberazioni degli ufficiali dei ribelli* (Florence, 1999), xvi, 56. I wrote this passage before seeing F. Caglioti's remarkable reconstruction of this event and its context in *Donatello e i Medici: Storia del "David" e della "Giuditta,"* 2 vols. (Florence, 2000), 1:266–69. Cf. the discussion in Kent, *Cosimo de' Medici*, 264–68.

161. L. Pagliai, "Da un libro del monastero di S. Benedetto," *Rivista d'Arte* 3 (1905): 153. The monastic writer reported that on 16.v.1491 Don Guido, prior of the Angeli (and the Medici confessor), borrowed two tabernacles "di mano di Cimabue maestro fu di Giotto," returning them some three years later (L. Pagliai, "Da un libro del monastero di S. Benedetto," ibid. 6 [1909]: 244).

162. This painter was Lippo di Benivieni, active 1300–1325, according to the work's caption. The painting is illustrated in E. Peters Bowron, *European Paintings before 1900 in the Fogg Art Museum* (Cambridge, Mass., 1990), 283. See esp. L. Bellosi, "Un Cimabue per Piero de' Medici e il 'Maestro della Pietà di Pistoia,'" *Prospettiva* 67 (1992): 49–52; and idem, *Cimabue*, trans. A. Bonfante-Warren, F. Dabell, and J. Hyams (New York, 1998), 12–13, 285.

163. Dante, *La divina commedia*, ed. N. Sapegno, vol. 2, *Purgatorio* (Florence, 1984), canto xi, lines 94–96.

164. Bellosi, *Cimabue*, 12; Rubin, *Giorgio Vasari*, 289–90. Caglioti, *Donatello e i Medici*, 1:281, notes that Landino's praise of Paolo Uccello coincided with Lorenzo's seizing of the Bartolini Uccello.

165. Spallanzani and Gaeta Bertelà, *Libro d'inventario*, 6, 80 (Masaccio), 80, 94 (Botticelli), 79–80 (Desiderio). See also M. G. Ciardi Dupré dal Poggetto, "I dipinti di Palazzo Medici nell'inventario di Simone di Stagio delle Pozze: Problemi di committenza e di arredo," in Fubini, *La Toscana al tempo di Lorenzo il Magnifico*, 1:131–61.

166. For one such turning point toward the end of the fifteenth century see the

persuasive argument of J. Burke, *Changing Patrons: Social Identity and the Visual Arts in Renaissance Florence* (University Park, Pa., 2004). I am most grateful to Jill Burke for sharing her unpublished research with me. See also Syson and Thornton, *Objects of Virtue,* esp. chap. 6. Rucellai's celebrated list, much commented upon in the literature, appears in Rucellai, *Giovanni Rucellai,* 1:23–24. Concerning Castagno, see J. R. Spencer, *Andrea del Castagno and His Patrons* (Durham, N.C., 1991), 128–29.

167. D. Carl, "Il ritratto commemorativo di Giotto di Benedetto da Maiano nel Duomo di Firenze," in *Santa Maria del Fiore: The Cathedral and Its Sculpture,* ed. M. Haines (Fiesole, 2001), 129–47 (133). See also M. Collareta, "Le 'Luci della fiorentina gloria,'" *Artista: Critica dell'Arte in Toscana* 3 (1991): 136–43.

168. Poliziano, *Prose volgari inedite,* 156–59.

169. Parenti, *Storia fiorentina,* 259; F. D'Accone, "Antonio Squarcialupi alla luce di documenti inediti," *Chigiana,* 3d ser., 23 (1966): 3–20.

170. See Nelson and Zambrano, *Filippino Lippi.*

171. I. del Lungo, "Un documento Dantesco dell'Archivio Mediceo," *ASI,* 3d ser., 19 (1874): 4–8; P. O. Kristeller, *Studies in Renaissance Thought and Letters* (Rome, 1969), 329. Landino is quoted in A. Field, *The Origins of the Platonic Academy of Florence* (Princeton, 1988), 266.

172. L. Polizzotto, "The Making of a Saint: The Canonization of St. Antonino, 1516–1523," *Journal of Medieval and Renaissance Studies* 22 (1992): 353–81 (359–60).

173. See M. Haines, "Il principio di 'mirabilissime cose': I mosaici per la volta della cappella di San Zanobi in Santa Maria del Fiore," in *La difficile eredità: Architettura a Firenze dalla Repubblica all'assedio,* ed. M. Dezzi Bardeschi (Florence, 1994), 38–54; and Fusco and Corti, *Lorenzo de' Medici, Collector,* chaps. 4, viii, 6, ii. See also R. Wedgwood Kennedy, *Alessandro Baldovinetti* (New Haven, 1938), 191. Giovanni Antonio, in Rome, went to the trouble of describing to Lorenzo in technical detail ancient "opere di mattoni minuti in forma di musaico" he had seen there (Gaye, *Carteggio,* 1:286, 1.viii.1488; Fusco and Corti, *Lorenzo de' Medici, Collector,* doc. 97). In general, see now E. Borsook, F. Gioffredi Superbi, and G. Pagliarulo, eds., *Medieval Mosaics: Light, Color, Materials* (Milan, 2000), esp. 11–14.

174. ASF, MaP, XXXIX, 415, Giovanni Tornabuoni to Lorenzo, 28.xii.1484: "et ingegnerromi che Piero la porti, che è piutosto bella modernità che cosa antica," a passage also published in Fusco and Corti, *Lorenzo de' Medici, Collector,* doc. 55.

175. J. Kraye, "Lorenzo and the Philosophers," in Mallett and Mann, *Lorenzo the Magnificent,* 151–66; J. Hankins, "Lorenzo de' Medici as a Patron of Philosophy," *Rinascimento,* 2d ser., 34 (1994): 15–53.

176. D'Accone, "Lorenzo the Magnificent and Music," 259–90 (285); F. W. Kent, "Heinrich Isaac's Music in Laurentian Florence" (forthcoming).

177. Mario Martelli's aphorism concerning Lorenzo as poet is quoted in Lorenzo de' Medici, *Selected Writings,* ed. C. Salvadori (Dublin, 1992), 11–12.

178. Vincenzo Calmeta, *Prose e lettere edite e inedite,* ed. C. Grayson (Bologna, 1959), 11, 13, 24, 72.

179. A. F. Verde, *Lo studio fiorentino, 1473–1503,* 5 vols. (Florence, 1973–94), 3, pt. 2:684–85, 688. On Jacopo Corsi, a poetic admirer who wrote lamenting Lorenzo's

death, see A. Ceruti Burgio, "La cultura fiorentina ai tempi del Magnifico: Echi della poesia di Lorenzo nelle rime di Jacopo Corsi," *Lettere Italiane* 26 (1974): 338–48.

180. Lorenzo de' Medici, *Laude,* 73–75; B. Toscani, "I canti carnascialeschi e le laude di Lorenzo: Elementi di Cronologia," in *La musica a Firenze al tempo di Lorenzo il Magnifico,* ed. P. Gargiulo (Florence, 1993), 131–42.

181. ASF, Guardaroba Medicea, I, an inventory of Medici possessions loaned between 1482 and 1538: "si prestò a Cosimo Rucellai [Lorenzo's cousin] el zibaldone nuovo delle compositioni di Lorenzo" (fol. 20r, 20.v.1493; see also fol. 20v).

182. C. E. Gilbert, *Italian Art, 1400–1500* (Englewood Cliffs, N.J., 1980), 128.

183. Dempsey, *Portrayal of Love,* 137–39.

184. Lorenzo de' Medici, *Comento,* 223–24. A. B. Barriault, *"Spalliera" Paintings of Renaissance Tuscany* (University Park, Pa., 1994), suggests allusions to Vitruvius and Pliny in this passage (52). I am grateful to Caroline Elam for advice on this translation.

185. C. Varese, ed., *Prosatori volgari del Quattrocento* (Milan, 1955), 985.

186. S. Sontag, *The Volcano Lover* (London, 1993), 71.

187. Lorenzo de' Medici, *Comento,* 188.

188. Ibid., 137. For a not dissimilar formulation of what Renaissance people sought in the classical past, see Barkan, *Unearthing the Past,* 61.

189. Piero Alamanni to Lorenzo, 22.vii.1489, published in Fusco and Corti, "Lorenzo de' Medici on the Sforza Monument," 16; for an earlier request, to which Lorenzo had agreed, see ibid., 14.

190. See above, chap. 1.

191. Francesco Guicciardini, *Storie fiorentine dal 1378 al 1509,* ed. R. Palmarocchi (1931; reprint, Bari, 1968), 75.

CHAPTER THREE. THE TEMPTATION TO BE MAGNIFICENT, 1468–1484

1. Letter of 20.vii.1470, quoted in Lorenzo de' Medici, *Lettere,* vol. 1, *1460–1474,* ed. R. Fubini (Florence, 1977), 177 n. 3. For a bout of extreme anger sixteen years later, see M. M. Bullard, *Lorenzo il Magnifico: Image and Anxiety, Politics and Finance* (Florence, 1994), 94.

2. Sacramoro da Rimini to the duke of Milan, 7.viii.1470, in Lorenzo de' Medici, *Lettere,* 1:207.

3. Alessandra Macinghi negli Strozzi, *Lettere di una gentildonna fiorentina del secolo XV ai figliuoli esuli,* ed. C. Guasti (Florence, 1877), 604–6. A. Brown, "Pierfrancesco de' Medici, 1430–1476," in *The Medici in Florence: The Exercise of Language and Power* (Florence, 1992), 73–102, discusses the intrafamily rivalry.

4. ASMan, Archivio Gonzaga, 1100, fol. 503r: "Quista tera da caschuno se dice piglia'l vivere civile, et pare se driçi a rendere l'honore al Palazzo et ala Signoria. A casa de Lorenzo non va persona, et esso tene serato la porta, nè fa dimostratione volersi impazare d'altro che de merchandate et se'l non s'è domandato non va a Palazo."

5. Milanese ambassador to the duke of Milan, 3.i.1470, published in G. Soranzo, "Lorenzo il Magnifico alla morte del padre e il suo primo balzo verso la Signoria," *ASI* III (1953): 42–77 (50 n. 12); the first quotation is from N. Rubinstein, "Lorenzo de'

Medici: The Formation of His Statecraft," in *Lorenzo de' Medici: Studi,* ed. G. C. Garfagnini (Florence, 1992), 41–66 (47).

6. ASMod, Cancelleria Ducale, Estero, Ambasciatori (Firenze), 1, fol. 6, Niccolò Roberti to Borso d'Este, 29.x.1470: "overo che repiglii el stato armata mano e dagali nova forma . . . overo che ruinarà el muro dela sua casa."

7. M. Haines, "After the Cupola: Santa Maria del Fiore during the 1470s" (paper delivered at a symposium at The National Gallery, London, 12–13 November 1999); I thank the author for sharing this information with me.

8. L. Reti, "Tracce dei progetti perduti di Filippo Brunelleschi nel codice Atlantico," in *Leonardo da Vinci (Letture Vinciana 1–xii, 1960–1972),* ed. P. Galluzzi (Florence, 1974), 91–122 (101). See also Luca Landucci, *Diario fiorentino dal 1450 al 1516,* ed. I. Del Badia (1883; reprint, Florence, 1969), 10; Benedetto Dei, *La Cronica,* ed. R. Barducci (Florence, 1984), 86, 94; Giusto Giusti d'Anghiari, "I giornali di Ser Giusto Giusti d'Anghiari (1437–1482)," ed. N. Newbigin, *Letteratura Italiana Antica* 3 (2002): 41–246 (149).

9. Galvano Fiamma, quoted in L. Green, "Galvano Fiamma, Azzone Visconti, and the Revival of the Classical Theory of Magnificence," *JWCI* 53 (1990): 98–113 (104). See also A. D. Fraser Jenkins, "Cosimo de' Medici's Patronage of Architecture and the Theory of Magnificence," ibid. 33 (1970): 162–70; and P. Rubin, "Magnificence and the Medici," in *The Early Medici and Their Artists,* ed. F. Ames-Lewis (London, 1995), 37–49.

10. D. Kent, "The Importance of Being Eccentric: Giovanni Cavalcanti's View of Cosimo de' Medici's Florence," *Journal of Medieval and Renaissance Studies* 9 (1979): 101–32 (130–31).

11. The first quotation is from Timoteo Maffei's treatise, quoted in M. Holmes, "Giovanni Benci's Patronage of the Nunnery, Le Murate," in *Art, Memory, and Family in Renaissance Florence,* ed. G. Ciappelli and P. L. Rubin (Cambridge, 2000), 114–34 (118). For such criticism see R. Bizzocchi, *Chiesa e potere nella Toscana del Quattrocento* (Bologna, 1987), 95–96; and, more generally, J. Onians, *Bearers of Meaning: The Classical Orders in Antiquity, the Middle Ages, and the Renaissance* (Princeton, 1988), chap. 8. Cavalcanti's comment is in his *Nuova opera,* ed. A. Monti (Paris, 1990), 120.

12. F. W. Kent, "Quattrocento Florentine Taste in Palaces: Two Notes," *Australian Journal of Art* 6 (1987): 17–24; B. Preyer, "The 'chasa overo palagio' of Alberto di Zanobi: A Florentine Palace of about 1400 and Its Later Remodelling," *AB* 65 (1983): 387–402.

13. G. Pampaloni, "I ricordi segreti del mediceo Francesco di Agostino Cegia (1495–1497)," *ASI* 115 (1957): 188–234 (222). Cegia had heard the celebrated sermon of 25.ii.1496, published in Girolamo Savonarola, *Prediche sopra Amos e Zaccaria,* ed. P. Ghiglieri (Rome, 1971), 1:238–59, with its attack upon a tyrant who "fa conventi con la arme sua alle spese del comune" (240). On Savonarola's criticisms, see now J. Burke, *Changing Patrons: Social Identity and the Visual Arts in Renaissance Florence* (University Park, Pa., 2004), chaps. 7, 8.

14. A. Lenzuni, ed., *All'ombra del Lauro: Documenti librari della cultura in età laurenziana* (Milan, 1992), 103–4.

15. Cosimo de' Medici, quoted in N. Rubinstein, "The *De optime cive* and the *De príncipe* by Bartolomeo Platina," in *Tradizione classica e letteratura umanistica: Per Alessandro Perosa,* ed. R. Cardini et al. (Rome, 1985), 1:375–89 (385).

16. Vespasiano da Bisticci, published in G. M. Cagni, *Vespasiano da Bisticci e il suo epistolario* (Rome, 1969), 159.

17. This view was attributed to him and to Tommaso Soderini by the Florentine Lionardo Niccolini, a servant of Barbara of Brandenburg, who informed Ludovico on 13.v.1471 that the two Florentine leaders thought it would be best: "se getarà per terra e farasse ad altro modo e in altro modello; e in questo modo, perderasse la memoria che quella fusse facta per Vostra Signoria" (ASMan, Archivio Gonzaga, 2100).

18. For the Medici at the Annunziata, see now D. Kent, *Cosimo de' Medici and the Florentine Renaissance: The Patron's Oeuvre* (New Haven, Conn., 2000), 202–10. Ludovico's Florentine agent, Piero del Tovaglia, reported to the marquis on 8.v.1471 that Lorenzo thought that people should be content with what Ludovico wanted "e che non dubitava che questo no' riuscissi una bella chosa, e amme disse 'fa quello che tti dicie el Signore e lascia dire chi vole'" (ASMan, Archivio Gonzaga, 1100, fol. 339r). On this debate, see W. Braghirolli, "Die Baugeschichte der Tribuna der S. Annunciata in Florenz," *Repertorium für Kunstwissenschaft* 2 (1879): 259–79; B. L. Brown, "The Patronage and Building History of the Tribuna of SS. Annunziata in Florence," *MKIF* 25 (1981): 59–146; and C. Vasic Vatovec, "Lorenzo il Magnifico e i Gonzaga: Due 'viaggi' dell'architettura," in *La Toscana al tempo di Lorenzo il Magnifico: Politica, economia, cultura, arte,* ed. R. Fubini, 3 vols. (Pisa, 1996), 1:73–102 (82–89).

19. Lorenzo to Ludovico Gonzaga, 21.v.1471, in Lorenzo de' Medici, *Lettere,* 1:277: "secondo il gusto et appetito suo." Ludovico's phrase "una frotta di lettere" is quoted in Braghirolli, "Die Baugeschichte der Tribuna," 273.

20. M. Martelli, *Studi Laurenziani* (Florence, 1965), esp. 180–90.

21. A. F. Verde, *Lo studio fiorentino, 1473–1503,* 5 vols. (Florence, 1973–94); P. Denley, "*Signore* and *Studio:* Lorenzo in a Comparative Context," in *Lorenzo the Magnificent: Culture and Politics,* ed. M. Mallett and N. Mann (London, 1996), 203–16; J. Hankins, "Lorenzo de' Medici as a Patron of Philosophy," *Rinascimento,* 2d ser., 34 (1994): 15–53.

22. See F. W. Kent, "Lorenzo de' Medici at the Duomo," in *La cattedrale e la città: Saggi sul Duomo di Firenze, atti del VII centenario del Duomo di Firenze,* ed. T. Verdon and A. Innocenti, 3 vols. (Florence, 2001), 1:340–68.

23. ASF, Balìe, 34, contains the information concerning these and other close associates; they are also discussed in my biographical study of the young Lorenzo, in preparation. For the war, see E. Fiumi, *L'impresa di Lorenzo de' Medici contro Volterra (1472)* (Florence, 1948); R. Fubini, "Lorenzo de' Medici e Volterra," *Rassegna Volterrana* 70 (1994): 171–85; E. Insabato and S. Pieri, "Il controllo del territorio nello stato fiorentino del XV secolo: Un caso emblematico: Volterra," in *Consorterie politiche e mutamenti istituzionali in età Laurenziana,* ed. M. A. Morelli Timpanaro, R. Manno Tolu, and P. Viti (Milan, 1992), 177–211; and idem, "Tra repressione e privilegio: I rapporti tra Volterra e Firenze dal 1472 al 1513," in *Studi in onore di A. d'Addario,* ed. L. Borgia, F. de Luca, P. Viti, and R. M. Zaccaria, 5 vols. (Lecce, 1995), 4, pt. 1:1215–44.

24. Gino Capponi to his son, Piero, 3.vi.1472, ASF, Carte Strozziane, I, 113, fols.

121r–122v: "ed èvi ito per chapomaestro el Francione, el Maiano, e' Grasso di messer Lucha, lengnaiuoli, e'l Chapitano, muratore."

25. ASF, Balìe, 34, fol. 23r; 35, fols. 63v, 68r (and fol. 31r–v of a register bound within this volume). Here the "Grasso" is called "Giovanni di Domenicho," not "di messer Lucha," which would mean he was the well-known woodworker associate of Giuliano da Maiano, Giovanni di Domenico da Gaiole, who was also called "the Fat" (G. Gaye, *Carteggio inedito d'artisti dei secoli xiv, xv, xvi,* 3 vols. [Florence, 1839], 1:172). On this Giovanni, mentioned in a letter to Lorenzo written by a Servite friar on 1.vi.1472 (ASF, MaP, XXIII, 458) as "architector amenissimus" and in Lorenzo de' Medici, *Protocolli del Carteggio di Lorenzo il Magnifico per gli anni 1473–74, 1477–92,* ed. M. del Piazzo (Florence, 1956), 28, see M. Haines, *The Sacrestia delle Messe of the Florentine Cathedral* (Florence, 1983), esp. 136–39. It is true that other woodworkers were nicknamed "il Grasso"; for example, Filippo d'Andrea, a near neighbor of Lorenzo's, "vocato el Grasso legnaiuolo" (Archivio di San Lorenzo, Florence, 1932, pt. 2, fol. 59v). It must have been irresistible so to nickname fat men, let alone woodworkers, after Antonio Manetti's eponymous antihero from the earlier generation (see Antonio Manetti, *Vita di Filippo Brunelleschi,* ed. D. De Robertis [Milan, 1976], 1–44, "La Novella del Grasso"). In a letter of 5.iii.1473 to Lorenzo, Bartolomeo Valori mentions discussing the new works with "el Capitano, muratore" (ASF, MaP, XXIX, 141). J. Hale, *Renaissance Fortification: Art or Engineering?* (London, 1977), is typical in assuming Francione's involvement (14).

26. ASF, Balìe, 34, fol. 57v, 18.vi.1472: "che cotesto excellentissimo capitano dice farà qualche pensiero e della forteza e delle altre cose che apartengono alla sicurtà di cotesta città per lo advenire."

27. ASMan, Archivio Gonzaga, 1101, fol. 58, Francesco Prendilacqua to Ludovico Gonzaga, 27.vi.1472: "Lo Signor Conte cum li Vinti dela Guerra ogi sono stati insieme circa tre hore et hanno facto il designo in che modo voglano fare una cittadella e fortificare Volterra."

28. Ibid., fol. 58v: "et maxime Lorenzo di Medici, col quale stete el Signor conte solo bon pezo." See, generally, C. Clough, "Federigo da Montefeltro's Patronage of the Arts, 1468–82," in *The Duchy of Urbino in the Renaissance* (London, 1981), 129–44.

29. Haines, *Sacrestia delle Messe of the Florentine Cathedral,* 135. See also S. Borsi, F. Quinterio, and C. Vasic Vatovec, *Maestri fiorentini nei cantieri romani del Quattrocento,* ed. S. D. Squarzina (Rome, 1989), 176–97; and D. Lamberini, "Architetti e architettura militare per il Magnifico," in *Lorenzo il Magnifico e il suo mondo,* ed. G. C. Garfagnini (Florence, 1994), 407–25. There are numerous published and unpublished documentary references to Francione, who deserves a systematic scholarly analysis.

30. Benedetto Dei, published in G. C. Romby, *Descrizioni e rappresentazioni della città di Firenze nel XV secolo* (Florence, 1976), 73.

31. Francione to Lorenzo, 30.ix.1479, in G. Milanesi, ed., *Nuovi documenti per la storia dell'arte toscana dal xii al xv secolo* (Florence, 1901), 128.

32. Pierpont Morgan Library, New York, Feltrinelli Collection, 132, no. 18, Lorenzo to Niccolò Michelozzi, 18.vi.1487: "el caso sinistro del nostro Francione, del quale ho tanta alteratione che in poche poche [*sic*] persone di questo campo poteva intervenire questo, che me la dessi maggiore." The letter is now published in Lorenzo

de' Medici, *Lettere*, vol. 10, *1486–1487*, ed. M. M. Bullard (Florence, 2003), 334–35. Doris Carl and I will shortly publish other pertinent documents.

33. ASF, Provv., Reg., 179, fol. 7r–v, 21.iv.1488.

34. Tribaldo de' Rossi, *Ricordanze*, vol. 23 of *Delizie degli eruditi toscani*, ed. I. di San Luigi (Florence, 1786), 242. Essentially the same comment—"[Cecca] valeva 4 Pianchaldoli"—was made by another contemporary, Gismondo Nardi, to Benedetto Dei (ASF, Corp. relig. soppr., 78, 317, fol. 6r, 17.v.1488). For other contemporary references, see ibid., 78, 316, fol. 169r, Bartolomeo Dei to Benedetto Dei, 30.v.1488; Filippo Redditi, *Exhortatio ad Petrum Medicem*, ed. P. Viti (Florence, 1989), 20, 71–72; Giorgio Vasari, *Le opere di Giorgio Vasari*, ed. G. Milanesi (Florence, 1906), 3:195–212, with useful footnotes.

35. Lorenzo de' Medici, *Protocolli*, 320, 321, 322, 422. The reference to a letter written "al Francio circ' a' marmi" (425) is also presumably to Francione. See also Martelli, *Studi Laurenziani*, 192 n. 55.

36. See above, chap. 2.

37. See below, chap. 5.

38. Vasari, *Opere di Giorgio Vasari*, 4:270; F. Buselli, "Fra Sarzana e Sarzanello," *Necropoli* 6–7 (1969–70): 61–68.

39. See M. J. Gill, "Baccio Pontelli," in *The Dictionary of Art*, ed. J. Turner (New York, 1986), 25:216–17.

40. D. Carl, "Giuliano da Maiano und Lorenzo de' Medici: Ihre Beziehung im Lichte von zwei neuaufgefundenen Briefen," *MKIF* 37 (1993): 235–56 (255); he had first written "devoted to [my] house." See, generally, D. Lamberini, M. Lotti, and R. Lunardi, eds., *Giuliano e la bottega dei da Maiano* (Florence, 1994).

41. F. Quinterio, *Giuliano da Maiano "Grandissimo Domestico"* (Rome, 1996), 49.

42. Luca Pacioli, "De divina proportione," ed. A. Bruschi, in *Scritti rinascimentali di architettura*, ed. A. Bruschi and D. De Robertis (Milan, 1978), 123: "suo grandissimo domestico Giuliano da Magliano." See also, above all, Carl, "Giuliano da Maiano und Lorenzo de' Medici," 235–56; and Quinterio, *Giuliano da Maiano*.

43. Haines, *Sacrestia delle Messe of the Florentine Cathedral*, 145–48, 163–65.

44. Cardinal Conchense to Lorenzo, 1478, published in G. Milanesi, "Tre lettere del Cardinal Conchense risguardanti il palazzo da lui fabbricato in Recanati col disegno di Giuliano da Maiano," *Giornale Storico degli Archivi Toscani* 3 (1859): 233–34 (234).

45. The documents concerning Giuliano's appointment are published in C. von Fabriczy, "Giuliano da Majano," *Jahrbuch der Königlich Preussischen Kunstsammlungen* 24 (1903): 137–76 (149–50). For the context, see Kent, "Lorenzo de' Medici at the Duomo," 358–61; and R. Goldthwaite, *The Building of Renaissance Florence* (Baltimore, 1980), 386, from which the quotation is taken.

46. Pierfilippo Pandolfini to Lorenzo, 12.x.1477, published in Carl, "Giuliano da Maiano und Lorenzo de' Medici," 253.

47. Baccio Ugolini to Lorenzo, 17.v.1489, published in ibid., 253–54. On 9.xii.1484 Alfonso had asked Lorenzo to send him "alcuno architecto et homo ingenioso de edificare et de forteze de terre" (published in E. Pontieri, "La dinastia aragonese di Napoli e la casa de' Medici di Firenze," *Archivio Storico per le Provincie Napoletane* 65

[1941–45]: 340–41), to which Lorenzo replied on 27.ii.1485, "che se gli manda Giuliano da Maiano per la muraglia" (Lorenzo de' Medici, *Protocolli*, 325).

48. See ASF, MaP, XXXIII, 31, Domenico di Francesco to Lorenzo, 20.iii.1476; and below, chap. 5.

49. Published in F. W. Kent, "Il Mediceo avanti il Principato al tempo di Lorenzo," in *I Medici in rete*, ed. I. Cotta and F. Klein (Florence, 2003), 123–41.

50. Domenico di Francesco to Lorenzo, 6.vi.1478, quoted in ibid, 137.

51. Domenico di Francesco to Lorenzo, 23.xii.1478, quoted in ibid, 139.

52. Da Sangallo's description is published in G. Uzielli, *Paolo del Pozzo Toscanelli* (Florence, 1892), 123–25.

53. Borsi, Quinterio, and Vasic Vatovec, *Maestri fiorentini*, 218; see, more generally, 214–23.

54. Lamberini, "Architetti e architettura militare," 417; Buselli, "Fra Sarzana e Sarzanello." On "the Captain"'s and Francione's still being at Sarzana in 1491, see also ASF, Corp. relig. soppr., 78, 317, fol. 216r, Niccolò della Stufa to Benedetto Dei, 3.vi.1491.

55. On artisans as entrepreneurial, see R. Goldthwaite, "La cultura economica dell'artigiano," in *La grande storia dell'artigianato* (Florence, 1998), 1:57–73, who cites Vasari. See also A. Thomas, *The Painter's Practice in Renaissance Tuscany* (Cambridge, 1995).

56. The drawing appears as fig. 2.18 in A. Petrioli Tofani, ed., *Il disegno fiorentino del tempo di Lorenzo il Magnifico* (Milan, 1992), 61. My transcription reads: "Vo' esere uno buono disegnatore e vo' [di]ventare uno buono archittetore."

57. Luca Fancelli, *Luca Fancelli—architetto: Epistolario Gonzaghesco*, ed. C. Vasic Vatovec (Florence, 1979), 17, 350–51. H. Burns calls the two "collaborators rather than simply patron and architect" ("The Gonzaga and Renaissance Architecture," in *Splendours of the Gonzaga*, ed. D. Chambers and J. Martineau [Milan, 1981], 27–38 [30]).

58. Angelo Poliziano, *Silvae*, ed. F. Bausi (Florence, 1996), 45: "cuius ego cliens et alumnusque sum."

59. Burke, *Changing Patrons*, chap. 4.

60. P. Nanni, *Lorenzo agricoltore* (Florence, 1992), 97.

61. The quotation is from T. E. Cooper, "*Mecenatismo* or *Clientelismo?* The Character of Renaissance Patronage," in *The Search for a Patron in the Middle Ages and the Renaissance*, ed. D. G. Wilkins and R. L. Wilkins (Lewiston, N.Y., 1996), 19–31 (20). See also Bullard, *Lorenzo il Magnifico*, esp. chap. 4; and Kent, *Cosimo de' Medici*, esp. chap. 3.

62. See, e.g., L. Pagliai, "Da un libro del monastero di S. Benedetto," *Rivista d'Arte* 3 (1905): 153. Above all, see C. Elam, "Lorenzo de' Medici's Sculpture Garden," *MKIF* 36 (1992): 41–84, esp. 48–49, 69, which lists Francesco's letters in ASF, MaP; see also Lucrezia Tornabuoni, *Lettere*, ed. P. Salvadori (Florence, 1993), 74, 113–14, 128–29.

63. Elam, "Lorenzo de' Medici's Sculpture Garden," 52.

64. ASF, Otto di Guardia, Repubblicana, 74, fol. 77r: "et noi in questo puncto lo mandiamo a V.M. chè, dela persona sua et d'ogni aspecto, sia da fare a chi lui offeso si riputassi." For Francesco's holding the office, see ibid., fol. 2v.

65. ASF, Otto di Pratica, Responsive, 1, fol. 135r, Luigi Guicciardini to the Otto, 10.iv.1481: "venne qui Francesco orafo col Frangione et tre altri capomaestri . . . et

presono certe misure di decto poggio"; Lorenzo de' Medici, *Lettere*, vol. 5, *1480–1481*, ed. M. Mallett (Florence, 1989), 335. On 1.xii.1477 Francesco had reported in technical terms to Lorenzo a visit "chon questi maestri" to the Medici mill of Librafatta, which needed repair (ASF, MaP, XXXV, 687). In a letter of recommendation to Giovanni Lanfredini on behalf of the goldsmith's brother, a priest, Lorenzo calls him "nostro Francesco orafo" (ibid., LI, 455, 24.iii.1489).

66. The document is published in Vasari, *Opere di Giorgio Vasari*, 4:305–9.

67. Pagliai, "Da un libro," 153.

68. Elam, "Lorenzo de' Medici's Sculpture Garden," 49; see also S. J. Cornelison, "A French King and a Magic Ring: The Girolami and a Relic of St. Zenobius in Renaissance Florence," *RQ* 55 (2002): 434–69 (456). On Belcari and Francesco, see A. Lanza, ed., *Lirici toscani del '400*, 2 vols. (Rome, 1973), 1:216–17.

69. C. Guasti, *La cupola di Santa Maria del Fiore* (Florence, 1857), 113, ellipses in the original. It must be said that there were several Florentine goldsmiths with the Christian name Francesco active at the time.

70. G. Cherubini and G. Fanelli, eds., *Il Palazzo Medici Riccardi di Firenze* (Florence, 1990), 107, 249, 252, 255. The standard work is now J. D. Draper, *Bertoldo di Giovanni: Sculptor of the Medici Household* (Columbia, Mo., 1992). See also C. Seymour, "Bertoldo di Giovanni," in *Dizionario biografico degli italiani* (Rome, 1967), 9:580–82; and A. Chastel's still illuminating pages in *Art et humanisme à Florence au temps de Laurent le Magnifique* (Paris, 1961), 76–82.

71. ASF, Notarile Antecos., 2308, fol. 221r, 13.xii.1473: "in domo magnifici viri Laurentii Petri de Medicis." Called "sculptore," Bertoldo di Giovanni is described as being from the parish of San Pancrazio, in the tax records of which (in the *gonfalone* of Lion Rosso) I have, however, been unable to find him. At almost the same time that, as if by serendipity, I found this early reference, Rolf Bagemihl also came across it and kindly discussed it with me.

72. For the medal, see Draper, *Bertoldo di Giovanni*, 86–95; and P. L. Rubin and A. Wright, *Renaissance Florence: The Art of the 1470s* (London, 1999), 128–29, who comment on its vivid "documentary value." See also Angelo Poliziano, *Della Congiura dei Pazzi (Coniurationis Commentarum)*, ed. A Perosa (Padua, 1958).

73. F. Caglioti has published new documents concerning the commission in "Tra dispersione e ricomparse: Gli spiritelli bronzei di Donatello sul pergamo di Luca della Robbia," in *Santa Maria del Fiore: The Cathedral and Its Sculpture*, ed. M. Haines (Fiesole, 2001), 263–87 (285–87).

74. The letter is published and translated with commentary in Draper, *Bertoldo di Giovanni*, 7–12; a facsimile of the original is in A. M. Fortuna and C. Lunghetti, *Autografi dell'Archivio Mediceo avanti il Principato* (Florence, 1977), 84–85, plate 42. See A. Parronchi, "The Language of Humanism and the Language of Sculpture," *JWCI* 27 (1964): 108–36, for the suggestion that Scala is Calvanese. I intend to publish a new translation of this very difficult text with commentary.

75. Draper, *Bertoldo di Giovanni*, 276–77. U. Middeldorf, "On the Dilettante Sculptor," *Apollo* 107 (1978): 310–22 (314–16), even suggested that Bertoldo was a Medici bastard.

76. Lorenzo de' Medici, *Protocolli,* 426.

77. E. P. Richardson, "Bertoldo and Verrocchio: Two Fifteenth Century Florentine Bronzes," *Art Quarterly* 22 (1959): 205–15 (206).

78. John Pope-Hennessy, "Italian Bronze Statuettes—I," *BM* 105 (1963): 14–23 (17); Draper, *Bertoldo di Giovanni,* 133–45.

79. For the first point, see L. Fusco and G. Corti, *Lorenzo de' Medici, Collector and Antiquarian* (New York, 2004), chap. 2, iii, and doc. 113; and Draper, *Bertoldo di Giovanni,* 277. The new document, very generously brought to my attention some years ago by Caroline Elam, is now summarized by S. K. Cohn, *Creating the Florentine State: Peasants and Rebellion, 1348–1434* (Cambridge, 1999), 16–17. For the quotation, "Lavora per Lorenzo de' Medici con Bertoldo schultore," see ASF, Catasto, 1123, fol. 452r. One hopes that Elam will publish this important document in full.

80. For the first quotation, see F. W. Kent, "Bertoldo 'sculptore' and Lorenzo de' Medici," *BM* 134 (1992): 248–49, and for the second, see ibid., 249 n. 9.

81. For this issue, see below, chap. 5.

82. L. Pellecchia, "The Patron's Role in the Production of Architecture: Bartolomeo Scala and the Scala Palace," *RQ* 42 (1989): 258–91 (260).

83. Ibid., 261. See also, more generally, G. Clausse, *Les San Gallo,* 3 vols. (Paris, 1900–1902); G. Marchini, *Giuliano da Sangallo* (Florence, 1942); and D. Hemsoll, "Giuliano da Sangallo and the New Renaissance of Lorenzo de' Medici," in Ames-Lewis, *Early Medici and Their Artists,* 187–205. The documentary basis is still provided by C. von Fabriczy, "Giuliano da Sangallo," *Jahrbuch der Königlich Preussischen Kunstsammlungen* 23 (1902): 1–42.

84. Giuliano da Sangallo to Lorenzo, 15.v.1486, published in Uzielli, *Paolo del Pozzo Toscanelli,* 123–25. See also H. Saalman, *Filippo Brunelleschi: The Buildings* (London 1993), 374–77. On the Prato church, see P. Davies, "The Early History of S. Maria delle Carceri in Prato," *Journal of the Society of Architectural Historians* 54 (1995): 326–35; and for the model for Lorenzo, see below, chap. 4.

85. Francesco Albertini, quoted in F. Ames-Lewis, *The Intellectual Life of the Early Renaissance Artist* (New Haven, Conn., 2000), 81. For Giuliano's intimacy with this circle, see also A. Bellinazzi, *La casa del cancelliere* (Florence, 1998), 129. The well-known, undated drawing for Poggio by Giuliano is discussed in S. Borsi, *Giuliano da Sangallo: I disegni di architettura e dell'antico* (Rome, 1985), 409–17.

86. P. P. Bober and R. O. Rubinstein, *Renaissance Artists and Antique Sculpture: A Handbook of Sources* (London, 1986), 153. For Giuliano as a draftsman after the antique see Petrioli Tofani, *Disegno fiorentino del tempo di Lorenzo il Magnifico,* figs. 2.16 (58–59), 2.17 (60), 2.25 (68–69), 6.11 (141–42).

87. Bullard, *Lorenzo il Magnifico,* 127. The literature on both Poliziano and Pulci is vast. For Squarcialupi, see G. Giacomelli, "Nuove giunte alla biografia di Antonio Squarcialupi: I viaggi, l'impiego, le esecuzioni," in *La musica a Firenze al tempo di Lorenzo il Magnifico,* ed. P. Gargiulo (Florence, 1993), 257–73, with bibliography. On the "court" artist, see Ames-Lewis, *Intellectual Life,* 62–66, and M. Warnke, *The Court Artist* (Cambridge, 1993).

88. F. A. D'Accone, "Lorenzo the Magnificent and Music," in Garfagnini, *Lorenzo il Magnifico*, 259–90 (285).

89. Published in H. Osthoff, *Josquin Desprez*, 2 vols. (Tutzing, 1962), 1:211 n. 12.

90. Lorenzo de' Medici, *Canzoniere*, ed. P. Orvieto (Milan, 1984), vii; Lorenzo de' Medici, *Selected Writings*, ed. C. Salvadori (Dublin, 1992), introduction.

91. The Anonimo Magliabechiano, cited in C. Pedretti, "L'era nuova con Leonardo," in *1492: Un anno fra due ere: Saggi*, by J. Le Goff et al. (Florence, 1992), 226–67 (227), and very widely accepted by scholarship on the young Leonardo.

92. R. Schofield, "Leonardo's Milanese Architecture: Career, Sources, and Graphic Techniques," *Achademia Leonardi Vinci* 4 (1991): 111–57, where this whole issue is discussed.

93. D. A. Brown, *Leonardo da Vinci: Origins of a Genius* (New Haven, Conn., 1998), 166, 206–7 n. 7.

94. The sketch appears in Pedretti, "L'era nuova con Leonardo," 226. See also A. Luchs, "Lorenzo from Life? Renaissance Portrait Busts of Lorenzo de' Medici," *Sculpture Journal* 4 (2000): 6–23.

95. See Sacramoro da Rimini to the duke of Milan, 8.i.1472, cited in R. Fubini, "Appunti sui rapporti diplomatici fra il dominio Sforzesca e Firenze Medicea," in *Gli Sforza a Milano e in Lombardia e i loro rapporti con gli stati italiani ed europei (1450–1535)* (Milan, 1982), 281–334 (324).

96. ASF, Capitoli delle compagnie religiose soppresse, 29, Compagnia di S. Paolo, fol. 31v: "civi sui reipublice primario."

97. Cited by F. W. Kent, "Lorenzo de' Medici, Madonna Scolastica Rondinelli e la politica di mecenatismo architettonico nel convento delle Murate a Firenze (1471–72)," in *Arte, committenza ed economia a Roma e nelle corti del Rinascimento (1420–1530)*, ed. A. Esch and C. L. Frommel (Turin, 1995), 354. For Cosimo's ecclesiastical commissions, see now Kent, *Cosimo de' Medici*, pt. 3. Rubin and Wright, *Renaissance Florence*, deal clearly and authoritatively with the Florentine artistic context of the 1470s, in which Lorenzo operated.

98. Both quotations are from Kent, "Lorenzo de' Medici, Madonna Scolastica Rondinelli," 354.

99. Quoted in ibid., 353.

100. Filippo Strozzi to Lorenzo Strozzi, 22.iv.1477, in A. Lillie, "The Patronage of Villa Chapels and Oratories near Florence: A Typology of Private Religion," in *With and Without the Medici: Studies in Tuscan Art and Patronage, 1434–1530*, ed. E. Marchand and A. Wright (Aldershot, 1998), 39, 46 n. 72.

101. Brown, "Pierfrancesco de' Medici," 85 n. 23, from ASF, MaP, 104, fol. 455, and ASF, Notarile Antecos., 10200, fol. 218v. In 1477 Lorenzo obtained some eighty cubic meters of timber "pe' palchi di San Lorenzo" (L. Zangheri, "Lorenzo il Magnifico in alcuni documenti dell'Opera di S. Maria del Fiore," *Quaderni di Storia dell'Architettura e Restauro* 6–7 [1992]: 19–23). In a bull of 3.viii.1514 cited in A. Butterfield, *The Sculptures of Andrea del Verrocchio* (New Haven, Conn., 1997), 206, Pope Leo X declared that both his father and his grandfather had enlarged San Lorenzo.

102. Lorenzo de' Medici, "Ricordi," published in W. Roscoe, *The Life of Lorenzo de'*

Medici, 10th ed. (London, 1902), 426. See most recently on the tomb, Butterfield, *Sculptures of Andrea del Verrocchio,* 44–55; the second quotation appears on 47.

103. Castello Quaratesi, tax report of 1458, ASF, Catasto, 785, fol. 79r: "che chosì rimasi d'achordo chon Cosimo, che detto lavoro innanzi si chominciassi che ne faciessi alloghagione a' maestri a mia pitizione, perchè si ne intende meglio di me e fè chon più vantaggio mio."

104. Published in Fra Dionisio Pulinari da Firenze, *Cronache dei frati minori della provincia di Toscana,* ed. P. Saturnino Mencherini (Arezzo, 1913), 187 n. 1. For Pacciani's contributions, see R. Pacciani, "Cosimo de' Medici, Lorenzo il Magnifico e la chiesa di San Salvatore al Monte a Firenze," *Prospettiva* 66 (1992): 27–35; and idem, "Attività professionali di Simone del Pollaiolo detto 'il Cronaca' (1490–1508)," *Quaderni di Palazzo Te,* n.s., 1 (1994): 13–35. See also V. Vasarri, "Il Cronaca e San Salvatore al Monte," *Antichità Viva* 20 (1981): 47–50; and L. Pellecchia, "The First Observant Church of San Salvatore al Monte in Florence," *MKIF* 23 (1979): 274–96.

105. Pacciani, "Cosimo de' Medici, Lorenzo il Magnifico," 32. For the ex-voto, see G. Trotta, *San Salvatore al Monte* (Florence, 1997), 13.

106. Lorenzo to the duke of Milan, 9.vii.1472, in Lorenzo de' Medici *Lettere,* 1:385–86.

107. E. H. Gombrich, "The Early Medici as Patrons of Art," in *Italian Renaissance Studies,* ed. E. F. Jacob (London, 1960), 279–311 (305). See also G. Soranzo, "Tre elogi poco noti di Lorenzo il Magnifico, uno a lui vivo, due in morte," *Rinascimento* 9 (1958): 203–16 (esp. 203–7); and Kent, *Cosimo de' Medici,* 212–14.

108. Kent, "Lorenzo de' Medici, Madonna Scolastica Rondinelli," 353–82 (358–59).

109. Ibid., 360. At precisely this time, just after the Volterra war, Lorenzo was given the right by the Twenty, of which he was a member, to allocate to whom he chose—in this case two representatives of the Buonomini di San Martino—alms "per l'amore di Dio a detti poveri e a luochi reliciosi" (ASF, Balìe, 35, fol. 58r).

110. ASF, Corp. relig. soppr., 81, 3, fols. 14r, 35r, late acts referring to the donation of 29.xi.1475. Kate Lowe courteously shared this document with me.

111. Kent, "Lorenzo de' Medici, Madonna Scolastica Rondinelli," 361.

112. Despite the excellent reconstruction work of S. L. Weddle, "Enclosing Le Murate: The Ideology of Enclosure and the Architecture of a Florentine Convent, 1390–1597" (Ph.D. diss., Cornell University, 1997). I am grateful to Saundra Weddle for allowing me to read her unpublished thesis; see now her "Women's Place in the Family and the Convent: A reconsideration of Public and Private in Renaissance Florence," *Journal of Architectural Education* 55 (2001): 64–72. On Le Murate, see, more generally, K. Lowe, "Female Strategies for Success in a Male Ordered World: The Benedictine Convent of the Murate in Florence in the Fifteenth and Early Sixteenth Centuries," *Studies in Church History* 27 (1990): 209–21; M. Holmes, *Fra Filippo Lippi, the Carmelite Painter* (New Haven, Conn., 1999), 215–44.

113. N. Rubinstein, "Lay Patronage and Observant Reform in Fifteenth-Century Florence," in Christianity and the Renaissance, ed. T. Verdon and J. Henderson (Syracuse, N.Y., 1990), 63–82.

114. So some Florentine nuns expressed themselves in 1478, as quoted in R. Trexler, "Le célibat à la fin du Moyen Age: Les religieuses de Florence," *Annales, E.S.C.* 27 (1972): 1329–50 (1329).

115. F. W. Kent, "Sainted Mother, Magnificent Son: Lucrezia Tornabuoni and Lorenzo de' Medici," *Italian History and Culture* 3 (1997): 3–34 (27).

116. Ibid.; F. W. Kent, "'Lorenzo . . . , amico degli uomini da bene': Lorenzo de' Medici and Oligarchy," in Garfagnini, *Lorenzo il Magnifico,* 43–60.

117. F. W. Kent, "'Un paradiso habitato da diavoli': Ties of Loyalty and Patronage in the Society of Medicean Florence," in *Le radici cristiane di Firenze,* ed. A. Benvenuti, F. Cardini, and E. Giannarelli (Florence, 1994), 183–210 (206).

118. Paolo Giovio, quoted in C. M. Sperling, "Verrocchio's Medici Tombs," in *Verrocchio an Late Quattrocento Italian Sculpture,* ed. S. Bule, A. P. Darr, and F. Superbi Gioffredi (Florence, 1992), 51–61 (54).

119. See most recently Butterfield, *Sculptures of Andrea del Verrocchio,* chap. 2 and 207–9.

120. Kent, "Un paradiso habitato da diavoli," 183–210 (207).

121. Kent, "Lorenzo de' Medici, Madonna Scolastica Rondinelli," 353–82.

122. K. Lowe, "Lorenzo's 'Presence' at Churches, Convents, and Shrines in and outside Florence," in Mallett and Mann, *Lorenzo the Magnificent,* 23–36 (32–33).

123. Ibid.; Kent, "Sainted Mother, Magnificent Son," 27–28; H. van der Velden, "Medici Votive Images and the Scope and Limits of Likeness," in *The Image of the Individual: Portraits in the Renaissance,* ed. N. Mann and L. Syson (London, 1998), 126–36.

124. L. Gatti, "Displacing Images and Devotion in Renaissance Florence: The Return of the Medici and an Order of 1513 for the *Davit* and the *Judit,*" *Annali della Scuola Normale Superiore di Pisa* 23 (1993): 350–73; K. J. P. Lowe, "Patronage and Territoriality in Early Sixteenth-Century Florence," *RS* 7 (1993): 258–71.

125. ASM, Archivio Sforzesco, 285, Filippo Sacramoro to Lodovico, 29.x.1473: "prima . . . che facto el principio del Studio."

126. ASF, MaP, XXXIX, 518, Sigismondo della Stufa to Lorenzo, 26.v.1486: "credendo certo in voi solo consiste il poter mantener lo Studio."

127. Angelo Poliziano, *Prose volgari inedite e poesie latine e greche edite e inedite,* ed. I. del Lungo (Florence, 1867), 47; Tornabuoni, *Lettere,* 143–44. Martelli, Studi *Laurenziani,* 180–85, discusses Lorenzo's creative burst at this point.

128. The documents are published in P. Foster, "Lorenzo de' Medici and the Florence Cathedral Façade," *AB* 63 (1981): 495–99. See also Kent, "Lorenzo de' Medici at the Duomo," 359; and L. W. Waldman, "Florence Cathedral: The Façade Competition of 1476," *Source* 16 (1996): 1–6. The contemporary reference to a competition among "ognuno intendente" is published in Giusti d'Anghiari, "I giornali di Ser Giusto Giusti d'Anghiari," 190. It has recently been suggested that Lorenzo encouraged Mino da Fiesole to submit a model on this occasion (S. E. Zuraw, "Mino da Fiesole's Lost Design for the Façade of Santa Maria del Fiore," in Haines, *Santa Maria del Fiore,* 79–93).

129. ASF, Provv., Reg., 167, fols. 146v–148r, 28.ix.1476; F. W. Kent, "The Making

of a Renaissance Patron of the Arts," in *A Florentine Patrician and His Palace: Studies,* by F. W. Kent et al. (London, 1981), 9–95 (62–64).

130. See, e.g., ASF, Consiglio del Cento, Registri, 1, fol. 87r–v, 21.x.1475, a provision in favor of Santo Spirito: "quanto s'appartenga a ciaschuno fedele christiano et maxime al popolo fiorentino, sempre et tenuto et suto religiosissimo sopra ciaschuno altro, honorare et magnificare il culto divino."

131. M. Haines, "The Builders of Santa Maria del Fiore: An Episode of 1475 and an Essay towards Its Context," in *Renaissance Studies in Honor of Craig Hugh Smyth,* ed. A. Morrogh, F. Superbi Gioffredi, P. Morselli, and E. Borsook, 2 vols. (Florence, 1985), 1:89–115.

132. See Haines, "After the Cupola."

133. See Kent, "Lorenzo de' Medici at the Duomo," 360.

134. Ibid., 360–61.

135. Ibid., 357–58, 360.

136. Ibid., 361.

137. Ibid., 357–58.

138. Ibid., 358.

139. M. Hegarty, "Laurentian Patronage in the Palazzo Vecchio: The Frescoes of the Sala dei Gigli," *AB* 78 (1996): 264–85; N. Rubinstein, *The Palazzo Vecchio, 1298–1532* (Oxford, 1995), 3.

140. P. Spilner, "Ut civitas amplietur: Studies in Florentine Urban Development, 1282–1400" (Ph.D. diss., Columbia University, 1987); M. Trachtenberg, *Dominion of the Eye: Urbanism, Art, and Power in Early Modern Florence* (Cambridge, 1997).

141. Filippo Rinuccini, *Ricordi storici dal 1282 al 1460 con la continuazione di Alamanno e Neri suoi figli fino al 1506,* ed. G. Aiazzi (Florence, 1840), xc. On the housing shortages reported in the 1470s and 1480s, see F. W. Kent, "Palaces, Politics, and Society in Fifteenth-Century Florence," *I Tatti Studies* 2 (1987): 41–70 (55–56).

142. Provision of February 1474, quoted in S. Tognetti, "Problemi di vettovagliamento cittadino e misure di politica annonaria a Firenze nel XV secolo (1430–1500)," *ASI* 157 (1999): 419–52 (437). See D. Herlihy and C. Klapisch, *Les Toscans et leurs familles: Une étude du catasto florentin de 1427* (Paris, 1978), for the demographic situation.

143. Vespasiano da Bisticci, quoted in Kent, "Palaces, Politics, and Society," 56.

144. C. Elam, "Lorenzo de' Medici and the Urban Development of Renaissance Florence," *Art History* 1 (1978): 43–66. See also G. Miarelli Mariani, "Il disegno per il complesso Mediceo di Via Laura a Firenze," *Palladio* 22 (1972): 127–62.

145. The document is quoted in Elam, "Lorenzo de' Medici and the Urban Development of Renaissance Florence," 50. Trachtenberg, in *Dominion of the Eye,* 11–14, 22, 126, is the recent scholar referred to.

146. M. Tafuri, *Ricerca del Rinascimento* (Turin, 1992), esp. 93–94. Elam revisits her fundamental article in "Lorenzo's Architectural and Urban Policies," in Garfagnini, *Lorenzo il Magnifico,* 357–84.

147. F. W. Kent, "The Rucellai Family and Its Loggia," *JWCI* 35 (1972): 397–401; B. Preyer, "The Rucellai Palace," in Kent et al., *Florentine Patrician,* 155–225.

148. Kent, "Making of a Renaissance Patron of the Arts," 71–74.

149. See Giovanni Rucellai, *Giovanni Rucellai ed il suo Zibaldone,* vol. 1, *Il Zibaldone Quaresimale,* ed. A. Perosa (London, 1960), 23–24.

150. Giovanni Rucellai, quoted in Kent, "Making of a Renaissance Patron of the Arts," 13.

151. H. Baron, *The Crisis of the Early Italian Renaissance,* 2 vols. (Princeton, 1955); Rucellai, *Giovanni Rucellai,* 1:121.

152. Lorenzo to Iacopo Ammannati, 2.xii.1472, in Lorenzo de' Medici, *Lettere,* 1:413.

153. Lorenzo to Giovanni Lanfredini, 11.iii.1489, in Lorenzo de' Medici, *Scritti scelti,* ed. E. Bigi (Turin, 1977), 663.

154. P. Foster, *A Study of Lorenzo de' Medici's Villa at Poggio a Caiano,* 2 vols. (New York, 1978), now revised as *La villa di Lorenzo de' Medici a Poggio a Caiano,* trans. A. Ducci (Poggio a Caiano, 1992); F. W. Kent, "Lorenzo de' Medici's Acquisition of Poggio a Caiano in 1474 and an Early Reference to His Architectural Expertise," *JWCI* 42 (1979): 250–57.

155. ASF, MaP, XCIII, 308, Otto di Prato to Lorenzo, 20.vi.1477: "in brievi gorni vi manderemo la deliberatione oportunamente per questa communità facta del prato del nostro Spedale della Misericordia, el quale è finitimo a' vostri del Poggio, in quel modo che scriva la vostra Excellentia." See also Lorenzo de' Medici, *Lettere,* 1:437 n. 3.

156. ASF, MaP, XXXIV, 37, Francesco Baroni to Lorenzo, 16.v.1486: "feci la via dal Poggio et primamente andai alla Cascina ove trovai Malherba, il quale ci raccolse lietamente et ci menò per tucto a vedere." The second passage is published in G. Ristori, "Il Carteggio di ser Francesco di ser Barone Baroni," *Rinascimento,* 2d ser., 17 (1977): 279–313 (281). See esp. P. Foster, "Lorenzo de' Medici's *Cascina* at Poggio a Caiano," *MKIF* 14 (1969): 47–56; and D. Lamberini, in *L'architettura di Lorenzo il Magnifico,* ed. G. Morolli, C. Acidini Luchinat, and L. Marchetti (Milan, 1992), 101–2.

157. Antonio Marchetti to Lorenzo, 28.iv.1477, published in Morolli, Acidini Luchinat, and Marchetti, *L'architettura di Lorenzo il Magnifico,* 48.

158. ASF, MaP, XXXV, 907, Antonio Marchetti to Lorenzo, 2.xii.1477: "Alla Cascina sono nati dui altri vitelli, una femmina et uno maschio, col quale s'à a bathezare Belfiore, cioè el luogo della Cascina." See also Lorenzo de' Medici, *Protocolli,* 115, and Lorenzo's letter to Piero Alamanni concerning Malherba's buying one hundred Milanese milk cows (Harvard School of Business Administration, Baker Library, Selfridge Collection, no. 103, 23.viii.1489).

159. R. Schofield has suggested that stylistically the Cascina at Poggio owes a good deal to Lombard examples ("Lodovico il Moro and Vigevano," *Arte Lombarda* 62 [1982]: 93–140 [100]). See also Foster, "Lorenzo de' Medici's Cascina," 52.

160. BNF, Fondo Ginori Conti, 29, 28 bis, fol. 34, Clarice Orsini to Lucrezia Tornabuoni, 24.vi.1480: "Vorrei dicessi a Lorenzo se quando harò finita la bagnatura, ho a stare in villa, ché starei più volentieri al Pogg[i]o che altrove, et farovi venire e fanculli." Lorenzo is recorded as visiting "Ambra" in the month after his purchase (N. Isenberg, "Una corrispondenza inedita di Niccolò Michelozzi: L'assedio di Città

di Castello raccontato dal segretario laurenziano," *Esperienze Letterarie* 10 [1985]: 139–61 [145, 147]).

161. Cino della Zecca to Lucrezia Tornabuoni, in Tornabuoni, *Lettere,* 143, 18.xi.1476: "la città del Poggio." The inventory of 1480 is in ASF, MaP, 104, 53.

162. Bardo Strozzi, quoted in Kent, "Lorenzo de' Medici's Acquisition of Poggio a Caiano," 252.

163. Alberti, quoted in ibid., 250. Cf. *The Letters of the Younger Pliny,* trans. B. Radice (Harmondsworth, 1971), 139–44 (esp. 140).

164. Kent, "Lorenzo de' Medici's Acquisition of Poggio a Caiano," 250–57.

165. Francesco Guicciardini, *Storie fiorentine dal 1378 al 1509,* ed. R. Palmarocchi (1931; reprint, Bari, 1968), 81.

166. Bernardo Rucellai to Lorenzo, published in Kent, "Lorenzo de' Medici's Acquisition of Poggio a Caiano," 254.

167. Lorenzo de' Medici, *Canzoniere,* 20. Vitruvius himself had mentioned Phidias, Polyclitus, and others in his ur-list of Greek painters "who have attained to fame by their art" (Vitruvius, *The Ten Books on Architecture,* trans. M. H. Morgan [1914; reprint, New York, 1960], 69).

168. A. Wright, "A Portrait for the Visit of Galeazzo Maria Sforza to Florence in 1471," in Mallett and Mann, *Lorenzo the Magnificent,* 65–92.

169. ASF, MaP, XXVII, 351, Ludovico da Fuligno, "orifice in Ferrara," to Lorenzo, received 20.vi.1471; Fuligno requested a gift for one of his six daughters in return. See also Fusco and Corti, *Lorenzo de' Medici, Collector,* doc. 11. The same man had earlier sent "teste" to Piero di Cosimo (undated letter in G. Milanesi, ed., *Nuovi documenti per la storia dell'arte toscana dal xii al xv secolo* [Florence, 1901], 95).

170. Elam, "Lorenzo de' Medici's Sculpture Garden," 41–84, esp. 50–51; idem, "Il palazzo nel contesto della città: Strategie urbanistiche dei Medici nel gonfalone del Leon d'Oro, 1415–1530," in Cherubini and Fanelli, *Il Palazzo Medici Riccardi di Firenze,* 44–57. See also above, chap. 1. The play performed at the Carnival of 1477 is mentioned in N. Newbigin, "Plays, Printing, and Publishing, 1485–1500: Florentine sacre rappresentazioni," *La Bibliofilia* 90 (1988): 269–96 (285).

171. L. Vertova, *Maestri toscani del Quattro e Cinquecento* (Florence, 1981), 5. See now Butterfield, *Sculptures of Andrea del Verrocchio;* and Rubin and Wright, *Renaissance Florence,* 148–221.

172. Rubin and Wright, *Renaissance Florence,* 35–36, fig. 14; D. A. Brown, "Verrocchio and Leonardo: Studies for the *Giostra,*" in *Florentine Drawing at the Time of Lorenzo the Magnificent,* ed. E. Cropper (Bologna, 1994), 99–109. See also D. A. Covi, "More about Verrocchio Documents and Verrocchio's Name," *MKIF* 31 (1987): 157–61 (158).

173. Brown, *Leonardo da Vinci,* 64–66.

174. Giorgio Vasari, quoted in F. Caglioti, "Due 'restauratori' per le antichità dei primi Medici: Mino da Fiesole, Andrea del Verrocchio e il 'Marsia rosso' degli Uffizi, I," *Prospettiva* 72 (1993): 17–42 (22).

175. C. de Fabriczy, "Andrea del Verrocchio ai servizi de' Medici," *Archivio Storico dell'Arte* 2, fasc. 1 (1895): 161–76 (167).

176. Lorenzo de' Medici, *Canzoniere,* 89–90; Francesco Petrarca, *Le Rime,* ed. E. Bel-

lorini (Turin, 1929), 1:113–14. See now F. Caglioti, *Donatello e i Medici: Storia del "David" a della "Giuditta,"* 2 vols. (Florence, 2000), 1:326 n. 136.

177. O. Merisalo, *Le collezioni medicee nel 1495: Deliberazioni degli ufficiali dei ribelli* (Florence, 1999), 75–76. Lucrezia died in December 1501 (I. del Lungo, *Gli amori del Magnifico Lorenzo* [Bologna, 1923], 61).

178. D. Carl, *Verrocchio's David* (Florence, 1987). Rubinstein, *Palazzo Vecchio*, 56, supplies the quotation from the contemporary act.

179. See most recently van der Velden, "Medici Votive Images," 126–36.

180. Rubin and Wright, *Renaissance Florence*, 40, 91, fig. 64. See also A. Wright, "Piero de' Medici and the Pollaiuolo," in *Piero de' Medici "il Gottoso" (1416–1469)*, ed. A. Beyer and B. Boucher (Berlin, 1993), 129–49. Federigo's letter of 23.v.1473 is published in P. Viti, "Lettere familiari di Federico da Montefeltro ai Medici," in *Federico di Montefeltro: Lo stato, le arti, la cultura*, ed. G. Cerboni Baiardi, G. Chittolini, and P. Floriani (Rome, 1986), 471–86 (483).

181. Antonio Pollaiuolo to Gentil Virginio Orsini, 13.vii.1494, reprinted in L. D. Ettlinger, *Antonio and Piero Pollaiulo* (London, 1978), 164. For Pollaiulo's relations with Lorenzo, see also C. Elam, "Art and Diplomacy in Renaissance Florence," *RSA Journal* 136 (1988): 813–26 (819, 824 n. 35); E. Borsook, "Two Letters concerning Antonio Pollaiuolo," *BM* 115 (1973): 464–68; and L. Fusco and G. Corti, "Lorenzo de' Medici on the Sforza Monument," *Achademia Leonardi Vinci* 5 (1992): 11–32, esp. 17–18. Misreading Gaye, *Carteggio*, 1:341, generations of scholars have mistakenly attributed the phrase *il principale maestro* to Lorenzo (see E. Frank, "Antonio Pollaiuolo, 'il principale maestro di questa città?'" *Source* 11 [1991]: 14–17).

182. ASF, MaP, LXXXV, 83, Antonia degli Orsi to Lucrezia Tornabuoni, 27.iv.1473: "Madonna [Ginevra] vuole una Nostra Donna di marmo, fatta come quella che à Lorenzo nella chamera, e ella mandò costì ne' dì passati uno suo mandato a cerchare se ne trovava delle fatte e non ne trovò, e dissegli che aveva trovato el maestro che lle faceva. El quale gli disse che llavorava un lavorio di Lorenzo, e che se lLorenzo gli desse licenzia, gli ba[s]tava la vista di servi[r]lla bene e a ttempo. Siché Madonna vi priegha quanto sa e può, che vi sia di piacere di preghar Lorenzo che dica al maestro che lla serva, e questo perchè qui s'usa di da[r]lle alle donne novelle quando vanno a marito. E questo bisogna che ssia fatto per tutto dì 20 di magio. Mandate per Cosimo Bartoli, che llui debe avere avuta una mia lettera, nella quale era la misura della lungheza e della largheza, e in quella diceva come voleva essere fatta. E sse Cosimo non avesse avuta [la] lettera mia, vi dirò come vuole essere fatta grande quanto sia possibile poi al mandarla qua; el marmoro sia bianco e ffine quanto dir si possa, e llavorata proprio in sulla maniera che è quella di Lorenzo." Either Lorenzo did not give his permission or the commission was impossible to complete in the time available. On 15.v.1473 Marco Parenti informed Filippo Strozzi that "ò fatto fare a mona Antonia, tua suocera, uno bel forzerino d'osso a' stanza di madonna Ginevra per la figliuola sua e di messer Santi Bentivoglio: costeràgli più che ducati 25; òllo ancora a mandare" (Marco Parenti, *Lettere*, ed. M. Marrese [Florence, 1996], 243).

183. Rubin and Wright, *Renaissance Florence*, 150–221.

184. U. Middeldorf, *Sculptures from the Samuel H. Kress Collection: European Schools, Four-*

teenth–Nineteenth Century (London, 1976), 31–32. This particular work was much copied. I cannot confidently identify the marble Madonna of 1473 with the several mentioned in the later inventory, *Libro d'inventario dei beni di Lorenzo il Magnifico*, ed. M. Spallanzani and G. Gaeta Bertelà (Florence, 1992).

185. Lorenzo de' Medici, *Protocolli*, 56; an entry of 6 June on the same page suggests that Zanobi was a military engineer.

186. Kent, "Palaces, Politics, and Society," 68–69. For Ercole d'Este's acquiring a Pazzi house through Lorenzo's agency, see T. Tuohy, *Herculean Ferrara: Ercole d'Este, 1471–1505, and the Invention of a Ducal Capital* (Cambridge, 1996), 152.

187. A. Brown, "Cosimo de' Medici's Wit and Wisdom," in *Cosimo "il Vecchio" de' Medici, 1389–1464*, ed. F. Ames-Lewis (Oxford, 1992), 95–113.

188. ASMan, Archivio Gonzaga, 1101, Piero del Tovaglia to the marquis of Mantua, 21.viii.1474: "e alle volte ischerzato mecho nel parllare e dettomi che io non mai churerei di mettere Firenze a saccomanno per fare grande la chasa da Ghonzagha."

189. Lorenzo, published in Roscoe, *Life of Lorenzo de' Medici*, 426.

190. C. Elam and E. Gombrich, "Lorenzo de' Medici and a Frustrated Villa Project at Vallombrosa," in *Florence and Italy*, ed. P. Denley and C. Elam (London, 1988), 481–92 (481).

191. Giovanni Rucellai, published in Kent, "Lorenzo de' Medici's Acquisition of Poggio a Caiano," 253.

CHAPTER FOUR. LORENZO AND THE FLORENTINE
BUILDING BOOM, 1485–1492

1. "[Patente a Luciano Laurana]," ed. A. Bruschi, in *Scritti rinascimentali di architettura*, ed. A. Bruschi and D. De Robertis (Milan, 1978), 20.

2. Opera del Duomo, quoted in M. Haines, "The Builders of S. Maria del Fiore: an Episode of 1475 and an Essay towards Its Context," in *Renaissance Studies in Honor of Craig Hugh Smyth*, ed. A. Morrogh, F. Superbi Gioffredi, P. Morselli, and E. Borsook, 2 vols. (Florence, 1985), 1:89–115 (90).

3. Lorenzo to Piero Molin, 8.vii.1477, in Lorenzo de' Medici, *Lettere*, vol. 2, *1474–1478*, ed. R. Fubini (Florence, 1977), 374.

4. S. Tognetti, "Problemi di vettovagliamento cittadino e misure di politica annonaria a Firenze nel XV secolo (1430–1500)," *ASI* 157 (1999): 419–52 (438–44); and idem, *Il Banco Cambini* (Florence, 1999), 303–7.

5. ASMan, Archivio Gonzaga, 2103, Rodolfo Gonzaga to Federigo Gonzaga, 25.viii.1478: "molti begli palazzi di quelli citadini, tanto è che hano facto e fanno di multi danni."

6. ASF, Provv., Reg., 169, fol. 25r, 23.v.1478: "lumen civitatis nostre."

7. Lorenzo to Pierfilippo Pandolfini, 26.xi.1481, in Lorenzo de' Medici, *Lettere*, vol. 6, *1481–1482*, ed. M. Mallett (Florence, 1990), 100.

8. G. Pieraccini, *La stirpe de' Medici di Cafaggiolo*, new ed., 3 vols. (1924; reprint, Florence, 1986), 1:120ff.; E. Panconesi and L. Marri Malacrida, *Lorenzo il Magnifico in salute e in malattia* (Florence, 1992); M. Martelli, *Studi Laurenziani* (Florence, 1965), esp. 190–223.

9. Lorenzo, letter of 17.iv.1485, in Lorenzo de' Medici, *Lettere*, vol. 8, *1484–1485*, ed. H. Butters (Florence, 2001), 163.

10. M. Tafuri, *Ricerca del Rinascimento* (Turin, 1992), esp. 90–97; see also chap. 5, below.

11. Niccolò Machiavelli, *Istorie fiorentine*, ed. F. Gaeta (Milan, 1962), 573; Bartolomeo Cerretani, *Storia fiorentina*, ed. G. Berti (Florence, 1994), 183.

12. ASF, Corp. relig. soppr., 78, 316, fol. 328, Iacopo Giannotti to Benedetto Dei, 2.vii.1491: "mai si vede tanta nobilità; il mondo non à un altro Firenze."

13. Tognetti, "Problemi di vettovagliamento cittadino," 445.

14. Ugo Caleffini, quoted in T. Tuohy, *Herculean Ferrara: Ercole d'Este, 1471–1505, and the Invention of a Ducal Capital* (Cambridge, 1996), 20 n. 79 (my translation).

15. E. Muir, *Mad Blood Stirring: Vendetta and Factions in Friuli during the Renaissance* (Baltimore, 1993), 95.

16. ASF, MaP, XXXVIII, 63, Gabriele Ginori to Lorenzo, 18.xii.1480.

17. A. Marquand, *Robbia Heraldry* (1912; reprint, New York, 1972), 93–94.

18. For these and similar descriptions, see F. W. Kent, "Patron-Client Networks in Renaissance Florence and the Emergence of Lorenzo as 'Maestro della Bottega,'" in *Lorenzo de' Medici: New Perspectives*, ed. B. Toscani (New York, 1993), 279–313; and idem, "'Lorenzo . . . , amico degli uomini da bene': Lorenzo de' Medici and Oligarchy," in *Lorenzo il Magnifico e il suo mondo*, ed. G. C. Garfagnini (Florence, 1994), 43–60.

19. Alessandro Cortesi, quoted in A. Brown, *The Medici in Florence: The Exercise of Language and Power* (Florence, 1992), 260. The phrase "leader of the Senate" was also Cortesi's.

20. Antonio da Bibbiena, published in *Miscellanea Fiorentina di Erudizione e Storia* 2, fasc. 21 (1899), ed. I. del Badia, 142.

21. Manfredo de' Manfredi to Ercole d'Este, 18.v.1490, published in A. Cappelli, "Lettere di Lorenzo de' Medici conservate nell'Archivio Palatino di Modena," *Atti e Memorie delle RR Deputazioni di Storia Patria per le Provincie di Modena e Parma* (sez. di Modena) 1 (1863): 231–320 (308).

22. ASM, Archivio Sforzesco, 311, Branda da Castiglione to the duke of Milan, 3.vi.1490: "non proponendoli per li examinatori titulo alcuno sopra che lo examinassero ma solo examinandolo che dicesse quello sapeva." Other letters in this archival collection refer to the incident.

23. Carlo Martelli, quoted in F. W. Kent, "Palaces, Politics, and Society in Fifteenth-Century Florence," *I Tatti Studies* 2 (1987): 41–70 (69). See also Tuohy, *Herculean Ferrara*, 152.

24. Bartolomeo Scala, will of 25.xi.1484, published in Bartolomeo Scala, *Humanistic and Political Writings*, ed. A. Brown (Tempe, Ariz., 1997), 481. In 1483 Dionisio Pucci's testament gave Lorenzo certain rights to decide how a pious bequest should be distributed (A. Luchs, *Cestello: A Cistercian Church of the Florentine Renaissance* [New York, 1977], 59, 172 n. 46).

25. ASF, Notarile Antecos., 1740, fol. 394v, will of Rinaldo detto Ballerino de' Nerli, 27.v.1489: "e questo perché Lorenzo né figluoli non mi dimentichino sti [*sic*] tosto."

26. E. H. Gombrich, "The Early Medici as Patrons of Art," in *Italian Renaissance Studies*, ed. E. F. Jacob (London, 1960), 279–311; E. B. Fryde, *Humanism and Renaissance Historiography* (London, 1983), chap. 6. These accounts are based on R. de Roover's classic book *The Rise and Decline of the Medici Bank, 1397–1494* (Cambridge, Mass., 1963), chap. 14. See also R. Goldthwaite, "The Medici Bank and the World of Florentine Capitalism," *Past and Present*, no. 114 (1987): 3–31; and, more generally, idem, "Lorenzo Morelli, ufficiale del Monte, 1484–88: Interessi privati e cariche pubbliche nella Firenze Laurenziana," *ASI* 154 (1996): 605–33.

27. Lorenzo to Iacopo Guicciardini, 19.vi.1486, published in J. Paoletti, "The Banco Mediceo in Milan: Urban Politics and Family Power," *Journal of Medieval and Renaissance Studies* 24 (1994): 199–238 (236), which tells the whole story.

28. Lorenzo to Giovanni Lanfredini, 8.viii.1488, published in M. M. Bullard, *Lorenzo il Magnifico: Image and Anxiety, Politics and Finance* (Florence, 1994), 175–76; see also, in general, x, 62, 64, and 170ff.

29. A. Brown, "Lorenzo and the Monte: Another Note," *Rinascimento*, 2d ser., 38 (1998): 517–22 (521), a response to G. Ciappelli and A. Molho, "Lorenzo de' Medici and the Monte: A Note on Sources," ibid. 37 (1997): 243–82. See also Brown's earlier *Medici in Florence*, 151–211, and now her "Lorenzo de' Medici's New Men and Their Mores: The Changing Lifestyle of Quattrocento Florence," *RS* 16 (2002): 113–42, esp. 134–37.

30. Piero Parenti, quoted in Brown, "Lorenzo and the Monte," 521.

31. Document of 28.ii.1496, published in C. Elam, "Lorenzo de' Medici's Sculpture Garden," *MKIF* 36 (1992): 41–84 (49–50, 80).

32. ASF, Corp. relig. soppr., 488, 319, a declaration to the syndics of Piero de' Medici's heirs dated 1490, though it must have been written after 1494: "comincarono a edificare et fare contro al dovere et in danno di detto monasterio et sanza detta autorità et sanza pagare alcuno prezzo." See also Luchs, *Cestello*, 13, 134–35 n. 27, 341. For another such case of nonpayment, see ASF, Provv., Reg., 187, fols. 59v–60v, 17.viii.1496.

33. Letter quoted in L. Böninger, "Francesco Cambini (1432–1499): Doganiere, commissario, ed imprenditore fiorentino nella 'Pisa Laurenziana,'" *Bollettino Storico Pisano* 67 (1998): 21–55 (29 n. 37).

34. Giovanni Soldi, representing the Calimala Guild, quoted in P. Foster, "I primi Medici e un 'albergo magno' per Firenze," *ASI* 129 (1971): 519–25 (520). See also ASF, Miscellanea Repubblicana, 109, fol. 72v, 9.vii.1482, a document first brought to my attention by Anthony Molho, which repeats that "quando et come potrà comodamente, [Lorenzo] debbe far fare uno abergo magno et degno nella città di Firenze."

35. Caleffini, quoted in Tuohy, *Herculean Ferrara*, 20 n. 79 (my translation).

36. Lorenzo de' Medici, *Lettere*, vol. 4, *1479–1480*, ed. N. Rubinstein (Florence, 1981), 34, 73, refers to the pope's scheme. The quotation is in ibid., *Lettere*, vol. 5, *1480–1481*, ed. M. Mallett (Florence, 1989), 238, 28.vi.1481. During late 1484, after Sixtus's death, Lorenzo did commission windows bearing (Medici?) arms in Saint Peter's at Rome (E. Müntz, "Le arti in Roma sotto il pontificato d'Innocenzo VIII [1484–1492]," *Archivio Storico dell'Arte* 2 [1889]: 485).

37. C. O'Brien, "Lorenzo's Book: A Medicean Manuscript of the 'Augustan History,'" *La Trobe Library Journal* 13 (1993): 72–77; idem, no. 31, *Scriptores Historiae Augustae,* entry in M. M. Manion and V. F. Vines, *Medieval and Renaissance Illuminated Manuscripts in Australian Collections* (London, 1984), 89–91. I owe to Margaret Manion the information that the late A. C. de la Mare believed these glosses were by Poliziano.

38. Luca Pacioli, "De divina proportione," ed. A. Bruschi, in Bruschi and De Robertis, *Scritti rinascimentali di architettura,* 123.

39. ASF, Map, LIX, 211 bis, Lorenzo to Giovanni Lanfredini, 8.viii.1488: "Io ho indugiato a rispondere ad alcune vostre lettere ricevute da più dì in qua per le medesime cagioni che sapete, perché l'animo mio quando è molto occupato in una cosa non fa bene le altre."

40. Lorenzo to Baccio Pontelli, in Lorenzo de' Medici, *Protocolli del Carteggio di Lorenzo il Magnifico per gli anni 1473–74, 1477–92,* ed. M. del Piazzo (Florence, 1956), 152. Six years later Lorenzo again gratefully thanked Pontelli, in Urbino, "pe' disegni havuti" (ibid., 160). For Filarete, see his *Trattato di architettura,* ed. A. M. Finoli and L. Grassi, 2 vols. (Milan, 1972), 1:41.

41. Pontelli to Lorenzo, 18.vi.1481, published in G. Gaye, *Carteggio inedito d'artisti de secoli xiv, xv, xvi,* 3 vols. (Florence, 1839), 1:274–75.

42. H. Saalman, "Alberti's San Sebastiano in Mantua," in Morrogh et al., *Renaissance Studies in Honor of Craig Hugh Smyth,* 2:645–50 (645).

43. Ibid.

44. Lorenzo to Niccolò Michelozzi, 16.ix.1485, in Lorenzo de' Medici, *Lettere,* 8:280–81, a famous letter first brought to light by M. Martelli in "I pensieri architettonici del Magnifico," *Commentari* 17 (1966): 107–11 (108). H. Butters, in Lorenzo de' Medici, *Lettere,* 8:281 n. 22, demonstrates that the "gamberi" were for Lorenzo's "nuova posesione" of Poggio. An earlier Laurentian letter, of 11 September, similarly exhorted Michelozzi—"Sollecita Francesco orafo nella camera mia"—which suggests that Lorenzo may not in fact have been referring to the model on which Giuliano was working (ibid., 267).

45. Lorenzo to Michelozzi, 29.iv.1485, quoted in Martelli, *Studi Laurenziani,* 194.

46. The quotation is published in Pieraccini, *La stirpe de' Medici,* 1:122.

47. P. Morselli and G. Corti, *La chiesa di Santa Maria delle Carceri in Prato* (Florence, 1982), esp. chap. 3; but see also P. Davies, "The Early History of S. Maria delle Carceri in Prato," *Journal of the Society of Architectural Historians* 54 (1995): 326–35. Martelli, "Pensieri architettonici," 107–11, suggested that it was the villa that preoccupied Lorenzo in September 1485. J. S. Ackerman, *The Villa* (Princeton, 1990), 290 n. 28, thinks it "more probable" that the reference was to the Prato project. For the contemporary accounts mentioning Lorenzo's interventions, see L. Bandini, "Il quinto centenario della 'mirabilissima apparitione,'" *Archivio Storico Pratese* 59–60 (1983–84): 55–96.

48. Luca Landucci, *Diario fiorentino dal 1450 al 1516,* ed. I. del Badia (1883; reprint, Florence, 1969), 47–48; R. Chavasse, "The Virgin Mary: Consoler, Protector, and Social Worker in Quattrocento Miracle Tales," in *Women in Italian Renaissance Culture and Society,* ed. L. Panizza (Oxford, 2000), 138–64, esp. 141–43, 154–55, 158; "Lauda di Sancta Maria dalla Carcere," *Archivio Storico Pratese* 53 (1977): 87–89.

49. R. Wittkower, *Architectural Principles in the Age of Humanism* (London, 1967), 19–21; A. Bruschi, "Religious Architecture in Renaissance Italy from Brunelleschi to Michelangelo," in *The Renaissance from Brunelleschi to Michelangelo: The Representation of Architecture*, ed. H. A. Millon and V. Magnago Lampugnani (Milan, 1994), 123–81; M. Trachtenberg, "On Brunelleschi's Old Sacristy as Model for Early Renaissance Church Architecture," in *L'église dans l'architecture de la Renaissance, De Architectura 7* (1995): 9–39, esp. 30–31. For Lorenzo's request, see his *Protocolli*, 333, on which see P. Foster, "Alberti, Lorenzo de' Medici, and Santa Maria delle Carceri in Prato," *Journal of the Society of Architectural Historians* 30 (1971): 238–39. P. Davies, "The Madonna delle Carceri in Prato and Italian Renaissance Pilgrimage Architecture," *Architectural History* 36 (1993): 1–18, suggests sources for the church other than San Sebastiano in Mantua. The review of Morselli and Corti's *La chiesa di Santa Maria delle Carceri in Prato* by L. Pellecchia in the *Journal of the Society of Architectural Historians* 44 (1985): 184–86, is a penetrating contribution to our understanding of the church's building history. Also helpful are G. Bardazzi, E. Castellani, and F. Gurrieri, *Santa Maria delle Carceri in Prato* (Prato, 1978); and I. Lapi Ballerini, "La fondazione di Santa Maria delle Carceri a Prato," in *L'architettura di Lorenzo il Magnifico*, ed. G. Morolli, C. Acidini Luchinat, and L. Marchetti (Milan, 1992), 102–8.

50. For Lorenzo's interventions in 1485 and 1488, see respectively, R. Pacciani, "Lorenzo il Magnifico: Promotore, fautore, 'architetto,'" in *Il principe architetto*, ed. A. Calzona, F. P. Fiore, A. Tenenti, and C. Vasoli (Florence, 2002), 377–411 (398); and the document in Morselli and Corti, *La chiesa di Santa Maria delle Carceri*, 109–11. On Carlo de' Medici, see ibid., 14–15; and Davies, "Early History," 326–35. For later Medici interest, see P. Morselli, "Immagini di cera votive in S. Maria delle Carceri di Prato nella prima metà del '500," in Morrogh et al., *Renaissance Studies in Honor of Craig Hugh Smyth*, 2:327–38. See also G. Marchini, "Della costruzione di S. Maria delle Carceri in Prato," *Archivio Storico Pratese* 14 (1936): 53–64. The decision to appoint da Sangallo in place of da Maiano signaled Prato's final loss of cultural autonomy to Florence and the Medici, according to Pratese historiography (L. Bellosi, A. Angelini, and G. Ragionieri, "Le arti figurative," in *Prato: Storia di una città*, ed. G. Cherubini [Prato, 1993], I, pt. 1:947).

51. See above, chap. 2.

52. Letter of Piero da Bibbiena to Niccolò Michelozzi, published in Martelli, "Pensieri architettonici," 107. For the first edition, see A. Lenzuni, ed., *All'ombra del Lauro: Documenti librari della cultura in età laurenziana* (Milan, 1992), 125–26.

53. I owe this point to C. M. Rosenberg, *The Este Monuments and Urban Development in Renaissance Ferara* (Cambridge, 1997), 257 n. 101.

54. M. Folin, "Ferrara: 1385–1505: All' ombra del principe," in *Fabbriche, piazze, mercati: La città italiana nel Rinascimento*, ed. D. Calabri (Rome, 1997), 354–88 (381 n. 47); Tuohy, *Herculean Ferrara*, 293. For Morolli, see C. Acidini Luchinat, ed., *Renaissance Florence: The Age of Lorenzo de' Medici, 1449–1492* (Milan, 1993), 43.

55. Pacioli, "De divina proportione," 123. See also Martelli, "Pensieri architettonici," 107–11.

56. Letter published in F. W. Kent, "'Più superba de quella de Lorenzo': Courtly

and Family Interest in the Building of Filippo Strozzi's Palace," *RQ* 30 (1977): 311–23 (317).

57. Tuohy, *Herculean Ferrara,* 277ff., champions Ercole's claims, as does Rosenberg, *Este Monuments,* 110, 148–52, though more cautiously (he cites Eleonora d'Aragona on 278 n. 214). For Gonzaga as "intendentissimo nello edificare," see A. Calzona, "Ludovico II Gonzaga Principe 'intendentissimo nello edificare,'" in Calzona et al., *Il principe architetto,* 257–77; L. Volpi Ghirardini, "La presenza di Ludovico II Gonzaga nei cantieri delle chiese albertiane di San Sebastiano e di Sant'Andrea," in ibid., 279–96; and G. Ferlisi, "I palazzi dei cortegiani e le scelte architettoniche e urbanistiche di Ludovico Gonzaga," in ibid., 297–326.

58. One of the Alberti, Jacopo di Caroccio, appears to have made a wooden model for a chapel in the late Trecento (G. B. Ristori, "Sancta Maria delle gratie," in del Badia, *Miscellanea Fiorentina di Erudizione e Storia,* 158–59). In a letter to Machiavelli of 1508, Biagio Buonacorsi mocks "quel matto di ser Antonio della Valle" for having "facto uno modello d'uno ponte, et vuol fare uno ponte levatoio sopr' Arno: et non se li può cavare del capo, in modo dubito non c'impazi su" (quoted in Consiglio Nazionale del Notariato, ed., *Il Notariato nella Civiltà Italiana* [Milan, 1961], 227). See also N. Rubinstein, *The Palazzo Vecchio, 1298–1532* (Oxford, 1995), 94.

59. Niccolò Valori, *Vita di Lorenzo de' Medici,* ed. E. Niccolini (Vicenza, 1991), 72, 127; L. Fusco and G. Corti, *Lorenzo de' Medici, Collector and Antiquarian* (New York, 2004), chap. 6, n. 9.

60. Fusco and Corti, *Lorenzo de' Medici, Collector,* chap. 4, iv.

61. Luca Fancelli to Lorenzo, 1487, in Luca Fancelli, *Luca Fancelli—architetto: Epistolario Gonzaghesco,* ed. C. Vasic Vatovec (Florence, 1979), 60–62.

62. J. S. Ackerman, "'Ars sine scientia nihil est': Gothic Theory of Architecture at the Cathedral of Milan," *AB* 31 (1949): 84–111.

63. Martelli, "Pensieri architettonici," 107–11; Morselli and Corti, *La chiesa di Santa Maria delle Carceri,* chap. 3; M. Hollingsworth, "The Architect in Fifteenth-Century Florence," *Art History* 7 (1984): 385–410, esp. 403–5; Ackerman, *Villa,* 79; B. L. Brown, "An Enthusiastic Amateur: Lorenzo de' Medici as Architect," *RQ* 46 (1993): 1–22; S. Frommel, "Lorenzo il Magnifico, Giuliano da Sangallo e due progetti per ville del codice barberiniano," in Calzona et al., *Il principe architetto,* 413–54. In my view, however, the last two scholars overclaim for Lorenzo as "principe architetto"; see the salutary caution of Pellecchia on this subject in the review cited in n. 49 above. George Washington, a surveyor by training, to be sure, has also recently been described as an "architect" (R. F. Dalzell and L. Baldwin Dalzell, *George Washington's Mount Vernon* [New York, 1998], chap. 4).

64. Matteo Franco, *Lettere,* ed. G. Frosini (Florence, 1990), 73.

65. Giuliano da Sangallo to Lorenzo, May 1486, published in G. Uzielli, *Paolo del Pozzo Toscanelli* (Florence, 1892), 123–25. For another explanation, see Hollingsworth, "Architect," 395.

66. Archivio dell'Opera del Duomo, Florence, II, 2, 7, fols. 13v–14r, 25v.

67. The last quotation is published by Gaye, *Carteggio,* 1:301. S. Borsi, *Giuliano da Sangallo: I disegni di architettura e dell'antico* (Rome, 1985), 395–404, cites da Sangallo and dis-

cusses the plan. Giuliano was back in Florence by March (Kent, "Più superba de quella de Lorenzo," 322 n. 43).

68. Gaye, *Carteggio*, 1:303–4.

69. Lorenzo to Lodovico il Moro, October 1492, published in L. H. Heydenreich, "Giuliano da Sangallo in Vigevano, ein neues Dokument," in *Scritti di storia dell'arte in onore di Ugo Procacci*, ed. M. G. Ciardi Dupré dal Poggetto and P. dal Poggetto (Florence, 1977), 2:321–23. See also C. de Fabriczy, "Progetto di Giuliano da Sangallo per un palazzo a Milano," *Rassegna d'Arte* 3 (1903): 5–6.

70. Louis de Rouvroy, duc de Saint-Simon, *Saint-Simon at Versailles*, trans. L. Norton (Harmondsworth, 1985), 143–45. Dale Kent speaks of the "patron's oeuvre" with reference to Lorenzo's grandfather Cosimo in *Cosimo de' Medici and the Florentine Renaissance: The Patron's Oeuvre* (New Haven, Conn., 2000), 3. In Morolli, Luchinat, and Marchetti, *L'architettura di Lorenzo*, we read of "la colta maniera architettonica laurenziana" (137).

71. Francesco Baldovinetti, published in C. von Fabriczy, "Aus dem Gedenkbuch Francesco Baldovinettis," *Repertorium für Kunstwissenschaft* 28 (1905): 539–44 (543).

72. Giovanni Sabadino degli Arienti, *De triumphis religionis ad illustrissimum principem Herculem Estensem Ferrariae Ducem*, ed. W. Gundersheimer, in *Art and Life at the Court of Ercole d'Este* (Geneva, 1972), 75.

73. ASF, Provv., Reg., 180, fol. 8r–v, 8.iv.1489: "ad aedificationem et ornamentum" (concerning the convent of San Gallo); see also fols. 8v–9v, 28v, 41v–42v, 125r.

74. Kent, "Più superba de quella de Lorenzo," 315.

75. ASF, Corp. relig. soppr., 78, 316, fol. 305, Iacopo Giannotti to Benedetto Dei, 22.ix.1489: "che conta il numero delle muragle degne si fabricano in quella et per quella città in essa et fuori . . . chè veramente è grandissimo honore di quella repu[bblica]; Dio tutto concede fruire in pace et il simile et meglio possin fare in omni stagione i cittadini prexenti e i loro posteriori."

76. Landucci, *Diario fiorentino*, 57–59.

77. Francesco Baldovinetti, list published in von Fabriczy, "Aus dem Gedenkbuch Francesco Baldovinettis," 543–44 (Palazzos Strozzi and Gondi, Lorenzo's urban project); Benedetto Dei, "Storia fiorentina," Biblioteca Comunale degli Intronati, Siena, MS I.VI.35, fols. 43r–113v, s.a. 1489 (Sarzana and Firenzuola fortresses, Palazzos Strozzi and Gondi, convent of San Gallo, new sacristy of Santo Spirito; Dei is unusual in *not* mentioning the villa of Poggio a Caiano and Lorenzo's urban project). Machiavelli, *Istorie fiorentine*, mentions Lorenzo's country estates and villas, his urban schemes, his interest in fortifications, and his building the convent of San Gallo (574–75). See also Tribaldo de' Rossi, *Ricordanze*, vol. 23 of *Delizie degli eruditi toscani*, ed. I. di San Luigi (Florence, 1786), 248–50, 253–54, 256–57, 272.

78. Francesco Guicciardini, *Storie fiorentine dal 1378 al 1509*, ed. R. Palmarocchi (1931; reprint, Bari, 1968), 76.

79. Suetonius, *The Lives of the Caesars*, ed. and trans. J. C. Rolfe, 2 vols. (London, 1960), 1:169.

80. Lorenzo Strozzi, *Vita di Filippo Strozzi il Vecchio scritta da Lorenzo suo figlio*, ed. G. Bini and P. Bigazzi (Florence, 1851), 23–25.

81. Tafuri, *Ricerca*, 96. Tafuri's few pages on Lorenzo and architecture (90–97)

remain a masterpiece of intelligent compression. However, see now C. Elam, "Lorenzo's Architectural and Urban Policies," in Garfagnini, *Lorenzo il Magnifico*, 357–84, esp. 369.

82. The legislation is published in G. C. Romby, *Per costruire ai tempi di Brunelleschi* (Florence, 1979), 41–42.

83. Ibid., 41. See, generally, Elam, "Lorenzo's Architectural and Urban Policies," 368–71.

84. C. Elam, "Lorenzo de' Medici and the Urban Development of Renaissance Florence," *Art History* I (1978): 47; for the document, of 29.x.1491, see ibid., 60–61 n. 26. Idem, "Lorenzo's Architectural and Urban Policies," revisits this and related themes.

85. F. W. Kent, "Lorenzo de' Medici at the Duomo," in *La cattedrale e la città: Saggi sul Duomo di Firenze, atti del VII centenario del Duomo di Firenze,* ed. T. Verdon and A. Innocenti, 3 vols. (Florence, 2001), 1:341–68 (348).

86. ASF, Consiglio del Cento, Registri, 3, fol. 117v: "s'è ordinato fare una via molto bella, et è giudicato esser bene nel cortile dell'entrata d'Orbatello aprire la via la quale riesca in questa nuova via . . . et puossi fare molto comodamente et sarà molto honorevole. . . ; [the Guelf Party captains are instructed that] . . . qualunque volta ne saranno richiesti da chi fa fare le detta nuova via . . . faccino aprire detta via d'Orbatello in quella forma et modo ch'è disegnato, rassettando la porta dinanza di Orbatello con le sue armi in modo che stia bene, spendendo de' denari della Parte per tale rassettamento quanto fusse di bisognio." Elam, "Lorenzo's Architectural and Urban Policies," 372 n. 62, refers to this matter, citing a version of the document from the archive of the Guelf captains.

87. Published in Elam, "Lorenzo de' Medici and the Urban Development of Renaissance Florence," 61, n. 27, from ASF, Balìe, 39, fol. 11r (another version is in ASF, Consiglio del Cento, Registri, 3, fols. 128v–129r).

88. ASF, Corp. relig. soppr., 78, 316, fol. 332, 4.viii.1491: "la città [è] sana e abundante e iocunda; le muraglie si tirano avanti." Cambi's comment is in *Istorie,* vol. 20 of *Delizie degli eruditi toscani,* ed. I. di San Luigi (Florence, 1785), 61–62; the guild's tax report of 1498 explained the situation (G. Carocci, "La famiglia Medici in possesso di vari beni dell'Arte del Cambio," *Arte e Storia,* 3d ser., 19 [1900]: 110). See, generally, Elam, "Lorenzo's Architectural and Urban Policies," 372–74.

89. See, for just one example, Lorenzo to Girolamo Morelli, 29.vii.1478, in Lorenzo de' Medici, *Lettere,* vol. 3, *1478–1479,* ed. N. Rubinstein (Florence, 1977), 149.

90. The quotation is from L. Pellecchia, "Designing the Via Laura Palace: Giuliano da Sangallo, the Medici, and Time," in *Lorenzo the Magnificent: Culture and Politics,* ed. M. Mallett and N. Mann (London, 1996), 37–63 (42). See also Elam, "Lorenzo's Architectural and Urban Policies," 374–82.

91. L. Pellecchia, "A Villa for the City: Giuliano da Sangallo's Medicean Project for the Via Laura," in Millon and Magnago Lampugnani, *The Renaissance from Brunelleschi to Michelangelo,* 672–73. See esp. Pellecchia, "Designing the Via Laura Palace"; and idem, "Reconstructing the Greek House: Giuliano da Sangallo's Villa for the Medici in Florence," *Journal of the Society of Architectural Historians* 52 (1993): 323–38. Elam,

"Lorenzo's Architectural and Urban Policies," argues similarly (374–82). See also Borsi, *Giuliano da Sangallo,* 441–53. For an urbanistic reordering of the district sketched for the Medici about 1515 by Leonardo da Vinci, see H. A. Millon and C. H. Smyth, *Michelangelo Architect: The Façade of San Lorenzo and the Drum and Dome of St. Peter's* (Milan, 1988), 41–44; and C. Pedretti, *Leonardo architetto* (New York, 1985), 250–55.

92. C. W. Westfall, *In This Most Perfect Paradise: Alberti, Nicholas V, and the Invention of Conscious Urban Planning in Rome, 1447–55* (University Park, Pa., 1974); for Pienza, see above, chap. 2.

93. Baldassare Castiglione, *Il libro del cortegiano,* ed. E. Bonora (Milan, 1981), 33. For the Urbino design, see above, this chapter.

94. Arienti, *De triumphis religionis,* 75.

95. See, most recently, G. Clarke, "Magnificence and the City: Giovanni II Bentivoglio and Architecture in Fifteenth-Century Bologna," *RS* 13 (1999): 397–411; and I. Robertson, *Tyranny under the Mantle of St. Peter: Pope Paul II and Bologna* (Turnhout, 2002), 89–98. See also W. E. Wallace, "The Bentivoglio Palace Lost and Reconstructed," *Sixteenth Century Journal* 10 (1979): 97–114; and C. James, "The Bentivoglio Palace in 1487," *MKIF* 40 (1997): 188–96.

96. Giovanni Pietro Cagnola, quoted in P. Pissavino, "Piazza e Potere," in *Vigevano e i territori circostanti alla fine del Medioevo,* ed. G. Chittolini (Abbiategrasso, 1997), 325–32 (326). See also R. Schofield, "Ludovico il Moro and Vigevano," *Arte Lombarda* 62 (1982): 93–140; L. Giordano, "Il rinnovamento promosso da Lodovico Sforza: Ipotesi per Bramante," in *Metamorfosi di un borgo: Vigevano in età visconteo-sforzesca,* ed. G. Chittolini (Milan, 1992), 289–323; and idem, "Milano, Pavia, Vigevano: le piazze lombarde. Linee di sviluppo di tre esempi storici," in *Fabbriche, piazze, mercati: La città italiana nel Rinascimento,* ed. D. Calabi (Rome, 1997), 103–29.

97. Tuohy, *Herculean Ferrara,* xv.

98. Rosenberg, *Este Monuments,* 130ff.

99. Tuohy, *Herculean Ferrara,* 179, 291. Niccolò Guicciardini reported to his kinsman Piero that the duke had visited Santo Spirito, which was the principal church of their quarter (Archivio Guicciardini, Florence, Legazioni e Commissarie, I, fol. 111, 7.iv.1492).

100. Arienti, *De triumphis religionis,* 75.

101. Rosenberg, *Este Monuments,* 130ff.; Tuohy, *Herculean Ferrara,* 134–38.

102. Rosenberg, *Este Monuments,* 140–41.

103. The phrase is Patricia Simon's, used of the Medici in general ("Portraiture and Patronage in Quattrocento Florence with Special Reference to the Tornaquinci and Their Chapel in S. Maria Novella" [Ph.D. thesis, University of Melbourne, 1985], 77). See also the insightful remarks of F. Ames-Lewis, "Lorenzo de' Medici Quincentenary," *Apollo* 136 (1992): 113–16; and A. Wright, "A Portrait for the Visit of Galeazzo Maria Sforza to Florence in 1471," in Mallett and Mann, *Lorenzo the Magnificent,* 65–92 (esp. 75, 80).

104. See the splendid analysis by A. Luchs, "Lorenzo from Life? Renaissance Portrait Busts of Lorenzo de' Medici," *Sculpture Journal* 4 (2000): 6–23. See also J. Warren, "A Portrait Bust of Lorenzo de' Medici in Oxford," ibid. 2 (1998): 1–12; and

V. Thomas, "Lorenzo de' Medici and the Rhetoric of Portraiture" (M.A. report, Courtauld Institute of Art, 1999), which the author kindly allowed me to read.

105. Luchs, "Lorenzo from Life?" 10–11, with illustration. See also R. Hatfield, *Botticelli's Uffizi "Adoration"* (Princeton, 1976), 73–83.

106. Luchs, "Lorenzo from Life?" 18; U. Middeldorf, *Sculptures from the Samuel Kress Collection: European Schools Fourteenth–Nineteenth Century* (London, 1976), 43–45.

107. ASF, Notarile Antecos., 15041, 25.viii.1489: "in utilitatem dicti hospitalis et in [h]onorem Dei et utilitatem totius civitatis Florentie et civium eiusdem." See too ASF, Provv., Reg., 187, fols. 59v–60v, 17.viii.1496.

108. Bartolomeo Dei to Benedetto Dei, 21.viii.1488, published in F. W. Kent, "New Light on Lorenzo de' Medici's Convent at Porta San Gallo," *BM* 124 (1982): 292–94 (292), the first of many such accounts repeated in numerous contemporary and near contemporary sources, including private records; see, e.g., Margherita Soderini's note of 1489 published in Z. Zafarana, "Per la storia religiosa di Firenze nel Quattrocento," *Studi Medievali*, 3d ser., 9 (1968): 1017–1113 (1104). See also K. J. P. Lowe, "Patronage and Territoriality in Early Sixteenth-Century Florence," *RS* 7 (1993): 258–71. It was perhaps no coincidence that during 1489 the Florentine government made extensive repairs to the San Gallo gate, describing it as not only one of the principal entrances to the city but "quasi la più frequentata" (ASF, Provv., Reg., 179, fol. 101v, 20.ii.1489; ibid., 180, fols. 62r–63r, 16.ix.1489).

109. Giovanni Sabadino degli Arienti to Benedetto Dei, 30.iv.1491, in Giovanni Sabadino degli Arienti, *The Letters of Giovanni Sabadino degli Arienti (1481–1510)*, ed. C. James (Florence, 2002), 118. See also D. A. Perini, *Un emulo di fra Girolamo Savonarola: Fra Mariano da Gennazzano* (Rome, 1917); and Lorenzo's undated letter to the Pope praising Fra Mariano, published in Fabroni, *Laurentii Medicis Magnifici Vita*, 2:290.

110. G. M. Montano, *Motivo Francescano in Piazza San Gallo* (Florence, 1955), 83–87, describes the opposition. Concerning the nonpayment, see ASF, Provv., Reg., 187, fols. 59v–60v, 17.viii.1496.

111. The document is published in N. Rubinstein, "Lay Patronage and Observant Reform in Fifteenth-Century Florence," in *Christianity and the Renaissance*, ed. T. Verdon and J. Henderson (Syracuse, N.Y., 1990), 63–82 (73, 80, n. 61). Some communal assistance was granted San Gallo on 8.iv.1489 to provide food and cloths "et ad aedificationem et ornamentum ipsorum loci et ecclesiae spectantibus" (ASF, Provv., Reg., 180, fol. 8r–v).

112. Kent, "New Light," 293.

113. Giorgio Vasari, *Le opere di Giorgio Vasari*, ed. G. Milanesi (Florence, 1906), 4:274–75. Benedetto Varchi, *Storia fiorentina* (Milan, 1803), 3:56, names Giuliano as "the architect." On the plans, see Borsi, *Giuliano da Sangallo*, 499–502. John Shearman believes a likeness of the church may be preserved in a contemporary drawing (*Raphael's Cartoons in the Collection of Her Majesty the Queen and the Tapestries for the Sistine Chapel* [London, 1972], 84 and fig. 54).

114. Francesco Castelli to Eleonora, duchess of Ferrara, 4.iv.1492, published in C. de Fabriczy, "Il convento di Porta San Gallo a Firenze," *L'Arte* 6 (1903): 381–84 (383). See also Tuohy, *Herculean Ferrara*, 179, 291, 483. Giovanluca Pozzi reported to the

duchess of Ferrara on 4.iv.1492 that the monastery "è novo et bellissimo" (ASMod, Ambasciatori, 10).

115. R. M. Zaccaria and L. Lenza, "Lorenzo per Pico," in *Pico, Poliziano e l'umanesimo di fine Quattrocento,* ed. P. Viti (Florence, 1994), 59–84 (83–84); Rubinstein, "Lay Patronage and Observant Reform," 73–74.

116. ASF, MaP, XL, 351, Fra Mariano to Lorenzo, 20.vi.1488: "non mancho per amor come figliuolo che per reverentia come servo." Concerning the sermon, see N. Rubinstein, *The Government of Florence under the Medici, 1434–94* (Oxford, 1966), 217–18, 321.

117. Kent, "New Light," 294. Another close Medici associate also became involved. On 17.iii.1494 Fra Mariano wrote to the Medici secretary Piero da Bibbiena describing the monastery as "più vostro che nostro" and urging him to ensure that "la vostra capella sia posta" (ASF, MaP, CXXIV, 100, a reference I owe to Alison Brown's kindness).

118. ASF, Corp. relig. soppr., 78, 316, fol. 327r, Iacopo Giannotti to Benedetto Dei, 9.iii.1492: "là sarà il fiore della città."

119. Michele Verino, cited by A. F. Verde, *Lo studio fiorentino, 1473–1503,* 5 vols. (Florence, 1973–94), 3, pt. 2:696–708.

120. H. Saalman, *Filippo Brunelleschi: The Buildings* (London, 1993), 401–4, suggests that Lorenzo may have planned to finish the Florentine building in the 1480s. The Benedictine wrote that Lorenzo "fece muraglie acchiese e monasteri, e massimo a San Ghallo e Agniano di Val di Calci e agli Angioli di Firenze" (L. Pagliai, "Da un libro di ricordi del monastero di S. Benedetto," *Rivista d'Arte* 6 [1909]: 246). For Lorenzo and Assisi, see H. van der Velden, "Medici Votive Images and the Scope and Limits of Likeness," in *The Image of the Individual: Portraits in the Renaissance,* ed. N. Mann and L. Syson (London, 1998), 126–36; and B. Bughetti, "Assisi e Casa Medici," *Studi Francescani* 35 (1938): 49–60.

121. F. W. Kent, "Lorenzo de' Medici, Madonna Scolastica Rondinelli e la politica di mecenatismo architettonico nel convento delle Murate a Firenze (1471–72)," in *Arte, committenza ed economia a Roma e nelle corti del Rinascimento (1420–1530),* ed. A. Esch and C. L. Frommel (Turin, 1995), 353–82 (354–55).

122. Ibid., 354, 373 n. 9. See, however, L. Borgo, "Giuliano da Maiano's Santa Maria del Sasso," *BM* 114 (1972): 448–52; and B. Giordano, *Il santuario e il convento di S. Maria del Sasso in Bibbiena* (Cortona, 1984).

123. The prior of San Lorenzo noted that on 10.iii.1491 "mi dè Lorenzo de' Medici la cura del votare la chiesa di sotto et aconciarla, et lui paga le spese per polize di mia mano." The most substantial passage concerning Giuliano, part of a series made by the prior regarding the "uscita de' danari mi verranno in mano, delle sepulture consegnarò nella chiesa di San Lorenzo," reads: "Da Giuliano di Francesco da Sangallo, per braccia dua di saxi comprò da noi, lire cinquanta quattro in dua volte; per noi, a Chimenti e Giovanni carretai; a Uscita, in questa, a c. 41–Lire 54—" (Archivio di San Lorenzo, Florence, 1938, pt. 5, fol. 3v; and see fol. 41r–v). The note concerning Lorenzo is on the reverse of the front cover of this register. See H. Saalman, "The New Sacristy of San Lorenzo before Michelangelo," *AB* 67 (1985): 199–228 (219);

idem, *Filippo Brunelleschi*, 198, 440; R. Trexler, "Lorenzo de' Medici and Savonarola, Martyrs for Florence," *RQ* 31 (1978): 293–308 (301, and n. 26); P. Ruschi, "Lorenzo e San Lorenzo," in Morolli, Luchinat, and Marchetti, *L'architettura di Lorenzo*, 117–23, where the new documents are published; and idem, "Un 'sepoltuario' quattrocentesco e il cantiere per la nuova cappella del Magnifico in San Lorenzo," in *La Toscana al tempo di Lorenzo il Magnifico: Politica, economia, cultura, arte*, ed. R. Fubini, 3 vols. (Pisa, 1996), 1:103–20, where they are more fully published. A different chronology for the new sacristy can be found in C. Elam, "The Site and Early Building History of Michelangelo's New Sacristy," *MKIF* 23 (1979): 155–86; H. Burns, "San Lorenzo in Florence before the Building of the New Sacristy: An Early Plan," ibid., 145–53; S. E. Reiss, "The Ginori Corridor of San Lorenzo and the Building History of the New Sacristy," *Journal of the Society of Architectural Historians* 52 (1993): 339–43. See also S. B. Butters, *The Triumph of Vulcan*, 2 vols. (Florence, 1996), 1:64. Lorenzo was notably absent in the rebuilding in the 1480s of the Cistercian church of Cestello, whose design has been attributed to Giuliano da Sangallo. Near the Medici quarter, Cestello had still other close Laurentian ties; see the cautious remarks of Luchs, *Cestello*, esp. 7, 11–13, 58–59.

124. R. Pacciani, "Cosimo de' Medici, Lorenzo il Magnifico e la chiesa di San Salvatore al Monte a Firenze," *Prospettiva* 66 (1992): 27–35 (31); and idem, "Attività professionali di Simone del Pollaiolo detto 'il Cronaca' (1490–1508)," *Quaderni di Palazzo Te*, n.s., 1 (1994): 13–35. See also Bruschi's description of this "new type of large monastic church"—San Salvatore, San Gallo, Cestello—in "Religious Architecture in Renaissance Italy," in Millon and Magnago Lampugnani, *The Renaissance from Brunelleschi to Michelangelo*, 154–55; V. Vasarri, "Il Cronaca e San Salvatore al Monte," *Antichità Viva* 20 (1981): 47–50; and F. Capecchi, "Le vicende del complesso conventuale di San Salvatore al Monte a Firenze," *Archivum Franciscanum Historicum* 89 (1996): 469–536.

125. ASF, Corp. relig. soppr., 122, 128, fol. 99r: "che la sagrestia si facesse nel modo e forma che sta uno modello à fatto fare Lorenzo di Piero di Chosimo a Guliano da Sanghallo, che si seghuiti quello, e quel più o meno che paresse a detto Lorenzo, il quale modello è in ottangholo colle trebune nella forma di San Giovanni." This is my transcription. The document has previously been published; see, e.g., C. Botto, "L'edificazione della chiesa di Santo Spirito in Firenze," *Rivista d'Arte* 14 (1932): 23–53 (24).

126. Ibid., fol. 217v, 18.iv.1492: "E più ch'io fussi con Guliano da Sanghalo e sapessi da llui se di quello resta a fare nella sagrestia se llui aveva inteso la voglia di Lorenzo di quella s'avesse a seghuire." See also Botto, "L'edificazione della chiesa di Santo Spirito in Firenze," 26.

127. ASF, Provv., Reg., 182, fol. 49r–v, 13.xii.1491: "per dare perfectione . . . per finire la nuova sagrestia, degno ornamento di decta chiesa." Lorenzo is first mentioned as an *operaio* on 10.ix.1490 (ASF, Corp. relig. soppr., 122, 128, fol. 119r).

128. ASF, Corp. relig. soppr., 122, 128, fol. 51v: "E più si contentorono che si sghrombi la mandorla della faccia nell'Opera dove sono l'arme del Popolo e Comune di Firenze per metterle in luogho dignio per contentare quegli della Compagnia de' Pippione, e a richiesta di Lorenzo di Piero de' Medici, huomo degnissimo." The confraternity's records refer to the matter (ASF, Compagnia di S. Maria delle Laudi e Spirito Santo detta del Piccione, 2, fol. 5r). See now the analysis of J. Burke, *Changing*

Patrons: Social Identity and the Visual Arts in Renaissance Florence (University Park, Pa. 2004), chap. 3.

129. ASF, Corp. relig. soppr., 122, 79, fol. 117v, for Lorenzo's joining. With much exaggeration, the *opera* of Santo Spirito later described "questa opera tanto bella et honorabile" in a letter of 26.x.1514 to Lorenzo's grandson Lorenzo as "principiata per la buona memoria di suo avo" (published in U. Cassuto, *Gli ebrei a Firenze nell'età del Rinascimento* [1918; reprint, Florence, 1965], 406). See, generally, C. Botto, "L'edificazione della chiesa di Santo Spirito in Firenze," *Rivista d'Arte* 13 (1931): 477–511, 14 (1932): 23–53.

130. Published in Giorgio Vasari, *Le opere di Giorgio Vasari,* ed. G. Milanesi (Florence, 1906), 4:304, and more recently in L. Zangheri, "Lorenzo il Magnifico in alcuni documenti dell'Opera de S. Maria del Fiore," *Quaderni di Storia dell'Architettura e Restauro* 6–7 (1992): 19–23.

131. Zangheri, "Lorenzo il Magnifico." Some forty years ago Gombrich mistakenly wrote that Lorenzo was himself a competitor ("Early Medici as Patrons of Art," 308), an error apparently so attractive that it continues to be repeated, for example, in *Encyclopedia of the Renaissance,* ed. P. F. Grendler (New York, 1999), 4:95.

132. Luca Fancelli to Francesco Gonzaga, 10.xi.1491, published in Fancelli, *Luca Fancelli,* 66.

133. Published in C. von Fabriczy, "Giuliano da Majano," *Jahrbuch der Königlich Preussischen Kunstsammlungen* 24 (1903): 175; see also Kent, "Lorenzo de' Medici at the Duomo," 364 n. 145.

134. C. Elam, "Art and Diplomacy in Renaissance Florence," *RSA Journal* 136 (1988): 813–26 (820). See also P. Foster, "Lorenzo de' Medici and the Florentine Cathedral Façade," *AB* 63 (1981): 495–500 (497–99).

135. The names are published in Vasari, *Opere di Giorgio Vasari,* 4:305–9. For the near-contemporary reference, see J. Shearman, *Andrea del Sarto,* 2 vols. (Oxford, 1965), 2:318.

136. Document of 6.v.1476, published in G. Poggi, *Il Duomo di Firenze: Documenti sulla decorazione della chiesa e del campanile tratti dall'Archivio dell'Opera,* ed. M. Haines, 2 vols. (1909; reprint, Florence, 1988), 2:156.

137. Leon Battista Alberti, *Ten Books on Architecture,* ed. J. Rykwert (London, 1965), 149.

138. Lorenzo may have rendered up thanks to Saint Zenobius for his salvation, as plausibly speculated by M. Haines in "Il principio di 'mirabilissime cose': I mosaici per la volta della cappella di San Zanobi," in *La difficile eredità: Architettura a Firenze dalla Repubblica all'assedio,* ed. M. Dezzi Bardeschi (Florence, 1994), 38–54 (44).

139. ASF, Arte della Lana, 62, fol. 26r, 25.iii.1491, published in Kent, "Lorenzo de' Medici at the Duomo," 366.

140. Poggi, *Il Duomo,* 1:193. See, generally, Haines, "Il principio.", 38–54, with full bibliography; J. K. Cadogan, *Domenico Ghirlandaio, Artist and Artisan* (New Haven, Conn., 2000), 286–87; A. Chastel, *Art et humanisme à Florence au temps de Laurent le Magnifique* (Paris, 1961), 158–67.

141. Alberti, *Ten Books,* 149; de' Rossi, *Ricordanze,* 272.

142. M. Hegarty, "Laurentian Patronage in the Palazzo Vecchio: The Frescoes of the Sala dei Gigli," *AB* 78 (1996): 264–85 (281); Rubinstein, *Palazzo Vecchio*, 3, 60–69.

143. The document is published in Rubinstein, *Palazzo Vecchio*, 68 n. 202. Two years later the *opera* gave Lorenzo the job of deciding what fee to pay Filippino Lippi for an altarpiece (G. Poggi, "Note su Filippino Lippi," *Rivista d'Arte* 6 [1909]: 305–8), although Lorenzo was an *operaio* by the time the judgment was made (308).

144. De' Rossi, *Ricordanze*, 245. See also above, chap. 2; and L. Masi, "La fortificazione di Poggio Imperiale," *Annali di Architettura* 1 (1989): 85–90, and idem, *La fortezza di Poggio Imperiale a Poggibonsi* (Poggibonsi, 1992). On 20.ix.1488 the Operai del Palagio, including Lorenzo, were given "piena et libera auctorità" over Poggio Imperiale and Firenzuola (ASF, Provv., Reg., 179, fol. 55v). For the broader authority granted them on 21.i.1491, see ASF, Consiglio del Cento, Registri, 3, fol. 62r. See also Hegarty, "Laurentian Patronage," 264–85.

145. ASF, Miscellanea Repubblicana, 6, inserto 205, fol. 29v, 29.xii.1489: "[The Otto di Pratica] deliberno come di sotto . . . [there follows a list of fortresses with garrison numbers], sicondo una nota di mano di Lorenzo de' Medici."

146. The quotations are from Rubinstein, *Palazzo Vecchio*, 93–94. F. Caglioti, *Donatello e i Medici: Storia del "David" e della "Giuditta,"* 2 vols. (Florence, 2000), 2:443, publishes the decree of 23.xi.1496; see also ibid., 446–47. Iacopo Giannotti was pleased to report to Benedetto Dei on 4.viii.1491 that "le muraglie si tirano avanti; li ornamenti noviter ordinati in la piazza de' Signori nostri non se li perde tempo, e laude di Dio" (ASF, Corp. relig. soppr., 78, 316, fol. 332).

147. ASF, Provv., Reg., 183, fols. 1r–2v. Bartolomeo Dei reported the information to his uncle (L. Frati, "La morte di Lorenzo de' Medici e il suicidio di Pier Leoni," *ASI*, 5th ser., 4 [1889]: 255–60 [260]), as did Francesco Baroni to Piero Guicciardini (Archivio Guicciardini, Florence, Legazioni e Commissarie, 1, fol. 119, 13.iv.1492).

148. A. Tönnesmann, *Der Palazzo Gondi in Florenz* (Worms, 1983), documents at 123–25; R. Pacciani, "'Tum pro honore publico tum pro commoditate privata.' Un documento del 1490 per l'edificazione di palazzo Gondi a Firenze," *Arte Lombarda* 105–7 (1993): 202–5.

149. Bartolomeo Dei, published in G. Uccelli, *Della Badia Fiorentina* (Florence, 1858), 94. See also Fusco and Corti, *Lorenzo de' Medici, Collector*, doc. 133.

150. Gaye, *Carteggio*, 1:362–63; G. Pampaloni, *Palazzo Strozzi* (Rome, 1982), 52.

151. BNF, Fondo Ginori Conti, 29, 3421539, 18.ix.1490: "Intendessi il ragionamento auto col padrone sopra la muraglia che vi pare troppo impresa alla borsa vostra . . . vorrassi alla tornata vostra ad ogni modo intendere l'oppinione suo per sighuirlo o giustificharsi per levare via la riprensione." See also P. Foster, *A Study of Lorenzo de' Medici's Villa at Poggio a Caiano*, 2 vols. (New York, 1978), 1:332 n. 80, which suggests that this letter may concern Michelozzi's designing of a garden at Quinto a year later; and Filippo da Gagliano to Michelozzi, in BNF, Fondo Ginori Conti, 29, 3421542, fol. 27, 2.ii.1492, and 3421548, fol. 33r–v, 14.iii.1492, both of which were very kindly transcribed for me from microfilm by Alison Brown. See also, generally, Elam, "Lorenzo's Architectural and Urban Policies," 359–62.

152. F. Flamini, "La vita e le liriche di Bernardo Pulci," *Il Propugnatore* 1 (1888):

217–48, esp. 235–39; Böninger, "Francesco Cambini," 40; Verde, *Studio fiorentino*, 4, pt. 2:671ff. For Prato, see above, this chapter. A. Belluzzi, *Giuliano da Sangallo e la chiesa della Madonna a Pistoia* (Florence, 1993), suggests without documentation Lorenzo's very early participation in the planning of this Pistoian church by Giuliano da Sangallo (see esp. 13).

153. ASF, S. Maria Nuova, 1254, fols. 590r (26.iv.1490), 602r (27.xii.1490), 623r (28.viii.1490).

154. Bartolomeo di Pasquino to the *studio* officials, 27.i.1489, published in Verde, *Studio fiorentino*, 4, pt. 2:793.

155. Ibid.

156. Bartolomeo di Pasquino to Bartolomeo Dei, 24.x.1490. reprinted in ibid., 902. Florentine legislation of 15.ix.1489 notes the speed with which the building was proceeding, "che già vi s'è murato qualche camera, et sarà opera et bella et degna" (ASF, Provv., Reg., 180, fols. 63r–64r). See also M. A. Giusti, "La Sapienza: 'academia pisana per Laurentium renovata,'" in Morolli, Luchinat, and Marchetti, *L'architettura di Lorenzo*, 206–7; M. Kiene, "Der Palazzo della Sapienza zur italienischen Universitätsarchitektur des 15. und 16. Jahrhunderts," *Romisches Jahrbuch für Kunstgeschichte* 23–24 (1988): 219–71; and P. Denley, "*Signore* and *Studio*: Lorenzo in a Comparative Context," in Mallett and Mann, *Lorenzo the Magnificent*, 203–16.

157. Kent, "Lorenzo de' Medici at the Duomo," 341–68. The *studio* officials ordered Francesco Cambini on 2.viii.1492 "per buono rispetto tu non seguiti più il murare alla Sapientia fino che altro non ti scriviamo, ma solo attendi per hora a finire se cosa alchuna vi fusse cominciata che non potesse restare inperfecta sanza danno o sanza guastarsi perché voglamo prima vedere che assegnamenti o quali possiamo adoperare avanti andiamo più oltre" (ASF, S. Maria Nuova, 1254, fol. 172r).

158. O. Merisalo, *Le collezioni medicee nel 1495: Deliberazioni degli ufficiali dei ribelli* (Florence, 1999), 68.

159. Piero Parenti, *Storia fiorentina*, vol. 1, *1476–78, 1492–96*, ed. A. Matucci (Florence, 1994), 259–60.

160. Operai del Palagio, 1496, quoted in Masi, *La fortezza di Poggio Imperiale*, 73.

161. Suetonius, *Lives of the Caesars*, 1:166–67. See Kent, "Più superba de quella de Lorenzo," 315 n. 17; Clarke, "Magnificence and the City," 399, and E. Lee, *Sixtus IV and Men of Letters* (Rome, 1978), 123–24, for Renaissance echoes of Suetonius's phrase.

162. A. Boëthius, *Etruscan and Early Roman Architecture* (Harmondsworth, 1978), 114.

163. On the "ideal city" views, see R. Krautheimer, "The Panels in Urbino, Baltimore, and Berlin Reconsidered," in Millon and Magnago Lampugnani, *The Renaissance from Brunelleschi to Michelangelo*, 233–57 (with bibliography) and in the same volume H. Damisch, "The Ideal City," 538–39, and P. C. Marani, "Renaissance Town Planning, from Filarete to Palmanova," 539–43.

164. For the demolition of the tower in 1505, after an earthquake, see Arienti, *Letters of Giovanni Sabadino degli Arienti*, 198–201; and for Giovanni Bentivoglio more generally, see Clarke, "Magnificence and the City," 397–411.

165. Quoted earlier in this chapter.

166. ASF, Provv., Reg., 177, fols. 110r–111r, 19.ii.1487: "unde accidit quod nulli tali

ornamento extrema manus imponitur et ob talem dilationem unum atque idem opus in parte novum in parte vetustum apparet" (fol. 110r). See also Leon Battista Alberti, *L'architettura (De re aedificatoria)*, ed. G. Orlandi and P. Portoghesi (Milan, 1966), vol. 2, bk. 6, chap. 2, 444–51. Rubinstein, *Palazzo Vecchio*, 68–69, discusses the decision.

167. Burke, *Changing Patrons*, esp. chap. 6. On the late Quattrocento Florentine taste for "candid purity" in churches, see P. Hills, *Venetian Color* (New Haven, Conn., 1999), 151.

168. Alberti, *L'architettura*, vol. 2, bk. 8, chap. 5, 698–99.

169. ASF, Provv., Reg., 183, fol. 1r, 13.iv.1492: "Cum vir primarius nostrae civitatis Laurentius Petri filius Cosmi patris patriae nepos, Medices, qui nuper vita functus est, nullam quamdiu vixit huius tuendae, augendae, ornandae, cohonestandaque civitatis occasionem pretermiseret." N. Rubinstein calls this the "official obituary" ("The Formation of the Posthumous Image of Lorenzo de' Medici," in *Oxford, China, and Italy*, ed. E. Chaney and N. Ritchie [London, 1984], 94–106 [94]).

170. See above, chap. 3 and this chapter.

171. Luca Landucci, discussed in Kent, "Più superba de quella de Lorenzo," 321–23.

172. Criticism of Estensi projects is discussed in Folin, "Ferrara: 1385–1505," esp. 374–75.

173. The documents are published in F. Buselli, "Fra Sarzana e Saranello," *Necropoli* 6–7 (1969–70): 61–68.

174. ASF, S. Maria Nuova, 1254, fol. 612r, Antonio di Bernardo Miniati to Francesco Cambini, 7.i.1491: "e s'è più volte disputato questo modelo dela muraglia di Vada, e chi è d'un'pinione e chi d'un altro; e finalmente s'è deliberato che'l fondamento si farìa a ogni modo e chon più presteza si può, e quando fia fondato poi si piglierà partito di quelo va sopra tera e'l modo s'abia fornire." This letter, one of several that refer to Vada (fols. 577r, 581r, 584r, 602r, 632r), mentions the Otto's transferring the authority to the *opera*, of which Antonio Miniati was a member (Rubinstein, *Palazzo Vecchio*, 69).

175. BNF, Autografi Palatini, VI, 56, Lorenzo to Pierfilippo Pandolfini, 3.xii.1489: "Io credo che ser Giovanni vi debba havere scripto che quelli disegni che facemo alla Camera dell'Arme non sono per riuscire sì grassi come lui disegnò, et alcuni quasi impossibile. Dicovelo perchè non crediate che resti per me, perché non vorrei credessi mi fussi mutato. Se pure ser Giovanni vi scrivessi altrimenti, vi dice il contrario di quello dice a me." I offer the above translation very tentatively. It is not even clear to what decorative work the passage refers (see Rubinstein, *Palazzo Vecchio*, 18, 36, for the Camera dell'Arme), and Caroline Elam has put it to me that the passage may refer to political "designs." For Bernardo Rucellai's political position, see F. Gilbert, "Bernardo Rucellai and the Orti Oricellari," *JWCI* 12 (1949): 101–31. R. M. Comanducci, "Gli orti oricellari," *Interpres* 15 (1995–96): 302–58, publishes a letter of 1491 concerning his collector's rivalry with Lorenzo (330).

176. Alberti, *Ten Books*, 100.

177. B. Preyer, "The Rucellai Palace," in *A Florentine Patrician and His Palace: Studies*, by F. W. Kent et al. (London, 1981), 159–61.

178. Alberti, *Ten Books*, 100.

179. Ibid., 100.

CHAPTER FIVE. LORENZO, "FINE HUSBANDMAN" AND VILLA BUILDER, 1483–1492

1. Cristoforo Landino, quoted in E. B. Fryde, *Humanism and Renaissance Historiography* (London, 1983), 132 n. 78. See, generally, A. Lillie, "Lorenzo de' Medici's Rural Investments and Territorial Expansion," *Rinascimento*, 2d ser., 33 (1993): 53–67; and P. Salvadori, *Dominio e patronato: Lorenzo de' Medici e la Toscana nel Quattrocento* (Rome, 2000). See also G. C. Romby and M. Tarassi, eds., *Vivere nel contado a tempo di Lorenzo* (Florence, 1992); and V. Franchetti Pardo and G. Casali, *I Medici nel contado fiorentino* (Florence, 1978).

2. Francesco Fracassini to Piero de' Medici, summer 1468, published in G. Baccini, *Le ville Medicee di Cafaggiolo e di Trebbio in Mugello* (Florence, 1897), 23.

3. M. Martelli, "Nelle stalle di Lorenzo," *ASI* 150 (1992): 267–302; M. Mallett, "Horse-Racing and Politics in Lorenzo's Florence," in *Lorenzo the Magnificent: Culture and Politics*, ed. M. Mallett and N. Mann (London, 1996), 253–62.

4. Lorenzo de' Medici, *Comento de' miei sonetti*, ed T. Zanato (Florence, 1991), 297.

5. Lorenzo Strozzi, quoted in A. Lillie, "Florentine Villas in the Fifteenth Century: A Study of the Strozzi and Sassetti Country Properties," 2 vols. (Ph.D. thesis, University of London, 1986), 2:292: "qualche diletto."

6. P. Foster, *A Study of Lorenzo de' Medici's Villa at Poggio a Caiano*, 2 vols. (New York, 1978), 1:25; Baccini, *Le ville Medicee*, 21–23.

7. Lorenzo de' Medici, *Ambra (Descriptio Hiemis)*, ed. R. Bessi (Florence, 1986). For a proposed later date, see C. Dempsey, "Lorenzo de' Medici's *Ambra*," in *Renaissance Studies in Honor of Craig Hugh Smyth*, ed. A. Morrogh, F. Superbi Gioffredi, P. Morselli, and E. Borsook, 2 vols. (Florence, 1985), 2:177–89, and idem, "La data dell 'Ambra' (Descriptio Hiemis) di Lorenzo de' Medici," *Interpres* 10 (1990): 265–69, on which see R. Bessi, "Ancora sulla data dell'*Ambra* Laurenziana," *Interpres* 11 (1991): 345–47.

8. G. Morolli, C. Acidini Luchinat, and L. Marchetti, eds., *L'architettura di Lorenzo il Magnifico* (Milan, 1992), 65–67, following earlier scholarship; Salvadori, *Dominio e patronato*, 160–62.

9. The description is Piero Parenti's (*Storia fiorentina*, vol. 1, *1476–78, 1492–96*, ed. A. Matucci [Florence, 1994], 14). ASF, MaP, C IV, 4, fols. 57r–59r, is an inventory of the Fiesole house (with the room "si dice di Lorenzo"), on which see A. Lillie, "Giovanni di Cosimo and the Villa Medici at Fiesole," in *Piero de' Medici "il Gottoso" (1416–1469)*, ed. A. Beyer and B. Boucher (Berlin, 1993), 189–205.

10. Angelo Poliziano, *Detti piacevoli*, ed. T. Zanato (Rome, 1983), 44. See also G. Galletti, "Una committenza medicea poco noto: Giovanni di Cosimo e il giardino di Villa Medici a Fiesole," in *Giardini medicei: Giardini di palazzo e di villa nella Firenze del Quattrocento*, ed. C. Acidini Luchinat (Milan, 1996; reprint 2000), 60–89 (83).

11. Fundamental is Amanda Lillie's doctoral thesis, "Florentine Villas." See also idem, "The Humanist Villa Revisited," in *Language and Images of Renaissance Italy*, ed. A. Brown (Oxford, 1995), 193–215, esp. 199; and idem, "Lorenzo de' Medici's Rural Investments."

12. E. Piccolomini, "Inventario della libreria medicea privata compilata nel 1495," *ASI*, 3d ser., 20 (1874): 51–80 (60, 70).

13. F. Battera, "L'edizione Miscomini (1482) delle *Bucoliche elegantissimamente composte*," *Studi e Problemi di Critica Testuale* 40 (1990): 149–85.

14. V. Branca, *Poliziano e l'umanesimo della parola* (Turin, 1983), 86 n. 22.

15. Angelo Poliziano, *Silvae*, ed. F. Bausi (Florence, 1996), 101, 283.

16. See ibid., xx, for Poliziano's knowledge of the genre; and Lorenzo de' Medici, *Protocolli del Carteggio di Lorenzo il Magnifico per gli anni 1473–74, 1477–92*, ed. M. del Piazzo (Florence, 1956), 227.

17. ASF, MaP, XXVI, 421, a Latin letter "Ex Caiano" written by Piero to his father on 3.ix.1485.

18. Ibid., XLVIII, 155: "Ho inteso el piacere che pigli più ogni dì della agricultura, che è felicità non conosciuta et nihil homine libero dignius." A concluding remark concerning "Giovanni Martini e Giampetro," if related to the above, may mean that Bernardo had in mind some practical agricultural enterprise.

19. Quoted from Giovanni Rucellai's commonplace book in F. W. Kent, "The Making of a Renaissance Patron of the Arts," in *A Florentine Patrician and His Palace: Studies*, by F. W. Kent et al. (London, 1981), 81–82 n. 1.

20. Piero de' Crescenzi, *Trattato della agricoltura*, 2 vols. (Bologna, 1784), 1:3; Cicero, *De officiis*, trans. W. Miller (London, 1951), 154–55. That villa life was a "felicità non conosciuta" is an idea derived from Leon Battista Alberti's *Della famiglia*, to be found also in Agnolo Pandolfini's *Del governo della famiglia* (Milan, 1802), 112.

21. See Lucius Junius Moderatus Columella, *On Agriculture*, ed. H. Boyd Ash, 3 vols. (London, 1960), 1:9.

22. Francesco Guicciardini, *Storie fiorentine dal 1378 al 1509*, ed. R. Palmarocchi (1931; reprint, Bari, 1968), 77–78.

23. A. Lenzuni, ed., *All'ombra del Lauro: Documenti librari della cultura in età laurenziana* (Milan, 1992), 118–19. On Cosimo de' Medici's interest in reading about horticulture and viticulture, see now D. Kent, *Cosimo de' Medici and the Florentine Renaissance: The Patron's Oeuvre* (New Haven, Conn., 2000), 299–304, 351.

24. Michelangelo Tanaglia, *De agricultura*, ed. A. Roncaglia (Bologna, 1953), 3.

25. Ibid., xi.

26. As R. S. M. Nisbet notes Roger Mynors having observed (introduction to Virgil, *Georgics*, ed. R. A. B. Mynors [Oxford, 1990], vi).

27. ASF, MaP, XLIII, 66, 9.iv.1489: "et ho posto tanti mori al Poggio, che ho imparato quando sono giovani et teneri non si possano difendere dal vento senza un palo più grosso et più duro."

28. Columella, *On Agriculture*, 1:9.

29. Tanaglia, *De agricultura*, 3–4. On Giuliano's role, see C. L. Frommel, "Poggioreale: Problemi di ricostruzione e di tipologia," in *Giuliano e la bottega dei da Maiano*, ed. D. Lamberini, M. Lotti, and R. Lunardi (Florence, 1994), 104–11.

30. King Charles VIII of France, quoted in T. Comito, "Renaissance Gardens and the Discovery of Paradise," *Journal of the History of Ideas* 32 (1971): 483–506 (483).

31. Bernardo Pulci, quoted in Battera, "L'edizione Miscomini," 151 n. 9.

32. Published in C. Elam and E. H. Gombrich, "Lorenzo de' Medici and a Frustrated Villa Project at Vallombrosa," in *Florence and Italy*, ed. P. Denley and C. Elam (London, 1988), 481–92 (491).

33. E. H. Gombrich, "The Sassetti Chapel Revisited: Santa Trinita and Lorenzo de' Medici," *I Tatti Studies* 7 (1997): 11–35 (31).

34. Lillie, "Lorenzo de' Medici's Rural Investments," 63; Franchetti Pardo and Casali, *I Medici nel contado fiorentino*; Salvadori, *Dominio e patronato*. One Martello made the Parisian reference in a letter of 28.vi.1478, published in G. Corti, "Il Boccaccio citato in due lettere a Lorenzo de' Medici," *Studi sul Boccaccio* 21 (1993): 275–78 (276–77 n. 8).

35. Poliziano, *Silvae*, 101, 283; Lorenzo de' Medici, *Comento*, 248–51.

36. Quoted in Elam and Gombrich, "Lorenzo de' Medici and a Frustrated Villa Project," 489.

37. Niccolò Machiavelli, *Istorie fiorentine*, ed. F. Gaeta (Milan, 1962), 574, as translated in Niccolò Machiavelli, *History of Florence and of the Affairs of Italy*, trans. M. W. Dunne with an introduction by F. Gilbert (New York, 1960), 405. Foster believes Lorenzo's motives to have been primarily "financial" (*Study*, 1:79–81).

38. Niccolò Valori, *Vita di Lorenzo de' Medici*, ed. E. Niccolini (Vicenza, 1991), 121–22.

39. For Lorenzo's bank, see R. de Roover, *The Rise and Decline of the Medici Bank, 1397–1494* (Cambridge, Mass., 1963), chap. 14; and R. Goldthwaite, "The Medici Bank and the World of Florentine Capitalism," *Past and Present*, no. 114 (1987): 3–31.

40. ASF, MaP, XXXV, 493.

41. Ibid., XXXV, 71, 17.i.1478: "ho trovato l'aqua servire degnissimamente, et meglio servire quando li argini saranno fortificati."

42. There are several references in Foster, *Study*, 1:295–308. See, more generally, Lillie, "Lorenzo de' Medici's Rural Investments," 53–67.

43. ASF, S. Maria Nuova, 1254, fol. 631r: "questa chosa ci tiene ala propietà di Lorenzo e però bisognia che tu avesi ogni diligienza posibile." See related letters at fols 572r, 607r.

44. Francesco Cambini, quoted in L. Böninger, "Francesco Cambini (1432–1499): Doganiere, commissario, ed imprenditore fiorentino nella 'Pisa Laurenziana,'" *Bollettino Storico Pisano* 67 (1998): 21–55 (43).

45. For the Sienese quotation, see P. Nanni, *Lorenzo agricoltore* (Florence, 1992), 143 n. 2. Alessandro da Filicaia gave the health warning to his son, Antonio, in a letter of 9.ii.1484 in ASF, Corp. relig. soppr., 78, 319, fol. 135: "Egli è vero che dove non si truova olio è concesso mangiare il burro."

46. P. Nanni, "L'olivo e l'olio nelle proprietà dei Medici (sec. xv)," *Rivista di Storia dell'Agricoltura* 32 (1992): 143–56.

47. F. W. Kent, "Lorenzo de' Medici's Acquisition of Poggio a Caiano in 1474 and an Early Reference to His Architectural Expertise," *JWCI* 42 (1979): 250–57 (251).

48. J. Gonzalez Moreno, ed., *Desde Sevilla a Jerusalen* (Seville, 1974), 179: "una casa de placer con buena renta a la redonda."

49. ASF, MaP, LIX, 179, Piero da Bibbiena to Giovanni Lanfredini, 26.vi.1488: "Lorenzo è chavalcato insino a Montepaldi per piglare um pocho d'aria et levarsi da

una confusione grande di faccende. È stato già due mesi, che mai non è uscito di questa terra."

50. Ibid., XL, 373, Monte de' Bardi to Lorenzo, 20.viii.1488, report from Montepaldi that "El Francione si partì."

51. Ibid., "inperò v'è ogimai da potere abitare e per quella prima parte vi resterà, si potrà fare a ogni tempo." See also Foster, *Study*, 1:306 nn. 608–9.

52. M. Spallanzani and G. Gaeta Bertelà, eds., *Libro d'inventario dei beni di Lorenzo il Magnifico* (Florence, 1992), 180–93.

53. M. Martelli, *Studi Laurenziani* (Florence 1965), 190–92. There are numerous references to Lorenzo's taking the waters at Spedaletto, as when Giovanni Angelo Talenti informed the Milanese ruler that "le aque le torra apresso ad Volterra in uno suo loco vicino a' bagni a quatro miglia, pur loy starà in quello suo loco apresso a Volterra" (ASM, Archivio Sforzesco, 937, 1.ix.1491).

54. Ibid., 937, 310–12.

55. Francesco Sassetti, quoted in Lillie, "Florentine Villas," 2:420.

56. E. Carusi, *Dispacci e lettere di Giacomo Gherardi nunzio pontificio a Firenze e Milano (11 sett. 1487–10 ott. 1490)* (Rome, 1909), 13.

57. ASF, MaP, XXIV, 494, 31.vii.1489: "et queste acque de' bagni del continuo mi fanno la migliore operatione, in modo che spero, piacendo a Dio, tornare sano come fussi mai."

58. Andrea Cambini to Niccolò Michelozzi, 22.ii.1492, quoted in Martelli, *Studi Laurenziani*, 218.

59. Piero di Lorenzo de' Medici to Niccolò Michelozzi, 11.iv.1492, cited in Foster, *Study*, 1:331 n. 80.

60. Martelli, *Studi Laurenziani*, 220–21.

61. Elam and Gombrich, "Lorenzo de' Medici and a Frustrated Villa Project," 65 n. 75. See also S. Borsi, *Giuliano da Sangallo: I disegni di architettura e dell'antico* (Rome, 1985), 404–9; and now S. Frommel, "Lorenzo il Magnifico, Giuliano da Sangallo e due progetti per ville del codice barberiniano," in *Il principe architetto*, ed. A. Calzona, F. P. Fiore, A. Tenenti, and C. Vasoli (Florence, 2002), 413–54. Charles Dempsey has suggested that Lorenzo had Lucullus's villa at Tusculum in mind when he built Poggio a Caiano ("Lorenzo de' Medici's *Ambra*," 177–89).

62. For letters from Poggio, for example, see Lorenzo de' Medici, *Protocolli*, 6–10, 43–44.

63. Lorenzo to Niccolò Michelozzi, 14.v.1485, quoted in Martelli, *Studi Laurenziani*, 205.

64. Giovanni Pontano, "Il Trattato dello Splendore," in *I trattati delle virtù sociali*, ed. F. Tateo (Rome, 1965), 277; Leon Battista Alberti, *Ten Books on Architecture*, ed. J. Rykwert (London, 1965), 104. See ASF, MaP, XXXIX, 480, Francesco Sassetti to Lorenzo, 9.v.1486, for an ambassador's being lodged at Poggio.

65. Published in Elam and Gombrich, "Lorenzo de' Medici and a Frustrated Villa Project," 489.

66. Foster, *Study*, 1:306–7, 610. A letter of 9.vii.1484 from Francesco Cegia mentions supplies being sent to "Grassina, chè credo Lorenzo v'andrà domenicha" (ASF,

MaP, LXXX, 102). According to the printed inventory of this collection, the recipient was Lucrezia Tornabuoni (who had died, however, two years earlier).

67. F. W. Kent, "Sainted Mother, Magnificent Son: Lucrezia Tornabuoni and Lorenzo de' Medici," *Italian History and Culture* 3 (1997): 3–34 (9–10, 19–20).

68. Lillie, "Lorenzo de' Medici's Rural Investments," 53–67; Foster, *Study*, 1:295–308; Salvadori, *Dominio e patronato*, 166–73.

69. Benedetto Dei mentions such plots in his newly discovered "Storia Fiorentina" (Biblioteca Comunale degli Intronati, Siena, MS I.VI.35, fols. 43r–113v, s.a. 1479). P. Salvadori, "Lorenzo dei Medici e le comunità soggette, tra pressioni e resistenze," in *La Toscana al tempo di Lorenzo il Magnifico: Politica, economia, cultura, arte*, ed. R. Fubini, 3 vols. (Pisa, 1996), 3:891–906, tells the Fucecchio story (904). For Lorenzo's mining interests "in partibus vicariatus Vici Pisani," see ASF, Notarile Antecos., G 120 (1472–1494), fols. 172r–173r, 29.iii. 1481.

70. A. Niccolai, *Palazzi, ville e scene medicee in Pisa e nei dintorni* (Pisa, 1914), 56; A. Perosa, ed., *Mostra del Poliziano* (Florence, 1955), 179.

71. L. A. Ferrai, "Lettere inedite di Donato Giannotti," *Atti del Reale Istituto Veneto di Scienze, Lettere ed Arti*, 6th ser., 3 (1884–85): 1567–88 (1570–72).

72. See above, chap. 3.

73. ASF, MaP, XXXV, 55, Antonio Marchetti to Lorenzo, 14.i.1477: "questa povera città, laquale è pure el secondo ochio del vostro dominio."

74. L. Gnocchi, "Paesaggi laurenziani," *Artista: Critica dell'Arte in Toscana* 2 (1990): 70–77.

75. Alberti, *Ten Books*, 104.

76. Luca Landucci reports on the terrible torture inflicted on a hermit *(romito)* who entered the old house at Poggio in September 1480 and was suspected of wanting to kill Lorenzo (Luca Landucci, *Diario fiorentino dal 1450 al 1516*, ed. I. del Badia [1883; reprint, Florence, 1969], 36–37). For a plot against Lorenzo at Poggio two years later, see W. J. Connell, *La città dei crucci: Fazioni e clientele in uno stato repubblicano del –400* (Florence, 2000), 100–101.

77. On one occasion the Milanese ambassador reported to his duke that Lorenzo planned to go to baths in Sienese territory with "per guardia de la persona sua ducento homini d'arme, che sono in quello de Aretio" (ASM, Archivio Sforzesca, 311, 18.iv.1490). For the Estensi villa-hopping, see T. Tuohy, *Herculean Ferrara: Ercole d'Este, 1471–1505, and the Invention of a Ducal Capital* (Cambridge, 1996), chap. 5. On the half-nomadic behavior of the contemporary kings of France and England, see F. Boudon and M. Chatenet, "Les logis du roi de France au XVIe siècle," and S. Thurley, "The Palaces of Henry VIII," in *Architecture et vie sociale à la Renaissance*, ed. J. Guillaume (Tours, 1994), 65–82 and 97–106, respectively.

78. Kent, "Lorenzo de' Medici's Acquisition of Poggio a Caiano," 250–57.

79. See Giovanni Capponi to Giovanni de' Medici, 23.iii.1461 (ASF, MaP, XXXIX, 457), expressing his assurance that by ceding land to the Medici he was acting in his order's interests since "è manifesto che tutti di chasa vostra senpre siete stati edifichatori e acrescitori de' luoghi pii." See, more generally, F. Muciaccia, "I cavalieri dell'Altopascio," *Studi Storici* 6 (1897): 33–92; 7 (1898): 215–32; 8 (1899): 347–97.

80. Lorenzo wrote to Francesco *orafo*, in Pisa, on 17.xii.1481, "che se ne vengha bene informato delle cose d'Agnano . . . " (Lorenzo de' Medici, *Protocolli*, 176). See Rucellai's several letters of 1484 written to Lorenzo from Vicopisano, where he left a handsome and still visible Latin inscription of his name over an archway, in ASF, MaP, XLVIII, 248, 249, 251, 253, 255, and other letters in the same file.

81. Ibid., XXXIX, 457 (quoted in part in Foster, *Study*, 1:596 n. 942): "al concepto mostrava V.M. averne facto"; "per tucto una buona aria molto conforme alla valitudine vostra."

82. ASF, MaP, CXLVIII, 40, is the private version of the agreement signed by Lorenzo himself and Guglielmo: "nel contado di Volterra et di Pisa, et e quali si chomprehendono sotto el nome dello Spedaletto et Agnano, et altri luoghi d'Altopascio confinati." Niccolò Capponi kindly gave me a copy of the longer Latin version of July, preserved in his family archive; see also ASF, Notarile Antecos., 21067, fols. 126r–130r, 150r–162v, 23.viii.1486. Earlier Medici interests in the area (see above, n. 79) concerned the Cambio guild, which played a role I cannot precisely determine in the exchange of 1486 (ASF, Cambio, 104, fols. 19v, 20r).

83. As a document concerning Spedaletto kindly shown me by Caroline Elam reveals: ASF, Signori e Collegi, Deliberazione (ordinaria autorità), 124, fol. 52v, 6.vi.1522.

84. Lorenzo Cieffi wrote to Lorenzo "allo Spedaluzzo" on 12.ix.1486 (ASF, MaP, XXXIX, 563).

85. BNF, Fondo Ginori Conti, 29, 68, fol. 41, 10.v.1487 (quoted in Foster, *Study*, 1:606 n. 965, with an incorrect date): "A giornni pasatti venono qui a vedere questa forteza qualchuno de' maestri di murare che murano alo Spedaletto del Magnifico Lorenzo, e domandandogli di quella muraglia e anchora del paese, me ne disero molto bene." The laborers are quoted as saying that "se lui [Pitti] aveva a governare questa posesione, no' si farebe chosa bu[o]na e che senpre minaci[a]va di busse e d'amazare."

86. ASF, MaP, CIV, 10, fol. 90.

87. Description of 1495, published in G. C. Romby, "Novità documentarie sulla villa di Spedaletto," in Fubini, *La Toscana al tempo di Lorenzo il Magnifico*, 1:173–82. See also idem, "La villa di Spedaletto," in Morolli, Luchinat, and Marchetti, *L'architettura di Lorenzo*, 212–14. Romby's is the best account of Spedaletto, Foster's pioneering work being marred by factual errors (see Foster, *Study*, 1:305–6).

88. Carusi, *Dispacci e lettere di Giacomo Gherardi*, 9, 20.ix.1487.

89. Lorenzo de' Medici, *Protocolli*, 407, 2.i.1490: "Al factore dello Spedalecto, e maestro Thomaso Marinari, pel Cronacha"; Elam, "Lorenzo de' Medici and a Frustrated Villa Project," 487 n. 9.

90. Francesco Malatesta to Francesco Gonzaga, 2.iv.1501, in A. Luzio, *La Galleria dei Gonzaga venduta all'Inghilterra nel 1627–28* (1913; reprint, Rome, 1974), 199. See also B. L. Brown, "Leonardo and the Tale of Three Villas: Poggio a Caiano, the Villa Tovaglia in Florence, and Poggio Reale in Mantua," in *Firenze e la Toscana dei Medici nell'Europa del –500*, 3 vols. (Florence, 1983), 3:1053–62; idem, "An Enthusiastic Amateur: Lorenzo de' Medici as Architect," *RQ* 46 (1993): 1–22 (16–19); and C. von Fabriczy's note in *Repertorium für Kunstwissenschaft* 26 (1903): 93–95. There is no reference to this

Lorenzo in Lorenzo de' Medici's *Protocolli*. It is, however, intriguing that he, the son of the well-documented master builder Giovanni da Monte Aguto, married Giuliano da Maiano's daughter Lucrezia in 1483 and was in charge of the fortifications at Poggio Imperiale in 1506–7 (F. Quinterio, *Giuliano da Maiano "Grandissimo Domestico"* [Rome, 1996], 46, 83, 86, 97; L. Masi, *La fortezza di Poggio Imperiale a Poggibonsi* [Poggibonsi, 1992], 89).

91. On Strozzi, see A. Lillie, "The Patronage of Villa Chapels and Oratories near Florence: A Typology of Private Religion," in *With and Without the Medici: Studies in Tuscan Art and Patronage, 1434–1530*, ed. E. Marchand and A. Wright (Aldershot, 1998), 19–46 (38). Tuohy, *Herculean Ferrara*, 193, comments on towers and game spotting.

92. Carusi, *Dispacci e lettere di Giacomo Gherardi*, 1, 9, 13; M. M. Bullard, *Lorenzo il Magnifico: Image and Anxiety, Politics and Finance* (Florence, 1994), 56 n. 47, which cites Lorenzo saying on 6.x.1487 that "sono tornato parte per pigliare un poco più di questa aria buona, ma non meno per la cagione che intenderai apresso."

93. Valori, *Vita di Lorenzo*, 122; Lorenzo de' Medici, *Protocolli*, 379, 380, 401, 410, 423, 426, 427, 437.

94. Manfredo de' Manfredi to the duke of Ferrara, 31.viii.1491, published in A. Cappelli, "Lettere di Lorenzo de' Medici conservate nell'Archivio Palatino di Modena," *Atti e Memorie delle RR Deputazioni di Storia Patria per le Provincie di Modena e Parma* (sez. di Modena) 1 (1863): 309. Manfredi's letter to Duke Ercole of 27.v.1489 is in ASMod, Cancelleria Ducale, Estero, Ambasciatori (Firenze), 7: "Il Magnifico Lorenzo heri cavalchò su quel de Vultera a certi suo poderi chiamase li Hospedaletti. Credese li starà per qualche giorni, essendo ito per bevere la aqua deli bagni como feze anche lo anno passato."

95. Spallanzani and Gaeta Bertelà, *Libro d'inventario*, 242–45.

96. Filippo da Gagliano to Niccolò Michelozzi, 18.ix.1490, quoted in Martelli, *Studi Laurenziani*, 214 n. 130.

97. See Spallanzani and Gaeta Bertelà, *Libro d'inventario*, 242–45 (131–62 for Careggi); and Lillie, "Florentine Villas," 268ff.

98. C. Elam, "Art and Diplomacy in Renaissance Florence," *RSA Journal* 136 (1988): 813–26 (818–20), which corrects the dating of H. Horne, "Quelques souvenirs de Sandro Botticelli," *Revue Archeologique* 39 (1901): 12–19. Horne could still discern traces of the cycle despite a fire in the early nineteenth century. R. Lightbown, *Sandro Botticelli*, 2 vols. (London, 1978), 1:97–98, 183, and 2:218, discusses the scarce evidence well and concludes that the cycle was painted about 1490.

99. Lorenzo wrote a letter on Ghirlandaio's behalf in March 1492, however (Lorenzo de' Medici, *Protocolli*, 488). See now J. K. Cadogan, *Domenico Ghirlandaio, Artist and Artisan* (New Haven, Conn., 2000), esp. x, 19, 166, 286–88. For Lippi, see J. Nelson, "Aggiunte alla cronologia di Filippino Lippi," *Rivista d'Arte* 43 (1991): 33–57, esp. 44. Botticelli wrote to Lorenzo in 1484. On this lost letter, see L. Taylor-Mitchell, "Botticelli's San Barnaba Altarpiece: Guild Patronage in a Florentine Context," in *The Search for a Patron in the Middle Ages and Renaissance*, ed. D. G. Wilkins and R. L. Wilkins (Lewiston, N.Y., 1996), 115–35, citing an as yet unpublished document discovered by L. Fusco (128–29). On 17.xii.1490 Lorenzo wrote on Sandro di Botticello's behalf

(Lorenzo de' Medici, *Protocolli*, 432; and he may be the "Sandro nostro" of a letter of 1484, in ibid., 305). Three Roman letters of Antonio Tornabuoni to Lorenzo mention *en passant* a "Botticiello" (evidently in correspondence with Medici) at the time when the painter was employed at the Sistine Chapel (ASF, MaP, XXXIX, 385, 20.xii.1483; ibid., LV, 20, 3.i.1484, and 37, 13.iii.1483). Other, indirect evidence linking Sandro and Lorenzo includes the latter's being present at the meeting in which the painter was voted payment "pro eius labore in pingendo proditores," the effigies of the executed Pazzi conspirators (ASF, Otto di Guardia, 48, fol. 35v, 21.vi.1478, published in H. P. Horne, *Botticelli* [Princeton, 1980], 350).

100. For the interpretation of the painting as the triumph of rhetoric, see C. Villa, "Per una lettura della 'Primavera': Mercurio 'retrogrado' e la retorica nella bottega di Botticelli," *Strumenti Critici* 13 (1998): 1–28. C. Dempsey, *The Portrayal of Love* (Princeton, 1992), argues for Lorenzo's direct patronage, and another recent writer takes for granted Lorenzo's commissioning the *Primavera* (F. Zöllner, *Botticelli: Images of Love and Spring* [Munich, 1998], 37, 64). A sympathetic reader of Dempsey's book such as Sir John Pope-Hennessy was not, however, convinced (see Pope-Hennessy's *On Artists and Art Historians: Selected Book Reviews of John Pope-Hennessy*, ed. W. Kaiser and M. Mallon [Florence, 1994]. 98–108; and see now N. Rubinstein, "Youth and Spring in Botticelli's *Primavera*," *JWCI* 60 [1997]: 248–51). For the paintings in Lorenzo's possession, see Spallanzani and Gaeta Bertelà, *Libro d'inventario*, 80, 94.

101. Isabella d'Este's comment in a letter to Francesco Gonzaga—"che volendo sempre vincere, o per uno modo o per un'altro" (ASMan, Archivio Gonzaga, 2107, fasc. II, fol. 158, i.vii.1491)—was a response to his letter of 28.vi.1491 saying that Lorenzo had in effect cheated (ibid., fasc. I, 2, fol. 52). I owe these references to Carolyn James. On Lorenzo's early competitiveness, see F. W. Kent, "The Young Lorenzo, 1449–1469," in Mallett and Mann, *Lorenzo the Magnificent*, 1–22 (esp. 1, 4–5).

102. M. Baxandall, *Painting and Experience in Fifteenth-Century Italy*, 2d ed. (Oxford, 1989), publishes the document and comments on the fact that the painters "are seen very much as individuals in competition" (26).

103. See A. Wright, "Dancing Nudes in the Lanfredini Villa at Arcetri," in Marchand and Wright, *With and Without the Medici*, 47–77.

104. Lorenzo de' Medici, *Protocolli*, 395 (with another reference to Filippo on 433). In a letter of 31.viii.1490 kindly brought to my attention by Laurie Fusco, Nofri Tornabuoni reported to Lorenzo that since Filippino Lippi was at Viterbo, "nonn ò possuto intendere da llui di quella cholonna del porfido" (ASF, MaP, XLII, 140). For both letters, see now L. Fusco and G. Corti, *Lorenzo de' Medici, Collector and Antiquarian* (New York, 2004), docs. 125, 140.

105. The quotation is in ASF, MaP, XL, 1385, Giovanni Lanfredini to Lorenzo, 4.viii.1488: "Saracci due lettere del Cardinale di Napoli al Abbate de' Mazinghi, e avisa le conclusione di Philippo dipintore a vostra contemplatione, el quale partì hiermattina con 100 ducati." Nofri Tornabuoni's report of 7.v.1490 to Lorenzo on Lippi is published in Bullard, *Lorenzo il Magnifico*, 31. See, generally, G. L. Geiger, *Filippino Lippi's Carafa Chapel* (Ann Arbor, 1986), 45–48, 186–87; and A. Chastel, "La chapelle Carafa à l'église de la Minerve," *Bibliotheque d'Humanisme et de Renaissance* 50 (1988): 111–19.

106. Cardinal Oliviero Carafa to Gabriele Mazzinghi, 2.ix.1488, published in Geiger, *Filippino Lippi's Carafa Chapel,* 186–87.

107. Giorgio Vasari, quoted in Cadogan, *Domenico Ghirlandaio,* 287.

108. Wright, "Dancing Nudes". Lillie, "Florentine Villas," 268–74, discusses the taste displayed in country houses.

109. T. F. K. Henry, "The Career of Luca Signorelli in the 1490s," 2 vols. (Ph.D. thesis, University of London, 1996), 1:56.

110. Vasari is quoted in ibid., 52 n. 128. For more recent literature citing the extensive bibliography, see ibid.; S. Kury, *The Early Works of Luca Signorelli: 1465–1490* (New York- London, 1978); and D. McLellan, "The Great God Pan Reborn in Renaissance Florence," *Spunti e Ricerche* 14 (1999): 74–90.

111. Spallanzani and Gaeta Bertelà, *Libro d'inventario,* 230–31.

112. Ibid., 228–33.

113. Lorenzo de' Medici, *Protocolli,* 388. See also Salvadori, *Dominio e patronato,* 172–73; and ASF, Notarile Antecos., 17126, fols. 499r–502v, 516r–524r.

114. ASF, MaP, LIX, 142, Lorenzo to Giovanni Lanfredini, 6.iv.1488: "[The bearer] ve informerà d'una renuntia che s'è facta in beneficio de' frati di Monte Uliveto che stanno ad Agnano, alli quali sapete quanta affection et reverentia io ho, el quale sono stato auctore di questa renuntia et non vorrei che qualchuno che la intendessi si levassi contra questo mio proposito." See also Lorenzo de' Medici, *Protocolli,* 372, 432. Salvadori, *Dominio e patronato,* 172–80, cites the documents concerning the Olivetan donation of property. It is not clear whether Lorenzo rebuilt the church, as a contemporary Benedictine claimed (see above, chap. 4).

115. Valori, *Vita di Lorenzo,* 122.

116. ASF, MaP, XLI, 191, Giovanni at Agnano to Lorenzo, 20.vi.1489: "Deli murattori, ànno muratto una porta della chorte hordinata, e chosì murano le doccie."

117. Ibid., 290, 22.viii.1489: "El chondotto che si murava quando voi v'eri"; "Io hone trovatto una pila sotteratta in una chorte, ch'ène lungha bracia trene e dua terzi, e largha bracia uno e quarti trene, e òne fatto pensiero di mettela le boche de' chondotti, dov'era ordinato di fare la fonte, salvo volendo voi." See also Fusco and Corti, *Lorenzo de' Medici, Collector,* doc. 128.

118. ASF, MaP, XLI, 120, 21.v.1489: "li mori si fanno belli"; ibid., 191, 20.vi.1489: "E porci salvatichi ci ànno mangiatto uno chanpo di grano, dove si puosono e chiriegi e meli apiè de' romitoro."

119. Lorenzo de' Medici, *Protocolli,* 402.

120. ASF, MaP, XL, 225, Francesco Nacci to Lorenzo, 14.iii.1488 (whether the date is in the Florentine style is not clear).

121. Ibid., XLI, 265, Giovanni Cambi to Lorenzo, 6.viii.1489: "Questa mattina è venuto da Angnano il Francone e mi dice avere misurato il luogho dove far volete la choniglera, . . . lo quale non vuol principiare prima che voi lo riveggiate, dicendo che istà una parte d'esso donde andar s'arebbe chol muro in un certo modo che nnon ve lo saprebbe disegnare." See also G. Lubkin, *A Renaissance Court: Milan under Galeazzo Maria Sforza* (Berkeley and Los Angeles, 1994), 44.

122. ASF, MaP, XLI, 21, Giovanni Cambi to Lorenzo, 2.i.1490: "In detto luogho

d'Angnano si seghuita li fondamenti, e non vi resta a ffare se nnon quello della logga di verso il gardino. Parmi abbino preso errore un braco nella lungheza che stimo maestro Piero muratore, sendo chosti venuto, ve ne doverrà aver detto ànno fatto in tutte le chamere e logge sole di sopra, la misura appunto e tale errore d'un braco, e in questo ultimo il quale soprassederanno di fare sino a vostra venuta."

123. Ibid., LXXIII, 429, 17.i.1490: "e fondamenti della chasa sono tutti muratti al piano della tera [except the loggia area], e tutti egli atri sono cholle misure che voi lasciasti d[i] punto."

124. Ibid., XLI, 12: "A Angnano nonn è seghuito altro di nuovo. Piero Chapponi ve n'arà raghuaglato, che questa mattina vi desinò e assai se ne satisfece."

125. BNF, Fondo Ginori Conti, 29, 69, 21, 20.ii.1490: "El padrone pare che ragioni d'andare verso Pisa, per essere a Agniano dove doverrà stare parecchi dì."

126. Lorenzo de' Medici, Protocolli, 416.

127. Ibid., 520, 522, two letters of 1474 written by Lorenzo on Maestro Graziadio's behalf. For Piero, see above, n. 122; and Spallanzani and Gaeta Bertelà, Libro d'inventario, 232.

128. Spallanzani and Gaeta Bertelà, Libro d'inventario, 241: "chasa, overo palagio da signore fornito secondo il modello." The drawings are illustrated in Foster, Study, vol. 2, plates cx, cxi.

129. ASF, MaP XLI, 120: "Lo Francone nonn è mai ritornnato da Serezzana e per ta' chagone non chonseghuita il farsi a Agnano quanto a llui avate ordinato. Evi fornnito tutte 3 le schale da andare nell'orto, e vi sono chotte doce assai per potere dar principio al chondur l'aqua, la qual chosa si principierà chome il Francone vengha."

130. The Otto di Pratica reproved him for his absence from Sarzana, to the detriment of the building campaign there, on 30.iii.1489 (ASF, Otto di Pratica, Missive, 12, fols. 88v–89v; see also fol. 101v, 6.iv.1489). Their letter to Iacopo Venturi of 30.iii.1489 states that Francione "è a Agnano o in costà" (ibid., fol. 87v).

131. ASM, Archivio Sforzesco, 312, Branda da Castiglione to the duke of Milan, 11.ix.1490: "per andare a Pisa ad visitare le sue possessioni et li dicessi starà per xv giorni."

132. Filippo da Gagliano to Niccolò Michelozzi, 18.ix.1490, published in Martelli, Studi Laurenziani, 214 n. 130: "dove si mura forte."

133. ASF, MaP, LXXXVIII, 227, 273: "Richordo di quanto lascio si facia a Angnano questo dì xiii di diciembre."

134. Lorenzo de' Medici, Protocolli, 468.

135. Ibid., 484.

136. Harvard School of Business Administration, Baker Library, Selfridge Collection, no. 273, Lorenzo to Piero Alamanni, 7.xii.1491: "Io mi truovo a [A]gnano, dove ho trovato Messer Giovanni mio figluolo."

137. Giovanni to Piero da Bibbiena, 13.i.1492, published in G. B. Picotti, La Giovinezza di Leone X (1928; reprint, Rome, 1981), 621.

138. ASF, Carte Strozziane, 3d ser., CLXXVII, fols. 212r–213v, 2.vii.1494, concession by Piero de' Medici and brothers to Francesco Cybo of the "luogo detto Agnano col palagio da S[ignore] nuovo, et non ancora interamente finito, et con giardini, case

da lavoratori, fattoio da olio, fornace da mattone et calcina, terreni lavorati, vignati, ulivate et seme pasture."

139. Ibid.; ASF, Decima Repubblicana, 31, fols. 685r–687v, Cybo's taxation declaration for 1498. Maddalena's dowry had already included lands at Spedaletto (Matteo Franco, *Lettere,* ed. G. Frosini [Florence, 1990], 39).

140. Spallanzani and Gaeta Bertelà, *Libro d'inventario,* 241: "Agnano chom più chase da lavoratore, fattoio da olio a aqua et chasa, overo palagio da signore fornito secondo il modello." Later in this document Agnano is described as "El palagio chominciato coll'orto, vivaio, pratelli—, stalle, tinaia, colombaie e pollai, corte e cortili e loggie e parte del palagio fornito."

141. Giovanni Pontano, "Il Trattato dello Splendore," 277.

142. ASF, MaP, XLI, 24, 13.i.1490: "quando v'achomoderà fare che chotesti del bancho facino buono qualche danaro; chome v'è noto, chontinuamente vi si spende."

143. Ibid., XXXIII, 31, 20.iii.1476: "egli è venuto el maestro del chondotto da Viterbo e ògli mostrato tutte l'aque e chosì gli ò mostro donde la s'à a chundurrre. Ora dice volersi achozzare cho'lla Vostra Magnificenza, siché pertanto avisatemi se voi volete che noi vegniamo chostà o volete lo facci aspettare qua." See, more generally, Foster, *Study,* vol. 1, chaps. 2, 3; Salvadori, *Dominio e patronato,* 163–66; and now A. Menzione and A. M. Pult Quaglia, "La proprietà medicea e le cascine di Poggio a Caiano," in *Carmignano e Poggio a Caiano,* ed. A. Contini and D. Toccafondi (Florence, 2001), 85–105.

144. Lorenzo de' Medici, *Protocolli,* 175, 184, 186, 187.

145. ASF, MaP, XL, 207, Lionardo Pucci to Lorenzo, 17.ii.1489.

146. Dempsey, "Lorenzo de' Medici's *Ambra,*" esp. 181–82.

147. Kent, "Lorenzo de Medici's Acquisition of Poggio a Caiano," 253.

148. ASF, MaP, XCIII, 308, Otto di Prato to Lorenzo, 20.vi.1477; Lorenzo de' Medici, *Lettere,* vol. 1, *1460–1474,* ed. R. Fubini (Florence, 1977), 437 n. 3.

149. ASF, Consiglio del Cento, Registri, 3, fol. 60r, 15.i.1491: "potrebbe acommodare a Lorenzo di Piero de' Medici, et non arecherebbe alcuno sinistro al chomune"; the quoted matter also occurs in ASF, Balìe, 39, fol. 24v.

150. Lorenzo de' Medici, *Protocolli,* 516, 521. For Marchetti and Lorenzo in Pistoia, see Connell, *Città dei crucci,* 97, 101.

151. Lorenzo de' Medici, *Protocolli,* 304.

152. ASF, MaP, XXXIX, 476, Lorenzo Corsi to Lorenzo, 30.iv.1486.

153. Kent, "Lorenzo de Medici's Acquisition of Poggio a Caiano," 254–55.

154. Lorenzo de' Medici, *Ambra (Descriptio Hiemis),* 32 n. 27.

155. Lorenzo de' Medici, *Lettere,* vol. 7, *1482–1484,* ed. M. Mallett (Florence, 1998), 36, 23.viii.1482.

156. ASM, Archivio Sforzesco, 312, Giovanni Angelo Talenti to the duke of Milan, 29.viii.1491: "et s'è facto condu[c]ere al Pogio in carretta per non potere cavalchare."

157. See above, chap. 3; and for Lucrezia, see Kent, "Sainted Mother, Magnificent Son," 29.

158. ASF, MaP, CIV, inserto 53, fol. 519r, inventory of Poggio a Caiano dated 29.ix.1480.

159. Ibid. This must be the "quadro dentrovi dua fighure di giesso di mezo rilievo che vanno in uno letto non di troppa valuta, fiorini—10," mentioned in Francesco Cegia's diary (G. Pampaloni, "I ricordi segreti del medíceo Francesco di Agostino Cegia [1495–1497]," *ASI* 115 [1957]: 188–234 [229]). For the idea that the cast was made after the famous antique relief of the *Letto di Polícleto*, a version of which had been owned by Lorenzo Ghiberti, see Fusco and Corti, *Lorenzo de' Medici, Collector*, chap. 8, x. L. Barkan, *Unearthing the Past* (New Haven, Conn., 1999), 152, discusses the eroticism of some ancient sculpture admired in the Renaissance.

160. Harvard School of Business Administration, Baker Library, Selfridge Collection, no. 103, Lorenzo to Piero Alamanni, 23.viii.1489. See also Lorenzo de' Medici, *Protocolli*, 1:368 n. 202.

161. Tribaldo de' Rossi, *Ricordanze*, in *Delizie degli eruditi toscani*, ed. I. di San Luigi, 23 (Florence, 1786), 247.

162. ASF, MaP, XXXXV, 228, 22.iv.1486: "Havendo inteso che la Magnificentia Vostra fa una possessione de novo, et che non è fornita de' bovi per cultivarla."

163. Foster, *Study*, vol. I, chap. 2. Dates in the early 1480s are proposed by some scholars on other grounds. See, e.g., G. Marchini, "Leonardo e le scale," *Antichità Viva* 24 (1985): 180–85; and G. Morolli, "Lorenzo, Leonardo e Giuliano: Da San Lorenzo al Duomo a Poggio a Caiano," *Quaderni di Storia dell'Architettura e Restauro* 3 (1990): 5–14. See also J. Shearman, "Il mecenatismo di Giulio II e Leone X," in *Arte, committenza ed economia a Roma e nelle corti del Rinascimento (1420–1530)*, ed. A. Esch and C. L. Frommel (Turin, 1995), 213–42 (233–34); and C. Rousseau, "Botticelli's Munich *Lamentation* and the Death of Lorenzo de' Medici," *Konsthistorisk Tidskrift* 59 (1990): 243–64.

164. See above, chap. 4.

165. Poliziano, *Silvae*, 158–59, 297.

166. Francesco Baroni, quoted in full in Foster, *Study*, 1:67–68.

167. Michelle Verino, undated letter to Simone Canigiani, published in A. F. Verde, *Lo studio fiorentino, 1473–1503*, 5 vols. (Florence, 1973–94), 3, pt. 2:696; Verde believes that this letter dates from 1485.

168. Ferrai, "Lettere inedite di Donato Giannotti," 1578 (a passage first cited by D. Coffin in his review of Foster's *Study* in *BM* 122 [1980]: 350–51). See also G. Pampaloni, *Palazzo Strozzi* (Rome, 1982), 95–96; and Landucci, *Diario fiorentino*, 58.

169. ASF, MaP, XLII, 172, Nofri Tornabuoni to Lorenzo, received on 7.ix.1490: "dapoi che me dicesti avere chominciato a ffabrichare il palazzo del Poggio." Some years ago Laurie Fusco most generously brought this letter to the attention of scholars; see, e.g., P. Foster, *La villa di Lorenzo de' Medici a Poggio a Caiano*, trans. A. Ducci (Poggio a Caiano, 1992), 98, 113 n. 11; and now Fusco and Corti, *Lorenzo de' Medici, Collector*, doc. 141.

170. BNF, Fondo Ginori Conti, 29, 3421539, 18.ix.1490 (partly edited in Martelli, *Studi Laurenziani*, 214 n. 130): "Al Poggio si mura forte e non vedesti mai la più bella cosa. E riesce, e di già comincia a parere dischosto." My thanks to Alison Brown for providing a photocopy of this difficult passage and discussing it with me.

171. ASF, MaP, LVI, 11, Piero da Bibbiena to Lorenzo, 26.v.1491, first quoted in Foster, *Study*, 1:390 n. 282: "sono ritornati cum stupore non solamente con admira-

tione di quelle cose, et messer Branda [da Castiglione] ne parla tanto honorevolemente che no' crede mai potere vedere simile cose. Quella muraglia in sino a qui pare loro delle cose vostre et uno bel principio et conveniente a quella possessione."

172. R. F. Dalzell and L. Baldwin Dalzell, *George Washington's Mount Vernon* (New York, 1998), 208.

173. See F. W. Kent, "Lorenzo de' Medici at the Duomo," in *La cattedrale e la città: Saggi sul Duomo di Firenze, atti del VII centenario del Duomo di Firenze*, 3 vols., ed. T. Verdon and A. Innocenti (Florence, 2001), 1:350 n. 56; and the additional information, including permission to acquire timber in 1487, in L. Zangheri, "Lorenzo il Magnifico in alcuni documenti dell'Opera di S. Maria del Fiore," *Quaderni di Storia dell'Architettura e Restauro* 6–7 (1992): 19–23.

174. BNF, Fondo Ginori Conti, 29, 3421539, 18.ix.1490: "e di già comincia a parere dischosto in modo la vorrà vedere presto; e prima che non farà lo Strozzo, non mutando modo di fare co' capitali ecc."

175. Ercole d'Este, quoted in F. W. Kent, "'Più superba de quella de Lorenzo': Courtly and Family Interest in the Building of Filippo Strozzi's Palace," *RQ* 30 (1977): 311–24.

176. I thank Alison Brown for drawing to my attention these undated *volgare* letters in Biblioteca Riccardiana, Florence, Manoscritti 2621 (see also Verde, *Studio fiorentino*, 3, pt. 2:670–96). At fols. 212v–213r Verino says of the Palazzo Strozzi that "la sua egregia e grande muraglia si crede pe' più che la si fornirà, perché si dice così nel testamento havere deliberato. Ma e più savii di questo molto dubitono. Et perché non si può per l'angustia epistolare tutte le ragioni explicare, nè anche sanza pericolo ogni cosa si scrive, però a bocha di questo ti dirò tutto quello che sento." Later he adds that "non penso che con celerità nè con quella diligentia che lui haveva, mai si fornisca," again hinting at hidden reasons, which will, however, be readily understood. Writing of Poggio at fol. 181r, he states his strong preference for "una bella libreria" over a fine villa. For Lorenzo as executor of Filippo's will, see G. Gaye, *Carteggio inedito d'artisti dei secoli xiv, xv, xvi*, 3 vols. (Florence, 1839), 1:362–63. On Verino's cultural, if not political, ambivalence about Lorenzo's rôle in Florence, see Ugolino Verino, *Epigrammi*, ed. F. Bausi (Messina, 1998), 136–40, 537–38.

177. Parenti, *Storia fiorentina*, 21.

178. ASF, Decima Repubblicana, 28, fol. 457v: "Uno chasamento overo palago, il quale sechondo il modello fatto è fornita la terza parte, e l'altre due parte è fatti i fondamenti tutti e parte delle mura, chon logge e portici atorno e ringhiera e schale fuori."

179. Dempsey, "Lorenzo de' Medici's *Ambra*," 179.

180. See above, n. 170. For the "palazzo di mecenate" and Poggio, see C. Brothers, "Reconstruction as Design: Giuliano da Sangallo and the 'palazzo di mecenate' on the Quirinal Hill," *Annali di Architettura* 14 (2002): 55–72.

181. Giorgio Vasari, quoted in Kent, "Lorenzo de' Medici's Acquisition of Poggio a Caiano," 255.

182. Piero di Lorenzo de' Medici to Lodovico Sforza, 5.x.1492, reprinted in L. H. Heydenreich, "Giuliano da Sangallo in Vigevano, ein neues Dokument," in *Scritti*

di storia dell'arte in onore di Ugo Procacci, ed. M. G. Ciardi Dupré dal Poggetto and P. dal Poggetto (Florence, 1977), 2:321–23.

183. ASF, MaP, LVI, 11, Piero da Bibbiena to Lorenzo, 26.v.1491: "Dicono che se'l Signor Lodovico vedessi quelle cose non li piacerebbe quella che ha facta, et in somma piacque loro supramodum." I thank Caroline Elam for helping me to improve upon my interpretation of this passage.

184. Pontano, "Il Trattato dello Splendore," 277.

185. F. W. Kent, "Palaces, Politics, and Society in Fifteenth-Century Florence," *I Tatti Studies* 2 (1987): 41–70, esp. 63–65. For Milan, see S. Lyons Caroselli, "The Casa Marliani and Palace Building in Late Quattrocento Lombardy" (Ph.D. diss., Johns Hopkins University, 1980); and for painting over brick and stone, P. Hills, *Venetian Color* (New Haven, Conn., 1999), 79.

186. Paolo Giovio, quoted in G. Billings Licciardello, "Notes on the Architectural Patronage in Bologna of the Bentivoglio" (Ph.D. diss., Columbia University, 1990), 182. See also R. Tamborrino, "Bologna, xv–xiv secolo: Società d'arte, potere e significati dello spazio urbano," in *Fabbriche, piazze, mercati: La città italiana nel Rinascimento,* ed. D. Calabi (Rome, 1997), 408–56; and C. James, "The Palazzo Bentivoglio in 1487," *MKIF* 40 (1997): 188–96.

187. Leon Battista Alberti, quoted and discussed in J. S. Ackerman, *The Villa* (Princeton, 1990), 76.

188. Document of 1468, published in Nanni, *Lorenzo agricoltore,* 30.

189. See Maso Finiguerra, *A Florentine Picture-Chronicle,* ed. S. Colvin (New York, 1980).

190. In 1495 "il chasamento che si chiama l'Anbra" was described as "parte rovinata e disfatto" (ASF, Decima Repubblicana, 28, fol. 457v).

191. Valori, *Vita di Lorenzo,* 67–68, 72, 121–22, 127.

192. Naldo Naldi, quoted in Foster, *Study,* 1:77–78.

193. Gregorio Dati, quoted in C. Gilbert, "The Earliest Guide to Florentine Architecure, 1423," *MKIF* 14 (1969–1970): 33–46 (46).

194. G. Pozzi, "Da Padova a Firenze nel 1493," *Italia Medioevale e Umanistica* 9 (1966): 191–227 (198).

195. Ugolino Verino, in Biblioteca Riccardiana, Florence, Manoscritti 2621, fol. 213r: "suo admirando edificio et mole regale."

196. Horace, *The Odes and Epodes,* trans. C. E. Bennett (London, 1924), 146–47.

197. Vitruvius, *The Ten Books on Architecture,* trans. M. H. Morgan (1914; reprint, New York, 1960), 182. On da Sangallo's correct use of the classical orders there, see J. Onions, *Bearers of Meaning: The Classical Orders* (Princeton, 1988), 189–91.

198. The quotations are from K. W. Forster's review of Foster's *Study,* in *Journal of the Society of Architectual Historians* 41 (1982): 158–59. For Bernardo Rucellai, see Kent, "Lorenzo de' Medici's Acquisition of Poggio a Caiano," 254.

199. G. Smith, review of *Dynasty and Destiny in Medici Art,* by J. Cox-Rearick, *AB* 69 (1987): 304–7. For the originality of Lorenzo's Poggio, see Ackerman, *Villa,* chap. 3.

200. J. Cox-Rearick, "Themes of Time and Rule at Poggio a Caiano: The Portico Frieze of Lorenzo il Magnifico," *MKHI* 26 (1982): 167–210; idem, *Dynasty and Destiny*

in Medici Art, 65–86. Other, often overlapping interpretations include F. Landi, *Le Temps revient: Il fregio di Poggio a Caiano* (San Giovanni Valdarno, 1986); and C. Acidini Luchinat, "La scelta dell'anima: Le vite dell'iniquo e del giusto nel fregio di Poggio a Caiano," *Artista: Critica dell'Arte in Toscana* 3 (1991): 16–25.

201. See, for the quotation, above, chap. 3. See also J. D. Draper, *Bertoldo di Giovanni: Sculptor of the Medici Household* (Columbia, Mo., 1992), 197–220; and C. Acidini Luchinat, "Di Bertoldo e d'altri artisti," in *La casa del cancelliere,* ed. A. Bellinazzi (Florence, 1998), 91–119. Draper dated the design of the frieze to about 1479–80 on stylistic grounds (*Bertoldo di Giovanni,* 217), and I have to assume that it was executed (and possibly put in place) after 1490, when building proper began. See also A. Chastel, *Art et humanisme à Florence au temps de Laurent le Magnifique* (Paris, 1961), 151–57, 217–25 (225).

202. Lorenzo to Ercole d'Este, 5.ii.1486, in Lorenzo de' Medici, *Scritti scelti,* ed. E. Bigi (Turin, 1977), 636.

203. Francesco Filelfo to Lorenzo, 8.vii.1477, quoted in Verde, *Studio fiorentino,* 4, pt. 1:267.

204. G. Ianziti, *Humanistic Historiography under the Sforzas* (Oxford, 1988), 217–21, 230–31, 238–39; A. Brown, "Between Curial Rome and Convivial Florence: Literary Patronage in the 1480s," in *The Medici in Florence: The Exercise and Language of Power* (Florence, 1992), 247–62, esp. 259–60. See also R. M. Comanducci, "Nota sulla versione landiniana della Sforziade di Giovanni Simonetta," *Interpres* 12 (1992): 309–16.

205. Ermolao Barbaro to Giovanni Pico della Mirandola, 1.i.1489, quoted in S. Gentile, "Pico e la biblioteca medicea privata," in *Pico, Poliziano e l'umanesimo di fine Quattrocento,* ed. P. Viti (Florence, 1994), 85–101 (85).

206. Parenti, *Storia fiorentina,* 21.

207. M. M. Bullard and N. Rubinstein, "Lorenzo de' Medici's Acquisition of the *Sigillo di Nerone,*" *JWCI* 62 (1999): 283–86. Fusco and Corti stress the achievements of the period 1484–92 in *Lorenzo de' Medici, Collector,* chap. 2; and for this gem, see ibid., chap. 5, iv, nn. 44 and 45, and docs. 79, 80, 82, 171.

208. Hills, *Venetian Color,* 21.

209. Quoted from Poliziano's *Orationes* by Fusco and Corti, *Lorenzo de' Medici, Collector,* doc. 212; see also ibid., chap. 1, n. 114.

210. The first quotation, of 27.iv.1502, appears in C. M. Brown, "I vasi di pietra dura dei Medici e Ludovico Gonzaga Vescovo eletto di Mantova (1501–1502)," *Civiltà Mantovana,* n.s., 1 (1983): 63–68. For the second, a letter from Malatesta of 12.v.1502, see A. Luzio, "Ancora Leonardo da Vinci e Isabella d'Este," *Archivio Storico dell'Arte* 1 (1888): 181–85 (182). See also S. Hickson, "Un concorrente per le collezioni antiquarie di Isabella d'Este: Ludovico Gonzaga e i vasi Medicei," in *Isabella d'Este: La primadonna del Rinascimento,* ed. D. Bini (Mantua, 2001), 155–65; and, more generally, C. M. Brown, "'Lo insaciabile desiderio nostro de cose antique': New Documents on Isabella d'Este's Collection of Antiquities," in *Cultural Aspects of the Italian Renaissance,* ed. C. H. Clough (Manchester, 1976), 324–53, and idem, "Isabella d'Este e il mondo greco-romano," in Bini, *Isabella d'Este,* 109–27. The relevant documents are now republished in C. M. Brown, *"Per dare qualche splendore a la gloriosa città di Mantova": Documents*

for the Antiquarian Collection of Isabella d'Este (Rome, 2002), 148–54; see also 175, 287–88. See also Fusco and Corti, *Lorenzo de' Medici, Collector,* docs. 183–92.

211. Ancient coins might be so inscribed by a princely owner, however (see B. Simonetta and R. Riva, "'Aquiletta' Estense o 'Aquiletta' Gonzaga," in *Quaderni Ticinesi di Numismatica e Antichità Classiche* [Lugano, 1979], 359–73, kindly brought to my attention by Bette Talvacchia).

212. S. B. Butters, *The Triumph of Vulcan,* 2 vols. (Florence, 1996), 1:142, n. 71.

213. See N. Dacos, A. Giuliano, and U. Pannuti, eds., *Il tesoro di Lorenzo il Magnifico: Le gemme* (Florence, 1973), 14 n. 24, 137; and C. Acidini Luchinat, "The Library," in *Renaissance Florence: The Age of Lorenzo de' Medici, 1449–1492,* ed. C. Acidini Luchinat (Milan, 1993), 120. See the meticulous discussion of this issue by Fusco and Corti in *Lorenzo de' Medici, Collector,* chap. 6, iii.

214. For visitors viewing the collection, see above, chap. 2.

215. For Verino, see Verde, *Studio fiorentino,* 3, pt. 2:685; and for Becchi, F. Caglioti, "Donatello, i Medici e Gentile de' Becchi: Un po' d'ordine intorno alla 'Giuditta' (e al 'David') di Via Larga II," *Prospettiva* 88 (1995): 22–25 (48 n. 89).

216. Hills, *Venetian Color,* 167, 178, 232, n. 39; G. Clarke, "Magnificence and the City: Giovanni II Bentivoglio and Architecture in Fifteenth-Century Bologna," *RS* 13 (1999): 397–411 (406).

217. H. C. Butters, *Governors and Government in Early Sixteenth-Century Florence (1502–1519)* (Oxford, 1985), 78. See also N. Rubinstein, "Cosimo optimus civis," in *Cosimo "il Vecchio" de' Medici, 1389–1464,* ed. F. Ames-Lewis (Oxford, 1992), 5–20.

218. R. Rubinstein, "The Treasure of Lorenzo the Magnificent in Florence," *BM* 114 (1972): 804–8.

219. On the engraving of gems on signet rings in antiquity, see Pliny, *Natural History, Books XXXIII–XXXV,* trans. H. Rackham (1952; reprint, Cambridge, Mass., 1999), 19; and idem, *Natural History, Books 36–37,* trans. D. E. Eichholz (1962; reprint, Cambridge, Mass., 2001), 165.

220. Published in Dacos, Giuliano, and Pannuti, *Il tesoro di Lorenzo il Magnifico,* 128; the translation is in Fusco and Corti, *Lorenzo de' Medici, Collector,* chap. 6, iii, and doc. 247.

221. Suetonius, *The Lives of the Caesars,* ed. and trans. J. C. Rolfe, 2 vols. (London, 1960), vol. I, bk. 2; Augustus, *Res Gestae divi Augusti: The Achievements of the Divine Augustus,* ed. P. A. Brunt and J. M. Moore (Oxford, 1967), 1–8. I am grateful to Roger Scott for his helpful remarks on this subject.

222. P. Godman, *From Poliziano to Machiavelli: Florentine Humanism in the High Renaissance* (Princeton, 1998), 52–55; E. Borsook and J. Offerhaus, *Francesco Sassetti and Ghirlandaio at Santa Trinita, Florence* (Doornspijk, Netherlands, 1981), 53.

223. Suetonius, *Lives of the Caesars,* 1:207. See also A. Wallace-Hadrill, "*Civilis Princeps:* Between Citizen and King," *Journal of Roman Studies* 72 (1982): 32–48. Lorenzo's commissioning the *Scriptores Historiae Augustae* in 1479 is relevant here (see above, chap. 4).

224. Parenti, *Storia fiorentina,* 24.

225. Biblioteca Moreniana, Florence, Fondo Palagi, 267, fol. 5r, commonplace

book of Don Guido: "tandem da Dio et dallo strumento suo Laurentio ogni cosa abbiamo."

226. Alamanno Rinuccini, *Ricordi storici di Filippo di Cino Rinuccini del 1282 al 1460,* ed. G. Aiazzi (Florence, 1840), cxlix: "lui avere destinatosi nello animo di occupare la repubblica, e manifestamente di quella in se trasferire il dominio."

227. Giovanni Cambi, *Istorie,* vol. 20 of *Delizie degli eruditi toscani,* ed. I. di San Luigi (Florence, 1785), 67: "si facieva Signore a bachetta, sechondo el suo disegnio."

228. See J. Kliemann, *Gesta Dipinte: La grande decorazione nelle dimore italiane dal Quattrocento al Seicento* (Milan, 1993), esp. 35–36, and for Lorenzo's not collecting Augustan images, Dacos, Giuliano, and Pannuti, *Il tesoro di Lorenzo il Magnifico,* 29–30.

229. Parenti, *Storia fiorentina,* 24. Fra Giovanni da Prato used the Caesarian image upon Lorenzo's death (G. B. Picotti, *Scritti vari di storia pisana e toscana* [Pisa, 1968], 93–94).

230. D. Thornton, *The Scholar in His Study* (New Haven, Conn., 1997), 84–85; A. Luchs, "Lorenzo from Life? Renaissance Portrait Busts of Lorenzo de' Medici," *Sculpture Journal* 4 (2000): 6–23 (7).

231. T. S. Eliot, "The Hollow Men," in *Modern Poetry,* ed. M. Mack et al. (Englewood Cliffs, N.J., 1961), 165.

232. ASF, Tratte, 132 bis, *Priorista* of Francesco Gaddi, fol. 222v: "et morì in quel tempo che di vivere più dovea giovare"; Parenti, *Storia fiorentina,* 21–24.

233. J. Nelson, "Filippino Lippi at the Medici Villa of Poggio a Caiano," in *Florentine Drawing at the Time of Lorenzo the Magnificent,* ed. E. Cropper (Bologna, 1994), 159–74.

234. The second contemporary phrase is to be found in F. W. Kent, "'Un paradiso habitato da diavoli': Ties of Loyalty and Patronage in the Society of Medicean Florence," in *Le radici cristiane di Firenze,* ed. A. Benvenuti, F. Cardini, and E. Giannarelli (Florence, 1994), 183–210 (209). For the first phrase, see L. Gatti, "Displacing Images and Devotion in Renaissance Florence: The Return of the Medici and an Order of 1513 for the *Davit* and the *Judit,*" *Annali della Scuola Normale Superiore di Pisa* 23 (1993): 349–73 (361).

Index

Index